E-ON SOFTWARE'S
VUE 6 REVEALED

Richard Schrand

THOMSON

COURSE TECHNOLOGY

Professional ■ Technical ■ Reference

Publisher and General Manager, Thomson Course Technology PTR:
Stacy L. Hiquet

Associate Director of Marketing:
Sarah O'Donnell

Manager of Editorial Services:
Heather Talbot

Marketing Manager:
Heather Hurley

Acquisitions Editor:
Megan Belanger

Marketing Assistant:
Adena Flitt

Project Editor:
Kezia Endsley

Technical Reviewer:
Beth Rogers

PTR Editorial Services Coordinator:
Erin Johnson

Copy Editor:
Kezia Endsley

Interior Layout Techs:
Danielle Foster & Sue Honeywell

Cover Designer:
Mike Tanamachi

Indexer:
Sharon Shock

Proofreaders:
Gene Redding & Steve Honeywell

Thomson Course Technology PTR and the author have attempted throughout this book to distinguish proprietary trademarks from descriptive terms by following the capitalization style used by the manufacturer.

Information contained in this book has been obtained by Thomson Course Technology PTR from sources believed to be reliable. However, because of the possibility of human or mechanical error by our sources, Thomson Course Technology PTR, or others, the Publisher does not guarantee the accuracy, adequacy, or completeness of any information and is not responsible for any errors or omissions or the results obtained from use of such information. Readers should be particularly aware of the fact that the Internet is an ever-changing entity. Some facts may have changed since this book went to press.

Educational facilities, companies, and organizations interested in multiple copies or licensing of this book should contact the Publisher for quantity discount information. Training manuals, CD-ROMs, and portions of this book are also available individually or can be tailored for specific needs.

ISBN-10: 1-59863-347-3

ISBN-13: 978-1-59863-347-4

Library of Congress Catalog Card Number: 2006907924

Printed in the United States of America

07 08 09 10 11 PH 10 9 8 7 6 5 4 3 2 1

THOMSON

COURSE TECHNOLOGY

Professional ■ Technical ■ Reference

Thomson Course Technology PTR,
a division of Thomson Learning Inc.
25 Thomson Place
Boston, MA 02210
http://www.courseptr.com

Ms. Nossi, Ira, Cyrus, and everyone at Nossi College of Art. Boy, do you guys put up with a lot from me! And, of course, all my students in both the Associate and Bachelor Degree programs; you keep me on my toes, make me pull my hair out (which is okay since it keeps the grays under control), and generally keep me inspired and excited for the future of design and animation.

DEDICATION

ACKNOWLEDGMENTS

As with all books, the process of producing a product like this takes the hard and often painstaking work of dozens of people. Some are those immediately responsible for what you now hold in your hands; others are the support groups that keep the writers focused and on schedule (or as close to schedule as is possible). Still others are the folks involved with creating the software packages we, hopefully, flesh out for you. So, with that said, I would like to take a moment to thank the following for putting up with my foibles and change-in-a-nanosecond mood swings:

Nicholas Phelps, the creator of the Vue line of products, consummate visionary and guiding force of E-on Software. Your friendship and trust never ceases to amaze me.

Matt Riveccie, Cécile Laurens, Eran Dinur, Vue gurus and friends who seem to never experience a problem they couldn't handle. And, trust me, I can get problematic at times.

Eran Dinur, my demo partner at SIGGRAPH. I couldn't ask for a better one.

Beth Rogers, my business partner and one heck of an artist and designer, who went above and beyond the call of duty to tech edit this book. You can now put away the pen that continually helped to burst my ego.

Megan Belanger and everyone at Thomson Publishing for their guidance, patience, and, ultimately, their hard work in getting this book out.

The great folks at Wacom, who provided me with their newest tablet to test while writing this book.

My family, Sharon, Cyndi, Courtney, Richard, Brandon, my grandchildren Samantha, Joseph, Shelby, and Chase. Maybe now we can see each other a little more often.

Nisrin Saqib, our daughter from India, who is the best foreign exchange student a family could want.

And, finally, a dedication to my parents, Ed and Jane. While mom is no longer with us, their inspiration and their sacrifices as they raised me have made me what I am today.

Richard Schrand might be considered a modern-day renaissance man. For more than 30 years, he toiled in the broadcast industry. He is an Emmy-winning producer and writer who escaped the daily deadlines of television to face the even more grueling daily deadlines of graphic design and software training. He is one of a team of software demonstrators and presenters for E-on Software (MacWorld, SIGGRAPH) and other companies.

Richard is co-owner of Broadsword Productions, which specializes in 3D product previsualization and animation, graphic design, and marketing. He is also a college instructor, holding the position of Computer Graphic Department Chair at Nossi College of Art in the Nashville, TN, region (www.nossicollege. edu). He helped create their Bachelor of Graphic Arts (BGA) Degree Program in Graphic Art and Design, which instructs designers on how to use 3D applications such as Vue, Poser, and LightWave 3D in their daily workflow.

He has written nine books on computer graphics and video software, including *Poser 4 Pro Pack f/x & Design, GoLive 5 f/x & Design, Final Cut Pro 3: The Complete Reference,* and *3D Creature Workshop Volume 2,* as well as contributed to content for 10 other books covering the aforementioned subjects. He is a frequent contributor to various magazines, reviewing software and editorializing on the design industry.

CONTENTS

CONTENTS

CONTENTS

Revealed Series Vision

A book with the word "Revealed" in the title suggests that the topic that is being covered contains many hidden secrets that need to be brought to light. For Vue, this suggestion makes sense. Vue is a powerful piece of software, and finding out exactly how to accomplish some task can be time-consuming without some help. Well, you're in luck, because the help you need is in your hands.

As you dive into the *Revealed* series, you'll find a book with a split personality. The main text of each lesson includes a detailed discussion of a specific topic, but alongside the topic discussions are step-by-step objectives that help you master the same topic that is being discussed. This unique "read it and do it" approach leads directly to "understand it and master it."

—The *Revealed* Series

Author Vision

Welcome to your first step in creating infinite worlds, fantastic landscapes, interior designs, and amazing animations. Welcome to the world(s) of Vue 5 and 6. Since 1997, E-on Software has been expanding its line of software to the point where the major animation studios are adding Vue to their toolset. Soon, you will be seeing environments created with these applications on television and the movies. Still images created in Vue have been created for illustrating articles in international publications such as *National Geographic*. In other words, your investment has put you into the realm of professional illustrators and animators around the world.

Having worked with the program since its introduction, I have been fortunate to be part of an exciting developmental journey. Initially a PC-only program, upon its introduction to the Mac community, I was honored to be asked to be part of the team that premiered it at MacWorld in San Francisco, CA. There, the program was named Best of Show. Since then, the Vue line of products has grown and matured, remaining accessible to hobbyists who just enjoy creating fun images as well as to professionals who need applications that can make their job easier without compromising quality. More and more high schools and colleges are incorporating Vue into their curriculums because you can easily show how to work in 3D space while having limitless possibilities unfold as a student becomes more proficient.

I know, this is starting to sound like a sales pitch. So, let me take a moment to explain how this book is laid out.

Clear, concise step-by-step tutorials guide you through what can seem like highly complex problems, so you can quickly and easily begin building scenes. Each tutorial builds upon the next, with many chapters continuing the creation process started in an earlier chapter. You'll discover how features in other versions of the program can add to your projects, which will help you make the determination of whether to upgrade or stay with the program you already have. And, no matter which version of Vue 6 you have purchased—Vue 6 Easel through Vue 6 Infinite—you will be able to draw upon the topics in this book to learn how to bring your vision(s) to life. Although not all the entry-level Vue 6 Easel tools are discussed here, most are included with that version; so for those who don't have Infinite, you're not left out at all.

Okay, it's sounding like a sales pitch again. You now have a book that will grow with you. You won't need to go out and buy other books to flesh out areas you were heretofore unsure of—except, of course, when you have to buy another one in order to replace your dog-eared copy.

—Richard Schrand

Since 1997, e-On Software has been driven to create the highest quality environmental software program on the market while keeping the cost low enough that virtually everyone can bring their vision to life. Over these years, the Vue line, including Vue 5 Easel (our introductory program), Vue 5 Professional, and Vue 5 Infinite, has earned many computer graphics awards worldwide. And now with Vue 6, we have empowered the artistic community with some of the most advanced tools for the generation of environmental design. If you have any questions regarding that claim, all you have to do is watch *Pirates of the Caribbean: Dead Man's Chest* for proof. Industrial Light & Magic (ILM) used Vue to create the complete island environment.

I am constantly amazed at how my "little program" has grown over the past decade, and I'm thrilled seeing the artwork Vue users worldwide are creating. Vue is not only being used in movies and television programs, but for print advertising, illustration, and pre-visualization. It's humbling at times to think that the program I conceived in college is now being used for such massive projects and in so many different ways.

What you hold in your hands is the first and only book on Vue, and covers our latest version, Vue 6. Almost since the program was introduced, Richard Schrand has been a supporter and valued partner in the program's growth. He has worked with us as a presenter at numerous software expositions, including MacWorld (where we won Best of Show when we premiered the Mac OS X version) and SIGGRAPH.

The Vue 6 line of products was created for you, the artist. And this book will definitely help you understand many of the intricacies and creative power to help you build the images of your dreams. I invite you to become active in our online communities as well. At cornucopia3d.com, you can get extra content as well as show off your work in our gallery section, and you can send your favorite images to us for possible display as our Picture of the Day at e-onsoftware.com.

Welcome to the international Vue family.

Nicholas Phelps
President
E-on Software
Paris, FR/Beaverton, OR

E-ON SOFTWARE'S
VUE 6 REVEALED

chapter

1

OVERVUE

1. Explore the Vue workspace.

2. Explore the window controls.

3. Explore the control panel.

4. Explore the object panel.

5. Explore the world panels.

6. Set preferences in Vue.

chapter 1 OVERVUE

The Vue family of programs allows you to create high-quality natural environments that can range from realistic to fantasyscapes. But you are not limited to just designing natural exterior scenery; you can build and render outer space and alien scenes, as well as interior spaces that range from cartoon-style to photorealistic. And for the most part, Vue is probably one of the easiest programs in which to do this. Within minutes of opening the program, and with a few clicks of the mouse, you can have a scene built. However, this does not mean it is merely a hobbyist's program. Rather, beneath the apparent simplicity is a rich, fully realized application that is being used for print, television, and motion pictures.

That's right. Vue is now being used by some of the top animation studios to create interior and exterior scenes much faster than they ever have before. If you have ever used a 3D modeling application such as 3D Studio Max, Lightwave, Cinema 4D, Carrerra, or others, the thought of building a forest filled with different trees and foliage, rigging each tree in order to get it (and its leaves) to blow in the wind, and then setting up the atmosphere parameters to do just that is daunting. With Vue, a simple click of a couple of buttons will do all of that for you.

Vue, on the other hand, is not a modeling program. You can easily import static or animated pre- and self-made models into the program, but you cannot build original models. Everything you do starts with a pre-set form, or *mesh*. These presets can be manipulated to become whatever you want them to be, but you cannot start with a cube, let's say, and mold it into a highly detailed alien being. There are some basic modeling features, though, such as Boolean operations (discussed in Chapter 4), *metaball* technology (herein called *metablobs*), and such, but Vue, as a whole, is used to create the scenes and atmosphere in which you place your characters.

Before you begin creating scenes, you need to become familiar with Vue's workspace. In this chapter, you will be introduced to the Vue environment. Much of this chapter is geared toward the novice—those of you who are experiencing a 3D application for the first time. If you are in that group and have seen images or screen captures of 3D software packages, it will help you learn how to work in literally every 3D program on the market. For those of you who are already familiar with 3D applications but are new to Vue, you might want to skip the first part of this chapter and move on to the application setup so you can prepare yourselves for the creative journey that begins in Chapter 2.

What is nice about the Vue family is the similarity between the versions. The Graphic User Interface (GUI) is the same in all of them. With each step up in the professional food chain, new tools and features are added, but the GUI remains the same. So no matter which version you are using, you won't feel lost.

Tools You'll Use

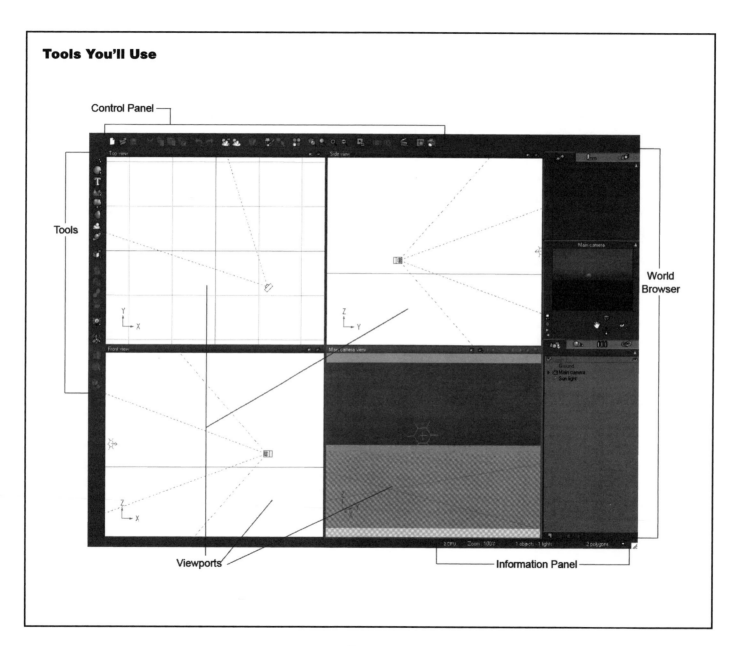

Control Panel

Tools

Viewports

World Browser

Information Panel

EXPLORE
THE VUE WORKSPACE

What You'll Do

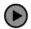

In this chapter, you become familiar with the Vue workspace.

QUICKTIP

Throughout this book, I emphasize quick key commands to help you not only work faster and more efficiently, but also to help stave off any possible repetitive stress injuries that can occur from using the mouse too much. These quick key commands are mentioned by the PC commands first, followed by the Mac command (such as Ctrl+N/Cmd+N for opening a new scene).

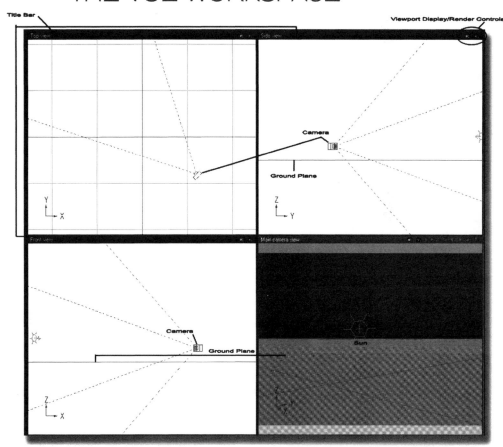

Using the Main Environment

Upon starting the program, you will be greeted with all the tools necessary to create your scenes. These tools, lined along the top, left, and right sides, frame the four viewports that make up your modeling environment. These four viewports give you access to different views of your scene, allowing you to position objects interactively on the screen.

QUICKTIP

In Vue 6 Infinite, the default look of the GUI has changed dramatically. Instead of the Vue 5 Blue interface, it is a medium-dark gray. You can change the GUI to the Vue 5 Blue interface by going to Display > Interface Colors and selecting Vue 5 Blue at the top of the control window.

The four viewports, clockwise from upper left to lower right, show you the scene from what can be considered a fixed camera view. In order, these viewports show you the Top, Side, Front, and Main views. You will use the first three viewports to set up your scenes, positioning items by clicking and dragging them to the location you want. The Main viewport shows you the way the scene will look in your render. You are literally viewing your scene through the camera that is "taking your picture".

FIGURE 1-1

The standard Vue workspace in all versions from Vue Easel to Vue 5 Infinite. Control buttons are on the top, tool buttons on the left, and layout controls on the right. The four windows in the center are what are used for placement of objects in y our scene.

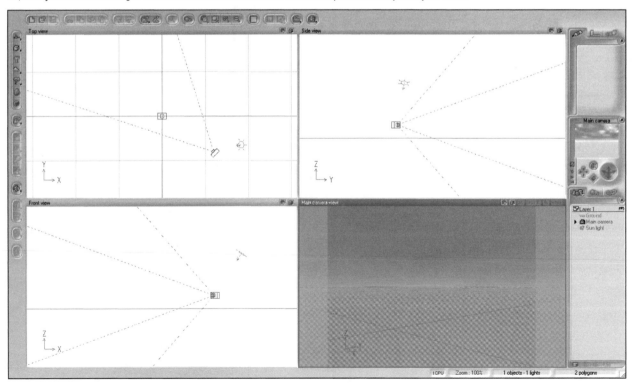

There are some basic objects that are seen within the Top, Side, and Front viewports. The ground plane is displayed in the Top view as a grid and in the Side and Front views as the straight line running through the center of the viewports. You will also see the camera, represented by two boxes that form to look like a still camera, and the sun, which is the circle with rays shooting out from it and has an arrow pointing toward the camera. In addition, in the Top view, you see a square in the center of the window—this represents a secondary, overhead camera that can be used for your renders. Each of these objects can be selected and moved around to different locations in your scene. Within the Main Camera View, the ground plane is represented as the gray area in the lower half of the window, the upper half is the sky, and depending on the default atmosphere that loads, the sun will be visible.

FIGURE 1-2

By default, the Vue 6 workspace looks like this. You can switch to the more traditional interface look if you like.

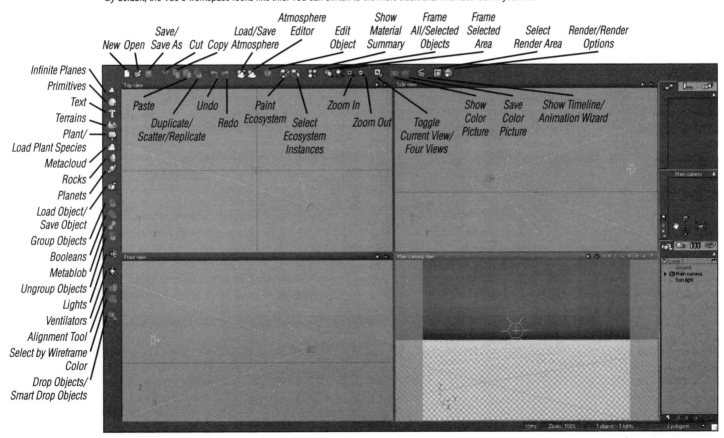

There are also two buttons on the right side of the Top, Side, and Front viewports' title bars. The left-most is the View Display Options button. Pressing and holding down the mouse button on it gives you display options for that particular window. The right-most button has two purposes: First, if you merely click on it, you will perform a quick render of the scene in that viewport; second, if you press and hold down the mouse button, you can change the way in which the layout is displayed in the window.

The Main Camera View window has its own unique set of control buttons along the right side of the window's title bar. From left to right these are:

View Display options. You can set how this window displays elements in your scene, from fog and haze to objects placed in the scene.

Quick Render/Quick Render options. Here, you can quickly perform a quick render. When you click and hold this button, a pop-up list appears that lets you set the quality of the quick render.

Display Last Render (Color). This button becomes active after you have performed a quick render. It displays the last render you did, no matter what changes you have made to your scene.

Display Last Render (Alpha). This will show you the alpha map that was created in the last render. Alphas are used for two purposes: a) In image editing programs like Photoshop, an alpha can be used to make selections, and b) in page layout, 3D, and video editing programs, alphas create transparencies so whatever is in black becomes transparent, and whatever is in white remains opaque.

Display Last Render (Depth). Many applications use depth maps to create fades to make objects look farther away or as if they are fading into the distance. Here, you can see the depth map that was created in the last render.

Display Multi-Pass, Masks, G-Buffer. Vue will create layered Photoshop files with visual information that can make your still image editing or video production work much easier. If you have this function turned on, you can look at the various channels and layers created when the render was made.

Increment Current G-Buffer Layer. Click left or right to view each G-Buffer layer individually.

FIGURE 1-3
The two buttons on the left of the Top, Side, and Front viewports give you basic controls that affect only that window.

Top view

View Display Options Quick Render/ Quick Render Options

Post Render options. Opens a window that gives you the ability to change the look of the image and modify it so it prints as you want.

Save Displayed Picture. Allows you to save the render to your hard drive.

FIGURE 1-4
The Main Camera View window controls located at the top of the viewport.

View Display Options Display Last Render (Depth) Display Last Render (Color) Display Last Render (Alpha) Post Render Options

Main camera view

Quick Render/ Quick Render Options Display Multi-Pass, Masks, G-Buffer Increment Current G-Buffer Layer Save Displayed Picture

Launch Vue and Work with the Viewports

1. Start Vue from your Programs (PC) or Applications (Mac) folder or from the Mac's program dock.

2. Select a viewport to become active by clicking on it once. The active viewport will be highlighted. You can now reposition objects within that viewport.

3. If, as you are working on a scene, the viewport is too small to show all the detail you need, double-click along the title bar (the top edge) of the port you want to expand. This will bring that viewport full screen.

4. When you want to return to the four-port or quad view, double-click the top edge of the port again.

5. You can also interactively resize the four-port layout. Place your cursor on the border between all four frames. Click and drag to resize the windows as you want.

FIGURE 1-5
Clicking on a viewport once will make it the active viewport, shown by the highlighted border.

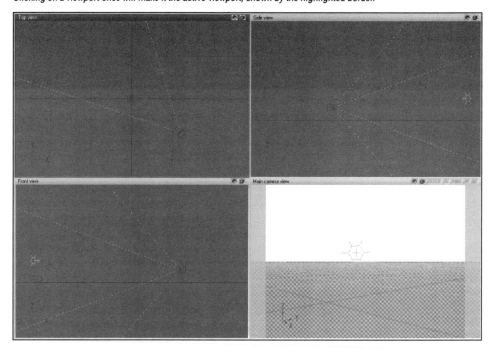

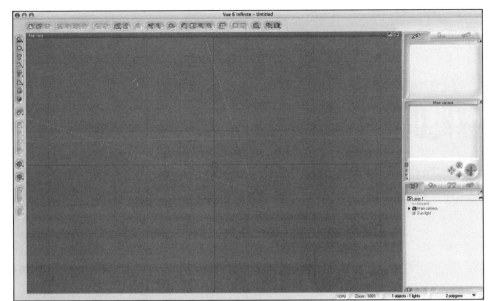

FIGURE 1-6

Double-click on the title bar of the selected viewport to bring it full, then double-click again to return to the quad screen view.

FIGURE 1-7

By clicking and dragging on the point between the four viewports, you can change how the four viewports are displayed.

Click and drag here
to resize windows
in the quad view

EXPLORE
THE WINDOW CONTROLS

What You'll Do

In this section, you learn how to use the various window controls in order to modify and position objects within your scene(s).

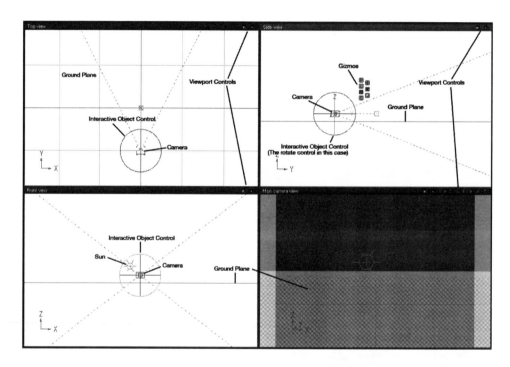

Learning the Interactive Controls

To successfully build your scenes, you need to be comfortable with the viewport and object controls at your disposal, moving between the different viewports to interactively move items into position. Although later in the book you will learn how to do this numerically, much of the time you will actually position and modify the scale—or size—of an object interactively. By interactively, I mean that you will click and drag the object to another location using the viewports (or windows). Although this is not as precise as using the Numerics panel, it is often quicker and easier as you initially build your project.

FIGURE 1-8

The camera has been selected, and the gizmos to control its movement are now available.

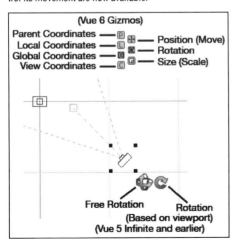

(Vue 6 Gizmos)

Parent Coordinates —— Position (Move)
Local Coordinates —— Rotation
Global Coordinates —— Size (Scale)
View Coordinates ——

Free Rotation Rotation
 (Based on viewport)
 (Vue 5 Infinite and earlier)

Interactively Select, Move, Rotate, and Scale Elements in a Viewport

To select and move an object in the viewport, first make one of the viewports active. In this case, start with the Top view:

1. Click on the camera. It will be highlighted in red. You will also see buttons appear to the lower right of the selection. These are called **gizmos**, and are used to tell the program how modifications are going to be made to the selected item.

2. In Vue Easel through Vue 5 Infinite, click and hold down the mouse button in the center of the camera icon and drag it to the location you want.

3. To change the orientation of the camera up or down (toward the sky or toward the ground), called *tilting*, click on the orientation gizmo, which looks like a globe made up of curving arrows. Holding down the mouse button and moving the cursor up, right, left, or down will make the camera pivot up or down.

4. To rotate the camera left or right (called *panning*), click and move the mouse when over the curved arrow to the right of the orientation gizmo.

5. To scale an object, click on the black squares surrounding the object. Click and drag from any of these squares to increase or decrease the object's size.

> **QUICK**TIP
>
> In the case of the camera, the object will not increase in size like other objects will. Scaling the camera will interactively change the *focal length* of the lens. You will see the lens get longer or shorter, rather than the camera getting larger in the window.

6. Once you have modified the camera the way you want it, click anywhere except on the object in that viewport to deselect it.

Select and Move Elements in Vue 6 Infinite

1. Select the camera in any window of the Vue 6 Infinite workspace.

 By default, the Global button (G) and the Move button should be highlighted. This means that all changes will be based upon the camera's position within the world space. You will see a blue and green square appear in the Top, Side, and Front views to the upper right of the camera icon.

Using the Vue 6 Infinite Gizmos

In Vue 6 Infinite, the gizmos for the modification of objects are vastly different. As you can see in Figure 1-9, there are no globe-like icons for orientation and rotation. Rather, there are six small buttons, a square shape with pointers jutting out at the top and side, and a bounding box around the selected element. In this section, you learn how to make the same modifications you just learned how to do in the Vue 5 family in Vue 6 Infinite. Table 1-1 explains the Vue 6 Infinite gizmos in more detail.

QUICKTIP

The gizmo buttons appear only in the active viewport.

QUICKTIP

You can also access the gizmo controls through the pull-down menus by choosing Display > Gizmos. Here, you can also increase the size of a gizmo, or you can use the + and the – (minus) keys to enlarge or reduce the gizmo's display scale.

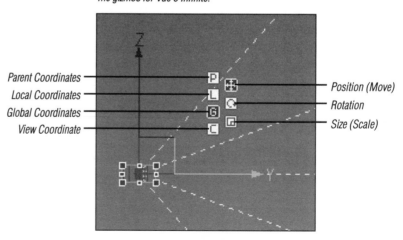

FIGURE 1-9
The gizmos for Vue 6 Infinite.

Parent Coordinates
Local Coordinates
Global Coordinates
View Coordinate

Position (Move)
Rotation
Size (Scale)

TABLE 1-1 Vue 6 Infinite Gizmos

Button Group	Description of Buttons
P	Parent. If you have multiple objects assigned to react to a parent object, click on this button to make all react the same. To quickly select the Parent control, click the P key on your keyboard (Mac and PC).
L	Local. This allows you to scale the object by its own coordinates. If, say, you want to rotate an object and then scale it down lengthwise, you would use this control. In the Vue 5 family, you need to scale an object prior to rotating it because scaling is done on a global basis. To quickly select the Local control, click the L key on your keyboard (Mac and PC).
G	Global. These are always fixed, based on the world coordinates. Every change is made based on the object's position in the overall scene. This can cause objects that are, for instance, rectangular to scale in a non-uniform manner, so you will not get a perfectly symmetrical rectangle. To quickly select the Global control, click the G key on your keyboard (Mac and PC).
C	View. These are based upon the Vue coordinates and measurement settings you define in the Preferences window. The Preferences window is discussed later in this chapter. To quickly select the View control, click the V key on your keyboard (Mac and PC).
Move	Select this button to activate the Move controls for that object. To quickly select the Move control, click the M key on your keyboard (Mac and PC).
Rotate	Select this button to activate the Rotation controls for that object. To quickly select the Rotate control, click the R key on your keyboard (Mac and PC).
Scale	Select this button to activate the Scale controls for that object. To quickly select the Scale control, click the S key on your keyboard (Mac and PC).

2. Move your cursor until the upward pointing arrow is highlighted in yellow. Click and drag up and down with this directional indicator highlighted.

 This constrains the movement of the object to an up/down direction.

3. Move the cursor over the right-pointing directional indicator and click and drag.

 This constrains the camera movement to a left/right direction.

4. Move the cursor into the box. The interior of this box will be highlighted. Click and drag with the cursor inside the box.

 This allows you to move the object freely around the scene.

5. Click on the Rotate button (or use the R key without a keyboard modifier such as Cmd or Ctrl) to switch to the Rotate button.

 The object controls will change to a circle around the object, with a cross-hair inside.

Depending on the viewport you use, the controls will change which camera movement they control, as you see in Figure 1-10.

6. Move the cursor over the edge of the circle control, the vertical crosshair, and the horizontal crosshair.

 The outlines will highlight when you move the cursor directly over them.

7. Select one of the outlines and click and drag.

 With the outline selected, either the vertical, horizontal, or circle, you can change the direction in which the camera is pointing. The horizontal outline will move the camera left/right only, the vertical outline will move the camera up/down only, and the circle outline will rotate around the center axis of the crosshairs.

8. Move the cursor into the circle, but not over one of the outlines.

 The entire control will be highlighted. You can now freely rotate the camera without having its movement constrained in one direction.

QUICKTIP

The Scale command is discussed in Chapter 2.

The Scale command, when assigned to the camera, will change the focal length. Focal length, at its most basic, is the size of a camera lens. Most cameras, whether with fixed lenses or interchangeable, come with a default 35mm lens. You can zoom in or out a fixed distance. Other lenses allow you to get closer or farther away from the subject by changing the focal length. This is how the Scale command works with the camera, allowing you to zoom in or out in the scene to see more or less of the layout.

FIGURE 1-10
The controls when Rotate is selected.

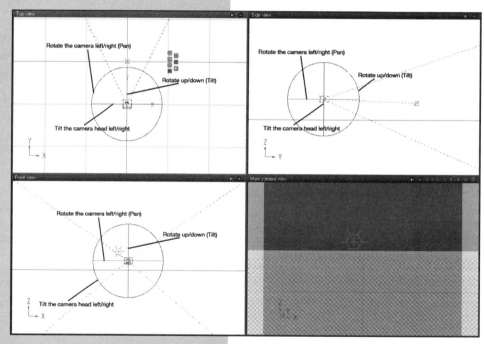

EXPLORE
THE CONTROL PANEL

What You'll Do

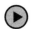

Positioned along the top of the Vue work-space, just below the pull-down menus, are the controls for the program. These controls, set up as buttons, give you access to all the main features in the program. In this section, you learn what these controls are so you can easily choose the one you need when you are working on your scenes.

QUICKTIP

In all cases, if you move your cursor over any button and let the cursor hover over it, a tooltip appears, giving you the name of that button.

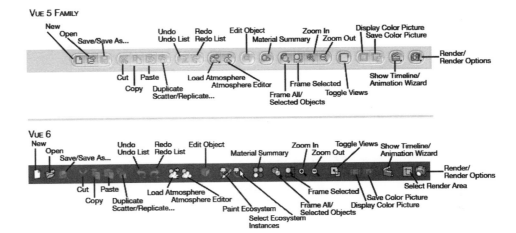

VUE 5 FAMILY

New
Open
Save/Save As...
Undo
Undo List
Redo
Redo List
Edit Object
Material Summary
Zoom In
Zoom Out
Display Color Picture
Save Color Picture
Render/
Render Options
Cut
Copy
Paste
Duplicate
Scatter/Replicate...
Load Atmosphere
Atmosphere Editor
Frame All/
Selected Objects
Frame Selected
Toggle Views
Show Timeline/
Animation Wizard

VUE 6

New
Open
Save/Save As...
Undo
Undo List
Redo
Redo List
Edit Object
Material Summary
Zoom In
Zoom Out
Toggle Views
Show Timeline/
Animation Wizard
Render/
Render Options
Select Render Area
Cut
Copy
Paste
Duplicate
Scatter/Replicate...
Load Atmosphere
Atmosphere Editor
Paint Ecosystem
Select Ecosystem
Instances
Frame All/
Selected Objects
Frame Selected
Save Color Picture
Display Color Picture

FIGURE 1-11

The Vue 5 and Vue 6 control panel. The Vue 5 family is on top; the Vue 6 Infinite panel is at the bottom.

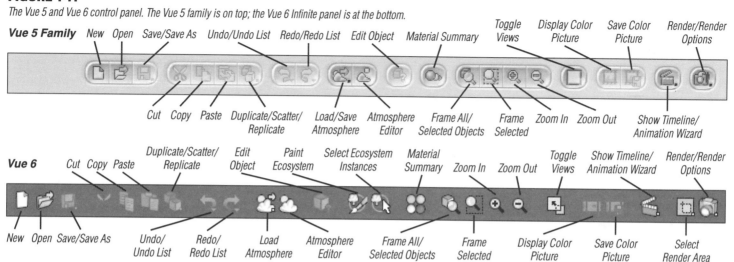

TABLE 1-2 The Vue Control Panel

Button Group	Description of Buttons
New	Creates a new scene. You will be asked if you want to save the scene you have been working on before the new scene is create. The corresponding keyboard shortcut is Ctrl+N/Cmd+N.
Open	Lets you open a previously saved scene or animation. The corresponding keyboard shortcut is Ctrl+O/Cmd+O.
Save/Save As	Lets you save your scene to a specified location on your hard drive. Also allows you to save your scene with a different name so you don't overwrite your original file. Click once to save your scene; to Save As, hold down the mouse button until the Save button is highlighted. The corresponding keyboard shortcut is Ctrl+S/Cmd+S. There is no corresponding default keyboard shortcut for Save As.
Cut	Removes the selected object from your scene. The corresponding keyboard shortcut is Ctrl+X/Cmd+X. You can also press the Delete key on your keyboard.
Copy	Allows you to copy the selected object. The corresponding keyboard shortcut is Ctrl+C/Cmd+C.
Paste	Places an exact duplicate of the last copied object into the scene. The corresponding keyboard shortcut is Ctrl+V/Cmd+V.

TABLE 1-2 The Vue Control Panel

Button Group	Description of Buttons
Duplicate/ Scatter Replicate	Clicking on this button makes an exact duplicate of the selected object, placing it slightly offset from the original. Pressing and holding down on this button until it is highlighted will access the Scatter/Replicate options. Scatter/Replicate can be used to make stairs or other objects that use repetitive shapes in your scene(s). The corresponding keyboard shortcut for Duplicate is Ctrl+D/Cmd+D. There is no default keyboard shortcut for Scatter/Replicate.
Undo	Deletes the last change you made. You can repeat this process to remove items in the order they were added to the scene. The corresponding keyboard shortcut is Ctrl+Z/Cmd+Z.
Redo	Brings back the object you just deleted. There is no corresponding keyboard shortcut for Redo.
Load Atmosphere/ Save Atmosphere	Allows you to load any existing atmosphere. Save Atmosphere lets you save an atmosphere you have created so you can add it to future scenes. Press and hold on the Load/Save Atmosphere button until it is highlighted to bring up the Save Atmosphere window. The corresponding keyboard shortcut is F5. There is no corresponding shortcut for Save Atmosphere.
Atmosphere Editor	Takes you to the Atmosphere Editor where you can create your own atmospheres. The corresponding keyboard shortcut is F4.
Edit Object	Opens the Terrain Editor when you have a Terrain object on your workspace. This is somewhat of a misnomer. It does not actually bring up an editing screen for any selected object in your scene. The other way to bring up the Terrain Editor is by double-clicking on the selected Terrain object.
Paint EcoSystem (Vue 6 Only)	Paint EcoSystem allows you to "paint" plants, rocks, and objects into your scenes interactively. This also lets you put EcoSystems onto an infinite plane, which was impossible to do prior to Vue 6. Ecosystems were introduced in Vue 5 Infinite. Earlier versions of the program and other Vue 5 programs do not have the EcoSystem feature. There are no corresponding keyboard shortcuts for this feature.
Select EcoSystem Instances (Vue 6 Only)	Gives you controls to modify the various EcoSystems in your scene. There are no corresponding keyboard shortcuts for this feature.
Show Material Summary	This opens a secondary window that breaks down every material instance in the scene. You can then select the material and edit it. If you have numerous objects with the same material, the material instance will show up only once in this screen, and changes will affect all instances of that material.
Frame All/Selected Objects	This button causes the program either to center the entire scene within the viewports or center the selected object in the viewports. In many cases, the latter will cause the selected object to be zoomed in on so it fills the viewport.

TABLE 1-2 The Vue Control Panel

Button Group	Description of Buttons
Frame Selected Area	Click on this button to move your cursor to a viewport. Click and drag, and the area you dragged across will be centered in the active viewport.
Zoom Into View	Click on this button to zoom in on your scene. You must click repeatedly to zoom in closer. The corresponding keyboard shortcut is Ctrl+ +/Cmd+ + (the plus key).
Zoom Out of View	Click on this button to zoom out to show more of your scene. You must click repeatedly to zoom out further. The corresponding keyboard shortcut is Ctrl+ –/Cmd+ – (the minus key).
Toggle Current View/ Four Views	Clicking on this button will either bring the current view full, or return you to the four window view. The corresponding keyboard shortcut is F7.
Display Color Picture	Will display a rendered version of your image in the Main Camera View window. The corresponding keyboard shortcut is F8.
Save Color Picture	Will save the rendered version of your image. There is no corresponding keyboard shortcut for this option.
Show Timeline/ Animation Wizard	Click once to open the Animation Timeline in your workspace. Press and hold to open the Animation Wizard window. The Animation Wizard window will open up no matter which way you select this option. If all you want is the Timeline, merely close the Animation Wizard window. The corresponding keyboard shortcut is F11.
Select Render Area (Vue 6 Only)	Lets you define the area within the scene that will render. This is helpful to make sure new elements look like you want them to without having to render the entire scene. This only works in the Main Camera View window. There is no corresponding keyboard shortcut.
Render/Render Options	Clicking on this button begins the still render process. By clicking and holding down the button until it is highlighted, you bring up the Render Options window, where you can define the render quality and other features. The Render keyboard shortcut is F9; the keyboard shortcut for Render Options is Ctrl+F9/Cmd+F9.

EXPLORE
THE OBJECT PANEL

What You'll Do

 In this section, you learn what each button contains and what it adds to your scene.

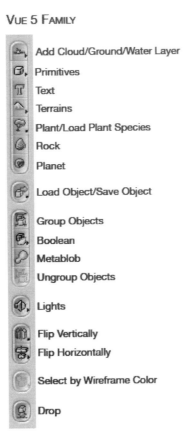

VUE 5 FAMILY

- Add Cloud/Ground/Water Layer
- Primitives
- Text
- Terrains
- Plant/Load Plant Species
- Rock
- Planet

- Load Object/Save Object

- Group Objects
- Boolean
- Metablob
- Ungroup Objects

- Lights

- Flip Vertically
- Flip Horizontally

- Select by Wireframe Color

- Drop

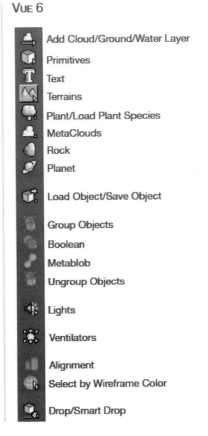

VUE 6

- Add Cloud/Ground/Water Layer
- Primitives
- Text
- Terrains
- Plant/Load Plant Species
- MetaClouds
- Rock
- Planet

- Load Object/Save Object

- Group Objects
- Boolean
- Metablob
- Ungroup Objects

- Lights

- Ventilators

- Alignment
- Select by Wireframe Color

- Drop/Smart Drop

Learning the Object Buttons

On the left side of the workspace are the Object buttons. This area gives you access to all the elements that can be placed into your scene. Where appropriate, elements that are version exclusive will be indicated.

QUICKTIP

Pressing and holding down on the Object buttons will give you access to other objects or variations of an object for your scene. These can be selected from the fly-out panel that appears. Move your cursor over the shape or selection you want to place into the scene.

QUICKTIP

The last selection you make for an object becomes the default object. If that is the object you want in the scene, merely click on the button rather than opening the fly-out panel.

FIGURE 1-12

The Vue 5 and Vue 6 Infinite toolbars.

VUE 5 FAMILY

 Add Cloud/Ground/Water Layer

 Primitives

 Text

 Terrains

 Plant/Load Plant Species

 Rock

 Planet

 Load Object/Save Object

 Group Objects

 Boolean

 Metablob

 Ungroup Objects

 Lights

 Flip Vertically

 Flip Horizontally

 Select by Wireframe Color

Drop

VUE 6

 Add Cloud/Ground/Water Layer

 Primitives

 Text

 Terrains

 Plant/Load Plant Species

 MetaClouds

 Rock

 Planet

 Load Object/Save Object

 Group Objects

 Boolean

 Metablob

 Ungroup Objects

 Lights

 Ventilators

 Alignment

Select by Wireframe Color

 Drop/Smart Drop

TABLE 1-3 The Vue Object Panel

Button Group	Description of Buttons
Add Cloud/Ground/ Water Layer	Adds an infinite plane to your scene. Press and hold on this button to select either a cloud, ground, or water plane.
Primitives	This is a group of basic shapes, called primitives. They include spheres, cubes, pyramids, cylinders, and more.
Text	Gives you access to the Text Editor, allowing you to create 3D text objects in your scenes. This gives you the ability to build high-quality logos that can be used in still images or be animated for use in your projects.
Terrains	Gives you access to different Terrain objects. For clarification, Terrains are mountain objects that can be modified to become virtually any type of ground object you want.
Plant/Load Plant Species	When you click on this button, it adds another instance of the last plant you placed in your scene. Pressing and holding down on this button will cause the Plant Species window to open, where you can select a different plant object to place.
MetaCloud/Load MetaCloud Model (Vue 6 Only)	Metaclouds are new to Vue 6. By clicking on the button, a metacloud will be added to your scene. Pressing and holding down on the button until it highlights will bring up the MetaCloud screen where you can select the type of metacloud to add.
Rock	Adds an individual Rock object to your scene.
Planet	Adds a Planet object to the sky area of your scene. These planet instances can be edited to look like any type of planet in our universe or any type of sci-fi universe you're creating.
Load Object/ Save Object	This button gives you access to the Object Selection window. From you here can load an object into the scene from a library of saved objects, or from anywhere else on your computer. With an object selected in your scene, press and hold on this button to open the Save window, where you can save that object to your Vue Objects Library.
Group Objects	When you have multiple objects that need to remain together (move as one element), use this button to group the objects so they are seen as one larger object. Each element can still be modified individually, or changes you make can affect every object in the group the same way.
Boolean	Boolean operations basically turn one object into a cutter, the other the cut-ee. This is a basic 3D modeling function that helps you create more complex objects. For instance, you can use a Boolean Difference to cut holes into a wall to make windows.
Metablob	Metablobs combine multiple objects into what is called an organic object. Basically think of your objects becoming something like mercury, with edges merging together fluidly to create some interesting shapes.
Ungroup Objects	Splits apart grouped objects into their original, ungrouped shapes.
Lights	Adds lights into your scene. Press and hold this button to select specific types of lights appropriate to your scene.

TABLE 1-3 The Vue Object Panel

Button Group	Description of Buttons
Ventilators (Vue 6 Only)	Ventilators are added to your plant objects to get them to react to atmospheric conditions. These can be used for very sophisticated wind effects.
Flip Vertically (Vue 5)	Flips the selected object on the vertical plane.
Flip Horizontally (Vue 5)	Flips the selected object on the horizontal plane.
Alignment (Vue 6 Only)	Aligns objects in specific manners defined by whichever alignment option you select.
Select by Wireframe Color	Depending upon how intricate your scene is, you can change the color of an object's outline so that you can choose it more easily. This tool lets you quickly select multiple items based upon the color of their wireframes.
Drop Objects	Causes an object to drop onto the first instance of an object it encounters.
Smart Drop Objects (Vue 6 Only)	Causes an object to drop onto the first instance of an object it encounters. Multiple clicks on this button make the object drop to the next object instance until it reaches the ground plane.

EXPLORE
THE WORLD PANELS

What You'll Do

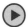

In this section, you become familiar with the three control windows that make up the World panels.

As you become more comfortable with Vue, and as you explore more precise placement of objects while creating more complex scenes, you will be referring to and working with World panels extensively. This area, located on the right side of the screen, is made up of three windows: the Aspect/Numerics/Animation panel, the World Browser proper, and the Objects/Materials/Library/Links window.

Numerics Window

Animation Window

Aspect Window

Camera View

Layers

Learn the Objects Area

As you add objects to your scene – terrains, primitives, plants, rocks, and so on—those objects will be listed here. They are listed in descending order, so as you add an object, it is placed at the bottom of the list. You can move these instances up and down in the window to keep like objects listed together (plants, rocks, terrains, etc.).

Four buttons at the bottom of this window are described as follows:

1. New Layer (the page icon). *Layer* is actual a misnomer. Vue does not actually work with layers as other programs do (such as Photoshop), because objects are not placed above one another in the image. A new layer creates a folder where elements can be stored to help your organization.

2. Trash Can. Deletes the selected object from your scene. You cannot delete the main camera from your scene.

3. Edit Selected Object. This gives you access to the objects modification screen. Works with lights, cameras, and terrains.

4. Save Selected Object. If you have imported an object or made modifications to an object that you want to use over and over again, click this button to save that object into the Library.

Exploring the Aspect/ Numerics/Animation Panel

This window, the top one of the three, gives you access to precise controls for the selected object in your scene. Broken down into three tabs, the default is the Aspect area. Depending on what you have selected, you will see control buttons on the left that will give you access to various object-specific features. The main display shows you visual and basic information about the selected object.

Clicking on the second tab, which has a right angle icon, takes you into the Numerics section. The button set on the left of this screen gives you access to numeric options for position, rotation, scale, twist, and pivot. Clicking on any of the buttons changes the main area of this window to a series of numeric text boxes. You can then change the numerics to the ten-thousandth of an meter/inch/yard setting (however you have your global settings assigned).

The third tab, the Animation panel, gives you the ability to make changes to animations assigned to that object. Again, there are tabs on the left of the window that let you forbid animating that particular object or changing tracking and linked tracking of elements that object might be assigned to.

Although this might sound like some foreign language to you at this moment, you will be working with these panels heavily in upcoming chapters.

FIGURE 1-13

This is the panel in Vue 6 Infinite, but other than the Vue 5 family color scheme, this panel set is identical in all versions of the program.

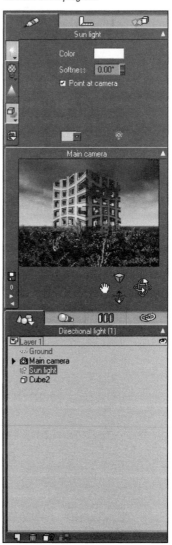

Exploring the Main Camera Panel

The Main Camera panel constantly updates. Every time you make any type of change to your scene, the main area of this window updates to give you a quick thumbnail of what your scene will look like when it renders.

There are three buttons on the bottom left of this window: Store Camera, a camera number indicator to let you know what camera you are viewing your scene through (this is not a button), and the Next Camera and Previous Camera buttons, which let you switch between the cameras you have assigned to your scene.

Under the preview screen are camera controls. Instead of using the numerics window or the gizmos, you can manipulate your selected camera by clicking and dragging on these control buttons. Set up in a triangular (or, if you prefer, circular) configuration, from the top and moving clockwise, these controls are Zoom, Rotate, Move Camera Back/Forth (known in the video industry as *trucking*), and Pan (which actually allows you to pan–move the camera head left/right—and tilt—move the camera head up/down).

NOTE

In this section, I have created a scene in order to show how the controls work. You don't have to do this in order to follow along in the section.

FIGURE 1-14
The Main Camera panel and its controls.

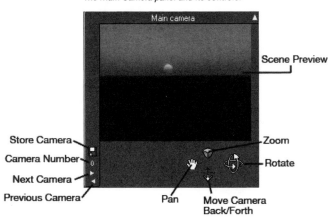

Learn the Materials Area

The Materials area gives you a hierarchical readout—a listing—of the materials used in your scene. There are two buttons that become available at the bottom of this window.

1. Edit Material. Select a material, click on this button, and the Material Editor window will open, letting you make changes to the look of the material.

2. Replace Material. Select a material in the list, click this button, and the Material selector window will open, letting you select a base material for the object.

Learn the Library Area

Shows a listing of Master and EcoSystem objects in your scene. Creating Master objects is discussed in later chapters, as are EcoSystems. You can select elements from the list and make scene-specific modifications to them using the three buttons at the bottom of this window.

1. Edit Selected Master Object. When you click this button, the appropriate editor window will open so you can change the look of an object or create new plant species.

2. Master Object Edition Mode.

3. Trash. Throws away that particular selection, deleting it from the scene.

Learn the Links Window

The Links window shows images and objects that you have linked to outside of the Vue application. These links might be in another area of your hard drive or on another hard drive altogether. There are four buttons at the bottom of this window that give you specific controls for the selected Texture Map or Object links.

1. Replace Link. Lets you change the file to another file or an updated version of your object or material.

2. Export Link. Like a Save feature, it allows you to save your Texture Map file or object to another location on your hard drive. This is especially helpful if you have linked to a file on an external hard drive that is not permanently attached to your computer.

3. Reload Link. If, for some reason, an image or object does not load or the link has, for some reason, been broken, this allows you to relink to the file.

4. Trash Can. Throws away the selected item.

Exploring the Objects/ Materials/Library/Links Panel

This panel, for the most part, will become your best friend. Here, everything involving each object in your scene is provided to you.

SET PREFERENCES
IN VUE

What You'll Do

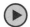 *In this lesson, you learn how to set various preferences in Vue.*

In many cases, when you open Vue for the first time, you are ready to begin working. But as you work with the program more, there are aspects of the way Vue works that you might want to modify. You might also discover that your computer's configuration might be such that it causes Vue to react erratically or even, in some cases, crash.

To alleviate those rare occurrences of the latter, or to change everything from the look of the program to how it reacts in your manner of workflow, you need to access the Preferences window. In this area you can change almost every aspect of the program, including the shortcut key commands.

In this section, you will learn how to do that. For the most part, until you are really familiar with the program, I would advise keeping the default preferences. But as you grow in confidence with the program, refer to this portion of the chapter to help you understand what the various controls will do.

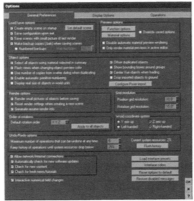

General Preferences

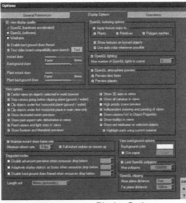

Display Options

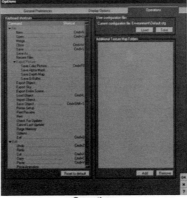

Operations

Understanding the Preferences/Options Panel

The Preferences window is broken into three sections: General Preferences, Display Options, and Operations. In the General Preferences section, you can make changes to the way the program as a whole works. Under Display Options, you make changes to the way the program looks while it is running. And Operations gives you the ability to change shortcut commands and have Vue include other folders you might have set up so their contents are available to you directly in the program.

To access the Preferences/Options panel, choose File > Options (PC) or Vue 5/6 > Preferences (Mac) or use Ctrl+, /Cmd+, (a comma).

The General Preferences Window

The General Preferences window gives you control of how the program will respond to your computer system, as well as giving you access to the way objects are seen and general file saving commands.

The General Preferences window is broken down into sections. Each section gives you control of specific features of the program.

FIGURE 1-15

The Vue 5 General Preferences window.

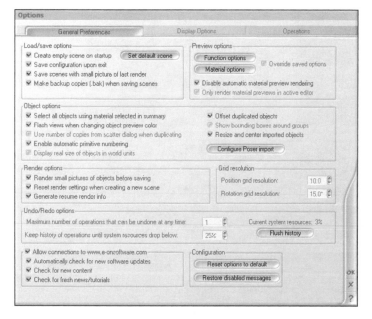

FIGURE 1-16

The Vue 6 Display Options window.

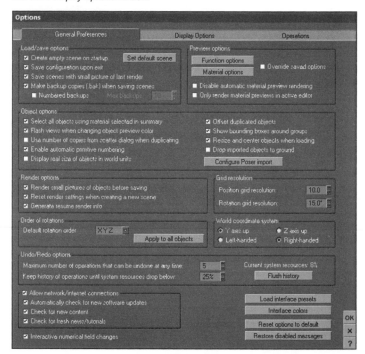

TABLE 1-4 General Preferences

Button Group	Description of Buttons
Load/Save Options	
Create Empty Scene on Startup	When turned on, a blank scene will be created, allowing you to quickly begin building a fresh image or animation. The Set Default Scene button to the left of this control lets you set your current scene/scene settings as the default scene that loads when you start the program.
Save Configuration upon Exit	If you have modified the look of your workspace while building your scene, this new layout will be the one that opens upon startup.
Save Scenes with Small Picture of Last Render	When saving your scene, this option saves a thumbnail image based upon the last render you did.
Make Backup Copies (.bak) when Saving Scenes/ Numbered Backups	Vue will create backup files (with the .bak extension) when this is turned on. If you decide you want backups of multiple renders, select Numbered Backups from the secondary selector. You can assign the maximum number of sequential backup files either by typing the number in the numerics field to the right of the Numbered Backups option or by clicking the up/down arrows to increase or decrease that number one unit at a time.
Preview Options	
Function Options	Allows you to select the look of the material display and the material display window so you can look at the effect the functions are having on your material.
Material Options	Same as the Function options.
Override Saved Options	If you have saved a specific look for your program, this allows you to override those fixed settings for the Function and Material options.
Disable Automatic Material Preview Rendering	This turns off the automatic updating of material renders.
Only Render Material Previews in Active Editor	This gives you an updated render of the material you are working on inside of the active window (the window you're working in).

TABLE 1-4 General Preferences

Button Group	Description of Buttons
Object Options	
Select All Objects Using Material Selected in Summary	With this turned on, when you open the Material Summary window and click on a material, all objects with that material assigned are selected.
Flash Views when Changing Object Preview Color	When you assign a preview color to an object (to help you identify it easier in your scene), on some machines, the viewports flash as the color changes.
Use Number of Copies from Scatter Dialog when Duplicating	This automatically adds the number of copies you assign in the Scatter dialog box when you perform a duplicate command. With this off, only one duplicate is made when you use the duplicate command.
Enable Automatic Primitive Numbering	Each time you add another of the same primitive (such as spheres, cubes, and so on), each new primitive will have a number assigned to its name in the Layers window.
Display Real Size of Objects in World Units	Instead of using inches, feet, meters, and so on when showing the size of an object, this displays the objects based on Vue's world measurements.
Offset Duplicated Objects	If this is turned off, duplicated objects are placed immediately on top of the original.
Show Bounding Boxes Around Groups	Puts a bounding box around all the items (as if they were one).
Resize and Center Objects when Loading	When bringing in objects, or objects created in other programs, this automatically sizes them based upon the measurement type you have set.
Drop Imported Objects to Ground	If this is turned off, imported objects will be floating in midair. With it turned on, they will automatically be placed on the ground plane.
Configure Poser Import	Before you can bring in a model or animation from e-Frontier's Poser program, you must tell Vue where your copy of Poser is stored on your hard drive. You can do this here, or the first time you try to import a Poser figure, you will be asked to locate the program.

TABLE 1-4 General Preferences

Button Group	Description of Buttons
Render Options	
Render Small Pictures of Objects Before Saving	Vue saves a thumbnail image of the object you're saving.
Reset Render Settings when Creating a New Scene	Each render you make has specific settings—rendering, file format, size, and so on. Having this option turned on will reset Vue's render settings to their defaults whenever a new scene is created. Turned off, the new scene has the same render settings as the one before it.
Generate Resume Render Info	If you stop a render or if the program should lock up or crash during a render, this saves information that allows you to resume the render the next time you open the program or tell the program to render the scene again.
Order of Rotations	
Default Rotation Order	This determines the direction in which the object is rotated based on the X/Y/Z coordinates. Clicking Apply to all objects applies the coordinate structure to all the objects in your scene.
World Coordinate System	
Y Axis Up/Z Axis Up/Left Handed/Right Handed	The majority of 3D applications use the Cartesian Coordinate system—X representing left to right (horizontal), Y representing up/down (vertical), and Z representing depth (closer/farther away). You can change this by selecting Z Axis Up to make height the Z coordinate. Left Handed and Right Handed change the way the directional pointers appear in the move/rotation/size gizmos (left pointing or right pointing).

TABLE 1-4 General Preferences

Button Group	Description of Buttons
Undo/Redo Options	
Maximum Number of Operations That Can be Undone at Any Time	This sets how many steps back you can go when using the Undo command. Caution: The higher the number, the more RAM is used to run the program; it has to remember more moves, thus taking up more system resources to do so.
Keep History of Operations Until System Resources Drop Below	Sets the percentage of RAM and virtual memory Vue uses as it is working. Once it reaches the percentage you set, the program will begin dropping information in order to clear out its cache.
Current System Resources	This shows you the percentage of system resources your program is using. If the program slows down, click the Flush History button to clear out the resources.
Allow Network/Internet Connections	Vue comes with a program that allows for network rendering. E-on Software's content website, contentparadise.com, can also link to your program to install purchased content. With this turned off, you cannot do either. If you don't have a network set up or the Internet connected to your computer, turn this feature off.
Automatically Check for New Software Updates	Vue will check the E-on Software site for any updates to your software and automatically download and update your program.
Check for New Content	Same as the previous, only this checks for any content updates.
Check for Fresh News/Tutorials	The Vue community is a very active one, with many users writing tutorials and tips/tricks they have found. And the program is being put to use in many professional settings. This keeps your tutorial and news database (accessed via the Help pull-down menu) up to date.
Interactive Numerical Field Changes	Automatically shows your changes as you type new numerical values.
Load Interface Presets	You can store various configurations of your workspace. Here, you can choose which saved preset you want to use.
Interface Colors	Changes the various colors that make up the GUI.
Reset Options to Default	Click this to revert to the default options.

Understanding the Display Options Window

The Display Options window gives you the ability to change the way the program displays elements in your workspace, as well as determine how your workspace appears.

The Display Options window, like the General Preferences window, is broken down into groups of options.

FIGURE 1-17

The Vue 5 Display Options window.

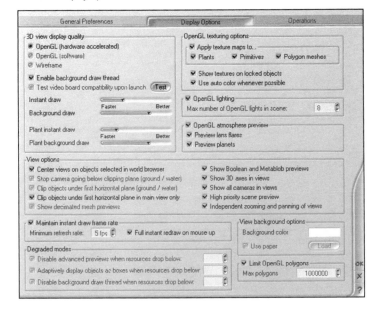

FIGURE 1-18

The Vue 6 Display Options window.

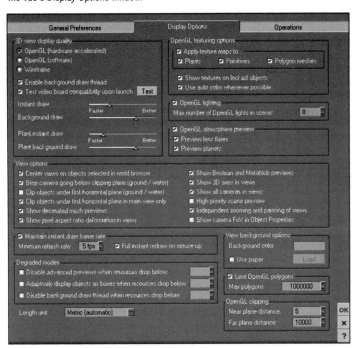

TABLE 1-5 Display Options

Button Group	Description of Buttons
3D Display Quality	
OpenGL (Hardware Accelerated)	This is the default setting for 3D display. In this case, Vue takes advantage of your computer system to generate the display. OpenGL, which virtually every computer takes advantage of, is an industry standard for displaying shading and color information while working on your projects. This is a simplified explanation, and for those interested, you can go to opengl.org to find out more about the technology. If you experience crashes or slowdowns, switch to OpenGL (Software).
OpenGL (Software)	Instead of using your system resources to display 3D information, you can utilize the OpenGL technology within the Vue software package to generate the visuals.
Wireframe	If you have an older computer or want Vue to run at blazing speeds without having to compute shadows and color information, choose this setting. All the elements in your scene will show up as wireframes—outlines without any detail.
Enable Background Draw thread	Computations for creating the visuals of 3D objects in your scene are done on-the-fly, happening "under the hood," as it were. Again, if Vue starts running slowly because of lack of RAM or because you have an older computer/video board, disable this setting.
Test Video Board Compatibility upon Launch	Vue will check your video board configuration every time you start the program. If you know you have a compatible OpenGL-compliant video board, turn this feature off. If you start experiencing problems with Vue, and you have turned off this feature, you can come back to this screen and click the Test button to make sure you aren't experiencing video board compatibility problems.
Instant Draw	Updates all panels and preview windows instantly when you make a change to the scene. Use the slider to set the quality of the draw display. The better the quality, the longer it can take to display the changes.
Background Draw	Determines the quality of the previews in the Main Camera world view. The higher the setting, the longer it will take for previews to render.
Plant Instant Draw	Determines whether the plant in your scene is shown as the actual plant when in the viewports, rather than as a primitive object.
Plant Background Draw	Has the program access Open GL to draw the plants in the viewports.

TABLE 1-5 Display Options

Button Group	Description of Buttons
OpenGL Texturing Options	
Apply Texture Maps To...	Shows a rough render of the attached texture maps. This can use up more system resources (RAM), so if you don't have a lot of RAM, turn this off.
Show Textures on Locked Objects	When you lock an object in the Layers window, you can set up Vue either to continue showing the textures assigned to the object(s) or to show a non-textured preview. Again, if you don't have a lot of RAM installed, you will want to keep this option turned off.
Use Auto Color Whenever Possible	Determines whether the objects placed into the scene will appear as dark-shaded shapes or light-shaded shapes.
OpenGL Lighting	Determines whether the lighting will be shown using OpenGL or not.
Max Number of OpenGL Lights in Scene	Lets you assign how many lights can be added to your scene showing OpenGL lighting.
View Options	
Center Views on Objects Selected in World Browser	When selected, the camera will always center the viewport(s) on the object you have selected.
Stop Camera Going Below Clipping Plane (Ground/Water)	Puts a bounding box around all the items (as if they were one).
Clip Objects Under First Horizontal Plane (Ground/Water)	When bringing in objects or objects created in other programs, this automatically sizes them based upon the measurement type you have set.
Clip Objects Under First Horizontal Plane in Main View Only	If this is turned off, imported objects float in midair. With it turned on, they are automatically placed on the ground plane.
Show Decimated Mesh Previews	Before you can bring in a model or animation from e-Frontier's Poser program, you must tell Vue where your copy of Poser is stored on your hard drive. You can do this here, or the first time you try to import a Poser figure, you are asked to locate the program.
Show Pixel Aspect Ratio Deformation in Views	If you are setting up scenes for print or video, there are different pixel aspect ratios used in the final output. This sets the program to show you if there will be any unwanted deforming of the primitives' meshes when rendered. There are a number of books that focus on properly preparing files for video and, if you plan to do professional video production using Vue, you should think about investing in some of them.

TABLE 1-5 Display Options

Button Group	Description of Buttons
View Options	
Fixed Camera & Light Sizes in Views	Locks in the sizes of the cameras and lights displayed in the scene.
Show Boolean and Metablob Previews	Vue saves a thumbnail image of the object you're saving.
Show 3D Axes in Views	Each render you make has specific settings—rendering, file format, size, and so on. Having this option turned on will reset Vue's render settings to their defaults whenever a new scene is created. Turned off, the new scene will have the same render settings as the one before it.
Show All Cameras in Views	If you stop a render or if the program should lock up or crash during a render, this option saves information that allows you to resume the render the next time you open the program or tell the program to render the scene again.
Independent Zooming and Panning of View	Determines whether each viewport will zoom independently or in unison (zoom in/out in one viewport, all viewports zoom in/out with it).
Show Camera FoV in Object Properties	FoV stands for Field of View. This selection changes the way Vue shows the focal length information in the Properties panel. When turned on, instead of focal information (lens size), you get the FoV numerics.
Show Tool Tips in Views	Determines whether the pop-up tool names appear when you hover the cursor over a tool.
Maintain Instant Draw Frame Rate	
Minimum Refresh Rate	This determines the direction in which the object is rotated based on the X/Y/Z coordinates. Clicking Apply to All Objects will apply the coordinate structure to all the objects in your scene.
Full Instant Redraw on Mouse Up	When you release the mouse, the entire scene is redrawn in the Main Camera View.

TABLE 1-5 Display Options

Button Group	Description of Buttons
Degraded Modes	
Disable Advanced Previews when Resources Drop Below	If your system resources go below a certain amount (you set that amount in the associated numerics field), preview renders will not be created. Also, color references for the textures on your objects will turn to gray.
Adaptively Display Objects as Boxes when Resources Drop Below	If your resources drop below a certain amount (you set that amount in the associated numerics field), all the objects in your scene will be displayed as box shapes rather than their actual shapes.
Disable Background Draw Thread when Resources Drop Below	If your resources drop below a certain amount (you set that amount in the associated numerics field), background details will not be drawn in your preview windows.
Length Unit	This lets you set how distance and object size are calculated. You can set it to metric, imperial, meters, centimeters, millimeters, kilometers, inches, feet, yards, and miles.
View Background Options	
Background Color	Change the color of the viewports' background. If you don't like the default light gray, you can double-click on the associated color chip and select a new color.
Use Paper	You can add a texture to the Main Camera View window. By default, when you first start Vue, a paper texture is assigned to the window.
Limit OpenGL Polygons	This assigns how many polygons can be in your scene before OpenGL no longer displays the texture and shading information.
OpenGL Clipping	This assigns how close to and far away from the camera objects are displayed. When you reach that clipping point, the object or part of the object becomes transparent.

Understanding the Operations Window

The Display Options window, like the General Preferences window, is broken down into groups of options. Other than the GUI of the window, the controls are exactly the same for Vue 5 and 6.

TABLE 1-6 Operations Options

Button Group	Description of Buttons
Keyboard Shortcuts	If you want to assign or add keyboard shortcuts to help you speed up your workflow, double-click on the existing shortcut or blank area to the right of the feature title and type in a new one. Many 3D Studio Max users reassign the keyboard shortcuts for the Move/Rotate/Size controls to match those in 3DS Max.
User Configuration Files	If you set up a folder where you store frequently used environments, you can tell Vue to draw from those environments when the program starts up.
Additional Texture Map Folders	If you keep textures in folders outside of Vue, you can tell Vue to add those to the list when loading scenes or saved objects that have textures already assigned to them.

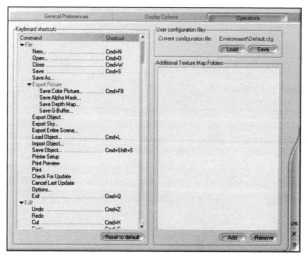

FIGURE 1-19
The Vue 5 Operations window.

CHAPTER SUMMARY

In this chapter, you learned about the basic controls and tools you will be using every time you create a new scene in Vue. You have also learned how to set up your program to work and display information in the way you most prefer. It's important to note that, if you are new to Vue, it is best to leave the program's preferences settings in their default modes. If you should happen to experience problems with the way your program runs or responds, refer to these charts so you know what does what.

What You Have Learned

In this chapter, you learned:

- How to switch between the quad (four panel) display and a single panel.
- Where the layout controls are located.
- Where the various objects are located in the Objects panel.
- How to access Vue's Preferences/ Options panel.
- How to interpret the numerous preferences in the Preferences/Options panel.

Key Terms from This Chapter

Alpha A channel added to an image that allows for quick selection of an image element in a photo-manipulation program like Photoshop or transparencies in 3D and video editing applications.

Cartesian Coordinates The way in which height, width, and depth are measured in 3D space.

Clipping If an object gets too close or too far away from the camera or goes below a certain point in the scene (such as below the ground plane), the program will not draw out the polygons in that portion of the object.

Focal length Very simply, it is the distance from the lens to the film, when focused on a subject at infinity. In other words, focal length equals image distance for a far subject. To focus on something closer than infinity, the lens is moved farther away from the film. This is why most lenses get longer when you turn the focusing ring.

Gizmos The Move, Rotation, and Scale control buttons that appear in the viewports when an object is selected.

Metablob Merges two or more objects in a more fluid manner than standard Boolean methods. This feature is used to create what are called organic shapes—elements that are more rounded and supple. All objects assigned as metablobs will be rounded, losing any sharp edges.

OpenGL The hardware and software feature that allows your computer and the program to display textured and shaded 3D information.

Polygons Three- or four-sided shapes that, combined, make up the mesh that describes the shape of an object. Each 3D object is made up of polygons. The number of polygons in a mesh describes how detailed, or high quality, an object is. For instance, with fewer polygons, a globe shape would have sharper corners along the edge, whereas more polygons would make the curve look smoother.

Primitives Pre-defined shapes such as blocks, spheres, or cylinders used to create objects in your scenes.

Tilting/Panning The act of moving the camera head up or down (tilting) or left to right (panning).

Viewports/Windows The windows in which your scene(s) is displayed and where you can make modifications to the positions and layout of your elements.

2

CREATING A
BASIC SCENE IN VUE

1. Select atmospheric conditions.

2. Add infinite planes to the scene.

3. Build a basic scene.

4. Add elements to your scene.

2 CREATING A
BASIC SCENE IN VUE

Beams of light shining through the clouds. A ray of light cuts through the darkness of a room, dust particles lazily floating in the brightness. Fog wafting across of field of wildflowers. Leaves gently blowing in the breeze. A voyage through deep space, passing planets and solar systems at greater than the speed of light.

Have I caught your attention yet?

If you can picture those scenes in your mind, you can create them in Vue 6 Infinite. With a few clicks of the button, you can build the images or the animations that have been heretofore playing across your mind's eye, allowing others to share in the wonder and awe of your creativity. Now that you know how to set up the program so it is laid out and

modified to work with you, you are ready to start translating your ideas into pixels and points of light. Yes, that means it's actually time to start working with the program.

In this chapter, you are going to begin your explorations by assigning and then modifying atmospheres, adding layers of clouds and water, placing primitive objects, and then repositioning them to build a basic scene. Yes, these are baby steps on the road to building complex projects, but they are important because they will lay the groundwork for everything else you will do in the program.

Tools You'll Use

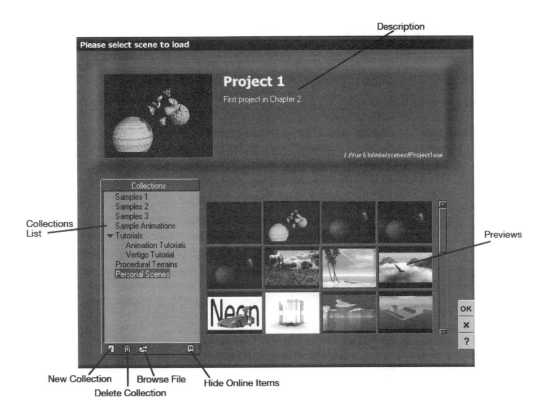

Description

Please select scene to load

Project 1
First project in Chapter 2

f:/Vue 6 Infinite/scenes/Project1.vue

Collections
Samples 1
Samples 2
Samples 3
Sample Animations
▼ Tutorials
 Animation Tutorials
 Vertigo Tutorial
Procedural Terrains
Personal Scenes

Collections List

Previews

OK
X
?

New Collection
Delete Collection
Browse File
Hide Online Items

SELECT
ATMOSPHERIC CONDITIONS

What You'll Do

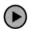

In this section, you change the atmosphere using the preset atmosphere library.

For every scene there is light. That light might be from the sun, the moon, a lamp, or a flashlight. Every time you open Vue or create a new project, a default atmosphere is automatically added to your scene. In most circumstances, this default atmosphere is not the one you want to use for your image. You are not stuck with this atmosphere; you can change it to another preset or you can go in and create any atmosphere you can imagine.

Load Atmospheres

Infinite Planes

Primitives

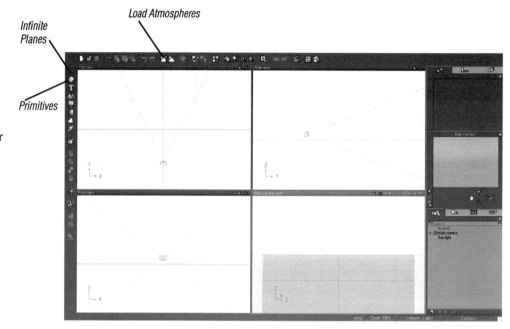

FIGURE 2-1

The Atmosphere Selection screen. To the left is the Category list, where you can select one of the dozens of pre-made atmospheres for your scene.

Description

Selection List

Expander Toggle
Switch

Thumbnails

1. Open your Vue application.

 By default, the scene will open up with either the default atmosphere or the atmosphere you set the program to open in the General Preferences controls (see Chapter 1).

2. There are three ways to load a pre-existing atmosphere:

 a. Click the Load Atmosphere button on the Control Bar.

 b. Choose Atmosphere > Load Atmosphere from the pull-down menu.

 c. Use the F5 key to open the Load Atmosphere screen.

 This will open the Atmosphere Library (see Figure 2-1), where you can choose from the preset atmospheres that came with Vue 6 Infinite, or the original atmospheres you have created. The screen is broken into three segments: Description, Selection List, and Thumbnails. The Description area gives you a larger thumbnail showing what the atmosphere will look like, and descriptive text about that atmosphere. The list on the left gives you access to the various libraries, broken down into categories, and the Thumbnails section gives you visuals of the various atmospheres in the selected folder.

QUICKTIP

The small triangle to the left of a folder name–the toggle switch–expands or contracts the folder so you can see what is inside that particular master folder or close the folder to hide all the subcategories. Click once on the toggle switch to expand the folder. Click again to close it.

QUICKTIP

Clicking anywhere but on the name of a folder is a good habit to get into because, in most cases, clicking directly on the name can activate the text box where you can change the name of the folder.

3. Expand the Daytime folder (if it isn't already expanded) and click on the Sunshine category.

4. Use the scrollbar to the right of the thumbnails and select the atmosphere titled Destination Unknown (see Figure 2-2).

You can do one of two things to select the atmosphere and assign it to your scene.

a. Double-click on the image thumbnail.

b. Click once on the image thumbnail, and then click the OK button.

The new atmosphere has been loaded.

FIGURE 2-2

Select Daytime and locate Destination Unknown for the atmosphere.

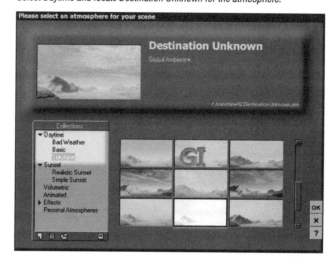

Performing a Quick Render of the Atmosphere

To see how your atmosphere looks in the scene, you can perform a quick render. Although the Main Camera display in the World Browser gives you a good representation, sometimes the images are too small to see the details. There are three ways to perform a quick render. Try each of them so you get a feel for where they are located as well as which method you prefer using.

FIGURE 2-3
Right-click on the Main Camera View window to bring up the submenu with numerous controls for that window.

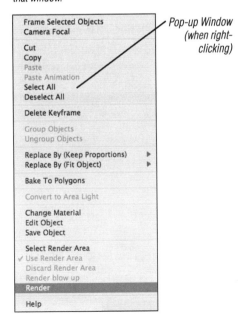

Pop-up Window (when right-clicking)

As with all renders, whether a quick preview or high-quality, when the render is complete, the Post Render Options window (see Figure 2-4) will appear (Vue 6 Infinite only). If you are using Vue 5, no screen will appear; only the finished render will be shown. Unless you want to make visual changes to your file (lighten or darken the image, color correction, and so on), click the X button to close this window and continue working.

QUICKTIP

There will be many times you choose an atmosphere that you think you want to use for a scene, but find out later you really want it to be a different one. To change an atmosphere, follow the previous steps you used to assign a new atmosphere to your scene.

FIGURE 2-4
The Post Render Options window opens automatically when you perform a quick render. This is a Vue 6 Infinite-only feature, and does not happen in the Vue 5 family versions.

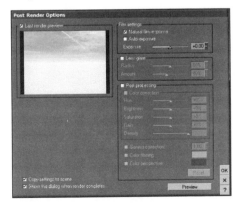

1. Click once on the Render button (the camera icon) in the control panel at the top of the screen (just under the pull-down menus).

 If you press and hold on the Render button, it will open the Render Options window, which is discussed in Chapter 14.

2. Click once on the Quick Render button (the small camera icon) in the title bar of the Main Camera View window.

 If you press and hold down the mouse button on this icon, a submenu will appear, letting you set the quality of the render.

3. Right-click on the Main Camera View window and select Render from the submenu (see Figure 2-3).

ADD INFINITE PLANES
TO THE SCENE

What You'll Do

In this lesson, you learn how to add infinite planes to your scene.

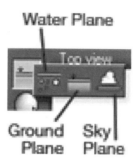

Not only do you have a default atmosphere that loads when you open your program each time, a default ground plane is added to the scene. This ground object is what is called an *infinite plane*, an element that goes on forever. No matter how far you move the camera, you will never reach the end of it. Vue comes with three types of infinite planes: ground, water, and cloud.

As with literally everything else in your scene, you are not stuck with dealing with this ground plane. In fact, if you are creating a space scene or some image or sky animation that does not show the ground, you will need to get rid of the ground plane altogether.

Selecting and Renaming Elements

In order to delete the ground plane, or any other object in your scene for that matter, you need to select it.

FIGURE 2-5

The ground plane becomes highlighted in all the viewports and in the Layers window when you select it.

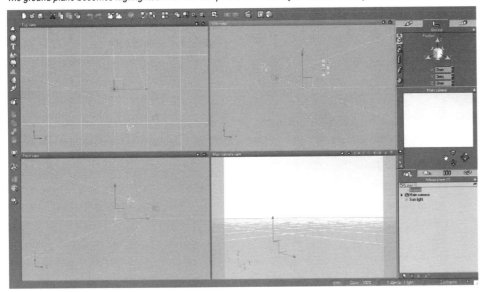

FIGURE 2-6

When you double-click on an object name in the Layers window, you can rename the element.

1. Click once on the ground plane in any of the viewports to select it.

The ground plane will be highlighted when you select it, as you see in Figure 2-5. Normally, for an object such as this, it is easier to use the Top View viewport or the Main Camera View window since you don't have to worry about exact cursor placement.

2. Another way to select the object is in the Objects window in the World Browser, which is located in the bottom section of the right side of the workspace in the Layer 1 area. Click once on Ground to select the plane.

After you have selected the object, notice that the various controls become active. At this point, you can add textures to the object, resize it, move it, or modify it in any way you want.

3. To rename an object, click on the object's default name in the Objects window of the World Browser.

This opens the text edit field (see Figure 2-6). The default name will be highlighted. You can now type in a new name for the object.

4. Press the Return key or click anywhere in the window to accept the name change.

Delete an Object

1. Select the ground plane using any of the methods you have learned.

2. Press the Delete key (PC and Mac Extended keyboard) or the Backspace key (Mac non-Extended keyboard).

3. The other method for removing an object from the scene is to right-click on the object in any window and select Cut from the submenu.

Deleting an Object from the Scene

If you decide you no longer need or want a particular object in the scene, you can delete it using a few different methods. In this example, you will delete the ground plane from the scene.

FIGURE 2-7

Right-clicking on the selected object in any window or in the Layers window gives you the option to delete the item from the scene.

Saving Your File

Now that the ground plane has been removed, it is time to save the file.

QUICKTIP

If you do not do a quick render prior to saving your scene, Vue will not create a thumbnail of the image. Make sure you perform a quick render (by right-clicking on the Main Camera View window and selecting Render from the submenu) before saving your files.

FIGURE 2-8

The Save screen with the default Scenes folder selected.

Save Your Scene

1. Choose File > Save or press Ctrl/Cmd+S to open the Save screen.

 If this is the first time you have saved the file (which, in this case, it is), the Save dialog box will open. By default, you will be in the Scenes folder inside the Vue 6 Infinite folder on your hard drive (see Figure 2-8). This is where you will want to save your scenes most of the time. If you do not want to save your scene in this default folder, navigate to the folder where you want your scene stored.

 Also, if you have already saved the file and use the Save command, the Save window will not appear. The file is automatically overwritten.

 QUICKTIP

 To use the Save As command in order to make a copy of the file without overwriting the original, choose File > Save As or go into the Preferences/Options window and set your own shortcut key. Your Save screen might appear different than what is shown, depending on whether you're using a Mac or a PC. But the same controls and text fields are available.

2. Give the file a name in the Save As text field.

 There are two locations to name your file. The first is the Save As text field at the top of the Save As screen. This title is the actual name of the file as it will be stored in the computer.

3. Now select the Title field in the middle of the window.

 This is the name that will appear in the library window when you select the file.

4. Add a description in the Description box.

 The description of the file can often be important, especially if you decide to save multiple versions of that file.

 QUICKTIP

 When adding a description to the file, it's usually best to give information regarding the file's use (if it is a professional project), details on elements in the scene, and/or notes to yourself if you are going to come back to work on the file at a later time.

 QUICKTIP

 ### Why You Should Save Multiple Versions of an Image

 As you are building your scene, you will often find yourself moving or removing objects because, at the moment, you don't think they belong. But after you make a dramatic change in the lighting or in the positioning of objects or the camera, you might decide you liked your image better the way it was. Instead of having to try to replace elements or place objects back into the scene, you can switch to the old image and continue to work.

BUILD A
BASIC SCENE

What You'll Do

In this lesson, you learn how to build a basic scene, including creating and populating a scene, scaling objects, and creating materials for the scene.

Now is the time to actually start placing elements into the scene you have started. You didn't really think that deleting the ground plane and then saving the file was all that was going to happen here, did you? From this point on, the file you are about to work on will be used for a few different projects, so you will need to save it frequently.

For this section, you will be building a space scene and saving it for later use in the chapter on animation. You will be adding different primitives and rock objects to this document, which will later be set up to fly past the camera.

Atmospheres

Primitives

Rocks

Load Material

Layers

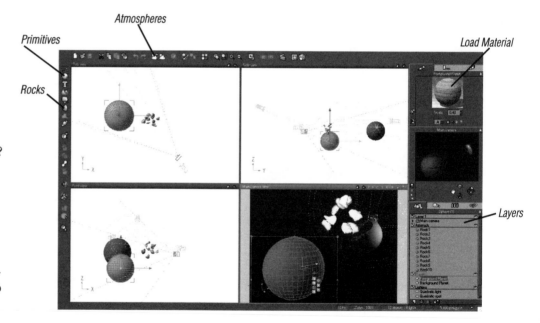

Opening a Saved Document

Vue 5 and 6 utilize libraries to store scenes, called *Collections*. The program comes with a number of preset and tutorial collections and one collection set titled *Personal Scenes*.

The Please Select Scene to Load screen, or for these purposes here, the Open screen (see Figure 2-9), is made up of three areas: Description, the Collections list, and a Preview window that shows thumbnails of each scene in the collection.

QUICKTIP

Immediately below the Collections list is a series of buttons. These buttons, from left to right, are New Collection, Delete Collection, Browse File, and Hide Online Items. New Collection creates a new folder in which you can store your scenes. Delete Collection removes a collection, or folder, from the list. Browse File lets you browse your computer's hard drive(s) so you can navigate to where you stored your scenes. Vue also allows you to connect to the Internet and purchase items online (cornucopia3d. com). Hide Online Items will turn off the visibility of any items you purchased that are stored online.

FIGURE 2-9

The Please Select Scene to Load (or Open) screen.

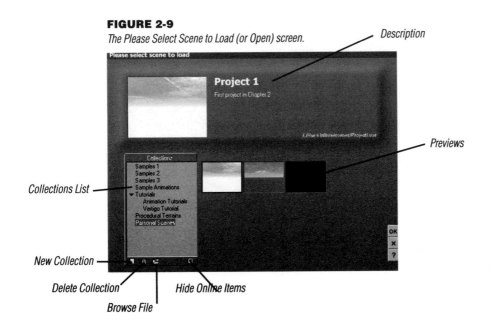

Open a Saved Scene

1. Choose File > Open or use Ctrl/Cmd+O to open the Collections window.

2. In the Collections list on the left side, click once on Personal Scenes.

 When you click on a collection, a series of thumbnails appears in the large area to the right of the list (see Figure 2-10). From here, you can choose which scene you want to load. At this point, you probably only have one thumbnail in your collection—the file you saved in the previous section of this chapter.

 > **QUICK**TIP
 >
 > If there are a lot of stored scenes in that particular collection, a scrollbar will appear. Click and drag on the scrollbar to reveal the other stored scenes.

3. Choose the scene you just saved.

 Click once on the thumbnail image to preview the file. This will appear in the upper third of the window, along with the title you gave the file and any notes you added.

4. To open the scene, do one of three things:

 a. Double-click on the thumbnail image.

 b. Click the OK button at the bottom right of the screen.

 c. Press Return/Enter on the keyboard.

 Any one of these methods will open your scene in Vue.

FIGURE 2-10

Clicking on a category will open a set of thumbnails showing which atmospheres are stored in that folder.

Creating a Space Scene

In preparation for creating your first scene, you are going to need to change the environment. The Destination Unknown atmosphere will not work for this. Luckily, Vue comes with a pre-built starry night atmosphere that is perfect for this scene.

FIGURE 2-11

The space atmosphere after using the quick render.

ADD ELEMENTS
TO YOUR SCENE

What You'll Do

 In this lesson, you learn how to add objects and other elements to your scene.

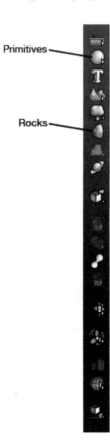

Primitives

Rocks

Populate the Scene

Now it is time to start populating your scene. In this section, you will be working with the Sphere primitive and adding rocks (space debris) to the scene. This will give you a good working understanding of how to add and interactively move elements within your scene, without having to worry about exact placement yet. That will occur in the next portion of this chapter.

FIGURE 2-12

The Primitives fly-out, giving you access to the other primitive shapes.

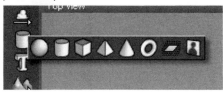

FIGURE 2-13

The sphere has been renamed Foreground Planet.

1. Press and hold down on the Primitives selection button (see Figure 2-12).

 When you press and hold on this and other buttons, a fly-out menu will appear, showing you the various types of objects that can be added to your scene.

2. Without releasing the mouse button, move your cursor over the Sphere primitive and release.

 The selected object is highlighted when the cursor moves over it. When you release the button, the object will be added to your scene. Notice that the Sphere object has also been added to the list in the World view.

 QUICKTIP

 If you release the mouse button either prior to moving or while moving your mouse, the fly-out menu will disappear, and you will have to click on the Primitives button again.

3. Click on the Sphere name in the List window, as you see in Figure 2-13. Rename the sphere **Foreground Planet**.

4. Selecting the Top window, make sure the Move gizmo is selected by either clicking on the top-right button or typing M on the keyboard.

5. Move your cursor into the square that is, by default, to the upper right of the selected object.

 When you move your cursor into this area, the square will fill with yellow.

6. While still working in the Top view, click and drag the object back until the top of the Move box is against the bottom edge of the window's title bar, as you see in Figure 2-14.

7. Now select the Side view. Move the object upward until it is approximately in the center of the window, as you see in Figure 2-15.

8. Add another sphere to the scene by clicking once on the Primitives button.

 Because you had last selected the Sphere object, this is the default object that will be placed when you click on the button. If you had wanted to add a different primitive to the scene, you would have had to repeat Steps 1 and 2. For now, leave this sphere as is.

9. Perform a quick render and save the scene (choose File > Save or press Ctrl/ Cmd+S).

 Again, by performing the quick render, you are guaranteeing that when you save your file, the thumbnail will be updated to show the changes you have made.

FIGURE 2-14
This is the approximate Top view position for the sphere.

FIGURE 2-15
The approximate Side view position for the sphere.

QUICKTIP

Checking Polygon Count

Keeping track of the number of polygons in your scene is extremely important. Each object is made up of polygons, the mesh that defines the shape of a 3D object. The higher the polygon count, the higher the **resolution** of the object (this is actually a misnomer; all this means is the more polygons in a mesh, the smoother the curves). But, with more polygons, the program needs more resources to run efficiently. As that efficiency deteriorates, you can experience slowdown in windows updating.

Any 3D program can quickly get into the millions of polygons, and Vue is no exception. Here is how to keep track of the number of objects and how many polygons are in your scene, as well as how much of your system resources is being used by Vue.

At the bottom of the Vue workspace, beneath the Main Camera View and the Object List, is an information bar. This bar tells you, from left to right, the number of Central Processing Units (CPUs) installed on your computer, the zoom percentage for the scene, the number of objects in your scene (including lights), and the polygon count/ resources field (see Figure 2-16). By default, the latter is set to the polygon count, which right now should be just under 2,000. Click on the downward-pointing arrow to the right of this number and select Free Resources (see Figure 2-17). Now the amount of free resources you are using is displayed.

FIGURE 2-16

The Vue system and scene information bar located at the bottom right of the workspace.

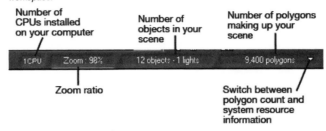

FIGURE 2-17

Access system resources using the downward-pointing arrow at the bottom right of the Vue workspace to see how much of your resources is left to work with.

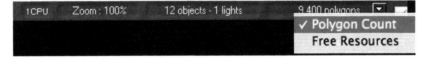

10. Click on the Rock button in the Objects bar to immediately add a rock element to the scene (see Figure 2-18).

Because you did not move the second sphere, this rock will be placed in the same location as the sphere. In other words, it is inside the foreground planet.

> **QUICK**TIP
>
> The Rock button is the seventh button down in Vue 6 Infinite, and the sixth button down in Vue 5. You do not have any choices in rock shapes, so you do not need to press and hold the mouse button down; no fly-out window will appear.
>
> Rocks are randomly generated meshes. This means that every time you click on this button, Vue will create an entirely new, random mesh for the rock. In this way, no two rocks will ever be the same. If you don't like the shape of the rock placed in your scene, delete it and click the Rock button again.

11. Click in the Top view viewport to make it active, and move the rock to the side of the planet. Refer to Figure 2-19 for the approximate position of the rock element.

FIGURE 2-18

The location of the Rock selector in both Vue 5 (all inclusive) and Vue 6 Infinite.

FIGURE 2-19

The approximate position for the rock you just added to your scene.

FIGURE 2-20

Ten rocks, soon to be referred to as asteroids, are positioned in the scene.

12. Repeat this process until you have 10 rocks in your scene.

You are creating an asteroid field. Notice how each rock you add is a different shape. This is a feature in Vue that you will come to appreciate, as have professionals around the world. Use each of the windows—Top, Side, Front—to position the rocks as you want. Refer to Figure 2-20 for an idea of placement.

QUICKTIP

Don't worry about trying to match the scene you see here exactly. Part of the learning process is to experiment, so you should feel free to move and scale elements as you want to.

13. Perform a quick render and save your scene.

At this point, you have created your first scene in Vue. It might not be anything to write home about or hang on your Mom's refrigerator—yet!—but that will come. What you have accomplished at this point is 90 percent of everything you will do to set up a scene in Vue.

Scale Your Objects

Let's begin the modification process. Right now, the asteroids are much too large; they're almost as large as the planets they are shooting past. Time to do some scaling.

1. Select Rock 1 from your list in the List window.

 It will be easier to select specific elements using the List window. When your scenes become more complex, the ability to select individual objects in your scene can get extremely frustrating if you're trying to click on an element in a window.

2. Click the Scale gizmo (bottom button) in the viewport of your choice, or use the S key on your keyboard. The Scale gizmo will be highlighted, as you see in Figure 2-21.

 > **QUICK**TIP
 >
 > At this point, it's a good idea to go to your Display Options window (choose Vue 5/6 Infinite > Preferences on the Mac or File > Options on the PC) and turn on Independent Zooming and Panning of Views. This way, when you zoom or pan in one screen, the rest of the views are unaffected.

 The Scale controls are now revealed. They appear as a 90-degree angle with two sections. The interior section scales uniformly. When you click and drag your mouse up and down, the overall size of the object will change uniformly (up increases and down decreases the size). The outer strip, the thin one immediately next to the uniform scale, allows you to scale width or height independently. When you move your cursor into either of these areas, the section fills with yellow to let you know it's active.

3. Select the Top viewport and click the Zoom In button in the control bar until your asteroid almost fills the screen. The Zoom tools are shown in Figure 2-22.

 You do not actually select the Zoom tool then drag within a window to zoom in. Each time you click, the view will zoom in or out in set increments. So if you want to zoom in fairly close, you will need to click the Zoom button repeatedly until the screen is how you want it.

4. Using the Uniform Scale control, reduce the asteroid's size by about half.

 > **QUICK**TIP
 >
 > There is a more precise manner to modify a selection, which is discussed in Chapter 11.

5. Repeat this process for each asteroid, switching between the Scale and Move tools to set the asteroid field up as you want it to look.

 Take your time doing this, making sure the asteroid field does not look like it is going to crash into the front sphere. Remember to check all your viewports, especially the Top and Side, to set your placement.

FIGURE 2-21

Using the S key will select the Scale gizmo in the active viewport.

FIGURE 2-22

The Zoom tools look like magnifying glasses with a plus and minus symbol in them.

> **QUICK**TIP
>
> **Checking Polygon Count**
>
> If your asteroids are extending beyond the view of the window you are working in, hold down the right button on your mouse, which will turn your cursor into a hand, and then click and drag. This will scroll the view within the viewport so you can get to out-of-reach objects. If you do not have a multi-button mouse, hold down the spacebar to activate the hand tool.

FIGURE 2-23

The New Layer button adds a new layer to your document, which can be used to store elements within your scene, thus making it easier to find and select them.

FIGURE 2-24

A new layer, shown at the bottom of the list, has been added to the scene.

Begin to Organize

Now is a good time to get used to organizing your list of objects in the scene. Your list of objects has already grown to 14 with the camera, sun, planets, and asteroids. You will be adding more objects into the scene, so the list is going to grow.

1. Click on the New Layer button (see Figure 2-23) at the bottom of the Objects window.

 This will add a new layer to the window (see Figure 2-24). Layers are actually folders into which you can put any objects in your scene.

2. Click on the Layer 2 name to bring up the text field.

3. Type in **Asteroids**.

 This changes the name of the layer to match the content.

4. Click on Rock 1 in the list.

5. Hold down the Shift key and click on Rock 10.

 This selects all the rocks in the scene, enabling you to move them as a group.

6. Click on any of the Rock names in the List window and drag downward to the Asteroids layer.

 Doing this moves all the rock objects into that folder.

7. Now create another layer and name it Planets.

8. Select both spheres and drag them into this new layer.

Layer Controls

There are two controls available to you for each layer: the Page icon to the left of the layer name and the Eye icon at the far right. Clicking on the Page icon will expand or contract the layer so you can hide the contents when you aren't working with them. The Eye icon determines visibility for the layer. First, when the eye is open (see Figure 2-25), the elements in that layer are visible in your scene. Click on that icon once, and it turns into a padlock (see Figure 2-26); this locks the layer so you cannot make additions or changes to it. Click on this icon one more time and you get a closed eye icon (see Figure 2-27). This turns off the visibility on that layer, making the contents invisible in your scene. It does not affect rendering; it does, however, help you place objects more easily if they are being blocked by that layer's contents.

9. Click on the Asteroids layer name. All objects within that layer are now highlighted as in Figure 2-28.

 You can now move all the objects in that layer as one group.

10. With the Asteroid layer selected, move the asteroid field to the upper portion of the screen, as you see in Figure 2-29.

11. Perform a quick render. This will show you how your scene is looking at this point as well as give Vue the information it needs to create a preview image in the Scene Selector window.

12. Save the file.

FIGURE 2-25

The open eye icon means the layer is visible in your layout.

FIGURE 2-26

The padlock means that the layer is locked and cannot be modified.

FIGURE 2-27

The closed eye icon makes the elements in that layer invisible in the workspaces.

FIGURE 2-28

All asteroid objects in your scene are now selected and can be repositioned as one.

FIGURE 2-29

The repositioned asteroid field.

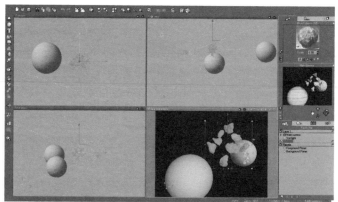

FIGURE 2-30

When you select an object in your scene, you will see a thumbnail of it in the Aspect area at the top of the World Browser.

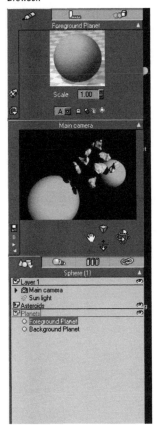

FIGURE 2-31

The Load Material button in the Aspect screen of the World Browser.

FIGURE 2-32

The Basic Material Editor window in Vue 6 Infinite. If your window does not look like this, click the button that says Basic Material Editor to change the screen layout.

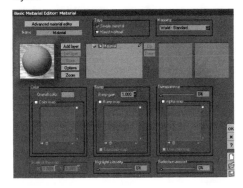

FIGURE 2-33

The Material Selection screen.

To bring some life to the planets in the scene, you will want to add a texture to them. Textures, or materials, can be as simple or complex as you want, but for this section, you will add a pre-defined material to the spheres in order to give them a more realistic look.

At this point, you learn how to assign a material to an object, but we will not delve into editing or creating our own materials yet.

1. Select Foreground Planet in the Planets layer.

 The sphere is highlighted in the windows, and a thumbnail of the object appears in the Aspect area of the World Browser (see Figure 2-30).

2. There are two ways to access the Materials Editor window from this area of the World Browser:

 a. Click on the Load Material button (the small icon at the lower left of the Aspect window). The Load Material button looks like Figure 2-31.

 b. Double-click on the thumbnail image.

 The Basic Material Editor window opens. This window, if it is the first time you have accessed it, should appear like you see in Figure 2-32.

3. Double-click on the thumbnail image at the top left of this window.

 This will open the Material Selection screen (see Figure 2-33).

4. In the Landscapes category, double-click on the Canyon material (see Figure 2-34).

 Here, you select and assign the material to your object. You will be taken back to the Basic Material Editor window. The Main Camera window in the World Browser will update to show the texture added to the Foreground Planet.

5. Click OK or press Return on the keyboard to assign the texture.

6. Repeat this process for the Background Planet object.

 Take a few moments to scroll through the various textures. Find one that you want, and assign it to the Background Planet.

7. Save your file.

FIGURE 2-34

Find and choose the Canyon material in the Landscapes category.

FIGURE 2-35

The light control buttons for both the Vue 5 family (left) and Vue 6 Infinite (right).

FIGURE 2-36

The Shadow controls in Vue 6 Infinite.

Fix the Shadows

As you have performed quick renders on your scene, you might have noticed that the shadows being cast by the sun light are too harsh. You can fix this using the Aspect screen in the World Browser. This is what you will do in this section: fix the shadow intensity to soften the shadows cast by the asteroids.

1. Select Sun Light from the list in the Layers section of the World Browser.

 The Aspect panel will change to reflect your selection. You will see a list of buttons going down the left side of the screen (see Figure 2-35). These buttons give you access to (from top to bottom)

 a. Lens flare settings

 b. Light gels

 c. Volumetrics

 d. Shadow controls

 e. Preview options

 These controls are discussed more completely in Chapter 12.

2. With your cursor over the Shadows button, press and hold down the mouse button and select Edit Shadows. In Vue 5, select Edit Shadow and Lighting.

 This will open the Light Editor window, as shown in Figure 2-36. From here, you will make changes to the shadow settings to make the scene look more natural.

QUICKTIP

The light control panel in V6I is different than in the Vue 5 family. In Figure 2-37, you see the Vue 5 Shadow and Lighting Editor, which is not as in-depth as in Vue 6 Infinite.

3. Reduce the shadow intensity by doing one of two things:

 a. Drag the triangular slider to the left until the number in the numerics panel is at 65%.

 b. Click in the numeric text field, highlight the number, and type **65%**.

 This will reduce the harshness of shadows cast by the Sun Light.

4. To make the shadow softer (have the edges blur), click on the Use Shadow Map check box, and then select Soft Shadow Map—No Hard Shadows (see Figure 2-38).

 For now, you will leave the Quality settings at their default.

5. Click the OK button or press Return on your keyboard to make the changes.

6. Perform a quick render and then save your file.

FIGURE 2-37

The Vue 5 family shadow control window.

FIGURE 2-38

Use the Soft Shadow Map control to soften the edges of the shadows cast by the objects in your scene.

CHAPTER SUMMARY

In this chapter, you created your first basic scene from start to finish. You worked in the various viewports in order to position your objects within the scene, organized yourself in the Layers window, learned to create quick renders and save your scenes for later modification, and learned how to add basic pre-defined materials (textures) to objects. At this point, you have the basic knowledge to build virtually any scene you can imagine. Now it comes down to practice and working with the numerous controls to fine-tune your scenes.

What You Have Learned

In this chapter you

- Selected and changed atmospheres
- Placed objects in the scene
- Moved objects within the various viewports
- Interactively scaled objects
- Renamed objects in the Layers window
- Created new layers
- Moved elements from one layer to another
- Adjusted shadow intensity

Key Terms from This Chapter

Atmosphere The representation of the atmospheric conditions of a scene, including clouds, sun/sun position, and fog or haze within the scene.

Cloud plane An infinite plane that adds cloud layers into your scene.

Collections A group of objects, scenes, plants, and so on, that are grouped into specific categories for easy inclusion in your scenes.

Ground plane An infinite plane that adds a ground surface to your scene. By default, a ground plane is added to your scene when you open Vue or create a new scene.

Infinite plane A flat surface that has no beginning or end points. It will extend to infinity in your scenes.

Polygon count/resolution The number of polygons that create a shape/element in your scene. The higher the number of polygons, the higher the resolution and the smoother a surface will be.

Populate The act of adding elements to your scene in order to create your final image.

Quick render A preview render of low quality that allows you to see a detailed representation of your image. Also used to generate a preview image in your Scene Selector window.

.vue extension This extension describes the file type when opening that file. This particular one represents a file created with the Vue program.

Water plane An infinite plane that represents water in your scene. This can be used to create lakes, rivers, or oceans.

Wireframe A surface that defines the shape and quality of a 3D object. The number of polygons making up a mesh determines its resolution (quality).

3

MANIPULATING
TERRAINS

1. Select and place terrains.

2. Design your terrain.

3. Modify terrains interactively.

4. Make global effects and changes to your terrain.

5. Use image maps to create terrains.

6. Learn the terrain options.

Terrains are the most common elements used when working with Vue 6 Infinite. With them, you can create grand mountain expanses, rolling hills, and undulating landscapes. Or, you can use an image editing program like Adobe Photoshop or Corel's Paint Shop Pro to design *height maps,* which allow you to define any type of terrain you want.

Adding a terrain to your scene, though, is only the beginning of the layout process. Vue 6 Infinite provides you with a myriad of tools to bring your scene to life–from interactive editing to numerous special effects that can add extra detail to the Terrain element. Whether you envision a scene deep within the crevices of an ice fissure, a field of corn with a wide mountain range in the distance, or a lunarscape, the way in which you place and modify the Terrain elements gives you almost limitless creative possibilities.

The first thing you need to decide with any scene you create is the final output for that scene; is it going to be used for the Internet, for high-resolution print (advertisements, a story illustration, and so on), or a feature film? Will there be close-ups of the terrains, or will they be background elements? As with any 3D programs, the amount of space your file will take up on your hard drive and the amount of system resources it will use while working on that file (RAM, scratch disk space, and so on) are determined by the number of **polygons** in the scene. There are specific terrain types you will want to place into your scenes based on these considerations.

In this chapter, you learn and work with the numerous controls that allow you to modify and define the terrains in your scene, so even if you start out using low-resolution meshes (those that have a small number of polygons making up the terrain), you can increase the resolution before rendering the final scene. You will also define various types of terrains and save them into your Vue 6 Infinite library for later use. And you will discover how limitless your scenic possibilities are.

Tools You'll Use

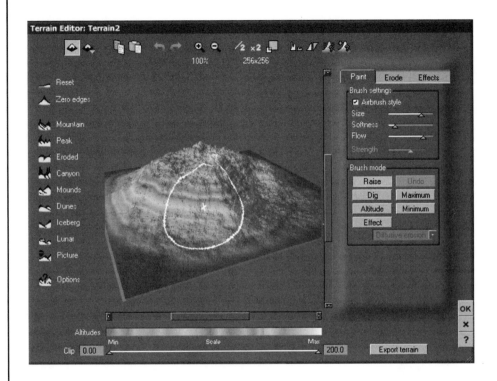

QUICKTIP

As with the rest of the chapters in this book, I ask that you not only follow along with the projects and tutorials, but experiment along the way. Begin by following what is outlined, but then take some time to experiment on your own in order to create your own unique terrain libraries.

SELECT AND
PLACE TERRAINS

What You'll Do

In this section, you learn what the different terrain types are, and how to place and position them into your scenes.

You can download the image maps used in this chapter from the book's website at www.courseptr.com/downloads.

There are two types of terrains you can place into your scene. There is the standard terrain, which starts off as a low-resolution mesh and can be resized after you have completed your image, and the Procedural Terrain, which provides unlimited detail to your mesh. With procedural terrains, the closer the camera gets to the element, the finer the detail becomes.

Adding either of these terrain types to your scene is exactly the same.

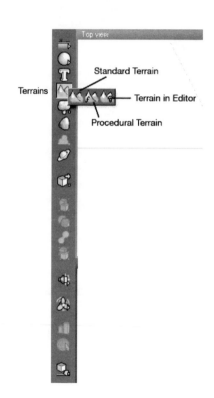

FIGURE 3-1

The Terrain button and the fly-out selector.

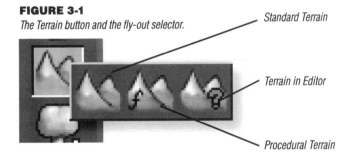

Standard Terrain

Terrain in Editor

Procedural Terrain

1. Open your Vue application.

 By default, the scene will open up with either the default atmosphere or with the atmosphere you set the program to open in the General Preferences controls (see Chapter 1). If you have not set a new default atmosphere, and the program opens to the preset default atmosphere, go into the Atmosphere Editor and select any daytime sky.

2. Place your cursor over the Terrain selector in the left panel.

 Press and hold down the left mouse button (LMB) to cause the selector to expand and show the Terrain types (see Figure 3-1).

 From left to right, the choices are:

 a. **Standard Terrain**. This is a standard mesh, also known as a **fractal mesh**, that starts at a low resolution (256×256 polygons). With low resolution meshes, curves and corners may not appear as smooth as you would like when viewing the terrain up close. You can later increase the number of polygons making up the mesh, smoothing out edges so they appear more natural. Once selected, the terrain will appear in the workspace.

b. Procedural Terrain. This terrain will dynamically increase mesh and material detail the closer the camera gets to the object. Inversely, the quality of detail will dynamically decrease as the camera moves farther away from the object. Once selected, the terrain will appear in the workspace.

c. Terrain in Editor. This selection allows you to set the **mesh density** (resolution) prior to placing the terrain into the scene. When it is selected, you will be taken directly to the Terrain Editor prior to the terrain being added to the workspace.

3. Select the standard terrain by moving your cursor over its icon (where the icon is highlighted) and releasing the mouse button.

> **QUICK**TIP
>
> If the Move gizmo is not visible, click the M key on your keyboard to quickly switch to the interactive move controls.

This will add the Terrain element into your workspace (see Figure 3-2).

> **QUICK**TIP
>
> I It is important to note that each terrain you place is randomly generated. This means that you will never place an identical terrain into the scene, no matter if it is fractal based or procedural.

FIGURE 3-2
A standard terrain added to the scene.

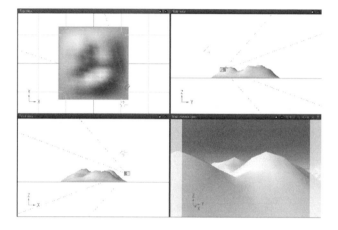

FIGURE 3-3

A procedural terrain added to the scene sitting next to the fractal terrain. The procedural terrain looks much smoother, a visual clue as to which you have in your scene.

FIGURE 3-4

The New Terrain Options window will appear when you select Terrain in Editor.

4. Click on the Top view to make it active, and then move the terrain to the left side of the window.

You do this so you can place another terrain into the scene without the new terrain being placed directly over the first one.

5. Select Procedural Terrain from the selector.

This will add a new Terrain element to the center of your workspace. It will more than likely overlap some of the first terrain you created, but that's okay for now. Notice the differences in the looks of the two terrains. The fractal-based terrain is more uneven or jagged, whereas the procedural one looks much smoother (see Figure 3-3). Move the procedural terrain to the right of the screen before moving to the next step.

6. Now select the Terrain in Editor.

When you do this, the New Terrain Options screen (see Figure 3-4) opens. Here you can do two things prior to being taken to the Terrain Editor window:

a. Set the mesh density for the fractal terrain (selected by default). By default, the resolution is set to 256×256, but you can set it to whatever you want.

b. Turn off Generate Fractal Terrain. By deselecting this command, you tell the program to not generate a mesh. What you get instead is a flat plane from which to build your terrain from scratch.

LESSON 2

DESIGN
YOUR TERRAIN

What You'll Do

In this section, you make interactive modifications to your terrains. Here, you use a fractal terrain, but all the controls pertain to procedural terrains as well.

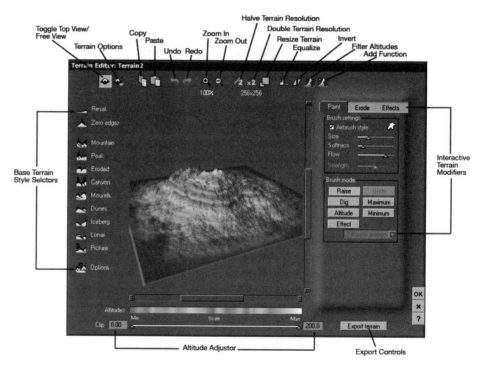

Toggle Top View/
Free View

Terrain Options

Copy
Paste

Undo Redo

Zoom In
Zoom Out

Halve Terrain Resolution
Double Terrain Resolution

Resize Terrain
Equalize

Invert
Filter Altitudes
Add Function

Base Terrain
Style Selctors

Interactive
Terrain
Modifiers

Altitude Adjustor

Export Controls

Now that you know how and what kind of terrains to add to you scene(s), it's time to discover how to modify them to fit your creative vision. Probably nine times out of ten (yes, that's right, nine times out of ten) you will want to modify the terrains you have placed into the scene. It's really a rare occurrence when the generated terrain is exactly as you want it.

The Terrain Editor is broken into four sections: the control panel (horizontal controls at the top of the window), terrain types (vertical controls on the left of the screen), the Preview window (an interactive window where you can interactively change the look of the terrain), and the Modification tabs (to the right of the Preview window). A button at the bottom right allows you to save the terrain to your terrain library folder.

First, let's look at the controls in the Terrain Editor before you begin working with them (see Figure 3-5).

- Title Bar–The title bar gives you the terrain name you are working on. This is a good way to double-check yourself to make sure you are not modifying the wrong terrain element. By default, when a terrain is added to a scene, the first will be called Terrain, and each subsequent terrain you add will have a number following (that is, Terrain 1, Terrain 2, and so on). Or if you have renamed the terrain elements, the name you assigned will appear here.

- Control Panel (see Figure 3-6)–Here, you can make basic changes, undo any changes you have made, and perform more advanced terrain modifications using Filters and Functions. Starting from the left:

QUICKTIP

Feel free to click on these control buttons as they are described to better acclimate yourself to how the controls work.

a. Toggle Free/Top View–Switch the Preview window from Free view, which allows you to interactively rotate the Preview window in order to make changes to the terrain, to a fixed top view of the terrain.

b. Terrain Options–Here you can change the terrain from fractal to procedural, as well as make the terrain symmetrical.

FIGURE 3-5

The Terrain Editor window.

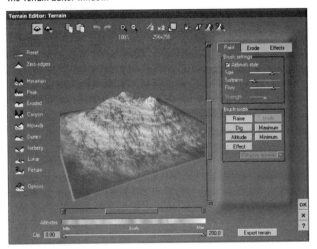

FIGURE 3-6

The control panel gives you numerous controls to help you work with and prepare your Terrain element.

c. Copy/Paste–These two buttons let you copy the terrain changes you have made and then paste them into the Terrain Editor window.

d. Undo/Redo–Clicking on these will allow you to step back if you make a mistake or step forward to restore changes you have made to the terrain.

e. Zoom In/Zoom Out–Click on these to zoom in on the terrain in the Preview window or to zoom back out when you have completed your close-up work.

f. Halve/Double Terrain Resolution– Click on these to increase or decrease the terrains mesh density.

g. Resize Terrain–This opens the Resize Terrain screen, where you can numerically change the mesh density (see Figure 3-7).

h. Invert–Inverts the terrain so it becomes a hole in the ground, rather than a mountain. Clicking it a second time returns the mesh to its original form.

i. Filter Altitudes–Uses Vue's predefined or your original filters to generate a complex terrain mesh.

j. Add Function–Uses Vue's advanced Function Editor to modify the terrain mesh.

FIGURE 3-7
The Resize Terrain screen, where you can numerically change the mesh density of your terrain.

- Terrain Styles–This series of buttons allows you to quickly generate specific styles of terrains, giving you a starting point from which you can create your finished terrain. Refer to Figure 3-8.
 a. Reset–Removes the altitude information, creating a flat plane.
 b. Zero Edges–Removes altitude information from the edges of the terrain. The terrain then begins to grow inside of the main planar element.
 c. Mountain–Lets you change the base mountain look.
 d. Peak–Creates mountains that rise into a single peak.
 e. Eroded–Smoothes the terrain, making it appear as if it has eroded over time. This is great to use when you want to create small rises.
 f. Canyon–Creates a layered appearance to the terrain, creating buttes that are perfect for canyons or wild west type scenes.
 g. Mounds–Adds lumpiness to the terrain.
 h. Dunes–Creates the appearance of sand dunes that have been affected by the wind.
 i. Iceberg–As it states, creates a terrain that is great for creating icebergs in water scenes.
 j. Lunar–Adds pockmarks to the terrain, giving the appearance of a moon-like surface.

 k. Picture–Opens the Import Terrain Data window (see Figure 3-9). Here, you can mix the terrain data with bitmap images you have created or simply assign a bitmap image from which your terrain will be built.

QUICKTIP

If you click on any of the Terrain Style buttons multiple times, you will generate a fresh terrain style/appearance. This way, you can create the base terrain that most closely matches your vision for the scene.

FIGURE 3-8
The Terrain Styles control buttons.

FIGURE 3-9
The Import Terrain Data window, where you can assign a bitmap image to design your terrain(s).

l. Options–Opens the Fractal Terrain Options window (see Figure 3-10), where you can modify the terrain using advanced filter techniques or numerically modify the look of the terrain. This can create some highly complex and original terrain styles.

QUICKTIP

If you make changes in the Fractal Terrain Options window, such as assigning a different noise or altitude filter, your changes will become part of the default look for any new terrains you create. To return to the default settings, right-click on these windows and choose Reset from the submenu.

- **Preview Window** (see Figure 3-11)–The Preview window lets you interactively make changes to the terrain using the Modification tabs. By pressing and holding the right mouse button (RMB), you can click and drag to rotate the terrain in this window so you can make changes to specific portions of the terrain. The colors you see in this window represent height values, the same as if you were looking at a topographical map of an area. Dark green represents low points, whereas pure white represents the highest points in the terrain. The striated colors between represent the height increments of the terrain.

FIGURE 3-10

The Fractal Terrain Options window.

FIGURE 3-11

The Preview window allows you to see your terrain from all sides, as well as gives you the ability to interactively redesign your terrain.

FIGURE 3-12

The Modification tabs give you access to special effects and interactive modification controls.

FIGURE 3-13

The Terrain Export Options window lets you save your terrain for use in other 3D applications such as 3D Studio Max, Maya, LightWave, Cinema4D, Truespace, and others.

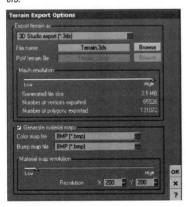

a. Altitudes–This shows the color range from low (left) to high (right) that represents height in your terrain. You can change these by double-clicking on the color strip and choosing a pre-defined set of colors or creating your own.

b. Clipping–You can also set the maximum height of a terrain by clipping the color values, making a specific color within the gradient the high value. By doing this, you will literally clip off the top of the mountain, creating a flat surface at the point you set for the clipping.

• **Modification tabs** (see Figure 3-12)– This area, broken into three distinct control panels, gives you control over terrain modification and adding special effects to the terrain.

a. Paint–Gives you the ability to redesign your terrain by painting over it in the Preview window. Here you control how hard the rock is (determining how strong an effect your brush will have on the terrain), brush size, flow, and the type of effect that will occur.

b. Erode–Lets you assign specific types of erosion effects to your terrain, from wind to water to heat.

c. Effects–Gives you specific effects to add to your terrain, such as pebbles, craters, plateaus, and trees. The latter is perfect to use if you have your terrain toward the back of a scene and want to give the illusion of trees without adding millions of polygons to place actual tree elements into the scene.

• **Export Terrain**–Clicking on this button allows you to save your terrain for use in other programs. When you click this button, the Terrain Export Options window appears (see Figure 3-13). Here you can choose the format, resolution, and image maps that are assigned to the terrain model.

Save a New Terrain

1. Create a new scene, using any of the daytime atmospheres.

2. Add a Standard Terrain element to your scene.

 QUICKTIP

 Because terrains are randomly generated, your terrain will look different than the ones shown in this section.

3. Double-click on the terrain in any of the windows to open the Terrain Editor.

4. First, click on the Mountain selector a couple of times until you get a terrain shape you like.

 I have chosen one with a single high peak (see Figure 3-14). The closer you can get to something like this one, the better.

5. Click once on the Eroded button.

 This will smooth out the terrain (see Figure 3-15), making it look almost like a blanket in the Preview window.

6. Click OK to return to the layout windows.

7. Right-click on the terrain to bring up the submenu.

Using Terrain Styles and Saving an Original Terrain

So now that you know what the controls do, I'm sure you're itching to actually use them. In this section, you create specific types of mountains using terrain styles. You will then save the new terrain into the Objects Library for later use.

FIGURE 3-14
Keep clicking on the Mountain button until you get something that is close to this terrain.

FIGURE 3-15
Using the Eroded control on the left side of the Terrain Editor window, the terrain is smoothed out and ready to be saved.

FIGURE 3-16

Choose Save Object from the submenu that appears when you right-click on the terrain object.

FIGURE 3-17

The Save window. Make sure to not only name your file in the Save As field, but also in the Title field near the bottom of the window. In this image, you see the Save As, Title, and Description fields filled in.

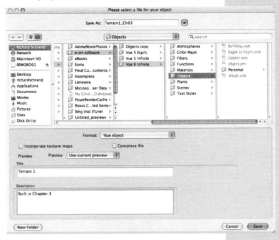

FIGURE 3-18

The Save Object Preview window appears after you name your file and click Save.

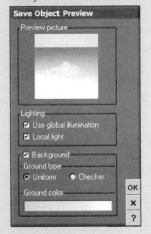

Choose Save Object from the menu (see Figure 3-16). This brings up the Save window (see Figure 3-17), where, the Objects folder inside of the Vue 6 Infinite folder is selected by default.

8. Name the file in two places—the Save As field and the Title field.

The Save As field names the file as it appears in the Objects folder. The Title field assigns the name that is displayed when you select the terrain from the Objects window. You might also want to add some descriptive text to help you remember what the terrain is.

9. Click Save, and then delete the terrain from the workspace.

Always wait until Vue finishes creating the thumbnail image in the Save Object Preview window (see Figure 3-18). This way, you will have a preview of the terrain prior to selecting it in the Objects window.

QUICKTIP

The various controls in the Save Object Preview window pertain to the way the thumbnail image will appear. Most of the time, you will not want to change the preview options.

The options are as follows:

Use Global Illumination–This is a lighting technique that creates very even lighting in the image. You really won't notice much of a difference in the preview with this turned on or off.

Local Light–Uses a light source specific to the render screen.

Background–Turns the background into a single color background.

Ground Type–Uniform is the default; Checker puts a checkerboard under the object in the preview.

Ground Color–Lets you select a different color map to use as the background color. Double-click on the color chip to open the color selection window to assign a different color map.

Place a Terrain in a Scene

1. Create a new scene. Use any atmosphere you want.

2. Click on the Load Object button (see Figure 3-19).

 As you learned in Chapter 2, this will open the Object Selection window. There should be a category titled Personal Objects in the Category window on the left. Select it to show your original saved objects.

3. Select the terrain object you saved. At the top of the Objects window, you will see the name you placed in the Title field and any descriptive text you might have added, as you see in Figure 3-20.

4. When you click OK, the Import Options screen appears, as shown in Figure 3-21.

 In this window, you can choose to decimate the object, center it within the viewports, or change the size before it is imported. For the most part, you will want to choose Center Object, but don't worry about the other commands. First, you can decimate the object at any time during your design process, and you can interactively scale the object up or down to better fit with the overall scene.

What does it mean to **decimate** an object? Decimating an object causes Vue (and other 3D applications) to mathematically review the object's geometry and remove what it considers to be unnecessary polygons from the mesh. Sometimes this can lead to unwanted changes in the shape of the object, but most of the time it simply reduces the object's resolution without affecting the shape.

5. Click OK again to place the terrain in your scene.

FIGURE 3-19
The Load Object button. When you click on it once, the Object Selection screen opens.

FIGURE 3-20
When an object is selected, its assigned name and description appear in the top section of the window.

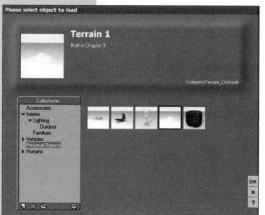

Opening and Placing a Saved Terrain

Now that you have a terrain saved in the Objects Library, you can add it into another scene.

FIGURE 3-21
The Import Options screen.

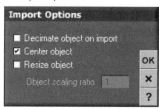

MODIFY TERRAINS
INTERACTIVELY

What You'll Do

In this section, you learn how to interactively modify your terrains.

Global Effects Panels

Paint Effects Erode Effects Special Effects

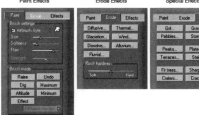

Interactive terrain modifications allow you to literally paint your terrains, adding to or subtracting from the mesh to build the type of terrain you want. You can also paint effects onto the surface of the terrain, giving your scenes unique looks that can satisfy your artistic needs without adversely increasing the number of polygons in your scene.

FIGURE 3-22

A river or canal runs through the terrain, a look you will create in this section.

Using Paint to Create a Unique Terrain

Now it's time to refine your terrains, adding and removing portions of the predefined terrain object to fit your needs. In this section, you create a river or canal (whichever you prefer) cutting through the terrain. Then you add an island that the river flows around–something like you see in Figure 3-22.

Paint a Terrain

The Vue family of programs supports drawing tablet technology, so if you have or use products such as Wacom drawing tablets, you can use the pen to perform the following steps.

1. Create a new scene and use any daytime atmosphere you like.

2. Add a standard terrain to the scene and then double-click on it to open the Terrain Editor.

3. Switch to the Top view.

 Because of the modifications you will be making, it will be much easier to use the Top view, looking down on the terrain, rather than using the Free view.

 Before you go further, take a look at the Paint section of the Terrain Editor. This area is broken into two sections: Brush Settings and Brush Mode. The settings let you control the settings of the virtual brush, its size, the softness of the brush (almost like a blur), the flow of the brush (how strong an effect it creates, or how quickly it will build or cut into the terrain), and when not in Airbrush Style, the strength of the brush (which acts the same as Flow in Airbrush mode).

 In the Brush Mode section, you can assign whether the brush will add to (Raise) or subtract from (Dig) the terrain, paint by altitude, automatically paint to the Maximum or Minimum height value, or paint effects onto the mesh.

4. Make sure Airbrush Style is active, and use Figure 3-23 to set the Size, Softness, and Flow of the brush.

5. Click on the Dig button in the Brush Mode area to make it active.

6. Move your cursor over the Preview window.

 The cursor will change to a white circle (see Figure 3-24), the size of which is determined by the Size setting you made.

7. Using the shape of your terrain as a guide, click and drag from the top edge of the terrain to the opposite bottom edge.

 By following the contours of the terrain, you create a more realistic cut through the mountains. Also, make sure to add an inlet somewhere along the river's path, as you see in Figure 3-25.

 QUICKTIP

 The longer you remain over a specific area while holding down the mouse button, the deeper the brush will dig, so if you did not set Flow to its maximum, you might have to move slowly and methodically over the thicker areas of the terrain in order to cut all the way through.

8. Once you have created the river, switch to Raise in the Brush Mode section of the Terrain Editor.

FIGURE 3-23
The approximate settings you should use when creating a river in your terrain.

FIGURE 3-24
When you move your cursor into the Preview section, it will turn into a white circle, indicating the size of the brush you are using

FIGURE 3-25
Your river should flow across the entire expanse of the terrain, and include an inlet.

FIGURE 3-26

The new brush settings for creating an island in the inlet.

FIGURE 3-27

With Effect selected, a wealth of special effects becomes available to you via the drop-down menu.

9. Reduce the size of the brush so it fits comfortably within the inlet area of your river, and reduce the flow by about two-thirds of its maximum (see Figure 3-26).

 By reducing the flow, you can control the height values of your island more efficiently. Depending upon the height you want, you need to hold the mouse button down longer while hovering over the same spot to increase the height in that particular area.

 QUICKTIP

 Remember to zoom in and out using the Zoom buttons in order to more precisely place your island in the inlet.

10. Click Erode on the left side of the Terrain Editor window to smooth the terrain.

 Doing this will allow you to paint things such as cracks, grit, and specific erosion effects directly onto the terrain.

11. Make Effect active in the Brush Mode section.

 The drop-down menu immediately underneath will become active, giving you access to all the effects that can be painted onto the terrain object (see Figure 3-27).

12. Switch to Free view. Do this by click-ing on the Toggle Top View/Free View button at the top of the Terrain Editor window.

Now you can rotate around the terrain model to easily and more precisely add the effects you want.

13. Select Cracks from the drop-down menu.

At this point, you need to determine the brush size and flow that best suits your needs.

14. Make changes to the size and flow of the brush and then paint onto one section of the terrain.

Click and drag across the terrain once to make sure the flow and size of the brush are as you want them. If not, click the Undo button to remove the effect. Remember, you can only remove the last change you made.

> **QUICK**TIP
>
> Use the right mouse button (RMB) to rotate the terrain in the Preview window.
>
> If you make multiple changes and find that you don't like how the terrain is looking, you might need to click Erode again to remove all the cracks (or other effects) you have painted.

15. Once you have the cracks placed on your terrain as you want them, switch to Fluvial Erosion in the Effect drop-down menu.

Fluvial erosion mimics the type of erosion created over time by water. Using the same techniques as before, add fluvial erosion effects onto the terrain, the most highly concentrated being along and slightly above the waterline in your river.

> **QUICK**TIP
>
> What you see in the Preview window is an extremely low-resolution representation of the terrain. As you rotate in this window, some of the effects you have painted on might look as if they are disappearing. Also, the effect might be more pronounced in the actual terrain than what you see here.

16. Finally, select Grit from the pull-down menu and paint a light coating of grit around the edges of the river (see Figure 3-28).

The grit is only being placed along the riv-erbanks in this project while the rest of the terrain is left clean. For this, the camera will only focus on the river portion of the terrain and not the outside areas.

17. Click OK to add the modified terrain to your scene.

Once you have it placed in the scene, right-click on the terrain and choose Save from the submenu. Save this into your Objects Library for later use.

FIGURE 3-28
The terrain after adding cracks, fluvial erosion, and grit. Your terrain will look different, but the placement of the effects should be close.

MAKE GLOBAL EFFECTS
AND CHANGES TO YOUR TERRAIN

What You'll Do

In this section, you learn how to make global changes to your terrain.

What you just accomplished can often be a time-consuming process, but a process well worth the effort in order to more realistically create elements in your scene. There are times, though, where you want to make global changes to a terrain without going through what some consider to be the hassle of hand-manipulating the mesh.

Adding Global Effects

The best time for making global changes to your terrains is when you are going to be using them in the background areas of your image, places where you don't need a lot of detail but still need a specific look that will fool the viewers' eyes.

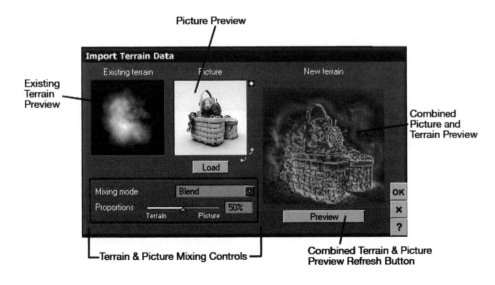

Picture Preview

Existing Terrain Preview

Combined Picture and Terrain Preview

Terrain & Picture Mixing Controls

Combined Terrain & Picture Preview Refresh Button

Experiment with Global Changes

This section is more experimental. Try the different effects controls to see what they do to your terrain.

1. Create a new scene and add a Terrain object to your workspace.

2. Go into the Terrain Editor.

3. Select Eroded from the Terrain Styles.

4. Click on the Erode tab on the right side of the screen (see Figure 3-29).

 These are the same erosion effects appearing in the Effects drop-down menu in the Paint section of the Terrain Editor window.

5. Click on any of these buttons to add the effect to the entire terrain element.

 If you continue holding down your mouse button, the effect will increase, sometimes dramatically.

6. Increase the rock hardness using the slider under the effects buttons.

 By doing this, you will gain a greater understanding of how rock hardness affects the overall effect of the various erosion selections.

 QUICKTIP

 When you have added an effect such as Fluvial or Dissolve, and it appears too strong or unnatural looking, click on Diffusive. This option softens the look, often creating a more realistic appearance.

7. Switch to the Effects tab (see Figure 3-30).

 This section is broken into three groups: generalized effects of grit, gravel, pebbles, and stones; terrain shape effects of peaks, plateaus, terraces, and stairs; and specific terrain effects simulating fir trees, sharpening of edges, craters, and cracks. Figure 3-31 shows a terrain with various Effects options added to it.

 Again, these effects are often harsh and don't lend themselves to close inspection. This is especially true for fir trees. But adding these effects to the terrain and placing that terrain toward the back of the scene can help save you time and system resources, allowing you to work more efficiently and with fewer rendering problems.

 QUICKTIP

 These effects do not work on flat terrains, those created using the Reset option in the Terrain Editor. There must be fractal information on the object.

8. If you like what you have created, click OK, and then save the terrain into the Objects Library for later use.

FIGURE 3-29

The Erode control panel in the Terrain Editor screen.

FIGURE 3-30

With the Effects tab selected, you can now add more details to your background terrains.

FIGURE 3-31

A terrain object with grit, gravel, fir trees, and cracks added to it.

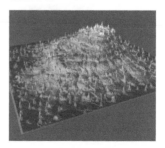

LESSON 5

USE IMAGE MAPS
TO CREATE TERRAINS

What You'll Do

In this section, you learn how to use image maps to create terrains.

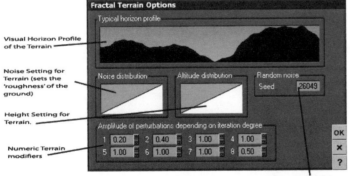

Visual Horizon Profile of the Terrain

Noise Setting for Terrain (sets the 'roughness' of the ground)

Height Setting for Terrain.

Numeric Terrain modifiers

Numeric indicator for the existing Terrain

You can also use bitmap files, images created in programs like Adobe Illustrator, Photoshop, Macromedia Fireworks, Corel Paint Shop Pro, or others, to create terrains. These files, saved as .bmp, .jpg, or .tif images, can be imported and either blended with an existing terrain or used as the terrain itself. In this section, you use bitmap files to both blend and create more intricate terrains for your scenes (see Figures 3-32 through 3-34).

QUICKTIP

The bitmap files used in this section of the chapter are downloadable from the book's website at www.courseptr.com/downloads.

FIGURE 3-32
A bitmap file used to fully create a terrain.

FIGURE 3-33
A bitmap file blended with a terrain element.

FIGURE 3-34
A bitmap photograph, converted to grayscale and used to create a terrain.

Blend a Terrain and an Image File

1. Create a new scene, add a terrain, and go into the Terrain Editor.

2. Click Picture in the Terrain Styles area.

 The Import Terrain Data screen appears. Here, you have numerous controls to assign images and blend them with the existing terrain.

 ### QUICKTIP
 ### The Import Terrain Data Controls

 Existing Terrain–This is a grayscale representation of the current terrain you are working on.

 Picture–The black screen is where a thumbnail of your selected image will appear. The small black square with a white circle inside (upper right of this window) will invert the grayscale information, turning black to white and white to black.

 Arrows–The two yellow arrows will rotate the image within the window, adjusting its effect within the terrain.

 Mixing Mode–When activated, the drop-down menu gives you various methods for the terrain and picture to interact, the most widely used being the default Blend.

 Proportions–Using the slider, you can assign the picture to be more or less prominent in the blending.

 Preview–Shows an instantaneous preview of your terrain. Right-click on the terrain image to rotate it in this area.

3. Click the Load button under Picture.

 This will open the Select Picture window (see Figure 3-35). Vue 6 Infinite comes with a number of bitmap images, which appear when this screen opens. At the bottom left of the window are three buttons: New Collection, where you can create a new folder to store images in, Delete Collection to delete an existing collection, and Load File.

FIGURE 3-35
The Select Picture window, which appears when you want to load an image into your scene.

New Collection Delete Collection Browse File

Blending Image Files and Terrains

The first thing you do here is blend a bitmap image with an existing terrain.

QUICKTIP
The default Select Picture image categories are:

Bitmap–Default collection containing bitmap images that come with Vue 6 Infinite (and the entire Vue family of software).

HDRI–Stands for High Dynamic Range Image. The intention of HDRI is to accurately represent the wide range of intensity levels from direct sunlight to the deepest shadows. They are so high quality that they are used for film and television to more accurately display realism in scenes.

Animations–These are animation files that can be added to your scenes through the use of Alpha planes or assigned to any object in your animations.

Personal Pictures–Saving your original images here will allow you to use them over and over again.

You can also assign **Digital Elevation Map** (DEM) files to your terrains. DEMs are grayscale image maps of real-world locations. You can go online to either purchase or download free DEM files for use in Vue.

A suggestion for terrain bitmaps: It's often a lot of fun to go out on a semi-cloudy day and shoot some pictures of the clouds. Those make great images to use for terrains in Vue.

FIGURE 3-36

The image file you selected will appear in the Picture window of the Import Terrain Data screen.

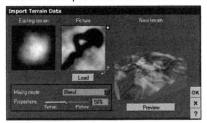

FIGURE 3-37

Moving the Blend slider to the right will increase the picture's effect upon the terrain.

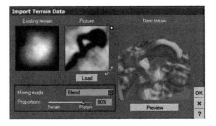

FIGURE 3-38

Using clipping, you can flatten the tops of the terrain, making this image more legible.

4. Click the Browse File button to open the navigation screen.

 Navigate to the Lake.bmp or Lake.jpg file you downloaded from this book's website, and then click Open. The image will now appear in the Picture window in the Import Terrain Data screen (see Figure 3-36). The terrain preview will update automatically to show this addition.

5. Move the Blend slider to the right to increase the picture's effect on the terrain (see Figure 3-37).

 Increase the picture's effect to 80%. You can do this using the slider or by typing **80** into the numeric field.

6. Click OK to place this new terrain in your scene.

7. Save the terrain to your Objects Library folder for later use.

8. Remove the terrain from the scene and add a new one to it.

9. Go into the Terrain Editor and click Reset.

 This will delete all height information from the terrain, leaving you with a flat plane.

10. Click Picture to go to the Import Terrain Data window.

11. Click Select and navigate to the TextImage_blur.bmp or .jpg image file.

Since this is now the only terrain data, the Blend slider will have no effect on the terrain mixture.

12. Click OK to get back to the Terrain Editor screen.

13. Using the Clipping slider, change the clip level to approximately 33%.

 This will flatten off the top of the letters so they do not go into a peak (see Figure 3-38). You can do this by either moving the slider to the left (toward Min) or typing the value into the numeric field to the right of the slider.

14. Click OK, and then save your terrain to the Objects Library for later use.

LEARN THE
TERRAIN OPTIONS

What You'll Do

In this section, you experiment with the features found in the Options command of the Terrain Editor.

The Options command in the Terrain Editor gives you advanced features for designing complex terrains in your scene. It's important to note that many of these controls are extremely advanced, and changing any of the settings will make all subsequent terrains in your scenes look exactly the same. Only work in this area when you are extremely comfortable with terrains.

QUICKTIP

If you are planning on changing the numbers in the Amplitude of Perturbations Depending on Iteration Degree fields, you should do a screen capture or write down the existing numbers for each field so you can return to your original terrain settings.

Designing a Terrain Using Options

Using the Options window is both simple and tricky. It's simple because you can assign specific profiles to create your terrain, and it's tricky because if you make specific changes here, they become the new defaults for all future terrains. In this section, you learn how to use the filters to generate interesting and intricate terrains and then how to return to the default settings.

FIGURE 3-39

The Fractal Terrain Options window.

FIGURE 3-40

Filters are displayed as lines, much like those created in graphs (remember those math classes in junior high and high school?).

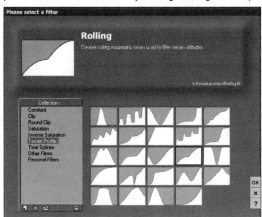

1. Create a new scene and place a Terrain object onto the workspace.

2. Go into the Terrain Editor.

3. Click Options to open the Fractal Terrain Options window (see Figure 3-39).

 There are various ways to make terrain modifications in this window. First, you can double-click on either the Noise or Altitude Distribution windows to bring up the filters to assign, or change the numerics in the Amplitude of Perturbations Depending on Iteration Degree fields. Unless you really know and are extremely comfortable with the program, do not—I repeat, do not!—change these numbers from their default. They control the amount of noise and smoothness of the mesh in various degrees along its X, Y, and Z axes.

4. Double-click on the Noise Distribution window.

 The Filter Selection screen will open. These filters, shown as a line much like those created in graphs (see Figure 3-40), determine altitude based upon black to white. Selecting any of these filters will automatically change the way in which height is determined throughout the terrain mesh.

5. Select Creases from the Terrain Profiles list and then click OK.

6. Repeat this process for Altitude Distribution.

7. Click OK when you are finished, and then OK again to put this new terrain into your scene.

 You should have a terrain that looks similar to the one in Figure 3-41.

 To revert back to the default Noise and Altitude Distribution filters, go back into the Options section of the Terrain Editor, right-click on the filter boxes, and select Reset Filter from the submenu.

FIGURE 3-41
After assigning the Crease filter to both the Noise and Altitude Distribution selectors, your terrain will look similar to this.

CHAPTER SUMMARY

In this chapter, you have learned how to manipulate terrain meshes to create or re-create virtually any terrain you want. It takes time to get used to how each of the controls works, and it's best for you to take a little time now to add and modify your own terrains using the various controls discussed in this chapter. It's not uncommon that people become so good at painting terrains that they literally use this area to create parts for their 3D models. For instance, a few years back, one digital artist used the Terrain Editor to *paint* the parts of a motorcycle, from the engine parts to the frame, and then exported each into his 3D modeling application and pieced the motorcycle together.

As a final note, as you delve further into the Terrain Editor, you might want to consider purchasing a drawing tablet like the Wacom Intuos so that you have more precise control when you paint your terrains.

What You Have Learned

In this chapter you

- Added and moved terrains around in the scene
- Painted modifications to your terrains
- Saved terrains into the Objects Library
- Used bitmap images to create new terrains
- Used filters to create new terrains

Key Terms from This Chapter

Digital Elevation Maps (DEMs) Grayscale images created by the US Geological Department that show height information for real-world locations around the globe.

Fractal mesh Mathematically calculated series of lines and shapes that, when combined, can create highly complex and resolution-specific 3D elements.

Mesh density Describes the resolution, or quality, of the object's mesh. The higher the mesh density, the more detailed and smooth the object will render out. But, the higher the mesh density, the more system resources are used in creating your scene.

Polygons Three- or four-sided shapes that, combined, make up the mesh that describes the shape of an object. Each 3D object is made up of polygons. The number of polygons in a mesh describes how detailed, or high quality, an object is. For instance, with fewer polygons, a globe shape has sharper corners along the edge, whereas more polygons usually makes the curve look smoother.

Submenu A list of options that appear when you right-click on an object or control window.

4

DISCOVERING BOOLEANS
AND METABLOBS

1. Set the scene for Booleans.

2. Explore the Vue workspace.

3. Combine multiple Booleans on a single object.

4. Use metablobs—funny name, cool results.

The Vue line of products—Vue Easel, Vue 5 Professional and Infinite, and Vue 6 Infinite—are not modeling programs per se. You cannot, for instance, model a humanoid figure within the program like you can in products such as Newtek's LightWave, Alias' Maya, 3D Studio Max, or CINEMA 4D (to name a few). Those are true standalone modeling programs where your only limitations are knowing what modeling style to use and your artistic ability to translate your thoughts into pixel-based reality. But that doesn't mean you have to learn how to be a 3D modeler to create complex shapes to use in Vue. All you need to do is learn how to work with **Booleans** and **metablobs**.

So what are Booleans and metablobs? Booleans take two or more shapes and combine them in specific ways to form a more intricate shape. They are great for creating man-made shapes like buildings, decorative posts, and more. Metablobs

basically turn your primitive shapes into magnetic blobs, attracting or repelling each other to form more **organic shapes**—those with rounded corners or that have more fluid form. With Booleans, you can combine shapes that retain their sharp edges; with metablobs, all shapes are rounded and without sharp corners.

And in Vue, Boolean and metablob operations are **nondestructive**, meaning they do not permanently change the mesh; you can move the elements to different locations where the Boolean or metablob command will then occur.

In this chapter, you work with Booleans and metablobs, learning the techniques to form complex models that can be saved into the Objects Library for use in any or all of your scenes.

Tools You'll Use

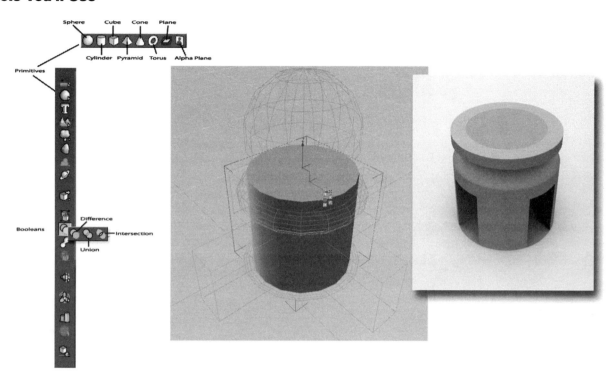

Sphere Cube Cone Plane

Cylinder Pyramid Torus Alpha Plane

Primitives

Booleans

Difference

Intersection

Union

Sphere Cube Cone Plane

Cylinder Pyramid Torus Alpha Plane

SET THE SCENE
FOR BOOLEANS

What You'll Do

In this section, you add and position primitive objects and learn the order in which the primitives must be in order to create Booleaned objects.

Working with Booleans (as well as metablobs) is a very specific procedure. How elements are stacked in the Layers window determines which shape (be it a primitive or a terrain) acts as the *attractor* or *cookie cutter* and which shape is affected (or cut into or merged). Because of this, you need to work not only with positioning of objects, but also with the Layers window in order to stack your elements in the correct order.

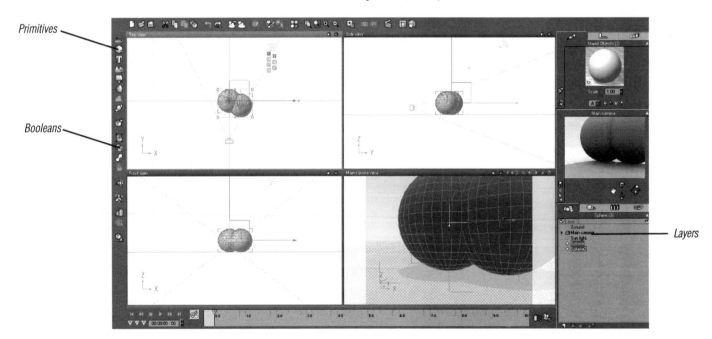

There are three types of Boolean operations, and Figure 4-1 illustrates their differences:

- **Difference**: Uses one object to cut into another object, removing **geometry** where the two objects meet. The cutter becomes invisible, leaving the cuttee to be rendered.

- **Union**: Combines the objects, turning the two into one at the points where the objects intersect.
- **Intersection**: Leaves only the geometry from the point where the objects intersect; the rest of the geometry turns invisible in the rendering.

In this instance, only two objects have been combined, but you can add more to the operation in order to build a much more complex shape.

FIGURE 4-1
The different Boolean operations, Difference, Union, and Intersection, and how they cause meshes to interact.

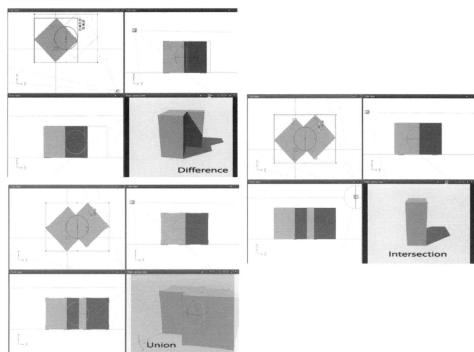

Manipulate Primitive Objects

1. Create a new scene in Vue, using any atmosphere you want.

2. Press and hold on the Primitives selector button.

 This will cause the selector to expand, allowing you to select the primitive shape you want.

3. Select the Sphere object and place it in your scene.

4. Use the Drop Objects button (see Figure 4-2) to drop the object to the ground plane.

 The Drop Objects button is located at the bottom of the content selector panel on the left side of the screen.

5. Now add a Cube primitive to the scene.

 Make sure the Move gizmo is active by either clicking on the top-right button in any viewport (see Figure 4-3) or typing M on your keyboard.

Selecting and Adding Primitive Objects

Before you get into building more complex shapes, though, you should perform the three basic operations so you get a feel for how they work.

FIGURE 4-2
The Drop Objects button.

FIGURE 4-3
The Move gizmo as seen in the Top viewport.

FIGURE 4-4

The cube should be positioned so it is intersecting with the top third of the sphere.

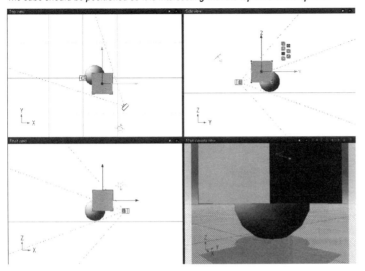

FIGURE 4-5

The order in which the objects are listed in the Layers window is important for how the objects react to each other in the Boolean operations.

I use Vue 6 Infinite's default Gizmo quick key commands in this chapter. Those are M for Move, R for Rotate, and S for Scale. Many people, however, like to change the default keyboard commands for the Gizmo controls. Some of the more popular 3D applications use W, E, and R for, in order, Move, Scale, and Rotate. The reason for this is these three keys are immediately next to each other in a standard QWERTY keyboard. If you have changed the default keyboard short-cuts, use the one you have assigned for Move to switch to that Gizmo.

6. Move the Cube primitive until it is positioned as you see in Figure 4-4.

Using all the viewports, move the cube until its lower-right corner is pointing into the top third of the sphere.

7. Check your Layers window to make sure the Sphere object is listed above the Cube object (see Figure 4-5).

It's very important to make sure the object you want to use as a cutter will actually cut into the object you want affected. Here's how it works: The top-most object in the list is the one that will be affected, whereas those objects under it will be the affectors. If these are out of order, you will get the wrong results when you perform a Boolean operation, as you will see in a moment.

8. Select both the Sphere and the Cube objects.

There are two ways in which to do this. First, you can hold down the Shift key on your keyboard and, in the Layers window, click on the items you want selected. Or you can hold down the mouse button and drag the mouse over the objects you want to select in any of the viewports.

> **QUICK**TIP
>
> Using the **click-and-drag** method to select an object is not always the most efficient. If you have numerous objects in your scene, you might accidentally select elements you don't want to include in your selection.

9. With the Sphere and Cube objects selected, the Boolean commands become active (see Figure 4-6). Remember, a Boolean operation combines two or more objects. If only one object is selected, there is no way to perform a Boolean operation, and the control will remain inaccessible.

10. Press and hold on the Boolean button and select Difference.

The object that is the cutter (the Cube) becomes an outline on the screen (see Figure 4-7), showing that the operation was successful. The cube will no longer be rendered in the scene, as it is now merely a device used to modify another element in the scene.

FIGURE 4-6

The Boolean operation selector will not be active unless you have more than one object selected.

FIGURE 4-7

After your Boolean operation is assigned, the object that acts as the affector becomes transparent and is shown as an outline in the viewports.

FIGURE 4-8
The results following the Boolean Difference operation.

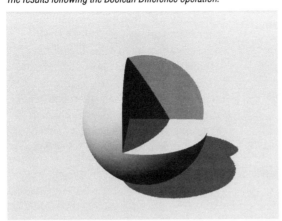

FIGURE 4-9
After performing a Boolean operation, the combined elements are renamed to the operation you performed.

FIGURE 4-10
By clicking on the small triangle to the left of the object's name (the toggle switch), you can expand or collapse the listing to see the elements in that object.

11. Perform a quick render by clicking on the camera button (the second from the left) in the Main Camera View window to see how the Boolean operation affects the Sphere.

The Cube has now cut out a section from the Sphere (see Figure 4-8).

The two objects have been combined into what Vue now sees as one object. This means that when you select the Sphere in any of the viewports, both it and the Cube are selected as one. Also notice in the Layers window that there is a new object called Difference (see Figure 4-9). When you perform a Boolean operation, the type of operation you choose becomes the default name for that new object. You can change this default name by doing the following:

12. Click on the word Difference in the Layers window.

This will activate the name text field at the top of the window (see Figure 4-10). Merely type a name into this field (in this case, I called it Sphere Char) and press Return to set that new object name.

You will also see a small triangle to the left of the name. This is called a **toggle switch**. It shows you that you can expand this section to show the entire group (see Figure 4-10). Click on the this triangle once to expand the listing, and click on it again to collapse the listing. From this listing, you can select any of the elements making up the Boolean operation to change that one particular portion of the group.

Use Nondescructive Technology

1. If you haven't already done so, click on the toggle switch next to the Booleaned Sphere object you just created. Doing so will expand the listing for the Booleaned object so you can see the Sphere and Cube objects.

2. Click once on the Cube.

 This will make the Cube active. You know it is the only active element because it is the only element highlighted in the listing (see Figure 4-11). Now, any changes you make will be to that object alone.

3. In any of the viewports, move the Cube to the bottom section of the Sphere object.

 The Cube object, even though it is selected, will still be in outline in the viewports. This is because it is still being used to cut into the main element (the Sphere), so you have a visual cue of its true nature in the scene.

4. Perform another quick render.

 You will see that the Cube now cuts into the bottom portion of the Sphere, and the top portion has been restored (see Figure 4-12).

Exploring Nondestructive Technology

As I stated earlier in the chapter, Boolean operations are nondestructive. For instance, now that you have performed the Boolean Difference on this sphere, you decide you want the Cube object to cut into the bottom of the Sphere object, rather than at the top.

This means that, as you are creating more complex shapes for your scenes (a building with numerous windows in it, for instance), you can interactively move the affectors to other locations without destroying the overall geometry. Some 3D applications use destructive Booleans, meaning that, when you perform a Boolean operation, the changes in the geometry are permanently applied; you would then have to start over if you needed to make a change.

FIGURE 4-11

The Cube is now the active object since it is the only one highlighted in the listing.

FIGURE 4-12

By moving the Cube to another location on the sphere, you cause the Boolean operation to affect that area while restoring the area previously affected.

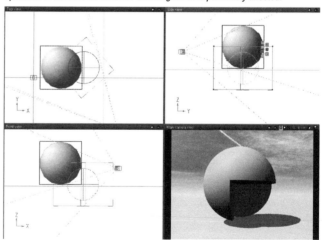

EXPLORE
THE VUE WORKSPACE

What You'll Do

In this section, you learn how colors, materials, and textures are applied to Booleaned objects.

When you perform a Boolean operation, the colors or textures you assign to the objects have an effect on the overall look of the Booleaned outcome. The material assigned to the affector appears where the objects intersect.

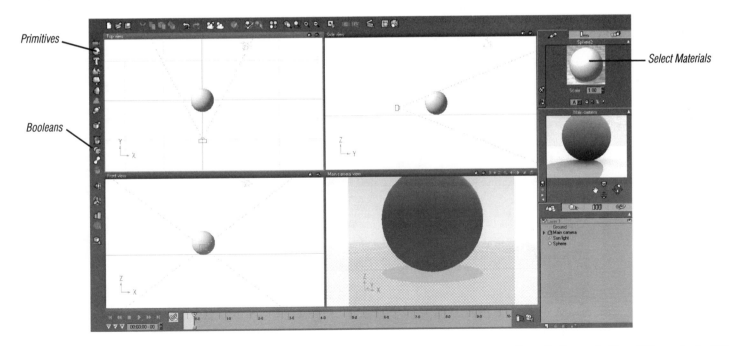

Primitives

Booleans

Select Materials

Add Materials to Objects

1. Move the Cube shape back to the top of the Sphere so it is cutting into the upper portion of the sphere.

 Doing this will allow you to see the interaction more easily.

2. With the Cube still selected, double-click on the thumbnail in the Aspect window (see Figure 4-13).

 As a reminder, the Aspect window is located at the top of this control group. When you double-click on this thumbnail, the Material Editor will open. By default, you should be in the Basic Material area of this window (see Figure 4-14). If your screen does not look like this, click the button at the top left of this window to switch to the Basic Material Editor.

3. Double-click on the thumbnail in the upper-left section of the Basic Material Editor.

Assigning Materials to Individual Booleaned Objects

To see how this works, let's take the shape you just created and add some materials to the individual objects. You'll use two materials that will show a strong change so you can better see how this works.

FIGURE 4-13
The object thumbnail in the Aspect window. Double-click on this to open the Material Editor screen.

FIGURE 4-14
The Basic Material Editor screen. This window has fewer controls than the Advanced Material Editor, which is discussed in Chapters 8 and 9.

FIGURE 4-15

The Material Selector window, which is opened by double-clicking on the object thumbnail in the Basic Material Editor.

FIGURE 4-16

The Checkerboard material in the Basic category of the Material Selector.

FIGURE 4-17

The checkerboard pattern appears at the cube and sphere intersection.

This will open the Material Selector window (see Figure 4-15). This window is set up like all of the other selection windows you have worked with, so it should look very familiar to you.

4. In the Collections section, choose Basic and Checkerboard from the material listings (see Figure 4-16).

5. Close both screens by clicking OK.

6. Perform a quick render to see how assigning a material to the affector interacts with the finished object.

The checkerboard pattern appears where the sides of the Cube object intersect with the Sphere object (see Figure 4-17).

7. Now, using the same procedures just listed, assign a material to the Sphere object.

In this case, I assigned the Grass texture from the Landscapes category (see Figure 4-18). But feel free to put any texture that captures your fancy onto the Sphere object.

8. Perform another quick render to see how the two textures now interact (see Figure 4-19).

FIGURE 4-18

The Grass texture in the Landscapes category.

FIGURE 4-19

The Grass and Checkerboard textures interacting with the Sphere object.

COMBINE MULTIPLE BOOLEANS
ON A SINGLE OBJECT

What You'll Do

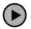

In this section, you learn how to combine multiple objects using different Boolean commands.

At this point, you have worked with two objects to create a Boolean, but you are not limited to that. You can combine multiple objects using different Boolean commands to make even more intricate and interesting shapes for use in your scenes.

Booleans

Layers

Make a Coffee Cup from Booleans

1. Create a new scene with any atmosphere you want (okay, this is the last time I'll mention that!).

2. Add a Cylinder object to the scene (see Figure 4-20).

 Press and hold on the Primitives button to expand it and then choose the cylinder from the fly-out menu.

3. Now add a torus to the scene.

Mixing and Matching Boolean Operations—Creating a Coffee Cup

The fun of Booleans is being able to mix and match the different operations to build an actual...something. In this section, you create a coffee cup using both the Union and Difference operations. Then you will save it into the Objects Library for later use.

Opening and Placing a Saved Terrain

Now that you have a terrain saved in the Objects Library, you can add it into another scene.

FIGURE 4-20
The Cylinder object will become the body of the coffee cup.

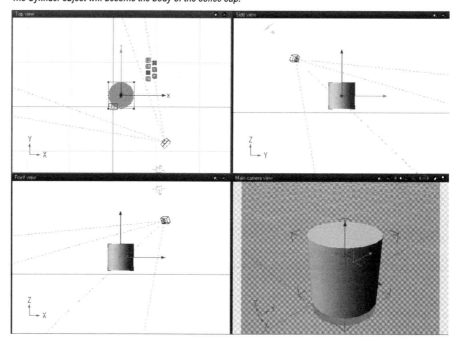

FIGURE 4-21

The final position for the handle of the coffee cup. Use this image to help you as you scale and position the torus.

FIGURE 4-22

Rename the Boolean operation Coffee Cup, and if you want, rename the elements within the Boolean to reflect what they are.

The torus is going to be the handle of the coffee cup. Rotate using the R key on the keyboard and scale (the S key) the torus so it fits comfortably on the side of the cylinder. Use Figure 4-21 to help in setting up the torus' position.

4. Select the Cylinder and Torus objects in the Layers window and perform a Boolean Union.

 Press and hold the Boolean Operations button and select Boolean Union from the fly-out menu. Let your mouse button hover over the different selections for a moment so the tooltip appears, telling you what operation that button performs.

5. Rename the Boolean **Coffee Cup** in the Layers window.

 If you want, you can also rename the Cylinder and Torus objects. As you see in Figure 4-22, I have renamed mine *cup* and *handle*, respectively.

6. Add another cylinder to the scene.

You will need to scale this cylinder to fit within the original cylinder. Make sure this new cylinder is tall enough to flow above the original cylinder (the cup), as you see in Figure 4-23.

Now for a little trick.

7. Select both the new cylinder and the Cup object inside of your Coffee Cup Boolean in the Layers window.

To do this without also selecting the Handle object, hold down the Command key on the Mac or the Control (Ctrl) key on the PC. This allows you to select noncontiguous elements (elements separated by other objects) without selecting all the objects in between. Your list in the Layers window should look like Figure 4-24.

8. Choose Edit > Align in the pull-down menu at the top of your screen (see Figure 4-25).

FIGURE 4-23
The resized cylinder will cut a hole into the cup section of the coffee cup.

FIGURE 4-24
You can select noncontiguous items in your list by holding down the Command (Mac) or Alt (PC) key and clicking on the items you want to select.

FIGURE 4-25
The Align command is accessed via the Edit pull-down menu at the top of your screen.

FIGURE 4-26

The Align Tool window gives you plenty of control for perfectly aligning selected elements in your scene.

FIGURE 4-27

When you select Center under the X Align column, the two cylinders will be perfectly aligned.

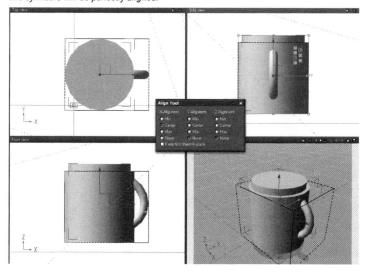

9. From this menu, select Alignment Tool (choose Edit > Align > Alignment Tool).

 This will open the Align Tool window (see Figure 4-26). Here, you can select along which axis (X – Horizontal, Y – Vertical, or Z – Depth, or front/back) you want to align the objects. In this case, choose X Alignment > Center. The two cylinders will now be aligned perfectly for the next Boolean operation (see Figure 4-27). After you have selected this, click the X button in the upper-right corner of the window to close it.

10. Using the Shift key, select both the new cylinder and the Coffee Cup Booleaned object.

 Do this by merely holding down the Shift key and clicking on Coffee Cup (your Booleaned object). This will automatically add the Handle object to the selection.

11. Perform a Boolean Difference operation.

12. Perform a quick render to see how the second cylinder has now cut into the Coffee Cup object (see Figure 4-28).

The second cylinder has now been combined with the Coffee Cup object.

QUICKTIP

You will also notice that the name of the object has been changed to Difference (whatever number). If you expand the listing, Coffee Cup has been added into the Difference operation. Whenever you perform a new Boolean operation, that becomes the name of the new group. Rename the cup by clicking on Difference and calling it whatever you want.

Save the Cup

To save the coffee cup to your Objects Library, do the following:

1. Right-click on the Coffee Cup object in any of the windows or in the Layers list.

2. Select Save Object from the submenu.

3. Name and save the file into the Objects Library.

QUICKTIP

Undoing Boolean Operations

There are times when, as you are creating a Boolean object, something gets messed up. This can happen particularly when you add a new Boolean operation to an existing one. There are two ways to undo your Booleans, as follows:

1. If you just performed the operation, use Cmd/Ctrl+Z to step back.

2. Right-click on the Boolean operation you want to undo and choose Ungroup Objects from the submenu.

Select any other embedded Boolean operations and repeat the process until you are back to where you want to be.

Included in the Chapter 4 folder on the book's website is a more complicated Boolean object—a glass with some beveled edges along the bottom. Feel free to download this model and add it to your collection, as well as use it as a study guide to see how more intricate models can be made using Boolean operations.

FIGURE 4-28
The completed coffee cup after multiple Boolean operations have been performed on the primitive objects.

USE METABLOBS—
FUNNY NAME, COOL RESULTS

What You'll Do

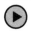

In this section, you learn how to convert an existing object to a metablob and create new objects using a metablob.

Primatives

Metablobs

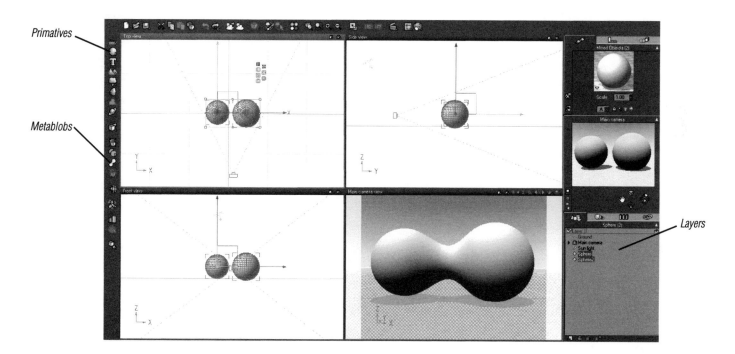

Layers

Metablobs work in much the same way as Booleans, only, as mentioned at the beginning of this chapter, they form more fluid, organic shapes. They do not contain hard edges at all, meaning that when you switch over to a metablob form, a cube will convert to a rounded object (see Figure 4-29).

QUICKTIP

Any primitive can become a metablob. Terrains, however, cannot. So when working with this technology, remember you can only use the basic primitive shapes.

Metablobs are a bit more difficult to work with than Booleans. Because of the way they interact, results can be different than what you expect. Also, there are a couple extra controls that let you make modifications to the reaction strength of the objects.

FIGURE 4-29
A Cube primitive turned into a metablob object.

Discovering Booleans and Metablobs Chapter 4

FIGURE 4-30

The metablob control button.

Convert to Metablobs

Converting an object into a metablob is an easy procedure.

1. Place a Cube primitive into the scene.

For this, you use the Cube primitive because you can see the greatest differentiation between the standard primitive and its conversion to a metablob.

2. With the Cube selected, click the metablob button in the left toolset (see Figure 4-30).

This button will convert the primitive into a metablob object.

> **QUICK**TIP
>
> If you do not see the shape change in the Main Camera View window, choose Preferences/ Options > Display Options and turn on Show Boolean and MetaBlob Previews.

That's really all there is to it to convert your shapes into metablobs. Now, let's go ahead and start putting something together and working with the metablob controls.

Create Objects Using Metablobs

You will continue where you just left off. Using the cube you just converted, you will begin building your new object and learn how metablobs react using that as a starting point.

1. Place another Cube into the scene.

 When you place the new Cube over the original, the second cube should be automatically converted into a metablob. If it isn't, select the new cube and click the metablob button to convert it into a metablob.

2. Move the second cube a short distance (as you see in Figure 4-31) from the first cube and perform a quick render (see Figure 4-32).

FIGURE 4-31

The two shapes combined as they look in the preview windows (with Show Boolean and MetaBlob Previews turned on in the Preferences/Options window).

FIGURE 4-32

A quick render of the two metablob shapes bridging into one.

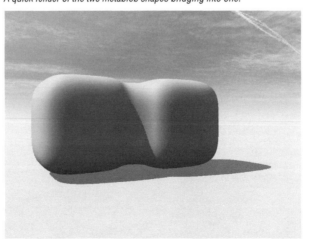

FIGURE 4-33

The resized block, approximately half the size of the other.

FIGURE 4-34

The smaller block should be positioned over the larger one.

3. Now you will position it more precisely. Select the second cube in the meta-blob group and scale it down until it is approximately half its original size (see Figure 4-33).

4. Move the resized block until it is centered over the larger one (see Figure 4-34).

When you do a quick render, you might see a slight attraction from the bottom of the first block to the top of the larger block. This is how metablobs work, almost like magnets attracting each other to form a new, organic shape.

5. Double-click directly on the icon for the metablob shape in the Layers window. Doing this will open the Metablob Options window (see Figure 4-35).

Be careful where you click. You need to be directly over the small icon or else you will activate the text editing mode to change the name of the metablob.

The three controls areas are:

- **Envelope Distance.** This determines how strong an attraction there is between the different shapes. When you click on the main metablob group, changes you make here are applied to any and all metablob elements placed inside it. If you clicked on an individual element and made a change, it would only affect that element and how it interacts with nearby shapes (see Figure 4-36).

FIGURE 4-35
The Metablob Options window.

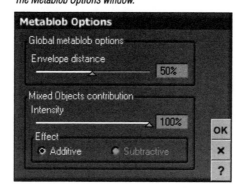

FIGURE 4-36
The result of increasing the Envelope Distance setting, making the two objects bridge more severely.

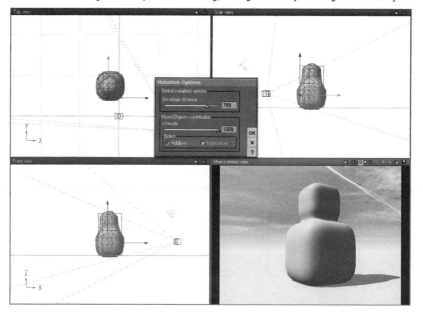

FIGURE 4-37

The effect of changing the settings in Mixed Objects Contribution.

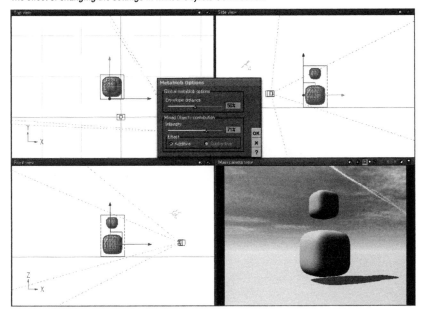

FIGURE 4-38

A sample of a subtractive metablob reaction.

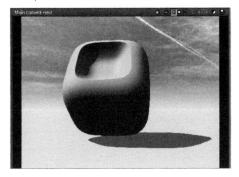

- **Mixed Objects Contribution.** This determines how much of an effect the secondary object has on the selected object. By changing this setting, the two objects can actually repel each other, cutting way and reducing the sizes of both shapes (see Figure 4-37).

- **Additive/Subtractive Effect.** Choose Additive to have the shapes blend together, forming the aforementioned bridge between them to create a new shape. Choose Subtractive (see Figure 4-38) if you want the object to push in on the other objects, creating a concave effect in the geometry.

QUICKTIP

You can assign Subtractive only to an individual object. If you have multiple objects selected, Subtractive will not be active.

6. Close the Metablob Options window without making any changes.

7. Choose the second Cube object in the metablob group, and then double-click on its icon to bring up the Metablob Options window.

8. Change the Envelope Distance to 95%. You can do this in two ways.

 a. Move the slider to the right to increase the percentage.

 b. Highlight the number in the text field and type in the new value.

 You have now created a pill bottle shape (see Figure 4-39). But that's not what the ending object will be. So, let's continue.

9. Add another Cube to the scene.

 This will become a leg that extends out from the bottom of the shape. Resize this Cube by stretching it so it looks similar to Figure 4-40. Make sure to use Drop Object to drop this cube onto the ground plane.

10. Copy the cube in one of four ways:

 a. Use the quick key command of Cmd/Ctrl+C (Copy), and then paste it using Cmd/Ctrl+V.

 b. Right-click on the object and select Copy from the submenu. Right-click again and choose Paste.

 c. Right-click on the name of the object in the Layers window and use the controls in Step b.

 d. Choose Edit > Copy and then Edit > Paste.

FIGURE 4-39

The changes you have made have created what could be called a pill bottle shape.

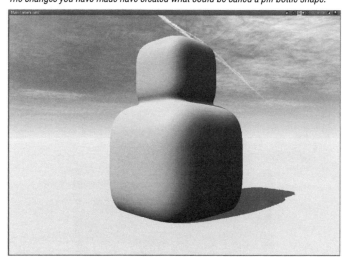

FIGURE 4-40

Resize your new Cube so it looks similar to this.

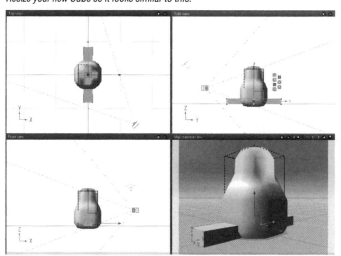

FIGURE 4-41

The copied cube in its final position.

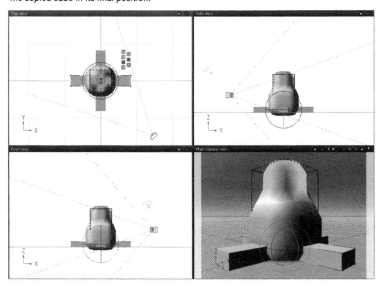

FIGURE 4-42

The Cube objects dragged onto the metablob group header. A very thin, almost imperceptible line appears under the header to show you that you are adding the elements to this group.

11. Rotate this Cube so it is at a 90 degree angle from the other one (see Figure 4-41).

 You have now created legs to act as the base of this object.

12. You can quickly turn these two cubes into metablobs and have them added to the metablob group. Select both by Shift+clicking on them, and then drag the two cubes onto the metablob group header in the Layers window (see Figure 4-42).

 When you do this, you will see a very pale blue-ish line appear immediately under the metablob header. When you release the mouse button, the two objects are added to the group and are automatically converted into metablob elements.

Perform a quick render to see the new object you have created. Then save the object into your Objects Library as Decoration. Sorry, that's the only name I could come up with for this object. If you have a better one, call it that.

Add Materials to Metablobs

Now you will add materials to the object. With metablobs, materials mix differently, meaning that one material will actually blend into another. This blending process can give your objects some extremely interesting looks.

1. Choose Cube 1 in the metablob list.

 For this, I used the Red Glass material (see Figure 4-43). The top cube shape being the body of the object, this material has been assigned there (see Figure 4-44).

FIGURE 4-43

The Red Glass material located in the Glasses category of the Material Selector window.

FIGURE 4-44

The Red Glass material after being assigned to the Cube object.

FIGURE 4-45

The Black Porcelain material as shown in the Material Selector window.

FIGURE 4-46

The Heavy Glass material as shown in the Material Selector window.

FIGURE 4-47

The three materials combined into an object created using metablobs.

2. Add the Black Porcelain material to the second cube.

Black Porcelain is located in the Basic category of the Material Selector window (see Figure 4-45).

3. Assign the Heavy Glass material to the last two cubes (see Figure 4-46).

4. Perform a quick render to see how the various materials interact with the metablob object (see Figure 4-47). Then save your object for use in later chapters.

Lesson 4 Use Metablobs—Funny Name, Cool Results

CHAPTER SUMMARY

Throughout this chapter, you have gained an understanding of how Boolean and metablob operations work within Vue and how you can build interesting objects that can be added to any of your scenes. With practice, the types of objects you can create using these two powerful tools can open your creative talents in order to build more complex and interesting images and videos.

Remember that one thing you *cannot* do is combine Boolean objects with metablobs (or vice versa). They are two very distinct operations that utilize different computational elements of the program. So, as you are practicing and increasing your knowledge of these features, remember this point.

What You Have Learned

In this chapter you

- Created objects using Boolean commands
- Created objects using metablob commands
- Modified your Boolean objects using Vue's nondestructive technology
- Added textures to the objects
- Saved the objects into your Objects Library for later use

Key Terms from This Chapter

Boolean, Boolean operations An effect in 3D applications that allows the user to combine two or more objects, making them interact by combining them in such a way as to create more complex shapes.

Geometry Another term for the mesh that defines the shape of an object.

Metablobs An effect in some 3D applications that combines two or more shapes into interactive forms that create more complex organic shapes. Metablobs can be likened to mercury in that, when two forms move closer to each other, they attract in a fluid manner to combine into one object.

Non destructive When two or more objects interact with each other during Boolean or metablob operations and do not make a permanent change to the mesh(es).

Organic shapes (Organic) Shapes that have more fluid angles. Angles are rounded rather than sharp. In 3D, organic shapes include humanoid and animal figures, water, and other shapes that do not have sharp edges.

Toggle switch A small triangle to the left of a group's name in the Layers window that, when clicked on, expands the list so you can see the individual elements that are combined or contracts the list to hide those elements.

5

ADDING VEGETATION AND SOLID
GROWTH™ TECHNOLOGY

1. Add, select, and position plants in a scene using Solid Growth technology.

2. Use the Drop and Smart Drop commands.

3. Use the Plant Editor to create vegetation.

ADDING VEGETATION AND SOLID
GROWTH™ TECHNOLOGY

In order to really bring your environmental scenes to life, you need to do more than modify a terrain and add a material to it. You need to add plants and rocks to bring that sense of reality to your projects. With Vue (all versions), you can quickly and easily add plants and rocks using foliage from the Plants Library.

One of the banes of the 3D designer's existence is creating foliage for a scene. Once a tree is built in a 3D modeling program and saved out, you basically have a "what you see is what you get" (WYSIWYG) object; any variations to the plant have to be specifically modeled and saved out as another object in order for the trees in a scene to not look identical. Then, there is the headache of setting up the trees and leaves to animate. To say the least, it's massively time consuming. In response to these issues, Vue has **Solid Growth** technology. This technology creates a fresh mesh for each plant you place in a scene. Now, you

can populate your scenes with a forest of cherry trees and no two will ever look the same. And each is ready to be animated using the Atmosphere Editor (covered in Chapters 6 and 7).

In this chapter, you create specific types of scenes and position foliage throughout in order to gain an understanding of placing plants in specific locations. You'll also get the added benefit of doing all this while using the techniques you learned in the previous chapters. Then, you learn how to modify plants in order to create your own species for your projects.

> **QUICK**TIP
>
> Only plants that come with the Vue family of programs take advantage of Solid Growth. Plant models you purchase or download, unless created using Solid Growth plants in the first place, will not have fresh geometries created each time they are added to a scene.

Tools You'll Use

Plant Selector Window

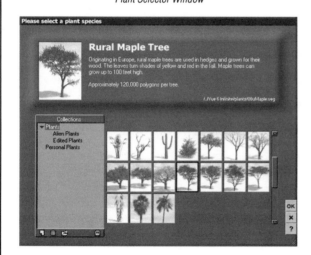

Plant Editor Window

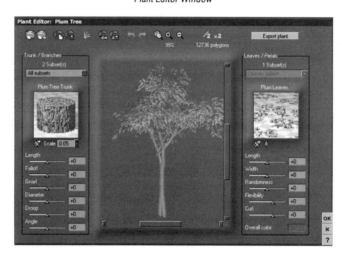

ADD, SELECT, AND POSITION PLANTS IN A SCENE USING SOLID GROWTH TECHNOLOGY

What You'll Do

In this section, you become familiar with the Plant Selection screen, while also learning how powerful and time-saving Solid Growth Technology is. You also discover how quickly the polygon count can increase as you add foliage.

Drop/Smart Drop

Plants are an essential part of creating a 3D environment. The placement of plants and the number of plants you place into your scene can either make a view "ooh" and "ahh" over the realism, or make the scene look unrealistic—even if it is a fantasy scene developed solely in your imagination. It is often amazing to think that, even if you build an environment based upon a photograph, people will often look at it and say "There is no way anything looks like this in the real world."

I'm sure you have all experienced it. And if you haven't, you should really go out into the country and study landscapes. There are so many places where a wide open field has a small rise in it, and on that rise is a stand of trees. It looks beautiful, but if you tried to paint that scene or recreate it in 3D, those looking at your pictures would probably comment on how fake it is; even if you have the photograph immediately next to the image. This isn't to say you shouldn't try to recreate reality, or dwell on what others might say. It is to say,

however, that no matter what you create in this or any other program, your results will always be viewed differently, depending on the perspective of the viewer. So what is an artist to do? Create. It's as simple as that. Add plants, rocks, rivers, and valleys in any way you want, because there is one truth in nature: Nothing we can imagine will ever compete with what nature can create.

QUICKTIP

The more complex the plant, the longer it can take Vue to generate the mesh. Something with a low polygon count, such as the coconut tree or a dead tree, will load relatively quickly (within a few seconds); something like a pine tree can take longer. After you load a plant, check out the progress bar in the lower-left corner of the Vue window. It shows the progress of "growing" the plant.

So, with that in mind, are you ready to learn how to add plants into your scenes in order to bring those scenes to life?

Creating a Basic Beach Scene

In this section, you learn how to add plants to your scenes by creating a new scene and then adding plants to it in order to build a final image.

FIGURE 5-1

The Plant/Load Plant Species... button (highlighted) is located on the left side panel of the workspace.

FIGURE 5-2

The Plant categories.

Category List

New Collection

Delete Collection

Browse File

Hide Online Items

1. After creating a new scene, press and hold down the mouse button on the Plant/Load Plant Species... button (see Figure 5-1).

 As with most of the object buttons, when you press and hold down on the Plant button, it will be highlighted. When you release the button, the Plant Selector window will open. If you merely click on the button, another variation of the last selected plant species will be added to the scene.

2. Choose a Plant collection (see Figure 5-2).

 Vue comes with a number of preset plant models to choose from. Every one of these plants takes advantage of Solid Growth, so for each instance of the plant in your scene, the mesh will be slightly or dramatically different.

 The control buttons at the bottom of this section of the window are (from left to right):

 a. **New Collection**—Create a new folder in which imported or modified plants can be stored.

 b. **Delete Collection**—Delete the selected folder from the collections window.

 c. **Browse File**—Brows for the file you want to import.

d. Hide Online Items—Vue can connect to online resources where elements might be stored. To hide any items that are in an online folder (so they won't show in the list), click the little blue ghost.

There are three distinct sub-categories in the Plants category:

a. Generic Plants—Accessible by clicking on the Plants header.

b. Alien Plants—Plants found nowhere on this planet (that I know of, at least!).

c. Edited Plants—Plants that have been created by Vue users around the world and licensed for distribution with the program.

3. To read a name and description of a particular plant, click on it once in the selection area (see Figure 5-3).

At times, a scrollbar will appear to the right of the plant thumbnails indicating there are more plants in the collection than can be displayed.

FIGURE 5-3

Each plant has a thumbnail image and information about what it is and where it is usually found.

FIGURE 5-4

A coconut tree added to the scene.

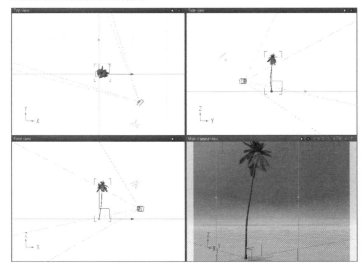

FIGURE 5-5

A second coconut tree added to the scene has a completely different geometry, thanks to Solid Growth technology.

4. Double-click on the plant you want to add to your scene.

This will place an **instance** of the plant on your workspace (see Figure 5-4).

5. Now, in order to see how Solid Growth technology creates completely new geometry for every plant instance, click once on the Plant button.

Do not hold down on the button. Merely click to add a second instance of the palm tree to the scene. This second tree is added immediately on top of the first instance (see Figure 5-5).

QUICKTIP

Because each mesh is freshly generated, the trees in your scene will look different than the trees you see in the book. Your result might not be as pronounced as what you see here.

6. Now add two more coconut trees to the scene.

These trees will appear grouped together since all their origination points are the same location in the scene. Use the Move command (the M key on the keyboard) to position these last two trees a little bit to the left of the original two trees so your scene looks like Figure 5-6. To select the trees, you can either click on them in one of the viewports, or select the individual tree in the Layers window. In this case, because you are moving the last two trees placed, you can also Shift-click on the bottom two tree instances and then move both as one unit.

7. Before moving on, save this file as **Beach Scene** in preparation for the next portion of this chapter.

FIGURE 5-6

Four coconut trees separated into two groups of two in preparation for a beach scene.

USE THE DROP AND
SMART DROP COMMANDS

What You'll Do

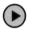

In this section, you learn how to use the Drop and Smart Drop commands to quickly and easily place objects flush against the first mesh they meet.

It is important to note here that what you are about to do is not necessarily the way you want to work when building a scene. Normally, you would place the terrains first, and then add foliage. But, for the purposes of this chapter, to practice moving, and to learn about Drop versus Smart Drop, you will add the terrain to the scene you just saved and reset the palm trees' positions afterward.

The Drop and Smart Drop commands (see Figure 5-7), the latter of which is only available in Vue 6 Infinite, allow you to quickly and easily place an object flush against the first mesh it meets. Multiple clicking of the Drop button will keep moving the object down until it reaches the ground plane. You cannot, therefore, drop an object below the ground using this command. Smart Drop, does the same basic job as Drop, but also takes one extra piece of work from you. As it drops the object, it reads the curves of the mesh the object is being dropped on to and rotates the object to match that curve.

FIGURE 5-7

The Drop/Smart Drop button at the bottom of the Objects panel.

FIGURE 5-8

Use the non-uniform Scale control, the thin line, to scale the terrain on the Y axis.

FIGURE 5-9

The scaled terrain. Use this as a reference for your terrain scaling.

To get a feel for using the Drop/Smart Drop command, do the following:

1. If the Beach Scene file isn't already open, choose File > Open or press Cmd/Ctrl+O to open it.

2. Add a Terrain object to the scene.

3. Go to the Terrain Editor and click Eroded.

 Click Eroded as many times as you want. Each time you click the button, it will erode the terrain a bit more. When you have the terrain look you want, click OK to set it.

4. With the terrain still selected, select Scale (the S key on the keyboard).

 You need to scale your terrain so the beach is not so steep and high. Using the Outside Scale gizmo (see Figure 5-8), scale on the Y axis until your beach looks something like you see in Figure 5-9.

5. In order to get a little more organized, and before you reposition the trees, create a new layer in the Layers window and call it **Palm Trees**.

 It is a good idea to get into the habit of organizing yourself. In this instance, you will separate the trees into a new layer (see Figure 5-10).

6. Select the bottom two palm tree instances in the Layers window.

7. Using the Move gizmo, move the trees above the beach terrain (see Figure 5-11).

 You will use the standard Drop command for these two trees. Once you have them above the terrain element, click the Drop button to drop them onto the terrain mesh (see Figure 5-12).

8. Now select the other two coconut trees and move them above the terrain.

9. Press and hold down on the Drop button.

 When you do this, the button will be highlighted (see Figure 5-13), letting you know that Smart Drop has been activated. When you release the button, the trees will drop onto the terrain and will rotate to match the angle of the slope (see Figure 5-14).

FIGURE 5-10
The Palm Trees layer with the coconut trees grouped inside.

FIGURE 5-11
The coconut trees have been moved above the terrain mesh in preparation to be dropped onto it.

FIGURE 5-12
The two coconut trees have been dropped and are resting at the top of the terrain mesh.

FIGURE 5-13
You will know Smart Drop is activated when the Drop button is highlighted.

FIGURE 5-14
The coconut trees have dropped onto the terrain and rotated to match the slope. In this case, they rotated into each other.

FIGURE 5-15

The trunks of the trees need to be moved into the terrain mesh so they don't appear to be floating above the terrain.

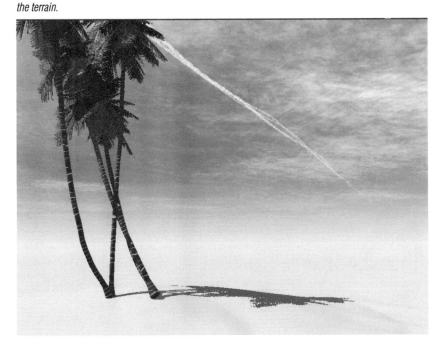

10. Double-click on the Main Camera View title bar to bring the window to full screen mode.

11. Perform a quick render to see how your scene looks so far.

You will probably notice a slight problem. As you can see in Figure 5-15, and probably in your scene as well, the coconut trees we used Smart Drop on are not embedded in the sand. They look fake. That's because the point where the trees' meshes meet the terrain is where they stop. They have no idea they need to be buried in the sand. You will want to lower them so the bases of the trees are buried in order to make the image look more natural.

Finesse Your Scene

1. Create a new layer in the Layers window and call it **Beach Elements**.

2. Drag the existing Terrain element into this new layer.

 This way, all the beach elements—the main beach and the bunched up sand—will be grouped into one unified area.

3. Rename the terrain so it is now called **Main Beach**.

4. Add a new Terrain element to the scene.

 Scale this terrain down, using both uniform scale and non-uniform scale, until it fits comfortably around one of the groups of trees (see Figure 5-17).

Making the Beach Look More Realistic

Although the trees have now been buried into the "sand" (the untextured sand, that is), the area where the trees meet the terrain looks fake (see Figure 5-16). The exercise on this page shows how you can fix that.

FIGURE 5-16

There is no sand bunched up against the trunks of the coconut tree, a detail that ruins the realism of the overall scene.

FIGURE 5-17

The terrain scaled down to fit against the tree trunks.

FIGURE 5-18

Both resized terrains have been placed so the sand appears to be gathered around the trunks of all the coconut trees.

FIGURE 5-19

Use the Soft Dunes material from the Landscape category to texture your terrains.

5. Repeat Step 4 and position the terrain around the base of the second group of coconut trees (see Figure 5-18).

In this case, I also let some of the terrain extend to other parts of the Main Beach terrain to add a little more chaos to the beach.

6. Select each of the terrain objects individually in order to change the texture to something more beach-like (or sandy, if you prefer).

Go into the Material Editor and select the Landscape category, and then choose Soft Dunes from the list (see Figure 5-19). Repeat this process for each of the terrain elements.

7. The last thing to do is add some water. Select the ground plane and, in the Material Editor, go to the Liquids category and choose a material you like.

Perform a quick render to see how you scene has turned out (see Figure 5-20) and then save your file.

| **QUICK**TIP
|
| Notice in the lower-right corner of the workspace,
| immediately under the Aspect window, that the
| scene you just built contains approximately
| 27,000+ polygons, an extremely light scene.
| Many scenes you create can go into the tens-
| and hundreds-of-million polygon range.

FIGURE 5-20
The final render looks more realistic.

USE THE PLANT EDITOR TO
CREATE VEGETATION

What You'll Do

In this section, you use the Plant Editor to create an original plant and then save it for future use.

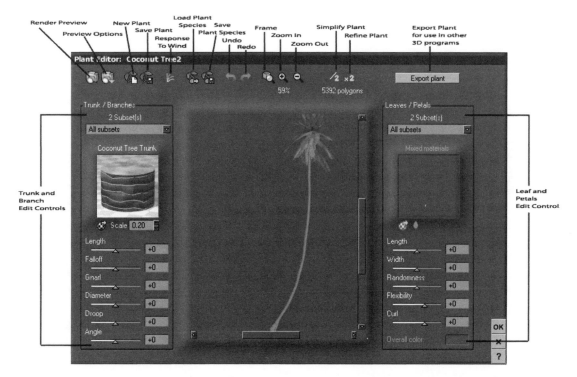

Make a Tree

1. Make a new scene and add a Summer Cherry Tree from the Plants collection.

 The Summer Cherry tree, like a Magnolia tree, has a lot of leaves on it. In order to create a specific type of tree, you want to start with a pre-existing plant that has the same characteristics as the one you want to create.

2. Double-click on the tree in any of the viewports to open the Plant Editor window.

 The Plant Editor window is broken into four parts. Using Figure 5-21 as reference (as well as your program), the sections and their elements are:

 a. **Control Panel**. This horizontal line of buttons at the top portion of the window contains the following controls:

 - **Render Preview**—Creates a rendered preview of your plant in the display window.

 - **Render Options**—Tells Vue how to show your plant as you're designing it. Use either Open GL (the default) or Auto Render to do a full render of the plant as your modifying it. Unless you have a super-fast computer, you should leave Open GL selected.

Making a Real-World Tree

In this section, you work with the Plant Editor, creating a magnolia tree that can be saved for later use, and you create another alien plant to add to your collection.

In order to create a new plant species that takes advantage of Solid Growth, you must start with an existing plant. You also need to download the Chapter 5 files from the book's website (www.courseptr.com/downloads), where a number of different leaf images and their alpha maps have been created for your use. Also included are photographs of bark to use on the tree itself.

QUICKTIP

With the Plant Editor, you can change a tree into a bush, a section of grass into grains of wheat, or change a cherry tree into a magnolia tree. You have control over the size of the trunk, how the trunk bends, and how scraggly it is. All of which can be animated so you can create a scene where the tree sprouts from the ground, grows into maturity, and then ages and dies. (What you cannot do is get the leaves—the alpha planes—to separate from the branches. So, you have to use other methods to create leaves dancing on a gust of air, for instance.)

Plus, if you create the new plant using an existing Solid Growth technology plant, your new plant will respond the same as the other plants in your collection.

FIGURE 5-21

The Plant Editor window and its controls.

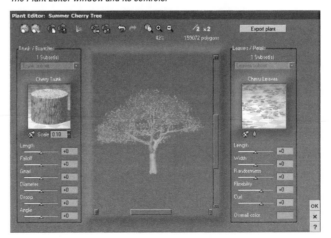

QUICKTIP

At the beginning of the chapter, I noted that Vue comes with a limited amount of foliage to add to your scene. Although there are online communities such as cornucopia3d.com, runtimedna.com, and renderosity.com, which have 3D content to add to your collection, you can also create your own plants using the Plant Editor. What you will need is a digital camera in order to take photos of leaves, bark, and foliage, and an image-manipulation program such as Photoshop to create your images and alpha maps. Leaves and grass are created in Vue using alpha planes, a primitive that accepts alpha maps to create transparencies in an image. Within the Plant Editor, you can assign these images as part of the new plant creation.

FIGURE 5-22
The Response to Wind Options window.

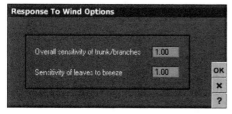

- **New Plant/Save Plant**—These two buttons, in order, create a different mesh of the plant you have selected, and, when you are finished, lets you save your plant for to your Plants library. This saved plant will be a standard model and does not incorporate Solid Growth technology.

- **Response to Wind**—This button opens a new window, the Response to Wind Options (see Figure 5-22). Here, you can set how sensitive the plant will be to wind conditions in your animations.

- **Load Plant Species/Save Plant Species**—The first button lets you change what type of plant you are modifying; it opens the Plant Selector window so you can choose a different plant. Save Plant Species will save your plant, incorporating Solid Growth technology so each instance of that plant will have different geometry.

- **Undo/Redo**—Removes or restores the last change you made.

- **Frame/Zoom In/Zoom Out**—Frame reframes the plant in the preview window if you have zoomed in or out to work on it. Zoom In and Zoom Out are…well…pretty self-explanatory. Underneath this, Vue shows you the zoom percentage.

- **Simplify/Refine Plant**—Simplify decreases the polygons of the plant, lowering its quality, whereas Refine increases the plant's quality for higher resolution display. Underneath these controls is listed the number of polygons making up your plant.

QUICKTIP

There are times you might want to save two versions of your plants—one high resolution and another low resolution. The low-resolution plants can be used for background elements, whereas the high-resolution plants can be used in the image's foreground.

- **Export Plant**—Clicking on this button lets you save the plant you create for use in other 3D applications.

b. Trunk/Branches—These section gives you control over the truck of the plant. Use the sliders to increase or decrease the various elements of the plant.

c. Preview Window—Shows a preview of the changes you are making to the plant. Right-clicking in this window lets you rotate around the plant to see it from all angles.

d. Leaves/Petals—Controls the size, shape, and other aspects of the leaves or petals in your new plant.

At this stage, you will not use the controls to create you new plant.

3. Double-click on the bark thumbnail in the Trunk/Branches section.

 This will open the Material Editor window. For this section, you will remain in the Basic Material Editor window as you create your new tree.

4. In this case, you want to place a new image file onto the model. To do this, click on Color Map in the Color section immediately below the bark thumbnail (see Figure 5-23).

FIGURE 5-23

You need to activate Color Map to add the new bark image to the plant.

FIGURE 5-24

Click this button to open the Image Navigation window.

FIGURE 5-25

Because the image you chose is part of a sequence of images, choose No when this screen appears.

FIGURE 5-26

When you use the same image as a bump map, the program will automatically convert the file to grayscale.

5. Click the right-pointing arrow under the image window of the Color section (see Figure 5-24) and navigate to the Bark1. bmp image you downloaded.

When you select Bark1.bmp, you will get a message like you see in Figure 5-25. Because the various bark images are numbered sequentially, Vue sees them as part of an animation. In other words, it will take these sequential files and scale them to wrap around the mesh you are assigning them to. Click No to only load Bark1.bmp.

6. Activate **Bump Map** and repeat Step 5. Then click OK to accept your changes.

The image will automatically be converted to grayscale (see Figure 5-26).

7. Using Figure 5-27 as reference, begin making changes to the trunk and branches of the tree.

You need to be careful while making these changes. For some sections, even a two- or three-point change can have a very strong affect on the tree. As you try different settings, the tree will be automatically updated in the Preview window, so keep an eye on that as you create your new plant(s).

8. Now it's time to add the leaves. In the Leaves/Petals section, repeat Steps 3 through 5, and assign the magnoliaLeaves.bmp.

9. You need to add an alpha map in order for the white area surrounding the leaves to disappear when rendered. Because Alpha Map is already active because of the existing leaf image, double-click on the alpha map thumbnail and assign the magnoliaLeaves_Alpha. bmp image (see Figure 5-28).

FIGURE 5-27

Use the setting in this image for your final settings. But, before you do that, play with the controls to see how the plant is affected.

FIGURE 5-28

The new leaves and their alpha channel assigned to the plant material.

FIGURE 5-29

The settings to use for your magnolia leaves

FIGURE 5-30

Vue tells you its progress as you save your new plant.

FIGURE 5-31

After saving, Vue shows you a rendered image of the plant in the Preview window.

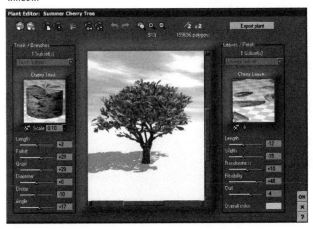

10. Experiment with the Leaves/Petals settings to see how the leaves are affected, but then use the numbers you see in Figure 5-29 for your finished tree.

11. Click the Save Plant Species button at the top of the Plant Editor window (fourth button from the left) to save your plant with Solid Growth technology assigned to it.

At the bottom left of the screen, you will see Vue saving the plant and setting up to display a preview image it (see Figure 5-30). When that is complete, the rendered Magnolia Tree will appear in the Preview window (see Figure 5-31).

12. Click OK to exit the Plant Editor.

Your new tree will be placed into the scene. If you access the Plant Selection window, you will see your Magnolia Tree in the Plants category (see Figure 5-32). Select it and add some more instances into your scene. You will see that each tree has its own, unique look (see Figure 5-33).

13. There is one more thing to do. Double-click on one of your magnolia trees to open the Plant Editor.

14. Increase the tree's resolution using the x2 button in the controls at the top of the window.

Be careful when you do this. Double the resolution of the mesh once or twice, keeping an eye on the polygon count. That's how many polygons will be added to your scene each time you place this plant in it. Going too high can cause the program to crash—depending on your system setup.

15. Resave the tree in the same was as Step 11, only this time name it **Magnolia Tree HR** (for high resolution).

You now have a tree that can be used in the background and another variation in the foreground. Both have Solid Growth technology assigned.

FIGURE 5-32

Your new tree should appear in the main Plants section of the Plants selector.

FIGURE 5-33

Because it has Solid Growth technology assigned to it, no two magnolia trees look exactly alike.

Creating an Alien Plant Species

In this section, you'll have some fun and choose an atmosphere that helps you set the mood. In the Atmosphere Selector window, choose Effects > Science Fiction > Busy Sepia Aliens (see Figure 5-34).

FIGURE 5-34

Use an alien atmosphere to help get in the mood for creating this new plant.

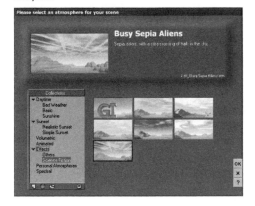

FIGURE 5-35

Use these settings when creating your alien plant

5. Click the Overall Color chip selector in the Color section (see Figure 5-36), and change the overall color to what you see in Figure 5-37.

6. At the bottom of the Leaves/Petals section, click the Overall Color chip and select a bright red color for the leaves.

You have now created a plant species unlike any on earth, yet it was based upon a tree you just built and added to your library. You can add this alien plant to your library if you want, or just enjoy it for a few minutes before you move on to the next chapter.

FIGURE 5-36
The Overall Color chip gives you access to the color selector window.

FIGURE 5-37
Use these color values to assign a color to your bark.

CHAPTER SUMMARY

You are now ready to start creating intricate scenes using Vue. In the following chapters, you begin learning about modifying atmospheres, the last step in truly high-quality scene composition. And, you can go into the next chapters knowing you are not limited to the number of plants that come with Vue; you can now go out and create your own species.

What You Have Learned

In this chapter you

- Selected and added plant species to your scene
- Used the Drop and Smart Drop features
- Looked at smaller details in an image to make it more realistic

- Used the Plant Editor to create a real-world tree
- Used the Plant Editor to create an alien plant
- Saved plants that take advantage of Solid Growth technology

Key Terms from This Chapter

Alpha map A black-and-white image that tells the program to create transparencies. Although most 3D applications use white to retain opacity, Vue uses black. So white areas of an alpha map become transparent, and black areas' visual information is retained.

Alpha plane A primitive object that supports transparencies (alpha maps). Alpha planes are located in the Primitives area of the program.

Bump map A grayscale image that defines high and low points in a texture.

Instance One appearance of a particular object. For instance, you have five palm trees in your scene, each individual palm tree is considered an instance of that plant.

Solid Growth™ technology Solid Growth technology is used to generate fresh, original plant meshes each time a species is added to a scene, ensuring that no two plant species ever look the same. This is trademarked by E-on Software and is not found in any other program.

chapter

6

THE ATMOSPHERE EDITOR—
PART 1

1. Explore the Atmosphere Editor controls.

2. Modify and save a standard atmosphere.

3. Change and add clouds to a scene.

4. Add fog and haze.

5. Create volumetric atmospheres.

6. Use the Environment Mapping style.

chapter 6 THE ATMOSPHERE
EDITOR—PART 1

Remember those science classes you had to take in school? Like most of us, you probably sat through the lectures on the earth's atmosphere saying to yourself "yeah, yeah...but what good does that do me? I don't care about light bouncing off of dust and moisture particles." Well, guess what! If you have purchased this program (or have any other iteration of the Vue product line), all those days studying cumulo-nimbus clouds and light refraction, ionospheres/troposphere/stratospheres and electron density are about to pay off.

You might now be saying "Hey, Mr. writer-person, I didn't buy this book to get a lesson in science; I want to create awesome pictures with this program!" This chapter won't be a dry lesson in global sciences, I promise. But, all those things you learned and might have retained from your days in science class will definitely help you when you begin to work with Vue 6 Infinite's Atmosphere Editor. Based on real-world sciences (see Figure 6-1), the more you can relate what happens in nature the more you will benefit as you design your atmospheres.

In fact, this is the perfect time to point out that, as you become more proficient with Vue and other 3D applications, you should become a student of nature. Watch and study everything. Like a true artist, view the world around you and take mental notes (if not physical ones). See how things interact, how light plays off different surfaces, how shadows interact with the environment, how different temperatures of sunlight affect color, and so on. By doing this, by noticing the small, often overlooked details in nature, you will become a better artist, one who causes people to stare in awe at your work.

Notice, also, this chapter is part one of two. The reason for this is simple. Vue Easel through Vue 5 Infinite's Atmosphere Editor is exactly the same as Vue 6 Infinite's except for one feature—Spectral Atmospheres. So, this chapter covers the commonalities between the entire program family in order for everyone to benefit; Chapter 10 focuses only on V6I's Spectral Atmospheres.

As you follow through this chapter, you will gain an understanding of the procedure for creating atmospheres, with the final outcome of this project being an alien landscape which will be populated with the alien plant you created in Chapter 5.

FIGURE 6-1
The atmospheric layers you learned about in science classes.

Tools You'll Use

Atmosphere Models

Atmosphere Control Tabs

Control Window

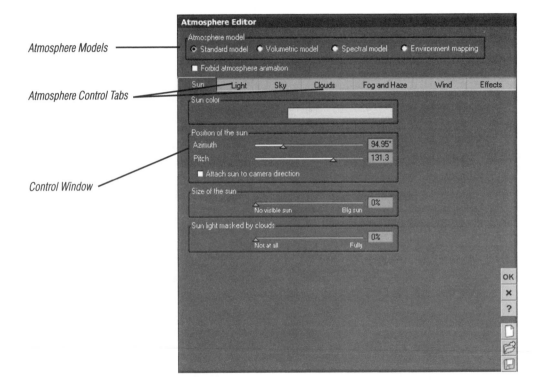

EXPLORE THE ATMOSPHERE
EDITOR CONTROLS

What You'll Do

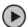

In this section, you learn the various elements of the Atmosphere Editor in preparation for creating your own high-quality atmospheres.

The Atmosphere Editor, shown in Figure 6-2, is broken into numerous sections, each of which give you specific control over various aspects of the atmosphere. In this panel, you can modify everything from the color of the sun to how the sun interacts with the camera lens. You can add stars, ice rings, and more to develop highly complex and fantastic environments for your scenes.

FIGURE 6-2

The V6I Atmosphere Editor. If you are not working with Vue 6 Infinite, Spectral Atmosphere will not be part of the Atmosphere Model list.

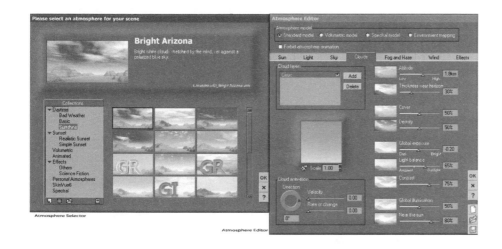

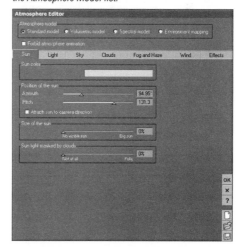

In many cases, small changes to a setting can make a dramatic change in the overall look of your scenes. So it's important to save your files often because, if you don't, you might create an atmosphere you absolutely love, decide to give it a little tweak, and then find you can't return to the original settings you liked.

Let's take a close-up look at the various screens in the Atmosphere Editor before working with it.

QUICKTIP

All the images are taken of Vue 6 Infinite's new **graphic user interface (GUI).** If you are using an earlier version of the program, your GUI will have the old interface look (see Figure 6-3).

The Atmosphere Models selector is shown in Figure 6-4. This section lets you determine the base model on which your atmosphere will be built.

- **Standard model**—A high-quality model that ignores many real-world reactions, such as light interacting with dust or water molecules. It renders quickly, because the program and the computer does not have to do as many high-end computations.
- **Volumetric model**—Volumetrics allow for interplay between light and the environment. Complex algorithms create the interaction between the atmosphere and the light, causing renders to take a bit longer. This is a

more realistic atmospheric model than Standard.

- **Environment mapping**—Based on raytracing technology, and incorporates high-end atmospheric conditions:

QUICKTIP

Environment mapping is not available in Vue 5 Easel. It is available in Vue 6 Easel, which should be out at the time of this printing. Check the E-on Software website (www.E-onsoftware.com) for the latest information about the Vue 6 Easel release and other up-to-date software information.

FIGURE 6-3
The Vue 5 graphic user interface. Only the base look differs; the controls are the same as in Vue 6 Infinite.

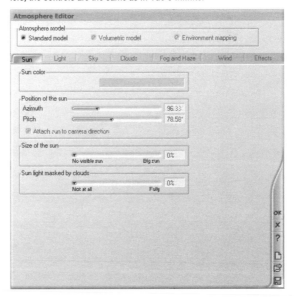

FIGURE 6-4
The Atmosphere Models selector.

Global Illumination (GI)—Captures subtleties of natural lighting by using the sky as a dome of light. This is perfect for outdoor scenes.

Global Radiosity (GR)—Uses reflective light to light the scene. Perfect for indoor lighting, because additional lighting is created by the light that bounces off and is absorbed by elements in a scene. GR increases render time because of the computational intricacies of this technology.

Spectral (*V6I only*)—A highly-advanced atmospheric model that produces ultra-realistic environments, giving control of air density, humidity, dust, and turbulence. This model is covered in Chapter 10.

Image Based Lighting (IBL)—Uses **High Dynamic Range Imagery (HDRI)** to control lighting in the scene. This is used in many movies, because it allows blending of computer graphics (CG) with real footage for true photo-realism.

QUICKTIP

Not all image files can be used for HDRI. HDRI files are 32-bit images with the .hdr **extension**. Adobe Photoshop CS2 can save image files as HDRI. HDRI images are provided on this book's website (www.courseptr.com/downloads), and are used later in this chapter.

This list discusses the next section of the Atmosphere Editor (see Figure 6-5):

- **Forbid Atmosphere Animation**—Turns off all animation controls in the Atmosphere Editor.
- **Sun**—Controls the positioning of the sun in the scene, as well as the sun's size and any corona that might appear around it.
- **Light**—Provides the controls for the way light appears and interacts in the scene.
- **Sky**—Allows you to control all aspects of the sky itself, from color to the way fog appears in the scene.

- **Clouds**—Gives you the ability to add clouds to the scene, control the appearance and texture of the clouds, and how they animate.
- **Fog and Haze**—Provides you with the controls to add haziness and fog density in the scene.
- **Wind**—Gives you control over the way wind will affect plants in your scene during an animation.
- **Effects**—Enables you to add special effects to the scene such as stars, rainbows, and lens flares.

FIGURE 6-5

The main sections of the Atmosphere Editor. Click on the tabs to bring up the controls for that particular effect.

MODIFY AND SAVE
A STANDARD ATMOSPHERE

What You'll Do

In this section, you use an existing atmosphere, modify it to make an entirely new one, and then save the new atmosphere into your Atmospheres Library.

Light Controls

Sky Controls

Clouds Controls

Fog & Haze Controls

All atmospheres you create will begin with an existing atmosphere. You cannot open Vue and go directly into the Atmosphere Editor before assigning a base atmosphere to the scene. After you have created your own, you can assign one of them as the default atmosphere at the program's startup.

Creating Your Own Atmosphere from an Existing One

There are three ways to bring up the Atmosphere Editor.

- Click on the Atmosphere Editor button in the Control panel at the top of the workspace (see Figure 6-6).
- Choose Atmosphere > Atmosphere Editor in the pull-down menus at the top of the screen (see Figure 6-7).
- Use the F4 key on your keyboard.

FIGURE 6-6

The Atmosphere Editor link in the control panel.

FIGURE 6-7

You can access the Atmosphere Editor via the Atmosphere pull-down menu.

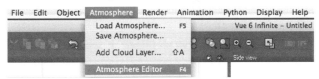

Modify an Existing Atmosphere

1. So you are working from the same starting point as the steps, assign the Destination Unknown atmosphere (see Figure 6-8) to your scene.

2. Open the Atmosphere Editor using one of the methods listed previously.

3. Select Standard for the Atmosphere Model.

4. If the controls aren't already open, click the Sun tab to open the Sun controls.

5. Select Sun Light from the Layers window.

 This will position the sun object in the center of the viewports (see Figure 6-9). This is critical for helping understand the controls in this section of the Atmosphere Editor.

 QUICKTIP

 If the selected object in the Layers window does not become centered in your viewports, choose Preferences/Options and, in the Display Options > View Options section, check the Center Views on Objects Selected in World Browser box.

FIGURE 6-8

The Destination Unknown atmosphere is in the Sunshine category.

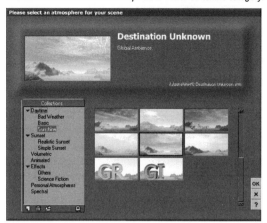

FIGURE 6-9

Objects selected in the Layer window are centered within the viewports.

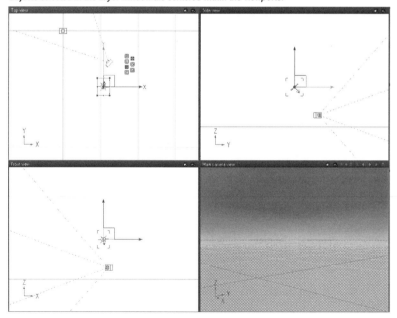

FIGURE 6-10

The sun's pre-defined color map window opens when you double-click on the Sun Color color chip.

FIGURE 6-11

The Blue Sky color map, which will be the new sun color.

6. You will be changing the color of the sun for this scene. To do this, you move the cursor over the color chip in the Sun Color section and do one of the following:

 a. To add a predefined color map to the sun, double-click on the chip.

 b. To create an original color map, right-click on the chip and select Edit Color Map.

 You learn about editing color maps in the next section. In this case, double-click on the color chip to open the Color Map selection window (see Figure 6-10).

7. Select Daytime Skies > Blue Sky (see Figure 6-11) for the sun's color map.

 The Blue Sky color map goes from white to a mid-range blue. This will not change the light color (the way the lighting affects objects in the scene). All it does is change the color of the sun when it appears in the scene.

8. Sun position is important for how it will light the scene. There are two controls here, Azimuth and Pitch, which, when combined, will move the sun in all directions in the sky. Change the Azimuth to 229.9 and the Pitch to 163.5.

The Sun Position controls:

Azimuth—In its simplest terms, this moves the sun along the horizon line. In relation to the viewports, it moves the sun left or right on the screen. Move the slider to the left, the sun moves to screen left, to the right it moves to screen right.

Pitch—Determines the height of the sun in relation to the camera. Move the slider to the left, and the sun moves in front of the camera and down to the horizon line, to the right and the sun moves in behind the camera and down to the horizon line.

This will position the sun in the upper-center portion of the sky in the Main Camera view, facing directly toward the camera (see Figure 6-12). Perform a quick render to see how the atmosphere looks so far, and what happens as the sun faces into the camera.

QUICKTIP

You can perform a quick render without closing down the Atmosphere Editor (or any other control window). When you start your render, the Editor window will disappear. When the render is complete, the Editor window will appear again so you can continue making changes.

9. By default, Size of the Sun is set to 0%. Change that to 10%.

When the sun size is set to 0, the sun will never be seen in the image, no matter where it is placed. By changing the size to 10%, a large, blue sun will appear in the scene.

10. Change Sun Masked by Clouds from 0% to 100%.

Now the clouds in the scene will appear to be in front of the sun (see Figure 6-13).

FIGURE 6-12

The sun is lower in the sky and facing the camera.

FIGURE 6-13

The big blue sun positioned and visible in the scene, with the clouds masking it out.

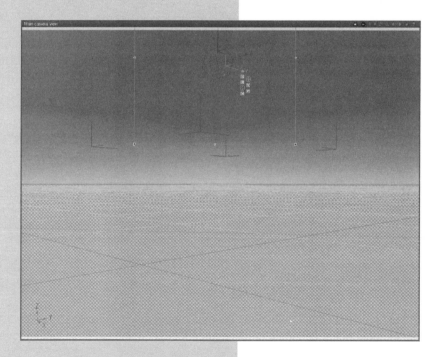

FIGURE 6-14

The selections for the Lighting Model section of the Atmosphere Editor.

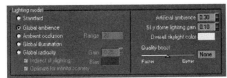

11. In the Light section, under Lighting Model, make sure Global Ambience is selected.

 In this section, you have a choice of five lighting models (see Figure 6-14). Two of the models you already know, Global Illumination and Global Radiosity. The others are as follows:

 a. Standard—Basic lighting model that works the same way in which its corresponding Atmosphere model works.

 b. Global Ambience—This lighting model takes into account all the different colors of the sky and how they will affect a scene. If, for instance, you have a red sky, it will give the part of the scene facing that light a reddish cast.

 c. Ambient Occlusion—Ambient occlusion is most often calculated by casting rays in every direction from the surface. Rays that reach the background or "sky" increase the brightness of the surface, whereas a ray that hits any other object contributes no illumination. As a result, points surrounded by a large amount of geometry are rendered dark, whereas points with little geometry on the visible hemisphere appear light. It is a crude approximation of global illumination, and gives the appearance of shading on an overcast day.

The other controls in this section perform the following functions:

 a. Artificial Ambience—How much the skylight color affects the overall ambience of the scene within shaded areas.

 b. Sky Dome Lighting Gain— Determines how much the Overall Skylight color affects the colors in the image.

 c. Overall Skylight Color—Change this color to change the overall color of the atmosphere.

 d. Quality Boost—How much quality for the lighting model is added when the scene is rendered.

12. The only thing you change for the Lighting Model is Overall Skylight Color. Double-click on the color chip to open up the color picker window (see Figures 6-15 and 6-16).

Although the Vue 5 color picker window is familiar to virtually everyone, the Vue 6 color picker has added some intricacies. The left strip controls the contrast of the colors, whereas the right strip controls the tonal value. By moving the bar in the left strip to the tip, you brighten the colors; their brightness is determined by where the horizontal bar in the right strip is positioned. You can also use numeric **RGB** or **HLS** color values from a color sampling in an image manipulation program.

13. Enter the following RGB values:

Red—214

Green—45

Blue—54

You will see the ground plane turn a reddish-brown in the Main Camera preview window in the World Browser or in a quick render (see Figure 6-17).

FIGURE 6-15

The Vue 6 color picker has a new look. Uncheck the Use Popup Dialog checkbox to make accessing the colors easier.

FIGURE 6-16

The Vue 5 color picker window.

FIGURE 6-17

After changing the Overall Skylight Color, your scene should look like this.

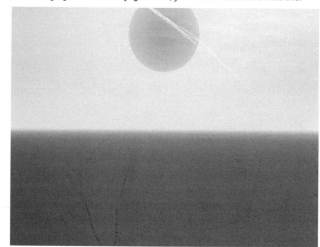

FIGURE 6-18

The *Global Lighting Adjustment* settings should remain at their default values.

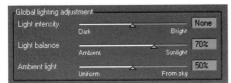

14. Keep the settings as they are for Global Lighting Adjustment (see Figure 6-18).

If you are understanding all the technical jargon up to now, you will have a good feel for what the Light Intensity, Light Balance, and Ambient Light controls do. For now, the default settings are fine. But come back at the end of this section and play with them a bit to see how they affect the final render of your scene.

15. Click on the Light Color color chip.

Change the RGB values to

Red—123

Green—152

Blue—218

16. Now change the Ambient Light Color RGB values to

Red—211

Green—211

Blue—127

17. In the Apply Settings section, have these changes affect only the sunlight, and turn on ...To Sky and Clouds.

Now, the changes affect not only the objects placed in the scene, but the sky and clouds as well.

18. And finally, activate Auto Decay Sunlight Color and set the decay color to

Red—189

Green—141

Blue—18

Decay of sunlight simulates how the colors within the light degrade as the travel great distances. The color you add to this section slowly applies to the sky color as the light gets closer to the ground plane.

19. Click OK to add these new settings and then save your scene as **SkyTest** before moving on.

Modify the Sun Color Set

1. In the Atmosphere Editor (since that is where you are working right now), select the Sun tab.

2. Right-click on the Sun Color color chip and select Edit Color Map.

This brings up the Sun Color Map editor window (see Figure 6-19). It will have the gradient color you assigned earlier titled Blue Sky.

The window is made up of three sections:

- **Color bar**—An interactive, visual display of changes you make to the map.

- **Position and Current Color Chip**—Defines the point where a new color appears (numerically or by defining a point under the color bar), and opens the color picker so you can choose a new color to add.

- **Upper and Lower Clamping**—The method used to define the maximum and minimum saturation of your chosen color.

3. Move your cursor underneath the color bar and click once. This will put a marker under the color bar showing where a new color will be added.

In the Position text field, type in .25

A small triangle indicator will appear at the 25% point under the color bar (see Figure 6-20). This shows the point where your new color will be added and a blend created between the existing colors.

Editing Color Maps

Color maps are solid or gradient colors that can be used as materials on objects as well as lights in your images. There are a number of preset color maps you can work with, but you can also create your own color maps and save them for later use. In this case, what you will do is modify the sun color set earlier in this chapter.

FIGURE 6-19
The Sun Color Map edit window.

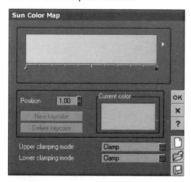

FIGURE 6-20
After you type a value into the Position numeric field, a small triangular marker will appear at that position under the color bar. The color of the image has been modified so you can better see the marker.

FIGURE 6-21

A yellow blend has been created in the color map.

FIGURE 6-22

The image map you created has been assigned to the sun.

4. Add the following color:

 Red—233

 Green—233

 Blue—94

 This color combination will create a dull yellow color. Click OK to accept the change. The color has been added to the color map (see Figure 6-21).

5. Repeat this process at the 75% mark, and enter the following RGB values:

 Red—183

 Green—14

 Blue—24

 When you click OK and close out the Atmosphere Editor, you will see you have created a multicolored sun (see Figure 6-22). Not good for the scene you're building, but a perfect example of how color maps can be used in your projects. Because you saved the scene earlier, do not save these changes. Choose File > Recent Files and select SkyTest to return to your saved project.

CHANGE AND ADD
CLOUDS TO THE SCENE

What You'll Do

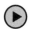

In this portion of the project, you add layers of clouds to the scene.

Clouds in the Standard and Volumetric Model atmospheres are basically image maps that are placed onto a sky dome. But, they are not static image maps. They can be animated, changing shape and position over time just as would happen in the real world. Yet they are not objects. Everything is achieved internally, with Vue calculating the details that will bring a scene to life. You can layer clouds for more detail, as well as assign numerous cloud materials. Then, you can modify each of those cloud layers, sometimes dramatically, which gives you full creative freedom over the look of your clouds.

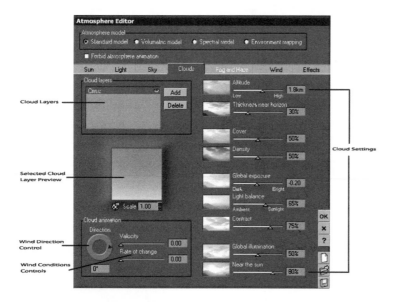

Adding and Modifying Cloud Layers

The atmosphere you have been working with so far, Blue Sky, is built with various layers of clouds. You will keep some of the cloud layers, add others, and modify some of them using the basic controls as well as the Filters and the Material Editor controls.

QUICKTIP

Cloud layers are infinite layers; you will never reach the end of them.

FIGURE 6-23
The Clouds control panel set in the Atmosphere Editor.

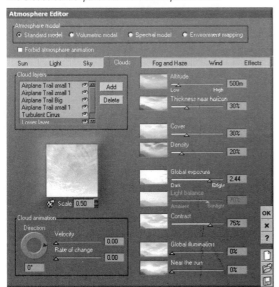

Add a Cloud Layer

1. Open the SkyTest scene (if it isn't already open).

2. Open the Atmosphere Editor window and click on the Clouds tab.

 At first, the Clouds controls (see Figure 6-23) might seem a bit overwhelming, there are so many of them.

 QUICKTIP

 Depending on the position of your camera, the clouds will appear differently in the sky. Although the layers are materials, they change infinitely so no two angles will have the same cloud pattern.

 a. Cloud Layers—Here you can add or delete cloud materials in your scene.

 b. Preview window—See a preview of the cloud material you have selected in the Cloud Layers section, as well as access the Material Editor window to modify the base look.

 c. Cloud Animation—Set the direction the clouds move across your scene, as well as how fast they move and how heavily they change.

 QUICKTIP

 The Cloud Animation controls affect the selected cloud layer, so you can have each layer moving independently from the others.

d. Layer Sliders—Here you select everything regarding the way the clouds appear in the scene, from how high they are in the sky to how they interact with sunlight.

3. Delete all the Airplane Trail small 1 instances from the scene.

You will need to click on each of the instances individually. When an instance is highlighted, click the Delete button to remove it. This will leave the Airplane Trail Big, Turbulent Cirrus, and Lower layer cloud layers (see Figure 6-24).

4. Select Lower layer in preparation for modifying that layer.

You will begin by changing the thickness of the clouds in the scene. As you work through the rest of this section, it will be a good idea to make a change, perform a quick render to see how the changes affect the look of the scene, and then modify from that.

5. Change the following settings to match what you see in Figure 6-25:

Altitude—500m (meters)

Thickness Near Horizon—55%

Cover—41%

Density—90%

Global Exposure— -3.34

Contrast—96%

Depending on the type of Atmosphere Model and the type of cloud layer you are working on, some controls (in this case Light Balance) will not be available to you. After you have made these changes, perform a quick render. Your clouds should have become darker in the upper portion of the atmosphere (see Figure 6-26).

FIGURE 6-24

Only three cloud layers remain in the scene....for now.

FIGURE 6-25

The settings for the Lower cloud layer.

FIGURE 6-26

A quick render reveals the Lower layer clouds have darkened in the sky and become more pronounced.

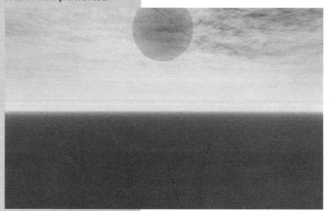

FIGURE 6-27

The settings for the Turbulent Cirrus cloud layer.

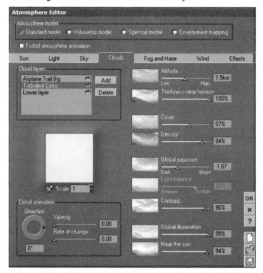

FIGURE 6-28

A quick render of the scene with the two modified cloud layers.

6. Select the Turbulent Cirrus cloud layer and make the following changes to the clouds' settings (see Figure 6-27):

Altitude—1.5km (kilometers)

Thickness Near Horizon —100%

Cover—57%

Density—84%

Global Exposure— -1.67

Contrast—90%

Global Illumination—99%

Near the Sun—94%

Scale (located under the cloud preview window)—1

QUICKTIP

The Scale modifier changes the size of the cloud layer to either reduce the size of the material, thus making more clouds appear in the scene, or stretch the cloud material to make fewer but larger cloud instances in the scene.

You have now made the clouds appear darker, blending them with the layer of clouds underneath to make a more ominous sky. Your scene should look similar to Figure 6-28.

7. With the Turbulent Cirrus cloud layer still selected, double-click on the cloud's preview window.

 This will open the Basic Material Editor window you have worked with in previous chapters.

8. Here, you want to change the color of the clouds. Double-click on the color chip in the Overall Color chip in the Color section, and set the HLS values to the following:

 Hue—241

 Luminance—110

 Saturation—212

 These settings create a hot pink color that will be assigned to the cirrus clouds in the scene (see Figure 6-29). As you can see, with the settings you have assigned to the cirrus cloud layer, these clouds now have a burnt umber cast to them.

9. Select the Airplane Trails layer.

 You will change the type of clouds assigned to this layer. Even though a default scene, or a scene you have created, has set cloud layers, you are not stuck with their predefined appearance. You can change the cloud types at any time to give your scenes entirely different looks.

10. Open the Basic Material Editor window for the Airplane Trail cloud layer, and then double-click on the cloud icon to bring up the Material Selector window.

FIGURE 6-29
Color added to the cirrus cloud layer has added to the feel of the scene.

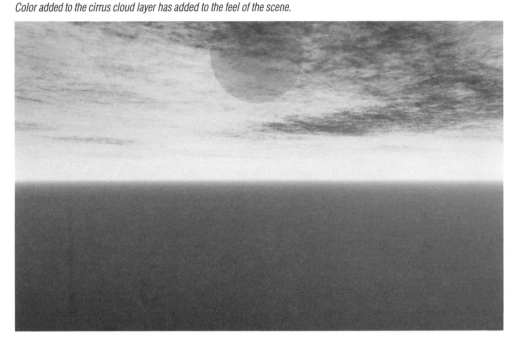

FIGURE 6-30

The Yellow Alto Stratus cloud material will take the place of the material assigned to the Airplane Trail cloud layer.

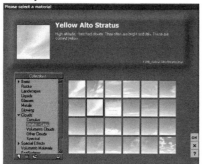

FIGURE 6-31

How the scene should appear with the Yellow Alto Stratus cloud material.

FIGURE 6-32

The multi-layered cloud banks give the scene a more surreal, alien appearance.

11. Choose the Clouds category. Click on Straus-Cirrus and select the Yellow Alto Stratus cloud material (see Figure 6-30).

12. Close all of the two material windows, leaving the Atmosphere Editor open, and perform a quick render.

Your atmosphere should now look similar to what you see in Figure 6-31.

13. Make the following changes to this cloud layer:

Thickness Near Horizon—100%

Cover—70%

Global Exposure—2.06

Near the Sun—80%

You have now made the cloud layer more prominent in the scene, with a good mixture between the yellow and reddish-brown clouds (see Figure 6-32).

You will also notice that, with these new cloud layers and the colors assigned, the look of the ground plane has changed. You are seeing the interaction between the actual light in the scene and how its affected by the atmosphere and clouds. The colors of the cloud layers are combining with the sky color you assigned to give a greenish cast to the overall scene.

Add Terrains

1. Place two terrain objects into the scene and position them as you see in Figure 6-33.

2. Add a third terrain.

 Move the third terrain behind (away from the camera) the other two terrains, and then scale it up so it looms behind the first two terrains (see Figure 6-34).

Adding Terrains to Flesh Out the Scene

Now is a good time to add some terrains to the scene. This way, you can gain a better feel for what you are creating. It will also help you in setting up the next section of the atmosphere, because you will see how the fog and haze settings affect the overall look of you scene, and how the fog and haze interact with the scenic elements.

FIGURE 6-33
Position two terrains in the scene as you see here.

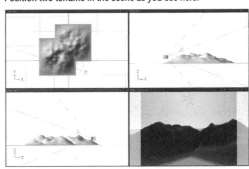

FIGURE 6-34
A third terrain becomes a mountain looming in the distance.

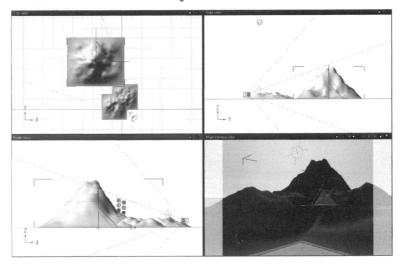

FIGURE 6-35

Textures added to the terrains and ground plane now help the image take on a life of its own.

3. Add the Burnt Rock and Lava material to the three terrains and the ground plane.

 Although the name suggests flows of lava that won't be conducive to the scene, because of the lighting and vegetation that will be added, this will give the scene a nice alien appearance (see Figure 6-35). It actually looks like rocks surrounded by deep, red soil.

4. Save your file before moving to the next section.

LESSON 4

ADD FOG
AND HAZE

What You'll Do

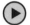

Using fog and haze controls, you add to the feeling of depth within the scene.

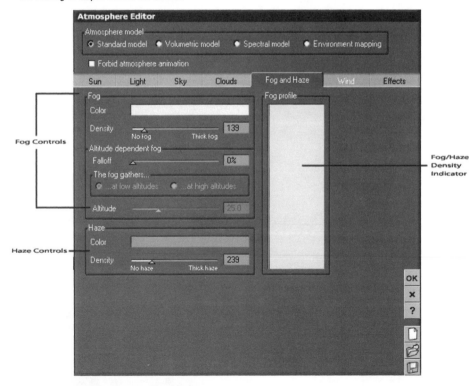

Yes, Vue is a 3D environmental application, which means you are working with depth as well as the traditional 2D axes of width and height. And, really, the latter is all you are working with; the monitor shows a 2D image, your printouts will be in 2D, and your videos will be in 2D. You have to add the semblance of depth to your images by mixing various elements—adjusting the camera focal length, blurring to soften the focus on distant objects, and, of course, adding atmospheric effects such as fog and haze.

Creating Fog and Haze

This scene is now taking on a life of its own. With the skies set up as they are, and the terrains looking as they do, there's almost a sense of heat emanating from the screen. And with heat, there is haze. So, in this section, you will work with fog and haze to add realism and depth to the scene.

FIGURE 6-36

The Fog and Haze control panel.

1. Open the SkyTest scene and access the Atmosphere Editor.

2. Select the Fog and Haze tab.

 This tab gives you access to the Fog and Haze control panel (see Figure 6-36), which consists of the following:

 Fog—Sets the color, how thick the fog is, and how it dissipates with height.

 Haze—Sets the color and thickness of the haze.

 On the right side of the screen is a graph, the Fog **Profile**, that shows the height and density of the fog. There is no visual indicator for haze. As you move the sliders, or type in a numeric value, this graph changes to reflect the amount of fog and/or haze in the scene.

 QUICKTIP

 How to read the Fog Profile: The height of the fog is shown by an increase in size from top to bottom. Density is displayed by the amount of color shown from left to right, meaning how close to the camera it will be (right side of the graph) from the furthest depth in the scene (left side of the graph).

3. First, let's change the fog and haze color. Click on the appropriate color chips and set the colors to

Fog—R = 251, G = 126, B = 171

Haze—R = 254, G = 46, B = 75

This will help you add that feeling of oppressiveness. When you change the fog color, you will also notice that color reflected in the graph (see Figure 6-37), giving you a secondary indication of what the fog color is.

4. Now make the following changes to the Fog settings:

Density—208

Falloff—36%

Altitude—15.5

You will notice these are not big changes. If you increased the density much beyond 208, your entire scene would become pink. Go ahead and try it. Figure 6-38 shows the way your scene would appear if the Density setting was changed to a value of 577.

FIGURE 6-37

The new fog color is reflected in the Fog Profile graph on the right side of the Fog and Haze control panel.

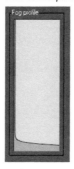

FIGURE 6-38

Too much fog can ruin the overall look of the image by washing out the background.

FIGURE 6-39

The fog and haze settings for your scene.

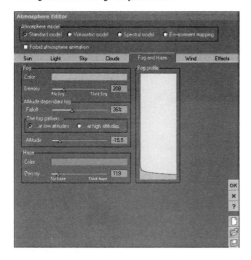

FIGURE 6-40

The rendering of the scene with fog and haze added.

5. Change the Haze Density to 119.

 The Fog and Haze screen should look like Figure 6-39. Your scene will now have a reddish haze throughout. The fog will be seen most dramatically along the horizon line, but the foreground should have a slightly pink cast to it (see Figure 6-40).

6. Change the Main Camera Window's render setting to Final (see Figure 6-41) and render. This will take a few minutes due to the higher quality of the render, as well as the fog settings you have chosen. But you will have a much cleaner rendering of your scene. Undo the render after admiring your work for a few moments by clicking anywhere in the window.

You come back to this scene in Chapter 10. At this stage, because this scene is a still image, you will not use the Wind or Effects tabs in the Atmosphere Editor. Those effects are discussed in Chapter 13.

Save Your Atmosphere

1. Click the Save button (the one that looks like a floppy disk—*does anyone remember what those are?*) to open the Save screen.

2. By default, you should already be in the Atmospheres folder inside the Vue 6 Infinite folder. Name this **alienHeat**, assigning the name to both the Save As and Title fields.

3. Click Save.

 You will receive a message that Vue is rendering a preview image, and you can sit back and watch as it does. Close both the Post Render screen that will pop up when the rendering is complete, and the render itself.

Now, when you access the Atmospheres window, your new atmosphere becomes available in the Personal Atmospheres category.

Saving Your Atmosphere

After all that work, you don't want to just let it vaporize into thin air. You might want to use it for future scenes, or for the basis of an even more interesting atmosphere. To save your work so you can add it to another scene in the future, follow the steps in the next exercise.

FIGURE 6-41
Change the quality of the rendering in the Main Camera View window to Final for a cleaner render of your image.

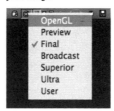

CREATE VOLUMETRIC
ATMOSPHERES

What You'll Do

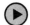

Fix the atmosphere you just created to interact in a volumetric world.

Volumetric atmospheres add even more detail to your scenes, a heavier sense of reality not available with the Standard model. That's because volumetric atmospheres simulate the interaction of light and elements in the air—water particles (fog/haze), dust, and so on. Because of this, volumetric atmospheres take longer to render because the program has many more calculations to perform to recreate the scene.

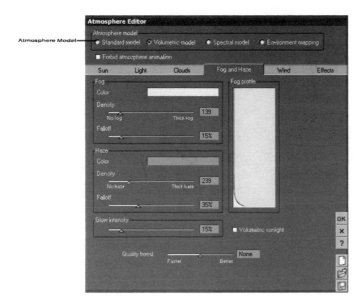

Create a Volumetric Atmosphere

1. With your alienHeat scene open, access the Atmosphere Editor and click the Volumetric button in the Atmosphere Model section.

 You will see your scene turn orange-ish red as the light interacts with the fog and haze in the scene (see Figure 6-42). The clouds have also become thicker, covering the sun completely, but having more details added to them., The haze is much too thick around the mountain, as well. In some ways, though, the volumetric atmosphere has given the scene a much more heated feel. It's up to you if you want to save this atmosphere for later use.

2. Change the following fog and haze settings to decrease their affect on the scene:

 Fog—Density: 65, Falloff: 22%

 Haze—Density: 95, Falloff: 17%

3. Check Volumetric Sunlight to activate it. This is located immediately underneath the Fog Profile section.

 Although this will also increase render time, the atmosphere is enhanced dramatically. The way the sun interacts with the clouds makes them look more realistic.

Modifying Your Existing Atmosphere with Volumetrics

Volumetrics can also dramatically change the appearance of the atmosphere. Because they interact with the elements, atmospheres like the one you created in this chapter have to be modified heavily.

FIGURE 6-42
The volumetric atmosphere has created a much different look for the scene you have been creating.

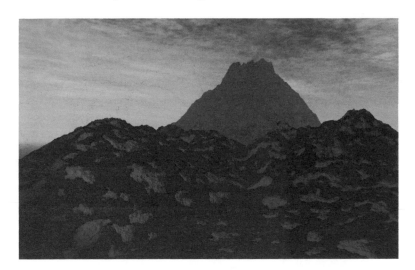

FIGURE 6-43

A look at the rendered image using Final Render, utilizing the volumetric atmosphere model you just tweaked.

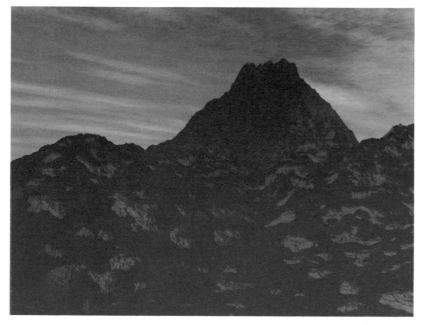

4. Switch to the Clouds section, and make the following changes:

Yellow Alto Stratus—Cover: 27%, Near the Sun: 100%

Turbulent Cirrus—Cover: 42%, Density: 53%

Although the sun will still be hidden behind the cloud cover, the feeling of being on an oppressively hot, humid planet has been exponentially increased by these few small tweaks (see Figure 6-43).

Save this atmosphere to your Atmosphere Library, take a deep breath, and then continue to the next section, where you discover how HDRI images can be utilized in your environments.

USE THE ENVIRONMENT
MAPPING STYLE

What You'll Do

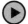

Add HDRI image files to light and affect a scene.

To add unparalleled realism to a scene, you can use the Environment Mapping style for your atmosphere model. Using photographs to help recreate lighting and environmental conditions in your scene, the ability to include 3D objects into an actual photograph has become as simple as a click of the button. Environment mapping not only lets you set the image to be used for the background, but what image will be reflected in objects, and what will be used for illumination of the scene.

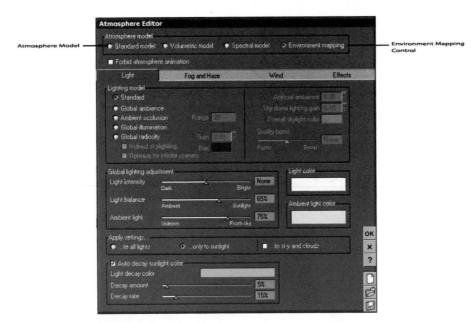

Tweaking Your Atmosphere with Environment Mapping

Included on the website are three HDRI images you can add to your image library. Vue also comes with base HDRI files to practice with. You can use any of those files to try the next exercise.

FIGURE 6-44

The Atmosphere Editor in Environment Mapping mode.

1. Create a new scene and choose the Destination Unknown atmosphere.

2. Open the Atmosphere Editor and click on the Environment Mapping button in the Atmosphere Models section.

 The Atmosphere Editor will change, with fewer control tabs (see Figure 6-44). All that will be available are Light, Fog and Haze, Wind, and Effects controls.

3. If it isn't active already, select the Effects tab to open its controls.

 With Environment Mapping selected, the Effects controls consist of the following:

 Environment Map—Select the image you want to use for your environment.

 Map Offset—Moves the image numerically, offsetting it from the base 0,0 **UV coordinates**. Because the image being used is placed onto a sky dome (a virtual globe), the position of the image along those coordinates will be determined by the values you input here.

 Exposure—Increases or decreases the brightness of the image.

 Contrast—Increases or decreases the range of colors within the image.

Map Upper Hemisphere Only—Places the image along the upper portion of the sky dome only. This option places the bottom of the image along the horizon line, and the image appears only above the ground plane.

Map Ground Plane—Available only if Map Upper Hemisphere is left unchecked. This option maps the image onto the ground plane as well as the sky dome.

Ignore Atmosphere on Map—Removes the default atmosphere you chose before switching to Environment Mapping.

Default Lens Flares For... —Lets you set lens flare styles and intensities for directional and other lights in your scene.

Separate Illumination Map—Have Vue use the same image or you can choose another image to use to illuminate the scene.

Separate Reflection Map—Have Vue use the same image or you can choose another image to reflect on objects in your scene.

4. Double-click on the Environment Map thumbnail to open the Load Picture window (see Figure 6-45).

 Select HDRI from the category list. A series of images will appear. Choose the Nature image from the list.

FIGURE 6-45
The Load Picture window.

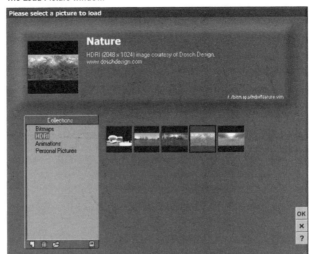

FIGURE 6-46

From this window, you can choose to use the image to light your scene, having Vue do the initial setup.

FIGURE 6-47

Make both Separate Illumination Map and Separate Reflection Map active.

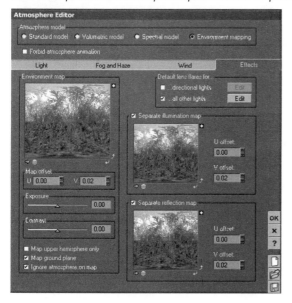

5. When you click OK, a sub-screen will appear (see Figure 6-46) asking if you want to use this image for lighting as well (IBL). Click Yes to accept the changes.

Much of the time, you will click Yes. But there are some instances where you might not want to use the image to also light the scene. So, it isn't necessarily to your benefit to check the box **Don't Show This Menu Again** at the bottom of the screen.

6. The image now appears in the three windows—Environment Map, Separate Illumination Map, and Separate Reflection Map (see Figure 6-47).

The latter two are not active yet. You can choose if you want to activate either or both. For this project, you will activate both.

7. Click OK to set the image to your scene.

8. Add a Sphere primitive to the workspace and center it in the scene.

 Before adding a texture, do a quick render. You will see how the image is being used to add light to the scene, making the sphere appear as if it were really in the Nature scene. No, it's not sitting on the ground, but lighting-wise it seems to be a part of the photo (see Figure 6-48).

9. Now, with the Sphere selected, go to the Materials Editor and choose Metals > Brushed Silver.

10. Do another quick render.

 Now the image is being used for the reflection on the sphere's material (see Figure 6-49). You can use this technique for cars, busses, windows, and so on, to easily add that extra semblance of realism to your projects (see Figure 6-50).

FIGURE 6-48

The sphere takes on the lighting conditions of the image.

FIGURE 6-49

A photograph is used as a background, lighting source, and a reflection map to add true realism to your projects.

FIGURE 6-50

Using a low-resolution model that comes with Vue, the car was added to a scene utilizing an environment map. Note the reflections in the car and the way the car is lit by the image map.

CHAPTER SUMMARY

Through the course of this chapter, you wended your way though the intricacies of the Atmosphere Editor. With time and practice, you can create more and more intricate realistic and fantasy scenes—literally anything that might come into your mind. This powerful set of tools takes what you have worked with in this chapter, smothers it in steroids, and helps you develop photorealistic images that include clouds you can actually fly through.

What You Have Learned

In this chapter you

- Learned how to modify sky and sun colors
- Added and modified cloud layers
- Worked with standard and volumetric atmospheres
- Learned how to use photographs to light and interact with your scenes

Key Terms from This Chapter

Bit In the case of images, a bit is the smallest unit of visual information in a pixel. Each bit is made up of one shade of gray out of a maximum 256 shades of gray. Most photographic images are 8-bit, meaning each pixel is broken into eight segments, each segment having a value of 0 (pure black) to 255 (pure white) assigned to it. In a 32-bit HDRI image, each pixel is comprised of 32 segments, each with a shade of gray assigned to it.

Extension The three letter code following the dot at the end of a file name that describes what type of file it is (such as .doc, .jpg, .tif, or .pdf).

Graphic User Interface (GUI) Describes the look of an operating system's screen display and a software applications graphic design.

HDRI (High Dynamic Range Imaging) The intention of HDRI is to accurately represent the wide range of intensity levels found in real scenes, ranging from direct sunlight to the deepest shadows.

HSL Stands for Hue, Luminosity, Saturation. Another system for determining displayed colors in an image. Also known as HSB, with B standing for Brightness.

Profile Just like a photograph of your profile, this shows the height or the height variations as if viewed from the side.

Ray tracing Traces rays of light as they would flow from the eye back to an object. These "rays of light" are then tested against all objects in the scene to determine how colors will appear in the scene. Ray tracing allows for soft shadows and reflections in your scene.

RGB Stands for Red, Green, Blue, the three color channels that make up basic photographs and illustrations. The three channels combine to produce up to 16.7 million colors.

UV coordinates System used for placement of image maps on a 3D object. U defines the horizontal position, whereas V defines the vertical position of the image.

7

TEXTURING WITH THE
BASIC MATERIAL EDITOR

1. Work with the Basic Material Editor.

2. Use pre-set mixed materials and mix your own materials.

3. Combine pre-set materials and image maps.

4. Create material layers.

Atmospheres. Terrains. Vegetation. Objects. They are all a part of creating interesting and effective scenes in Vue. But materials....those are what help bring reality to a scene. Imagine a brick wall without a brick-colored surface (see Figure 7-1) or a field of grass growing out of a non-textured ground plane (see Figure 7-2); the semblance of reality would be halted immediately and your work would be viewed as unfinished.

QUICKTIP

Reality is not perfect. Everything, from shapes to textures, have a chaotic quality to them. So, when I talk about chaos in a texture or a scene, I am talking about creating imperfections, and adding those imperfections to a scene or a material to then create reality.

Realistic textures are a complex system of color and chaos, with light interaction thrown in for good measure. Effective texturing includes:

- Color—Either through a basic color or the inclusion of a bitmap image.

- Bumpiness—Either through a **bump** or a **displacement map**.
- Transparency—Either through an **bit-map image** or filters.
- Reflection—Either created with an image map or via the objects in the scene themselves.
- Highlights—Reflection of light off the surface of the material.
- Translucency and subsurface scat-tering—How light enters and then escapes from within the surface of an object (see Figure 7-3).

FIGURE 7-1
A composite image showing the same wall textured and untextured. In both cases, a displacement map has been assigned.

With Vue 6, you have control over all of these texturing techniques, giving you the full creative potential to build high-quality images and animations. First, you learn to modify these textures through the use of the Basic Material Editor categories (see Figure 7-4). Although you have had experience with this window in previous chapters, you have not delved into its powerful controls. Until now, you merely used it to quickly assign a pre-defined texture to an object, but there is much more to it. You aren't stuck using only those materials supplied with Vue. So, the Basic Material Editor is a good place to begin understanding how Vue combines visual information to create a material. Later on, you will move into the Advanced Material Editor where more of these other features become available to you, and your creative genius can begin shining through.

FIGURE 7-3

A sample of subsurface scattering. The light enters the material, is dispersed, and escapes. This is perfect for marble surfaces or, in this case, ice.

FIGURE 7-2

A quick rendered composite showing grass on an untextured ground plane and on a textured ground plane.

FIGURE 7-4

The three main sections of the Basic Material Editor—Color, Bump, and Transparency.

Tools You'll Use

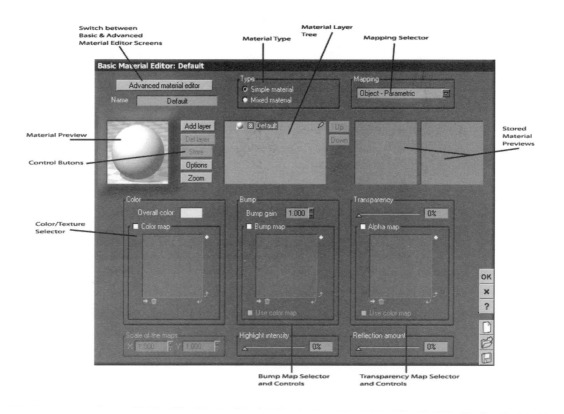

Switch between Basic & Advanced Material Editor Screens

Material Type

Material Layer Tree

Mapping Selector

Material Preview

Control Butons

Color/Texture Selector

Bump Map Selector and Controls

Transparency Map Selector and Controls

Stored Material Previews

Basic Material Editor: Default

Advanced material editor

Name Default

Type
○ Simple material
● Mixed material

Mapping
Object - Parametric

Add layer
Del layer
Store
Options
Zoom

Default Up Down

Color
Overall color:
☐ Color map

Bump
Bump gain 1.000
☐ Bump map

Transparency
0%
☐ Alpha map

☐ Use color map

☐ Use color map

Scale of the maps
X 1.000 Y 1.000

Highlight intensity 0%

Reflection amount 0%

OK
✕
?

WORK WITH THE BASIC
MATERIAL EDITOR

What You'll Do

In this section, you learn how to work with the Basic Material Editor section by section. You modify a material using Color, Bump, and Transparency controls.

Creating materials is a study in perseverance. There are people around the world who specialize in it, studying the physics of how light interacts with surfaces in order to recreate reality in a two-dimensional space. These people often specialize in skin texturing, others at wood or rock textures. They study how light reflects and refracts. In fact, as I talk about refraction values later, there are specific numerics to assign to accurately simulate these effects on materials. Practice is the only key to the success of developing ultra-realistic textures in a scene.

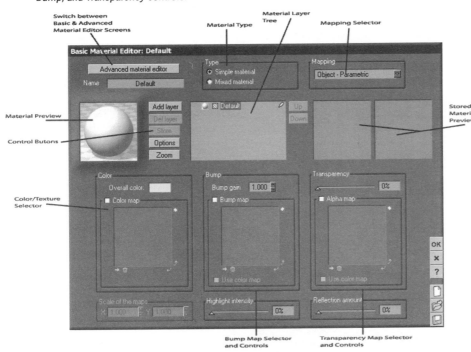

Modify Color Settings

1. Open a new scene.

 Use any atmosphere setting you want, and then place a cube object into the scene.

2. Go to the Object Preview in the World Browser and double-click on it.

 You have done this in previous chapters. When you double-click on the object's preview window, the Material Editor opens so you can assign a material to the object.

3. If your Material Editor window does not look like Figure 7-5, click the Basic Material Editor button.

 The Basic Material Editor button is located in the upper-left portion of the window. The button should read Advanced Material Editor, letting you know that, when you click on it again, you will be taken into that material editing mode.

 This list breaks the screen down so you understand the controls.

 - Basic/Advanced Material Editor button.
 - Name—Give your new material its own unique name.
 - Type—Choose between Simple Material, which uses only one image or color to define the material, and Mixed Material, which lets you combine multiple images or colors to define the material.

- Mapping—The way in which the material is placed onto the object.
- Preview Window—Has two functions. First, it shows a preview of how the material will appear on your object, and second, it gives you access to the Material Picker window.
- Layer buttons—Enable you to add, delete, store, open material options, and zoom in for a better look at your material. Vue 6 utilizes layer technology, so you can combine multiple layers of materials and colors to create more complex textures.
- Layer Map—Shows each of the material layers assigned to your texture. The Up/Down buttons let you reposition the material in the hierarchy.
- Store Previews—Shows preview images of stored materials that can be assigned at any time to a new texture.
- Color—Gives you control over the base color via the Overall Color chip, or lets you assign an image to the object.
- Bump—Gives you control over the base bump size in the Bump Gain numerics field, or lets you assign an image to the object to use as a bump map. You can also assign a highlight size if you want high points in the bump to give off highlights.

Modifying a Material's Color Settings

At its most basic, a texture is made up of color, bump, and, when necessary, transparency. That is what the Basic Material Editor gives you control over. There is much more to it than merely assigning an existing material and then clicking OK. To begin, take a look at how you can modify a material's color settings both visually and numerically.

FIGURE 7-5
The Basic Material Editor screen.

FIGURE 7-6

You can change the preview object shape and the preview background display from the Preview Options window.

FIGURE 7-7

Click the right pointing arrow to access the image selection screen in order to assign a bitmap image to the object.

> **QUICK**TIP
>
> You can find many free and low-cost pre-built textures on the Internet. Three places to get some of the best are cornucopia3D.com, renderosity.com, and Syyd Raven's runtimedna.com. Syyd is considered one of the premiere texture artists in the world, creating high-quality skin textures for programs such as Poser (e-frontier.com).

- Transparency—Gives you control over how strong the transparency of the object is, from fully opaque (0%) to fully transparent (100%), or lets you assign an image that will create the transparency (alpha map). You can then control whether the transparency has reflective properties.

Before continuing, download the image files in the Chapter 7 folder on the book's website (www.courseptr.com/downloads).

4. Change the preview window from a sphere to a cube by clicking the Options button.

Clicking this button opens the Preview Options window, where you can assign the shape of the previewed object, the background appearance, and the background color (see Figure 7-6). Select Cube from the list and close the window.

> **QUICK**TIP
>
> By always having the preview object as the default sphere, you often can't tell exactly how a material will react on a flat surface or other surface shape. Changing the preview object style helps you to create a texture that's right for the shape.

5. You already know how to assign a predefined material to the object (refer to Chapter 2 if you don't remember), so here, you will assign an image and bump map to the cube. Activate Color Map and click the right-pointing arrow immediately underneath the preview window (see Figure 7-7).

The Image Selector window opens. Navigate to the grid.bmp file you downloaded and click OK until you get back to the Basic Material Editor window.

There are a number of controls available to you to modify the image once it has been assigned. These controls are the same for Color, Bump, and Transparency. These controls are (see Figure 7-8):

- **Invert**—Changes the color settings for the image, inverting them to their opposite colors (white becomes black and black becomes white).
- **Rotate**—Rotates the image in 90° angles.
- **New Image/Remove Image**—Adds an image map or removes it from the object.

6. Repeat this process to assign the same image to the Bump channel. If you need to rotate the image or invert it, you will need to use the previously mentioned controls, otherwise, import the image into the bump channel section.

Black areas become the low points and white becomes high. Shades of gray that might be in the image create rises. In this case, the bars appear to be pushing inward. Notice I said, appear; perform a quick render (see Figure 7-9) and you will see that the bump is only an illusion. The edges of the mesh are still perfectly even. This is the purpose of a bump map, to give the appearance of chaos without actually creating chaos.

FIGURE 7-8
The controls for the color, bump, and transparency maps.

FIGURE 7-10

The invert button changes blacks to whites and whites to blacks.

FIGURE 7-11

The inverted bump now makes the bars appear to be raised.

FIGURE 7-13

Inverting the transparency map segments the cube, leaving only the white panels.

FIGURE 7-12

The base transparency map cuts out the areas where white appears, leaving a wireframe object.

7. Click the Invert button for the bump map (see Figure 7-10).

Now the bars of the texture appear to be raised, whereas the white blocks seem to be pushing in (see Figure 7-11).

8. Add the same image to the Alpha Map section of the Transparency control.

The box will become a *wireframe* (see Figure 7-12), with the white areas transparent and the black lines opaque. Invert the alpha map to make the lines disappear and the blocks remain (see Figure 7-13).

QUICKTIP

You will see an edge on the transparencies on the cube. This is because you still have the image and bump maps information active and they are being read with the transparencies. Turn them off and then re-render. There will be no indication of the cube where the transparencies are assigned.

These are true transparencies. The geometry is being removed from the render, so light is showing through the holes. This is a great technique for creating complex shapes that might otherwise start cutting into your system resources due to increased geometry.

USE PRE-SET MIXED MATERIALS
AND MIX YOUR OWN MATERIALS

What You'll Do

In this section, you learn about using
mixed materials to build your textures,
as well as discover how to modify layers
through pre-set material mixing in order to
create your own material files.

Mixed Material Selctor

Material 2
Mixing Control

Material 1 Editor Material 2 Editor

Designing Your Own Material

One of the true powers of Vue's Material Editor is to delve deeper and deeper into material mixing in order to design your own unique materials. The possibilities are endless as you begin to make the modifications, and the outcome can be truly breathtaking.

FIGURE 7-14

Mixed Material selected in the Type selector.

FIGURE 7-15

The new controls when using Mixed Materials: Mixing Proportions and Materials to Mix.

1. Create a new scene and place a Standard Terrain object into it.

2. In the Material Editor, select Mixed Material (see Figure 7-14).

 When you do this, the screen will change. You will no longer have Color/Bump/Transparency fields, now you have two new controls: Mixing Proportions and Materials to Mix (see Figure 7-15). Here is what those two controls do:

 - **Mixing Materials:** This assigns how much of Material 2 will appear in the new material. Moving the slider to the left adds more of Material 2 to the texture, whereas moving to the right brings out more of Material 1.

 - **Materials to Mix:** Lets you assign a second material from the Material Selector to the overall material. The Scale settings immediately underneath the two preview windows allows you to assign how large the material will appear on the object. The Swap button swaps the two materials, so Material 1 becomes Material 2 and vice versa.

 As soon as you switch to Mixed Material, the main thumbnail becomes darker. That's because of the blend occurring with this second material added.

3. Double-click on the Material 1 preview. This will open a second Material Editor window over the original one (see Figure 7-16).

This is not a mistake. Because you are now going to make changes to a material or image for Material 1, this second Material Editor window gives you that ability.

4. In this second window, double-click on the main image thumbnail to open the Material Selection window.

Select the Rocks category, and then choose Mossy Rock 2. You will see this screen change to a mixed material, and you will see your main Material Editor screen update to show this material assigned to Material 1, and a mix of this and Material 2 in the main thumbnail (see Figure 7-17). You can double-click on Material 1 or 2 in Material 1's Material Editor, opening up another layer to mix, but for now, click OK to accept this change to the main Material 1.

QUICKTIP

At times there is an anomaly that occurs where the Material Preview window does not update automatically. This occurs more frequently in the Mac version (at least at the time of this writing). If your material preview does not update, click on the Material Preview window once to refresh it.

FIGURE 7-16

No, you're not seeing double. A second Material Editor window opens when you want to assign a new material to either Material 1 or 2.

FIGURE 7-17

Material 1's Material Editor window has changed to reflect the mixed material you just chose.

Material 1 Material Editor

Main Material Editor

FIGURE 7-18

The material (its name is in the text field above the main thumbnail) chosen for Material 2.

FIGURE 7-19

Now a third Material Editor window is open!

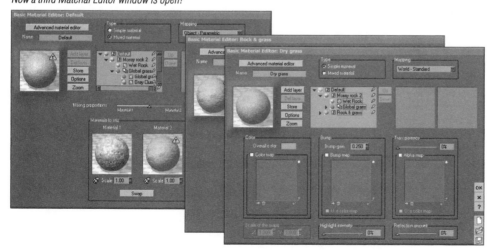

As you become more adept at designing materials, you can have numerous Material Editor windows open. These work somewhat like layers in that whatever changes are made to the topmost screen affects only the one immediately under it, which will affect the one under that, and so on. A good habit to get into is moving the original Material Editor window to the side so you can see how the final material will look based upon the changes made in every other material window.

5. Double-click on Material 2.

 In the Material Selector, assign Landscapes > Rock and Grass as the material (see Figure 7-18). Do not close this window as of yet.

6. Now you're going to go further into material modification, modifying the material that will become the main Material 2. Double-click on Material 1 in this Material Editor window.

 This now opens another Material Editor window (see Figure 7-19). Here, all you will do is change the color of the grass. Instead of that dead-looking brown grass, make it a lush green.

7. Click on the Overall Color chip in the Color section and set the RGB values (see Figure 7-20) to

 Red—9

 Green—44

 Blue—7

8. Close these secondary windows so you are left with the main Material Editor window.

 Perform a quick render to see how the material looks on the terrain (see Figure 7-21). It's already looking pretty good, but let's see how Mixing Proportions and Swap can affect the material's outcome.

9. Before doing that, save the material.

 Click the floppy disk icon at the bottom-right corner of the Material Editor window, and save this material as **Lush Grass and Rocks**.

10. Change Mixing Proportions to 70% by clicking in the numerics field.

FIGURE 7-20

The deep green color has been added to the material mix.

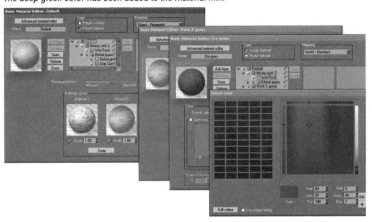

FIGURE 7-21

The material as it looks assigned to the terrain.

FIGURE 7-22

The materials have been swapped, with the grass now appearing at the lower elevations and rocky surface at high points.

11. Click Swap to swap Materials 1 and 2.

Now the rocky material is at the high points of the mountain and the grass appears at the lower elevations (see Figure 7-22). Also notice how, by changing the mixture of the materials and the way they interact, the grass has become less lush-looking. That's because there is more of the rocky texture showing through. Try playing with the Mixing Proportions to how you can bring out the deep green grass better. Or, go back into Material 1's Material Editor and tweak that material to get a different outcome.

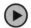

LESSON 3

COMBINE PRE-SET
MATERIALS AND IMAGE MAPS

What You'll Do

In this lesson, you mix pre-set materials with image maps to create a complex texture.

Working with and modifying the pre-set materials, and then mixing and matching those materials, is only one way to create a new texture. You can also use bitmap images in combination with the materials to add some complex looks to your scene;

making it appear as if you spent hours slaving over a hot image-manipulation program creating textures from scratch.

Color Map Activator

Image Map Preview

Image Map Scale Control

Adding Graffiti to a Brick Wall

In this section, you add an image map onto a cube, combining it with a texture so it appears the text has been spray painted on the wall. OK. OK. You're going to add graffiti to a brick wall.

FIGURE 7-23
The Brick Wall material located in the Rocks section of the Material Editor.

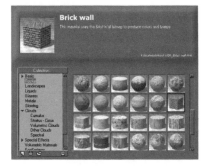

FIGURE 7-24
Notice how the text is overlayed on the brick surface in the preview window.

FIGURE 7-25
Tiling causes an image to repeat over and over again onto the surface of the object.

Add an Image Map to an Object

1. Create a new scene and add a cube to it.

2. Go into the Material Editor and switch to Mixed Material mode.

3. Set Material 1 to Rocks > Brick Wall (see Figure 7-23).

 This step will assign the brick material to the entire cube. It also automatically assigns the bump map to the object. Make sure to also switch the object preview thumbnail to Cube, so you can see it as it will appear on the cube object.

4. For Material 2, activate Color Map and assign the text.bmp image.

 This image can be found in the Chapter 7 files folder on the book's website. Once assigned, you will see it overlayed on the brick surface (see Figure 7-24).

5. Do a quick render to see how it looks. You'll notice that, first, the image appears on all sides. Second, it is not positioned correctly on the faces of the cube and it **tiles** (see Figure 7-25).

Lesson 3 Combine Pre-Set Materials and Image Maps

Use UV Mapping

1. Double-click on Material 1.

2. In its Material Editor window, set Mapping to Object Standard (see Figure 7-27).

 Now if you rotate the cube, the brick texture will move with it, which is what you want (see Figure 7-28).

3. Select Material 2 and go into its Material Editor window.

4. Choose Object Parametric for the mapping style.

Tweaking Your Graffiti Using UV Mapping

Vue's standard mapping procedure for an image is *projection mapping*. Basically, projection mapping is like having the image shone onto the surface of the object in the same way a film is projected onto a movie screen. If you rotate the cube, the image will not move with the cube, causing the image to look as if it has slid to a different location on the object (see Figure 7-26). To get an image to stay with the object, and actually rotate or move with it, you need *UV mapping*. UV mapping actually assigns the image to particular faces or polygons on the object.

FIGURE 7-26
An example of projection mapping, where the image is projected onto surfaces as if from a projector onto a movie screen.

FIGURE 7-27
The settings for mapping in the Material Editor window.

- World Standard—The default setting. Vue assigns images and material surfaces using world standards. That means the materials are assigned based upon their position in the overall scene, not on the object. In the upper-right of the Material Editor is the Mapping pop-up menu. You can also base this upon cylindrical, spherical, or **parametric** settings.

- **Object Standard**—Sets the material to set itself to the object it's assigned to. Again, you can assign the maps to fit on cylindrical, spherical, or parametric objects.

You can assign these globally (the mixed materials) or to the individual materials. In this case, you need to assign them to each material individually.

FIGURE 7-28
With Object Standard selected, the material moves with the object.

FIGURE 7-29

With Object Parametric chosen for the mapping procedure, the image resizes to fit onto the surface of the object.

FIGURE 7-30

The scaling controls of the gizmo. Choose L for local.

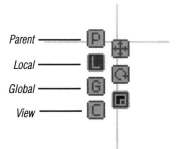

Parent

Local

Global

View

The image will now resize itself to fit onto the face of the cube (see Figure 7-29).

5. Now save the file as **MappingProject**. This is as far as you can go with modifying the look of the textures without being in the Advanced Material Editor, which you work with in the next chapter.

6. Exit the Material Editor and select Scale (s) to resize the cube.

 Since the image (Material 2) was set to parametric, you are able to make size changes to the object without it tiling.

6. Working in the Top view, change the scale control to Local.

 Click the L button on the gizmo (see Figure 7-30). This will change the scaling procedure from global (G) coordinates to, for lack of a better term, object coordinates. Think of it in terms of materials. L translates to Object mapping in the Material Editor.

7. Move your cursor onto the X axis line (see Figure 7-31) and drag to the left.

 This will constrain the scaling of the object to the X axis only. The cube will stretch out to become a rectangle, but will not increase in size or depth.

8. Perform a quick render.

 The text.bmp file has now stretched along with the cube (see Figure 7-32). If you had left the mapping in World coordinates, the image would tile, repeating along the length of the brick wall.

The texture takes on the bumps in the brick surface giving the illusion of being painted onto the bricks, but upon closer inspection you will see you are actually being faked into thinking the bricks have depth. The edges of the cube are perfectly smooth. This is the function of a bump map—giving the illusion of depth.

FIGURE 7-31
Use the X axis control line to scale only along the horizontal plane.

FIGURE 7-32
The image map has stretched to fit onto the cube's new shape.

CREATE
MATERIAL LAYERS

What You'll Do

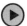

In this section, you learn to build images using layers.

In a way, what you have just done is worked with layers. For each material zone that you modified you went into its layers to make modifications. In Vue 6, material zones can be used for many different effects—those you just worked on (modifying the materials to create an entirely new one) or assigning ecosystems to specific areas and having them inter-relate to each other (which you will learn to do in Chapter 9). What you are about to accomplish in this section of the chapter is finding other ways in which to build your images.

Material Layers Window

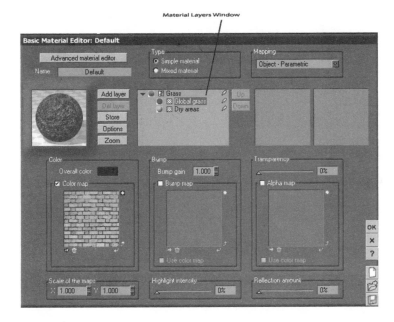

Add a Layer

1. You know the drill: New scene. Add cube. Drop cube onto ground plane. Go into the Material Editor. Then switch to Mixed Materials.

 In the Layers section of the Material Editor (see Figure 7-33), you will now see a material tree, a graphical listing of materials assigned to the object. Their names appear next to a small (a very small) icon of the material itself. These materials correspond with the two material thumbnails at the bottom of the screen.

 QUICKTIP

 By default, Material 1 is named Default, because it is the base material assigned to the object. Material 2 is just titled Material because nothing has been assigned to it yet.

2. Select Material 2 by clicking on it once.

3. Double-click on the thumbnail to go to the Material Selector, and select Rocks > Mossy Rock 1 from the list. Then click OK.

 The Layers tree expands to show the materials that make up Mossy Rock 1. Also, Material has been renamed to reflect which material is assigned to it (see Figure 7-34).

Adding Layers for Your Materials

Using Layers is a new feature in Vue 6. It is a quick way to switch between materials on the fly, without having to double-click on, or go back to, materials embedded deep within material zones. It helps keep screen clutter down, because you don't have to have dozens of windows open to make a change to a particular material.

FIGURE 7-33
The Layers controls are located immediately to the right of the thumbnail image.

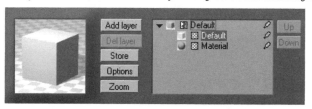

FIGURE 7-34
The Layers list reflects the materials that make up the material you have assigned to the texture.

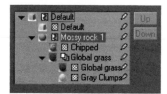

FIGURE 7-35

The sub-material is selected and ready for editing.

FIGURE 7-36

The layers tree expands to show the materials that make up the texture you just added.

FIGURE 7-37

Choose a sub-material making up the main material and click the up or down button to reposition it.

4. By clicking on any of the sub-materials in the list, that material becomes active (see Figure 7-35).

 You can now make changes to that particular material.

5. Select Gray Clumps from the list.

 You change this material to another to modify the look of the texture.

6. Select Rocks > 2 Lichens Desert for the material and click OK.

 The layers tree has expanded (see Figure 7-36) to include the new materials you just assigned. Now you can choose a material in that listing to quickly activate and modify it.

 QUICKTIP

 Unfortunately, the Material Editor window does not expand, so you can't make it larger to see more. Use the scrollbars in the Layers section to scroll up and down to see the different layers that make up your material.

7. You can swap layers by selecting one in the tree, and then clicking the Up or Down button to reposition them.

 This is the same as using the Swap button. You can do this only with the sub-layers of a particular material layer (see Figure 7-37). You cannot switch the order of the main material itself.

CHAPTER SUMMARY

So now you are ready to begin experimenting with textures. Create a few on your own using the basic Material Editor. Add a bitmap image and blend them. Mix, match, and combine pre-set materials to see what you come up with. Don't be afraid to keep going deeper and deeper into the material zones to see what you can create. Then, when you're comfortable, you can take it a step further by going into the extra controls afforded by the Advanced Material Editor.

What You Have Learned

In this chapter you

- Mixed pre-set materials
- Mixed pre-set materials with image maps
- Learned how to assign mapping procedures for your materials
- Worked with the Layers feature

Key Terms from This Chapter

Bitmap An image created in a photo manipulation or paint program that is made up of pixels and mapped to an object.

Bump map A grayscale image that gives the visual representation of bumpiness in a texture without actually modifying the shape of the mesh. Can be created in a paint or photo manipulation program.

Displacement map A grayscale image that actually affects the shape of the mesh to show true bumpiness and texture. Can be created in a paint or photo manipulation program.

Parametric Texturing procedure that maps coordinates so the 2D image will fit onto a surface.

Projection mapping Adds a texture to an object that does not move with the object. It is as if the image were being projected onto a screen; when you move the screen, the image stays in place, ultimately repositioning the image on the object.

Tile/tiling The term used when an image repeats itself on the surface of an object.

UV mapping Actually assigns the texture to an object so that, when the object is moved or rotated, the image moves and/or rotates with the object. U represents the X (horizontal) coordinate of the image and V represents the Y (vertical) coordinate.

Wireframes Define the shape of an object in 3D applications. A wireframe is called that because it looks like wires (think of a chain link fence or chicken wire) that are molded to form a particular shape.

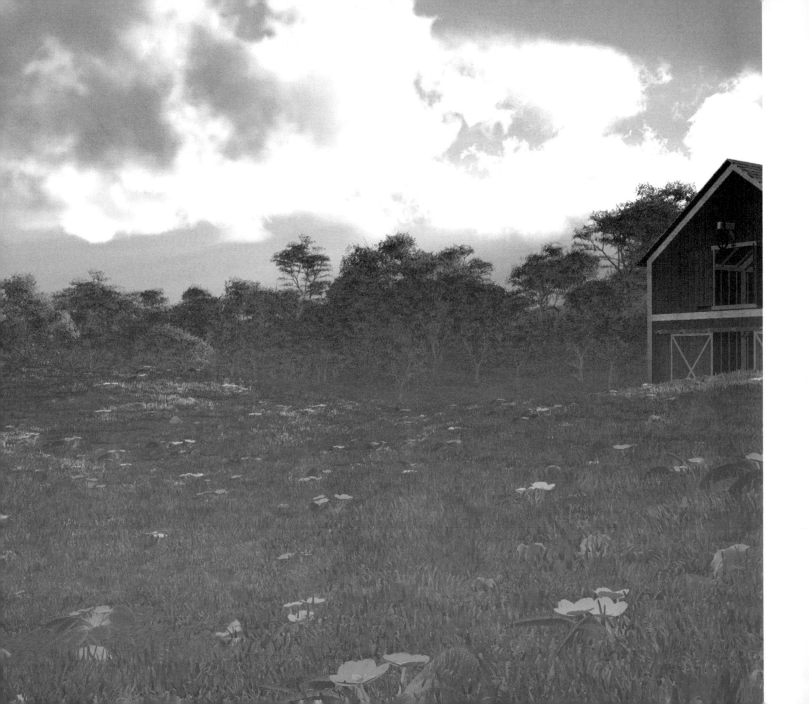

8

BUILDING TEXTURES USING THE
ADVANCED TEXTURE EDITOR

1. Advance your material editing.

2. Use filters to change texture and bump appearances.

3. Create and save your own filters.

4. Harness the power of hypertextures.

5. Change materials on objects.

6. Use highlights and reflectivity.

7. Employ subsurface scattering.

8. Employ dispersion.

chapter **8** **BUILDING TEXTURES USING**
THE ADVANCED
TEXTURE EDITOR

In Chapter 7, you learned how to use the Basic Texture Editor, which works well when you want to quickly add or modify textures. If you're really serious about bringing your scenes to life, and just aren't satisfied with the number of textures included with the program, you need to do your work in the Advanced Texture Editor (ATE). With the ATE, you have many more controls with which to build high-quality materials for your scenes. Unlike the BTE, with the ATE you have control over

- Bump and displacement mapping
- Transparency settings
- Subsurface scattering
- Highlights and reflections
- Volumetrics
- Translucency
- Dispersion

All of the controls you learned in Chapter 7 apply here. Only now you're moving from the little league into the majors— and you're bypassing all the middle steps. There is only one feature in Vue that is more powerful for texture generation, and that's the Function Editor, discussed in the online download chapter, available at www.courseptr.com/downloads. For now, suffice it to say, you're entering a world where you have control of the vertical, the horizontal, and all directions in between.

Before you begin, you need to understand some aspects of light and how it interacts with objects.

What we perceive as color is really nothing more than certain spectrums of light bouncing off an object and being sent back to our retinas. The rest of the spectrum is absorbed by the material itself. That's why, when you wake up in the middle of the night drenched in a cold sweat because you just imagined the next great scene you're going to create in Vue, the lights are out and everything looks black and white. There's not enough light being sent to your receptors to discern color.

The bouncing of light off a surface is called **diffusion**. In 3D, a color map is often called a diffuse, or diffusion, map because that light bouncing off the surface is what makes us see color. Diffusion is a tricky business. Color perception can vary dramatically based on whether a surface is flat and smooth, wavy and rough, or some combination thereof.

3D applications have to try to simulate all of this, because, although texture and 3D artists are a technical bunch, they really don't want to have to break down the molecular structure of every object they are creating.

There is definitely a lot more detail to these subjects! Let's just say that you're going to now draw upon your powers of perceptive recall in order to recreate reality through the use of the Advanced Texture Editor.

Tools You'll Use

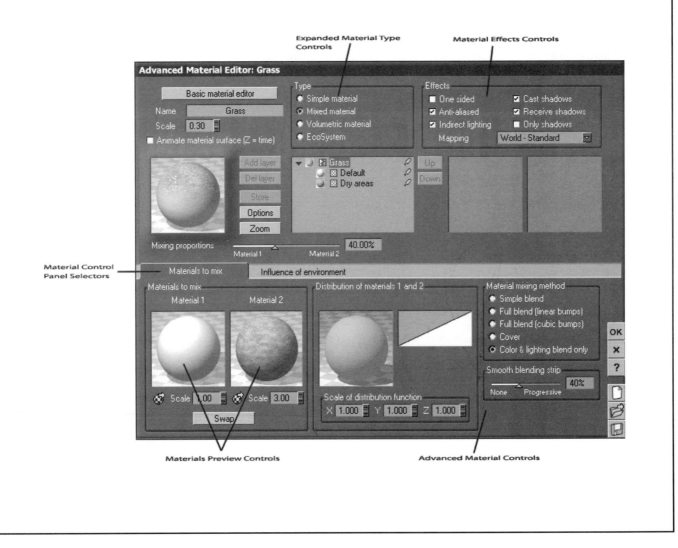

Expanded Material Type Controls

Material Effects Controls

Advanced Material Editor: Grass

Basic material editor

Name — Grass

Scale — 0.30

☐ Animate material surface (Z = time)

Type
- ○ Simple material
- ◉ Mixed material
- ○ Volumetric material
- ○ EcoSystem

Effects
- ☐ One sided
- ☑ Anti-aliased
- ☑ Indirect lighting
- ☑ Cast shadows
- ☑ Receive shadows
- ☐ Only shadows

Mapping — World - Standard

Add layer
Del layer
Store
Options
Zoom

▼ ● ☒ Grass
 ● ☒ Default
 ● ☒ Dry areas

Up
Down

Mixing proportions — Material 1 — Material 2 — 40.00%

Material Control Panel Selectors

Materials to mix | Influence of environment

Materials to mix

Material 1 Material 2

⊞ Scale 1.00 ⊞ Scale 3.00

Swap

Distribution of materials 1 and 2

Scale of distribution function
X 1.000 Y 1.000 Z 1.000

Material mixing method
- ○ Simple blend
- ○ Full blend (linear bumps)
- ○ Full blend (cubic bumps)
- ○ Cover
- ◉ Color & lighting blend only

Smooth blending strip
None — Progressive — 40%

OK
✕
?

Materials Preview Controls

Advanced Material Controls

236

ADVANCE YOUR
MATERIAL EDITING

What You'll Do

▶ *In this section, you recreate and modify a material you made in Chapter 7, adding a displacement map to the object on which the material is assigned.*

Expanded Material Type Controls

Material Effects Controls

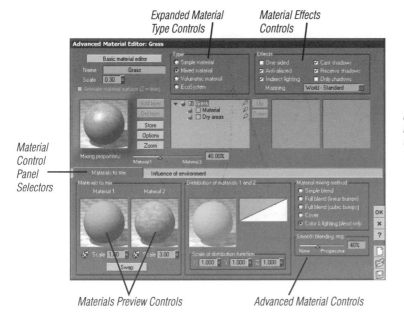

Material Control Panel Selectors

Materials Preview Controls

Advanced Material Controls

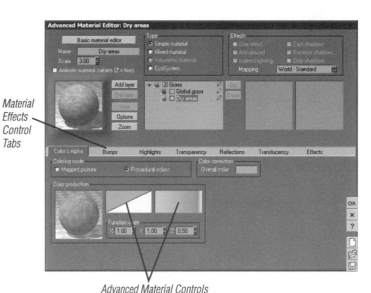

Material Effects Control Tabs

Advanced Material Controls

Use Displacement Mapping

1. New scene. Cube. Material Editor. Again, you know the setup drill.

Click on the Advanced Material Editor button if you are still in the Basic Material Editor. First, you will notice the AME control panel is a lot more complicated (see Figure 8-1). You now have the following additional controls:

- **Volumetric Material**—Turns a standard material into a volumetric material that interacts with the light as it passes through the object.

- **Ecosystem**—A special material that supplies information for the placement of plants, rocks, and objects.

Also, in the lower half of the window, you have many more tabs from which to choose controls affecting every nuance of your material.

2. Assign the Rocks > Brick Wall material to the cube by double-clicking on the Material preview window, selecting the Rocks category, and then selecting Brick Wall from the selections.

Remember to switch the Preview Options to cube so you get a better idea of how the texture will appear on the cube.

3. Change to Mixed Material mode.

Recreating a Cube with Displacement Mapping

Let's start out by recreating a material you built in Chapter 7. This is a good way to learn about some of the extra features afforded by the Advanced Material Editor before you dive into even more complex areas

FIGURE 8-1

The Advanced Material Editor affords you with many more controls to affect your material creation.

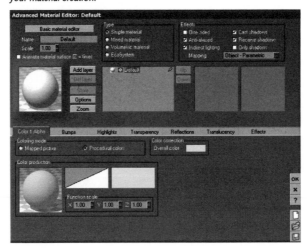

FIGURE 8-2

Set Object Parametric for the mapping of Material 2.

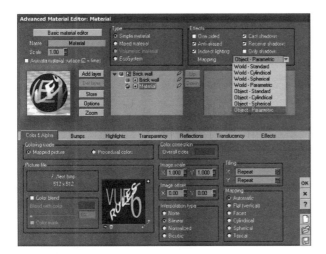

FIGURE 8-3

With mixed materials, the Material Editor screen gives you options to set how materials appear on the object.

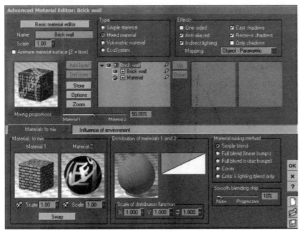

4. For Material 2, select the text.bmp file.

This is the image file you used in Chapter 7. If you deleted that file, for some reason, go back to the book's website to download it. In the Material 2's Material Editor window, make sure to set Mapping to Object Parametric before clicking OK (see Figure 8-2).

At this point, the controls at your disposal deal with precise placement of your two materials (see Figure 8-3). You can change how materials are distributed across an object, or modify how slopes and height affect the appearance of a material on the selected object. For this introductory project, don't worry about those controls. You will instead change the bump map into a displacement map so you actually have rough surfaces on the model.

5. Double-click on Material 1 to open its Material Editor screen.

Now you have the Material Editor that gives you control of the material design.

6. Click the Bumps tab to go to the bump control panel (see Figure 8-4).

Once again, you are given advanced controls to help you design how your bump map appears on the object.

7. Check the Displacement Mapping checkbox.

When Displacement Mapping is activated, you can then make the following modifications to the displacement effect (see Figure 8-5):

- **Quality Boost**—You need to consider the displacement quality in regard to your final output. If you are rendering for print, for example, you increase the quality setting.

- **Automatic Extension**—With this turned on, it will set the displacement effect to the numeric value defined by the map. If you want the displacement to be rougher, increase this value (to a maximum value of 10); if you want to smooth it out, decrease the value (down to a max of 0). Automatic Extension must be unchecked to change the values.

- **Clamp Bump with Displacement**—Makes sure the displacement map corresponds with the bump information.

Don't make any changes to the displacement values right now.

FIGURE 8-4

The Bumps screen gives you more precise control over the way the bump map affects the object.

FIGURE 8-5

The displacement controls.

FIGURE 8-6

An example of displacement mapping, where the mesh is actually warped to add more realism to the object.

8. Perform a quick render.

 Instead of smooth edges on the cube, the displacement map has actually warped the mesh, which gives the object more realism (see Figure 8-6).

 QUICKTIP

 When should you use only a bump map and forego the displacement map? If an object is in the background, using a bump map will suffice; there is less computational power needed to render it and, because it's not the focus of your image, there is no need to add the greater detail. If the object is the subject or in the foreground of the scene, assign a displacement map.

USE FILTERS TO CHANGE TEXTURE
AND BUMP APPEARANCES

What You'll Do

In this section, you explore the use of filters to make changes to the appearance of a material and its related bump and/or displacement map.

Filters are mathematical equations that define the distribution of materials, bump maps, or other effects in a scene. They are represented by a graph-like display that shows how they will affect the appearance of whatever they are assigned to.

Selected Filter Thumbnail & Description

Filter Collections

Filter Thumbnails

Building Textures Using the Advanced Texture Editor Chapter 8

Using a Filter to Modify a Material

You worked with filters for a brief time in Chapter 3 when you assigned them to terrain profiles to change the look of the terrain element. Now, you use them to affect the appearance of materials on your objects.

FIGURE 8-7
The Eroded effect makes the edges of the terrain more chaotic, actually adding to the realism of the mountain.

FIGURE 8-8
The filter control window.

Preview

Filter Control

Color Production

1. New scene. This time, though, put a terrain into the scene.

2. Go into the Terrain Editor and click Eroded a few times.

 Two or three clicks should do it. You want to get the edges of the terrain to go in a bit, like you see in Figure 8-7.

3. Open the Advanced Material Editor and assign the Landscapes > Grass material to the terrain.

 You will make changes to this grass texture so you can have a second original ground texture in the Personal Library. Notice this is already a mixed material, so you make changes to both in order to create the new material.

4. Open Material 1's Material Editor.

5. Make sure you are in the Color & Alpha section of the AME.

 To gain a better understanding of the way filters affect a material, you will modify the color distribution of Material 1.

6. Double-click on the Filter window in the Color Production section (see Figure 8-8).

The filter control window is the gray/white box immediately to the right of the Color Production preview window. In this case, it is controlling the amount of dark green to light green shown in the color preview window. When you double-click on the filter window, the Filter Selection window opens. This window gives you access to the preset filters you can assign (see Figure 8-9).

7. Select Saturation > Saturation 1.67/80% then click OK.

You will see the deep green of the material increase in the overall color (see Figure 8-10). If you compare what the filter graph looks like to the final output, you will see that, with the line (or gray area) extending over a greater portion of the filter, more of the dark shade will appear. On the other hand...

FIGURE 8-9

The Filters Selection window.

FIGURE 8-10

The saturation filter has increased the amount of dark green in the material.

FIGURE 8-11

The Inverse Saturation filter now brings out much more of the light green in the material.

FIGURE 8-12

In the main material, the lighter green is blended with Material 2.

8. Go back to the Filter Selector and choose Inverse Saturation/16/80% (see Figure 8-11) and click OK.

Now more of the light green material is appearing, taking up most of the overall texture. But, notice what it is doing to the appearance of the main material (see Figure 8-12).

9. To return to the default filter, right-click on the filter control window and select Reset Filter.

1. Select the Grass material again (Material 1) and, in the Material Editor window, go to the Bump controls.

2. Double-click the filter control and choose Terrain Profiles > Lips (see Figure 8-13).

 Just because a filter category has a certain name, does not mean you have to use those filters for only that purpose. Although Terrain Profiles is a good starting place for modifying the look of a Terrain object, these profiles also add some interesting effects to materials.

3. Click OK and watch the preview window.

 The way in which the bump is generated changes, giving Material 1 an entirely new look.

4. Now let's select something more radical. Go back to the Filter Selector and select Terrain Profiles > Fortification. Click OK.

 Not much has really happened (see Figure 8-14). There's a slight change in the overall bump pattern, but...

Affecting Bumps and Displacements with Filters

In the following exercise, you will learn how filters can affect bump and displacement.

FIGURE 8-13

Use a terrain profile to assign bump definition to your materials

FIGURE 8-14

The Fortification filter has made a slight change to the overall bump pattern.

FIGURE 8-15

The bump with its new filter is assigned as a displacement map. Here you see Material 1 on the right, and its effect on the main material (left).

FIGURE 8-16

The displaced material and how it affects the terrain it's assigned to.

FIGURE 8-17

When moved to the background, this material makes the terrain appear well foliated.

5. Activate Displacement Mapping.

Now you're seeing some ridging appear as the mesh is being warped to match this filter's pattern (see Figure 8-15).

6. Click OK and perform a quick render on the scene to see what this filter does to the display of the material on your terrain.

What you have just done is, using a material displacement map, caused the terrain mesh to warp based upon color generation. When you're up close (see Figure 8-16), this doesn't look that great, but move your terrain way back in the scene and it looks like a background mountain with trees growing all over it (see Figure 8-17).

> **QUICK**TIP
>
> Save this material with a name such as **mountainGrass** or **grassyHill**. Whatever name you use, be sure to use one that allows you to quickly identify the material, because you might want to use it in your own projects sometime in the future.

7. Time for some real fun now. Go back to Material 1's Material Editor window, and stay in the Bump section.

8. Notice immediately underneath the filter control window is the Depth control. By changing the numeric value here, you can increase or decrease the overall strength of the bump or displacement. Change the value in the numeric field to 5.

You now have a "hairy" look to the material (see Figure 8-18). So how can this effect be used? For one, with a rocky texture you can create a very complex asteroid (see Figure 8-19) or an ice molecule, a germ, or even give the semblance of fur on an object.

FIGURE 8-18

The higher the Depth setting, the more pronounced the displacement will be. On the left is the final material appearance, on the right, the appearance of Material 1.

FIGURE 8-19

An example of a complex asteroid using a displacement map on its texture. A terrain with the same texture was added and used as the cutter in a Boolean difference.

CREATE AND SAVE
YOUR OWN FILTERS

What You'll Do

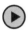

You are not limited to the filters provided with the program. In this lesson, you create your own filters and save them for future use.

Editing your own filters can be a lot of fun. Very challenging, but a lot of fun nonetheless. When creating an original filter, you can start from the default filter or assign an existing filter to a material or object, and then modify that as the starting point.

Smooth Curves
Auto Tangent
Smooth Joint
Show/Hide Grid
Snap to Grid
Zoom In
Zoom Out
Reset Pan/Zoom

Profile Display/Editor

Control Panel Tabs

Edit Controls

Create Your Own Filter

1. Place any object (primitive, terrain, and so on) into a new scene.

2. Open the Material Editor window and assign the Landscapes > Scrubland material to the object.

3. In the Materials to Mix section of the Material Editor, go to the filter control window in the Distribution of Materials 1 and 2 section (see Figure 8-20).

 This time, you will create a filter that will control the placement of the materials on the surface of the object.

4. Right-click on the window and select Edit Filter from the sub-menu.

 The Distribution Filter window will open (see Figure 8-21). This window looks more complicated than it really in (in some respects). It's broken into two sections: Profile and Influence of Environment (see Figure 8-22). With these sections, you can create your profile as well as tell the program how the materials will be affected by the slope of the terrain.

Creating an Original Filter from an Existing Filter

In this section, you learn how to select an existing filter and then modify it to fit your specific needs.

FIGURE 8-20
The filter control window in the Distribution of Materials 1 and 2 section of the Material Editor.

FIGURE 8-21
The Edit Filter window's Profile controls.

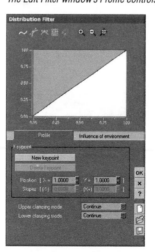

FIGURE 8-22
The Edit Filter window's Influence of Environment controls.

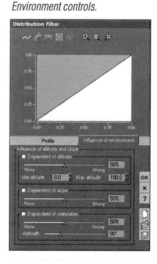

FIGURE 8-23

A keypoint has been added to the filter line. Its numeric position on the X/Y plane is indicated in the Position numeric fields.

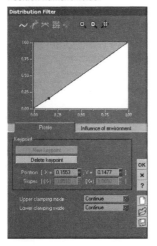

FIGURE 8-24

The second keypoint and its position.

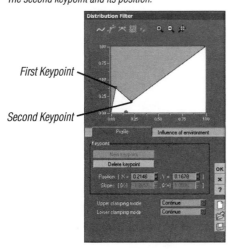

First Keypoint

Second Keypoint

FIGURE 8-25

The third and last keypoint and its position.

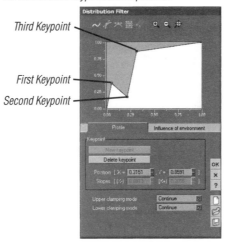

Third Keypoint

First Keypoint

Second Keypoint

FIGURE 8-26

The buttons at the top of the window give you modification controls of the filter path.

Smooth Curves

Auto Tangents

Smooth Joint

Zoom In/Out

Snap to Grid

Show/Hide Grid

Reset Pan/Zoom

9. Right now, the curves you created are sharp points, indicating an immediate change in direction. You can round these out by clicking on the Smooth Curves button at the top of the screen (see Figure 8-26).

When you click the Smooth Curves button, the active keypoint (filled with black) is the first modifiable keypoint on the line. Two arrows will appear from the point. These are the control handles (see Figure 8-27). By clicking and dragging on either one, you can modify the curve's shape.

10. The last keypoint you created should have been active, so click and drag on its control handles to create a curve like you see in Figure 8-28.

You can modify the other points by clicking on them once to make them active, and then moving the control handles to change the curve or position of the keypoint. Use Figure 8-29 as a reference for making changes to the other two keypoints.

11. You should still be in the Edit Filter window. Switch to the Influence of Environment pane by clicking the tab.

Here you make settings that affect how and where the two materials will position themselves on the terrain or object.

- **Dependent of Altitude**—This sets how high Material 2 appears on the altitude of the terrain.

- **Dependent of Slope**—Will Material 2 appear on slopes or will the slopes have no effect on material placement.

- **Dependent of Orientation**—Will Material 2 appear based upon the object's orientation (how much it's skewed or rotated in the scene).

FIGURE 8-27

The arrows pointing out from the active keypoint are called control handles.

FIGURE 8-28

Modify the last keypoint to look like this.

FIGURE 8-29

Use this image as a reference for modifying the other two keypoints in your filter.

FIGURE 8-30

Use this image to make final changes to your filter.

FIGURE 8-31

The filter will make the material appear like a band around the object.

12. Use Figure 8-30 to set the previous values.

Your material should now look like what you see in Figure 8-31, with the grass almost acting as a band.

13. To save this filter, click the floppy disk icon at the bottom right of the window and name it whatever makes sense to you.

14. To assign the filter to another material or to a terrain at a later time, click the Load button (immediately above the Save button) and navigate to the filter you want to use.

So what might this particular filter be used for? With some more tweaking, you could create a wall with some moss growing on it. You could have a steep mountain where the grass grows on the slopes, but rocks take over on the sheer cliffs. The filters alone will not accomplish this, but by changing environment settings in the Material and the Bump Editor, you can make changes that will impress friends, family, and online cohorts alike.

Let your imagination run wild.

LESSON 4

HARNESS THE POWER
OF HYPERTEXTURES

What You'll Do

In this lesson, you create a shrub using hypertextures, and then save it as an object for use in other scenes.

Hyptertextures are new to Vue 6. They use volumetric materials to create complex shapes that keep a low polygon count. They can also be animated for exciting effects such as lava boiling or undulating ocean water. They are a fascinating addition to Vue, because they can create virtually anything from viral molecules to real world items like shrubbery. That's not to say the first time you try this on you own you will make anything that resembles anything, but experimentation is the true joy of working with this feature.

Material Type

Hypertexture Lighting Model

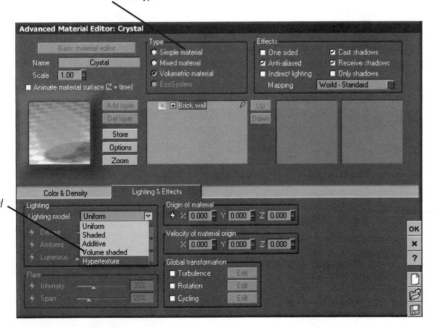

Using Hypertextures to Create a Shrub

In this next exercise, you learn how to utilize Volumetric textures to create effects for background objects in your image.

FIGURE 8-32

The Color & Density controls.

FIGURE 8-33

The Lighting & Effects controls.

Work with Hypertextures

1. Once again, create that infamous New Scene and add a cube object to the workspace. Go into the Material Editor.

2. Switch to Volumetric Material.

 The screen changes to where you only have two tabs to work with—Color & Density and Lighting & Effects. Volumetrics get their look from not only the material but from how the light interacts with that material.

 QUICKTIP

 Clouds (in the real world) are volumetric materials. They show density, but also transparencies, and their color and overall look depend upon how light is interacting with that material.

 Under Color & Density (see Figure 8-32), you can assign pre-defined functions (the same thing used to define bump maps) and filters using the Density Production section, as well as set the base color for the object (if you don't use a material), its density, fuzziness, and quality.

 Under the Lighting & Effects section (see Figure 8-33), you set how light interacts with the material. This is accomplished through the Lighting Model pop-up. The rest of the controls help you fine tune the effect of light and color on the material.

3. First go to Lighting & Effects. Select Hypertexture from the Lighting Model drop-down menu (see Figure 8-34).

A third section now appears— Hypertexture Material. The only selector you have in this new area is Hypertexture Material (see Figure 8-35), where you access the Material Editor and assign a material to the (now) volumetric object.

4. Using the method you probably now know like the back of your hand, select the Landscapes > Grass material and assign it to the object.

5. Switch to Color & Density. In Density Production, double-click on the preview window and assign Bumps > Desert Bump .

Once Bumps > Desert Bump is assigned, you will see the main preview change dramatically, giving the first indication of branches in the shrub (see Figure 8-36).

The minute you assign a bump map to the density of the material, the first indications of shrub branches appear.

By default, the overall density of the volumetric material is set to 5 (relatable to 50%). Move the slider to the right to increase the density, making the object more solid, or move it to the left to let more light show through.

FIGURE 8-34

Hypertexture is accessed at the bottom of the Lighting Model drop-down menu.

FIGURE 8-35

The Hypertexture Material window only lets you assign a material to the object.

FIGURE 8-36

The minute you assign a bump map to the density of the material, the first indications of shrub branches appear.

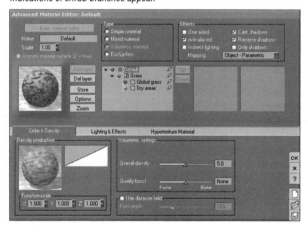

FIGURE 8-37

The edges of the object now begin to look like errant branches sticking out.

FIGURE 8-38

The material preview shows an object that has the look of a shrub.

FIGURE 8-39

The completed shrub. This poor thing is in need of a good trim.

6. Change the Overall Density setting to 4.0.

 This will allow some transparency around the edges (see Figure 8-37), showing the beginnings of the edge of a shrub.

7. Activate Use Distance Field.

 The Distance Field option basically sets the amount of visual information that will appear. A higher distance field allows more light to show through, thus making the object appear smaller, whereas a smaller distance field makes the material thicker, letting less light show through.

8. Change the Distance Field to 65%.

 Now you have a material that looks like a shrub (see Figure 8-38).

9. Click OK and then perform a quick render.

 Your scene now has only eight polygons, but a highly complex-looking object filling it (see Figure 8-38). As with other things you have accomplished so far in this chapter, this object would only look good in the background. In the foreground, all its faults become much too apparent and the sense of reality is lost.

QUICKTIP

Due to the complexity of the material, render time for a hypertexture object can increase dramatically. There's a lot of computer thinkin' that has to occur to render these kind of textures.

Time to save this as an object so you can use it over and over again, as well as use it as an element in an Ecosystem (see Chapter 9).

QUICKTIP

Because this shrub is being saved as an object, you need to be aware it will not have Solid Growth technology assigned to it. Every shrub you add to your scenes will look exactly the same. You would need to modify the hypertexture material and resave it as another shrub in order to give each plant a different look.

10. First, remember to rename the cube to Shrub1 in the Layers window.

11. With the cube selected, right-click on it in any of the viewports to bring up the submenu.

 You can also right-click on the cube name in the Layers window

12. Select Save Object from the submenu.

 Remember to give it some sort of detailed description if you are planning to make a few more shrubs for your collection.

CHANGE MATERIALS
ON OBJECTS

What You'll Do

In this lesson, you learn how to work with objects that have multiple elements, selecting those elements and changing their materials. You also learn about the Material Summary window and how it can speed your workflow.

So far, you have worked with objects with a single component—terrains and primitives. However, there are objects included with Vue that have numerous sections, each of which has its own texture assigned or shares a common texture. For this project, you work with a model included with Vue that has 17 different parts making up the whole.

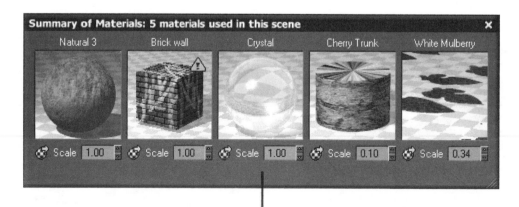

Material Summary Window and Thumbnails

Modifying an Object with Numerous Sections

Through this process outlined in the following exercise, you use two different methods to select and modify textures. By the end, you will have transformed the model into a statue that's used in the next section of this chapter.

FIGURE 8-40

You will work with Marlenestand, a model that comes packaged with Vue 6.

FIGURE 8-41

The Import Options window appears when you select an importable object.

1. You know what to do....create that new scene file.

2. Click the Objects button to open the Object Selector. Navigate to Humans and locate Marlenestand (see Figure 8-40).

 This model, along with a number of others (some animatable), are low-resolution objects that are good for background crowds. Their quality would not hold up under close scrutiny.

 QUICKTIP

 Your Object Selector window will probably be different than mine. I was using a pre-release version of Vue 6, and some of the content was not available with this version of the program.

3. In the Import Options window that appears after selecting the model (see Figure 8-41), choose Center Object. If the other choices are selected, uncheck them.

 The other choices do the following:

 - **Decimate Object on Import—** Removes polygons it says it doesn't need to recreate the model in the scene. This helps make the polycount smaller, but can sometimes cause the model to warp or lose its shape.

- **Resize Object**—When you select this option, you can tell Vue to scale the model before placing it in the scene. Usually it is best to wait until the object is on the workspace so you know how much to actually scale it.

Click OK to place Marlenestand in the scene.

> **QUICK**TIP
>
> The Marlenestand model is a bit larger, so you will have to move the camera away from the object until you see the entire thing. Also, rotate the object so she is facing toward the camera.

4. In the Layers window, click the triangular switch to expand the Marlenestand object.

You will see the elements that make up the model (see Figure 8-42). Click on one of the sub-objects to highlight it in the workspace and see which part of the model it selects.

> **QUICK**TIP
>
> If you do not see the entire name text in the list, move your cursor over the dividing line between the Layers window and the Main Camera View window. The cursor will turn into a double-headed arrow. Now you can click on the edge and drag inward to expand the width of the World Browser.

FIGURE 8-42

The elements that make the object in the scene.

FIGURE 8-43

Changing Color Correction to white turns the Yellow Marble material into white marble.

FIGURE 8-44

The Material Summary button at the top of the Vue workspace.

FIGURE 8-45

The Material Summary window.

5. Click on the first object in the group, marlenesta Belt_2.

The belt is highlighted and is ready to be modified.

6. Open the Material Editor.

A color has been assigned to this object, but you will replace that color with a new material and new color in just a moment.

7. Add the Rock > Yellow Marble Material.

This material adds a yellow cast to the marble. It's not what you want for this particular project, so in the Color Correction selector located in Color & Alpha, select white. This will make the marble more workable for you (see Figure 8-43). Also, save the material you just modified into your Materials library because it's going to be assigned to each part of the model, and you don't want to have to repeat this process 16 more times.

8. Select marlenest Body_1.

Repeat Steps 6 & 7, this time adding the White Marble material you just saved. You could do this 15 more times, but there's actually a more efficient means to change textures. That is with the Material Summary window.

9. Access the Material Summary screen by choosing Display > Show Material Summary, clicking the Material Summary button (see Figure 8-44), or pressing the F6 key on your keyboard. Whichever why you choose, open the Material Summary window (see Figure 8-45).

The Material Summary window shows all the materials that are assigned in your scene. Depending on how many trees, terrains, objects, and so on, are in the scene, the list can grow rather long. You can scroll across to see any materials not displayed using the scroll bar under the preview windows, and you can click and drag the bottom-right corner of the window to enlarge it horizontally.

When you click once on a material, the element or elements that have that material assigned are selected and highlighted on the model(s).

10. Go down the list of materials (except Default) and change them all to White Marble.

> **QUICK**TIP
>
> Do not change the Default color to White Marble unless you want the ground plane to have the same material as the statue.

Double-click on the material in the Material Summary screen to open the Material Editor window. As you assign White Marble to the various pieces, the list will grow smaller. That's because there are fewer materials associated with the model.

Now perform a quick render to see the statue you just created (see Figure 8-46). Then save the object as **WomanStatue**.

I also created a pedestal to put the statue on. I added a sphere and two cubes. Then, using the cubes as cutters, I performed a Boolean Difference, and then scaled the newly created pedestals to make it taller.

FIGURE 8-46
The newly created marble statue.

USE HIGHLIGHTS
AND REFLECTIVITY

What You'll Do

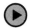

In this lesson, you learn how to make your objects take on more realism through the use of highlights and reflections

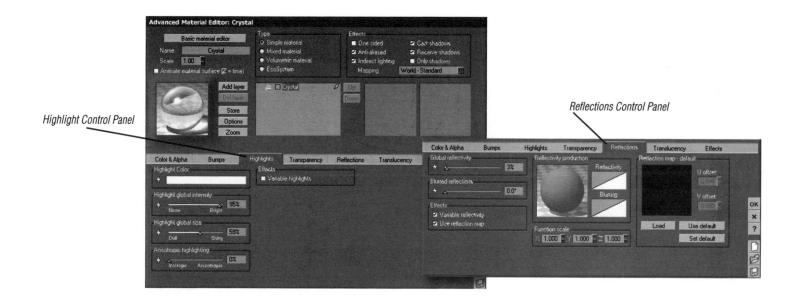

Highlight Control Panel

Reflections Control Panel

Work with Highlights and Reflectivity

1. Select the statue object and go to the Material Editor.

2. In the Material Editor window, select the Highlights tab.

 You will see there is a small highlight setting already assigned to this material (see Figure 8-47). It was part of the original material you modified, and that feature was saved with the modified material. But for this statue, it's not enough.

 The controls in the Highlights section include:

 • **Highlight Color**—Assigns a color that will be used for the highlights.

 • **Highlight Global Intensity**— Determines how strong the highlight will be.

 • **Highlight Global Size**—Is the highlight dull or shiny? Shiny will spread out more along the surface of the object, which is why the term size is used.

• **Anisotropic Highlighting**—Choose a setting between full **Isotropic** or full **Anisotropic** highlighting. (*Isotropic highlighting* is a method where the light spreads evenly from the point where the light hits the object's surface until it fades out, whereas *anisotropic highlighting* is a highlighting method where the light literally creates a ring around the point where the light hits.)

• **Variable Highlights**—When this is selected, more controls are at your disposal for creating more realistic highlights based on functions.

3. Change the Highlight Global Intensity to 31%.

4. Change Highlight Global Size to 62%.

5. Set Anisotropic Highlighting to 87%.

 Do a quick render to see how these changes have affected the surface of the statue. The surface areas where the sun hits are brighter, but there is still more work to be done to make this a more realistic marble texture.

Adding Sheen to a Marble

Sheen can be added to your marble statue in two ways—through the use of highlights and reflectivity.

FIGURE 8-47
The Highlights control window with Variable Highlights selected.

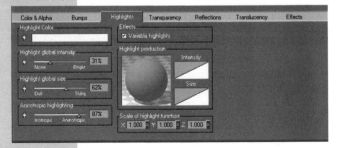

FIGURE 8-48

The Chipped function and the original filter created earlier in the chapter added to the Highlight effects.

FIGURE 8-50

The base reflection controls.

FIGURE 8-49

A plane object was added and the Global Reflectivity set to 100%, creating a mirrored surface.

6. Activate Variable Highlights.

Under Highlight Production, select Bumps > Chipped from the Function Selector window (see Figure 8-48). Also change the Intensity filter to the one you created earlier in the chapter. The highlights are becoming a bit more realistic.

7. Select Reflections.

You can make objects more reflective, to the point where they become a full mirrored surface if you want (see Figure 8-49). The controls in this section are defined as follows (see Figure 8-50):

- **Global Reflectivity**—Sets how reflective the object's surface is.

- **Blurred Reflections**—Will set the blur amount for the reflective surface, making the objects reflected therein look out of focus.

- **Variable Reflectivity**—Uses functions to warp or distort the reflection.

- **Use Reflection Map**—Assign a bitmap image that will be reflected in the surface.

8. Change the following settings:

- Global Reflectivity—5%
- Blurred Reflections—7.1

These settings will give the statue a slightly reflective surface, and the blurring will keep any recognizable features that might appear in the surface unrecognizable.

9. Check the Variable Reflectivity box (see Figure 8-51).

You have worked with the same controls in other windows through these chapters. Select the same function and filter as with the Highlights.

10. Perform a quick render to see the difference in appearance with these settings (see Figure 8-52).

FIGURE 8-51
The controls for Variable Reflectivity.

FIGURE 8-52
The statue with highlights and very modest reflection values.

EMPLOY SUBSURFACE
SCATTERING

What You'll Do

In this lesson, you learn how to make your objects take on more realism through the use of subsurface scattering.

Subsurface scattering is also new to Vue 6. Again, this is the technique simulating light entering an object, bouncing around, and then exiting, giving the appearance of luminosity (or self-glowing). In this section, you turn the marble statue you created in the last section into a high-gloss onyx-ish statue, adding highlighting through the use of subsurface scattering.

Subsurface Scattering Control Window —

Learn to Use Subsurface Scattering

1. For this scene, use the Basic > Clear Blue atmosphere.

2. Import the statue model you saved and place it in the center of the scene.

3. Open the Material Editor.

 Because you set all the materials to White Marble, the changes you are about to make will be set globally, meaning over the entire statue.

4. The first change that will be made is to Transparency. Change Global Transparency to no more than 5%.

 It is best to add a slight transparency to the material so the light will have some room to interact, giving a more realistic sheen to the object. You could set this to zero (which you should try at some point) to see what happens, but much over 5% and you will make the object too transparent for the effect to be realistic.

5. Add a slight reflection to the material, somewhere between 9% and 12%.

 This statue is going to be highly polished. With this slight reflection, the surroundings will be reflected off the surface giving the statue a very interesting appearance.

6. Now it's time to set the Translucency. Click the Translucency tab and check the Enable Subsurface Scattering box (see Figure 8-53).

Adding Gloss to Your Statue with Subsurface Scattering

To add a high gloss to the statue, follow these steps:

FIGURE 8-53

The controls in the Translucency panel.

FIGURE 8-54

Examples of BDRF and BSSRDF and how light is scattered after it hits an object.

BDRF BSSRDF

FIGURE 8-55

The finished onyx statue.

Notice your preview has taken on a milky sheen. This is what you want to see. Although experimentation is the key, keep in mind these points as you work with translucency:

- Average Depth should remain small. This controls how far into the object light will travel. For most objects like the one you are creating, the light would not enter very far, a few centimeters at the most.

- Refraction Index sets the parameters for how light interacts with an object. This controls not only light dispersion, but how objects are reflected through the material. Think of a glass of water and how, when you put your hand in that water (hopefully not drinking it after you do that!), your hand seems to split apart. This is refraction; light bending as it goes through a material.

QUICKTIP

Base Refraction Values

Air = 1.000

Water = 1.333

Glass = 1.500

Diamond = 2.417.

- Absorption. These settings determine how thoroughly the light will be absorbed; literally how much comes back and escapes from the object. You can set the value from –1 to 1, with the former allowing more light to escape, the latter allowing no light to escape.

- Multiple Scattering. Will the light 'bounce back' uniformly (bidirectional reflectance distribution or BDRF), or will it be broken apart and dispersed over a wider area (bidirectional surface scattering reflectance distribution or BSSRDF). Usually, you do not want to turn this feature off (see Figure 8-54).

7. Make the following changes to the Translucency settings to each element of the object:

- Average Depth—5.00
- Refraction Index—1.25
- Absorption— -1

Perform a quick render to see the onyx statue. Figure 8-55 shows the statue with a preview render setting of Final.

Take a little time to play with the settings. Turn off reflection. Change the values in the various numeric fields in the Translucency window. With some practice, you can create some dazzling looks for your objects.

LESSON 8

EMPLOY
DISPERSION

What You'll Do

In this lesson, you learn how to create a crystal object and have light pass through it to create rainbow effects.

Dispersion is the process of light passing through an object and splitting it into separate frequencies. One of the most common dispersion effects is light passing through

glass or crystals and then creating a rainbow on the surface it strikes. This effect is easy to achieve in Vue.

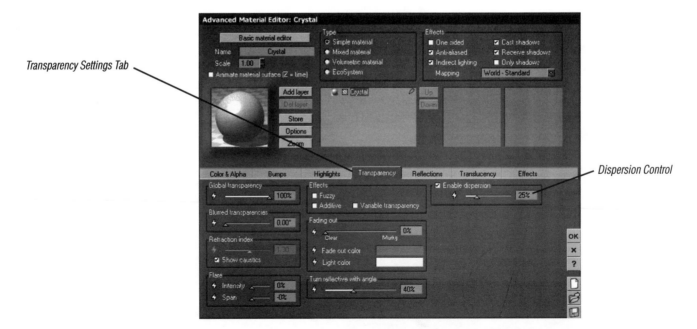

Transparency Settings Tab

Dispersion Control

Using Dispersion to Emulate Light Passing Through an Object

Here, you learn how to make light bend as it goes through an object, creating a rainbow-like effect as the light hits other surfaces:

FIGURE 8-56

This sphere has the crystal material assigned to it.

FIGURE 8-57

The Render/Render Options button.

5. In the Render Options window, check the Compute Physically Accurate Caustics checkbox (see Figure 8-58).

Caustics simulate light moving through the atmosphere and interacting with particles and objects in a natural way.

> **QUICK**TIP
>
> If you do not have Computer Physically Accurate Caustics turned on, Dispersion is not available in the Transparency section of the Material Editor.

6. Go back to the Material Editor and select the Transparency tab.

7. Turn on Enable Dispersion and set it to 37% (see Figure 8-59).

The higher the value you place for the dispersion setting, the better the results. Also, the brighter the lighting, the better the results of this effect.

8. Click OK, and then add a spot light to the scene.

Spot lights are located in the Lights button on the left side of the workspace (see Figure 8-60).

FIGURE 8-58

Check the Compute Physically Accurate Caustics checkbox, found in the Render Options window.

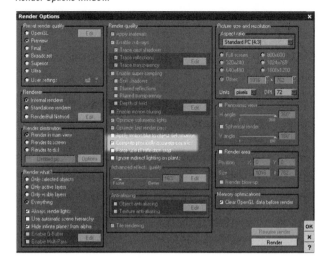

FIGURE 8-59

The Enable Dispersion control in the Transparency section of the Material Editor.

FIGURE 8-60

The Light button gives you access to various styles of lights to add to your scene.

FIGURE 8-61

The approximate position your light should be in.

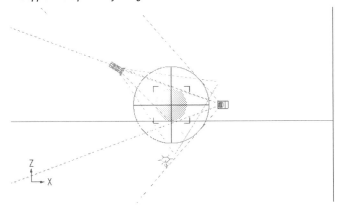

FIGURE 8-62

You can focus the beam of light using the Spread control in the Aspect window.

9. Move and rotate the light so it is pointing down at the sphere, as you see in Figure 8-61.

10. In the Aspect window of the World Browser (see Figure 8-62), change Spread to 10.

 This focuses the beam so it is tighter and the effect will be better.

11. Perform a quick render.

Notice the rainbow effect as the light escapes the object and hits the ground (see Figure 8-63). Figure 8-64 shows another object (a Cube with multiple Booleans) and a higher quality render setting.

QUICKTIP

Due to the fact these images are in black and white, the rainbow effect may not be as pronounced as it would be in color.

FIGURE 8-63
The sphere and its dispersion effect.

Rainbows

FIGURE 8-64
A cube with Booleans and the dispersion effect assigned to it.

Rainbows

Working with the Advanced Material Editor gives you much greater flexibility and creative control than the Basic Material Editor. There are many more realistic effects you can add to your materials, and, as stated earlier, many people make a career out of creating photorealistic textures by working in areas like this and combining them with image maps they create in image-manipulation programs.

Now is the time to stop and explore this area even more. Let you imagination run wild and see what types of materials you can create with a few clicks of the button.

What You Have Learned

In this chapter you

- Used the Advanced Material Editor
- Modified and mixed bumps, transparencies, highlights and more
- Discovered subsurface scattering
- Added dispersion effects to achieve greater light interactivity with your materials

Key Terms from This Chapter

Anisotropic A highlighting method whereby the light literally creates a ring around the point where the light hits. Good for glass highlights.

Caustics Calculates photons of light starting at a light source (like real light), which can then be reflected, refracted, bounced off mirrors, or concentrated by a lens, accurately simulating more of the ways real light can move through a scene.

Dispersion The effect of light as it passes through materials.

Isotropic A highlighting method whereby the light spreads evenly from the point where the light hits the object's surface until it fades out.

Keypoint An indicator of a change in either a profile or the timeline of an animation.

Subsurface scattering (SSS) Light penetrates the surface of a translucent object, is scattered by interacting with the material, and exits the surface at a different point. The light will generally penetrate the surface and be reflected a number of times at irregular angles inside the material, before passing back out of the material at an angle other than the angle it would reflect at had it reflected directly off the surface.

Translucency The effect of light traveling into a surface, lighting a surface from the inside (see subsurface scattering).

Volumetrics Simulates the interactions of light and air as light travels through the atmosphere. Can also apply to textures, where the light interacts with the material elements to create realistic light interaction.

9

ECOSYSTEMS

1. Turn materials into Ecosystems.

2. Define Ecosystems by altitude and material placement.

3. Create Ecosystems that interact with foreign objects.

4. Create interactive Ecosystems with the Paint tool.

chapter 9 ECOSYSTEMS

In the past (a whole year or two ago), if a 3D designer or animator wanted to create a forest scene, he or she had to painstakingly model numerous variations of a plant or set of plants and then place each instance individually. The designer would then go in and tweak the location and orientation of each of those plants to get the look he or she ultimately wanted. Well, those days are over.

With the introduction of Ecosystems, E-on Software freed the designers from that sort of tedious work. Ecosystems allow 3D artists to populate their scenes with as many plant species, rocks, or objects they want with the click of a button. Changes can be made within moments, not hours. And placement of these items can be controlled through material, bitmap files, or altitude. No longer do you have to spend untold hours positioning squadrons of planes in the sky. No longer do you have to rip your hair out in order to get 50 trees and thousands of blades of grass placed as you want.

Tools You'll Use

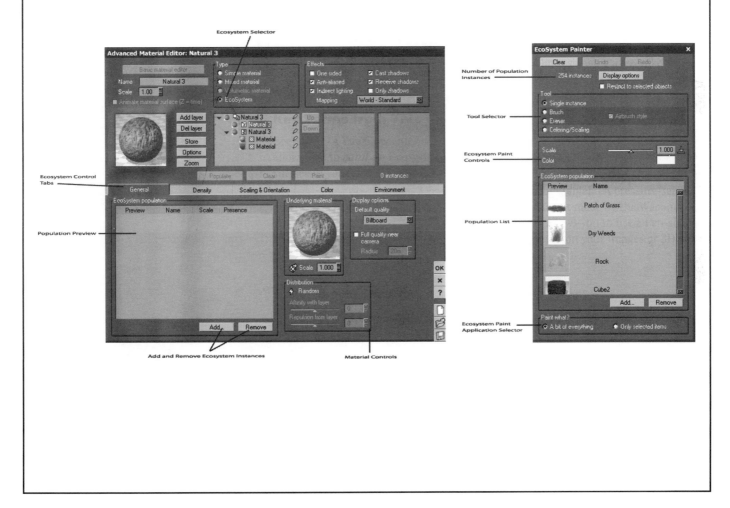

Ecosystem Selector

Advanced Material Editor: Natural 3

Basic material editor

Name — Natural 3
Scale — 1.00

Animate material surface (Z = time)

Type
- Simple material
- Mixed material
- Volumetric material
- EcoSystem

Effects
- One sided
- Anti-aliased
- Indirect lighting

- Cast shadows
- Receive shadows
- Only shadows

Mapping — World - Standard

Add layer
Del layer
Store
Options
Zoom

Natural 3
 Natural 3
 Natural 3
 Material
 Material

Up
Down

Populate Clear Paint 0 instances

Ecosystem Control Tabs

General Density Scaling & Orientation Color Environment

EcoSystem population
Preview Name Scale Presence

Population Preview

Underlying material
Scale 1.000

Display options
Default quality
Billboard
Full quality near camera
Radius 20m

Distribution
Random
Affinity with layer
Repulsion from layer

Add Remove

OK
X
?

Add and Remove Ecosystem Instances

Material Controls

EcoSystem Painter

Clear Undo Redo

254 instances Display options
Restrict to selected objects

Number of Population Instances

Tool
- Single instance
- Brush
- Eraser
- Coloring/Scaling
 - Airbrush style

Tool Selector

Scale 1.000
Color

Ecosystem Paint Controls

EcoSystem population
Preview Name
Patch of Grass
Dry Weeds
Rock
Cube2

Population List

Add... Remove

Paint what?
A bit of everything Only selected items

Ecosystem Paint Application Selector

279

TURN MATERIALS
INTO ECOSYSTEMS

What You'll Do

In this section, you assign materials as Ecosystems and populate the scene with plants.

Ecosystem Selector

Advanced Material Editor: Natural 3

Ecosystem Control Tabs

Population Preview

Add and Remove Ecosystem Instances

Material Controls

Basic Ecosystems cannot be used on the ground plane or on infinite planes. You must use terrains or primitives to make them work. With Ecosystems, you can assign rocks, plants, and any objects you have in your libraries or in folders on your computer. Because they work from materials and material settings, you must turn your material into an Ecosystem (see Figure 9-1).

When you turn your material into an Ecosystem, your Material Editor window changes to reflect the controls now at your disposal.

The General control panel (see Figure 9-2) has the following controls:

- **Ecosystem Population**—What you will populate the scene with.
- **Underlying Material**—Set a material to use on the plane itself.

- **Display Options**—How the Ecosystem will appear.
- **Distribution**—Use image maps or functions to determine placement of the Ecosystem elements.

The Density control panel (see Figure 9-3) has the following controls:

- **Overall Density**—Controls how thick the Ecosystem population will be on the object.

FIGURE 9-1

Turn your material into an Ecosystem by choosing the Ecosystem radio button in the Type section.

FIGURE 9-2

The Ecosystem's General control panel.

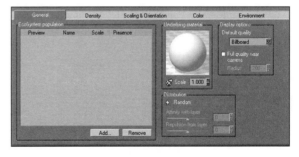

FIGURE 9-3

The Ecosystem's Density control panel.

- **Placement**—Determines how the population will be placed on the object.
- **Offset from Surface**—Controls where in relation to the object the population will be placed.
- **Variable Density**—Uses functions to control the population density.
- **Decay Near Foreign Objects**—Determines how close to any non-Ecosystem object the population will get. Encroachment might be a good word to use here.

The Scaling & Orientation control panel (see Figure 9-4) has the following controls:

- **Overall Scaling**—Controls how the elements of the population will be scaled.
- **Direction From Surface**—Determines the rotation of the population based on the main object's orientation.
- **Rotation**—Whether elements in the Ecosystem will be rotated as they are placed, and how.
- **Variable Scaling**—Uses a function to control size variations of the Ecosystem population.

- **Shrink at Low Densities**—Determines if and how the elements will automatically reduce in size if there is a change in density.

The Color control panel (see Figure 9-5) has the following controls:

- **Overall Color**—Determines the base color used for each item in the Ecosystem. Unless you are going for some sort of special effect (see Figure 9-6), there isn't much need to change this from the default color.

FIGURE 9-4

The Ecosystem's Scaling & Orientation controls.

FIGURE 9-6

The effect that changing Overall Color can have on Ecosystem objects.

FIGURE 9-5

The Color controls in the Ecosystems window.

- **Color at Low Densities**—Controls color variations as the density decreases.
- **Variable Color**—Using functions, determines how color will vary and what color will be used for those variations (see Figure 9-7).

And, finally, the Environment (see Figure 9-8) control panel determines how much altitude and slope affect the placement of the Ecosystem population.

FIGURE 9-7

Basic color variations in the Ecosystem.

FIGURE 9-8

The Ecosystem's Environment controls.

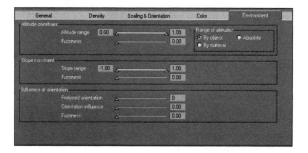

Create Your First Ecosystem

1. Place a Plane object into your new scene.

 This plane will become the object onto which the Ecosystem is placed. Scale it up so it's at least twice the size when placed (see Figure 9-9).

2. With the Plane selected, open the Material Editor window.

3. Change the material Type to Ecosystem.

 The window will change to show the controls listed previously.

4. Make the General tab active.

5. Click the Add button to access the types of objects you can add to your Ecosystem.

 A pop-up menu will open (see Figure 9-10) allowing you to select Rocks, Plants, or Objects.

Assigning an Ecosystem

With all of that in mind, it's time to create your first Ecosystem. Initially, you place one element into the Ecosystem. Later, you will add multiple items.

FIGURE 9-9
The Plane object scaled to approximately twice its original size.

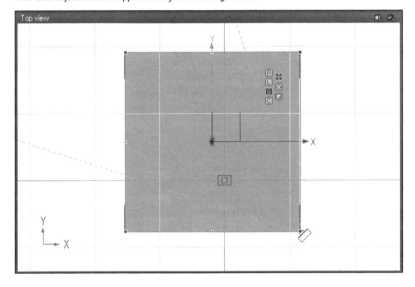

FIGURE 9-10
When you click the Add button, this pop-up menu will appear allowing you to choose what type of element to place into the Ecosystem.

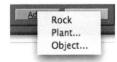

FIGURE 9-11

A choice must be made—do rocks have variable color or not? For this project, choose Yes.

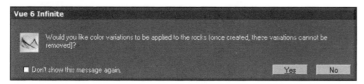

FIGURE 9-12

A comparison between having variations (top) and not having variations (bottom) in rock color.

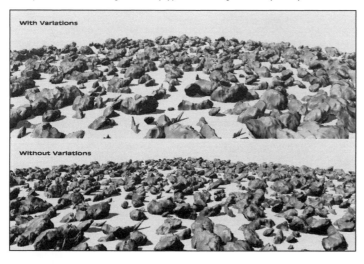

FIGURE 9-13

Controls for the Ecosystem item.

6. Choose Rocks from the list.

When you do this, a secondary window opens (see Figure 9-11). If you want the rocks to have a uniform color, click No. If you want variations in the color (which is often more natural), click Yes. For this project, choose Yes. Figure 9-12 shows the differences depending on which you choose.

> **QUICK**TIP
>
> The rock variations window appears only the first time you assign rocks to an Ecosystem. If you want to change your mind, you have to restart the program to make the screen appear again.

There are two numerics fields that appear next to the item in the population list (see Figure 9-13): Scale and Presence. Scale controls the maximum size of the objects when placed into the scene, and Presence controls the number of times the item will appear in relation to any other item(s) in the Ecosystem. In this case, keep the rocks' settings as they are.

7. Click the Populate button to add the rocks to the Plane object.

Populate is immediately above the tabs. There is also a Clear button, which will remove all the items from the object, and a Paint button, which opens the EcoPaint controls (discussed later in this chapter). The number of instances of the items in your Ecosystem is displayed to the right of these buttons (see Figure 9-14).

| **QUICK**TIP
|
| Due to variations of the size of your Plane object
| and the random generation of the rocks, your
| number of rock elements will vary from what you
| see here.

And there you have it. Ecosystems. Imagine having to place each of those rocks individually; the time spent would be astronomical.

FIGURE 9-14
To the right of the buttons, a display tells you how many items were assigned to your Ecosystem.

Assigning Multiple Items to an Ecosystem

Now you'll make some changes to this Ecosystem by adding some grass and other vegetation, plus you'll add an underlying material to the plane. You will make the changes to the same scene, which illustrates how you aren't limited to the look of your Ecosystem even after it has been assigned to the object.

FIGURE 9-15

Multiple items assigned to the Ecosystem.

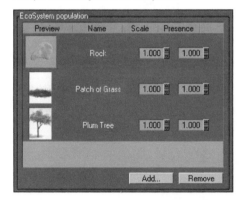

1. Reopen the Material Editor and click the Clear button.

 This will remove the rocks from the Plane object.

2. Double-click the Underlying Material preview to open the Material Selector.

 Choose Landscapes > Natural 3 for the material then click OK.

3. Click the Add button.

 From the pop-up menu, choose Plant, and then select Patch of Grass from the Plant Selector window. It might take a moment for the grass to show up in the list because the mesh is being generated along with its assigned Solid Growth capabilities.

4. Click the Add button again.

 Choose Plant again, and then the Plum Tree. Your Ecosystem Population window should look like Figure 9-15.

 QUICKTIP

 The Ecosystem items have been highlighted so you can see them better in the image. To highlight specific items in the list, click on them, or Shift-click to select contiguous items, or Cmd/Ctrl-click to select non-contiguous items.

5. Click the Populate button.

There are fewer instances assigned because there are more objects that have to fit into the scene. Now you'll make a few changes to this to see how it affects the population.

6. Click the Clear button to remove the Ecosystem from the Plane object.

7. Change the scale of the Rock instance to .325, the Presence of the Plum Tree instance to .5, and the Patch of Grass Presence to 3 (see Figure 9-16).

To do this, click in the appropriate numeric field and type in the new value.

8. Click the Populate button again.

More instances of the different items now fit onto the plane (see Figure 9-17). If you don't like their positioning, click the Clear button and then the Populate button again. You can do this over and over until the population appears as you want. Each time you click the Populate button, the items' placements are randomly generated.

FIGURE 9-16
New values assigned to the Rock and Plum Tree instances.

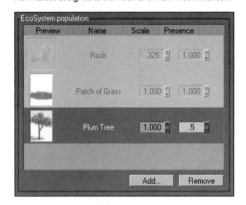

FIGURE 9-17
Looking down at the populated plane.

Changing Density

Let's face it, Figure 9-17 shows a pretty barren Ecosystem. Here, you'll fix that by changing density settings in the Density panel.

FIGURE 9-18

A thickly-populated Ecosystem.

FIGURE 9-19

Random placement has been generated using the Variable Density control.

1. Clear the Ecosystem by clicking the Clear button.

2. Switch to the density controls by clicking on the Density tab.

 To start with, make a global change (one that affects the overall density of the Ecosystem). Change overall density to 85%. You can do this by either moving the slider control, or typing the value into the numeric field. Click the Populate button to make the change. Now you have one heck of a thick Ecosystem (see Figure 9-18). Too thick, actually. Let's fix that.

3. Clear the Ecosystem again, and activate Variable Density.

 Add the Bumps > Chipped function to the Ecosystem. Then, click on the spline window and select Time Splines > Smooth Repeat 3 Times. Also, so you can see the results better, change the Overall Density to 75% and click Populate. The elements will be placed in more of a pattern (see Figure 9-19).

Adjust the Colors of Your Ecosystem

1. Open the Material Editor (again) and select Colors.

2. Activate Variable Colors.

 Double-click on the color chip to open the Color Map Selector window. Choose Terrain Editor Maps > Red Stone for the color map.

3. Click the Clear button, and then repopulate the scene.

 The color you have assigned will affect everything in the Ecosystem (see Figure 9-20) including branches, tree trunks, rocks, and so on, so you need to be careful when you use this. If all you are placing into the Ecosystem are trees, changing the color can work perfectly to change from summer to fall.

 > **QUICK**TIP
 >
 > Be aware that, with every plant instance, the polygon count will rise dramatically. This will affect not only how efficiently you work in the program, but also how long it will take for the scene to render. The Preview screen capture in Figure 9-20 took a little over four minutes to render.

Changing Color

Now you use the Color controls to give the scene more of a fall-like appearance. You use a preset group of colors for this, but you can come back and modify those later on.

FIGURE 9-20
The scene has been given a fall-like appearance through the use of the Color control.

DEFINE ECOSYSTEMS BY ALTITUDE
AND MATERIAL PLACEMENT

What You'll Do

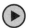

In this section, you use materials to assign Ecosystem placement.

Ecosystem Distribution Controls

You just worked with global placement of Ecosystems, but you can also use materials to control where the different instances are placed. With this method, you can more precisely place trees where you want them rather than having them populate onto the entire object.

1. Create a new scene, add a Terrain object to it, and use Eroded on the terrain until your mountain looks as you want it.
2. Assign the Landscapes > Scrubland material to the terrain.

For this project, you want to use a highly-demarcated material so you can see exactly how material placement works.

Assign an Ecosystem Based on Height

1. In the Material Editor, switch to Influence of Environment.

2. Change Material 2's (the grass material) Influence of Altitude to 48%.

 This will reduce the amount of grass on the terrain dramatically. It will only appear on approximately the top half of the terrain (see Figure 9-21).

3. Switch to Ecosystem.

4. In Ecosystem Population, select the Fir Tree and Rocks.

5. Select the Environment tab at the far right of the Material Editor window.

 Here, you can make general assignments for the placement of the Ecosystem.

6. On the right side of the window, under Range of Altitudes, select By Material (see Figure 9-22).

 This tells Vue to use the material placement for positioning of the Ecosystem elements.

Assigning an Ecosystem Based on Height

The first thing you need to do is assign the Ecosystem to the material using the material's placement on the terrain. You use Influence of Environment to accomplish this.

FIGURE 9-21
By changing Influence of Altitude, Material 2 appears only at the top of the terrain.

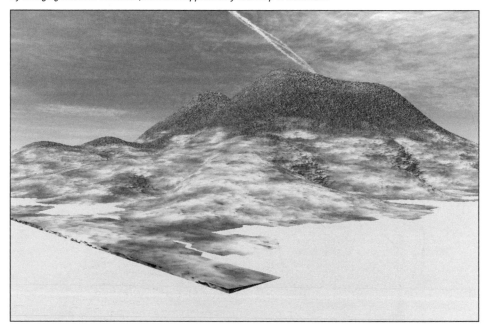

FIGURE 9-22
Range of Altitudes lets you control how the Ecosystem will be controlled.

FIGURE 9-23

The Ecosystem populated with Material selected in Range of Altitudes.

FIGURE 9-24

The Ecosystem placed when By Object is selected in Range of Altitudes.

7. Click the Populate button.

The Ecosystem will now appear on the upper portion of the terrain, where the grass is growing (see Figure 9-23).

8. Go back to Range of Altitudes and choose By Object. Then repopulate.

Now, the Ecosystem sees only the object, not the material on the object, and uses it for placement (see Figure 9-24).

Use Material Assignment

1. Clear the population and then reassign the overall material to the terrain.

 Do this by reassigning the Scrubland material to the terrain.

2. Change Influence of Altitude back to 48%, and then return to Materials to Mix by closing this materials window.

 You will now assign each separate material (Material 1 and Material 2) its own Ecosystem.

3. Double-click on Material 1.

 Depending on the amount of RAM in your computer and its processor speed, it might take a few moments for the new screen to open. Be patient during this process.

4. Change Material 1 to an Ecosystem.

 Assign Rock to this material, and change Scale to .224 and Density to 25%. The rocks have been placed only where the rock material is on the terrain (see Figure 9-25). Click OK to go back to the main Material Editor screen.

 QUICKTIP

 You will notice that some errant rocks appear in the grass material. That's because of the blending between the two materials; there is some overlap that occurs so there isn't a hard edge where one material ends and the other starts.

Using Materials for Placement

The method you just used for assigning the Ecosystem is not really precise enough. You either don't have elements you want placed where you want them, or you have elements placed where you don't need them. So, how can you fix this? Through the use of material assignment.

FIGURE 9-25

Rocks appear only on the rock texture.

FIGURE 9-26

Two distinct Ecosystems created using Materials.

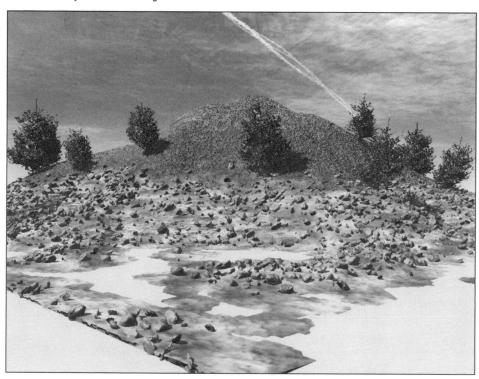

5. Open the Material 2 Material Editor window.

 This material is also a mixed material, which means you can add two more Ecosystem instances. However, you will only add one more, because with the way these two materials mix, the Ecosystem elements would overlap anyway.

6. Open Material 1 and change it to an Ecosystem.

7. Add the Fir Tree to Ecosystem Population and change Density to 90%.

8. Perform a quick render.

 The fir trees are placed on the grassy areas, showing a clear line between the two Ecosystems (see Figure 9-26). This technique can help you create unique placement of foliage, rocks, and objects in a very short period of time based upon the height information in the terrain.

Use Bitmaps to Assign Materials to Your Scene

1. Place a Terrain element into a new scene and then open the Terrain Editor.

2. Click Reset, and then click the Picture button at the bottom of the list.

 Reset will remove all height information from the terrain. For this project, you don't want any vestiges of the original terrain to interact with the image you're about to assign.

3. In the Import Terrain Data screen (see Figure 9-27), click Load located at the bottom of the list.

 You will need to navigate to the Clearing. bmp image. Once assigned, the terrain will take on the shape of the image. With grayscale images, white represents the high points and black represents the low points of the terrain. Shades of gray represent the in-between heights, which is why this image has a blur assigned; you don't want a sharp line between the path and clearing and the rest of the terrain.

4. In the Proportions section of this window, take the slider down to 7% (or type the value in the numerics field).

 This will reduce the height of the terrain (see Figure 9-28). You are setting the height between the flat terrain and the image map. Once you have it set, click OK.

Using Bitmaps to Assign Ecosystems

But wait! There is another way to assign materials and Ecosystems to your scenes.

You can use bitmap images to place Ecosystems as well as to assign textures to your scenes. Here, you use a bitmap image (downloadable from the book's website at www.courseptr.com/downloads) to create your terrain, place the textures accordingly, and assign a specific Ecosystem.

FIGURE 9-27
The Import Terrain Data window.

FIGURE 9-28
The new terrain shape, which is a blend between the flat terrain and the image map.

5. Return to the workspace (closing out the Terrain Editor). Select Main Camera in the Layers window, move it up and rotate downward so the terrain fills the Main Camera View window.

This way, you can better see the effect you will be creating. You will also want to move the Terrain off the ground slightly, otherwise the ground plane will cover up the material assigned to the indented portion of the terrain.

6. Assign the Landscapes > Rock & Grass texture to the terrain.

Also change to Object Parametric so the material is UV mapped onto the terrain.

7. Right-click on the Distribution of Materials 1 & 2 preview window and select Edit Function.

This takes you into the Function Editor (see Figure 9-29). For now, without going into a lengthy dissertation, the Function Editor is a very powerful tool for texture creation. It displays the texture information in tree form, with links connecting the various **nodes** to generate the materials. Because you are only changing a distribution function, this window is fairly easy to understand. For the material position, a Basic Repeater has been linked; it tells Vue how the two materials are to look. A combiner is added to make the mixed materials combine together using the repeater. And finally, the Distribution function makes sure that the combined materials are distributed using the repeater. Sounds complicated in one sense, but this is how the Grass & Rock material has been defined.

You're going to use the Clearing.bmp image map to make the materials combine in a different manner.

8. Click on Distribution.

The node will highlight, letting you know it's active.

FIGURE 9-29

The Function Editor window, which gives you a graphical display of the elements that make up a material.

9. Click on the Add Texture Map Node (see Figure 9-30).

This will break the link between the Basic Repeater and Combiner to the Distribution function. The Projected Texture function is now linked to Distribution (see Figure 9-31). In other words, the image you're about to assign will tell Vue how to distribute the materials on the terrain.

At the bottom of the Function Editor is the area where you assign the texture map. By default, Projected Texture Map is assigned to the pop-up menu. That's what you want. You can also give your new texture node a title and a description if you want, but it isn't necessary.

FIGURE 9-30
The Add Texture Map Node is highlighted.

Add Input Node
Replace by Output

Add Noise Node
Add Fractal Node

Add Color Node
Add Texture Map Node
Add Filter Node
Add Constant Node

Add Turbulence Node
Add Combiner Node
Add Math Node

FIGURE 9-31
The texture node is now assigned to the Distribution node.

FIGURE 9-32

Use the load button to link to the image map file.

FIGURE 9-33

The image map in the Function Editor window.

10. Click the Load button (the right-pointing arrow) under the blank preview window in the Texture Map Node section (see Figure 9-32), and assign the Clearing. bmp image.

Once it is chosen, the image map appears in the two Texture Map Node previews, and in the Projected Texture Map node. Here, I gave the texture map the title *Clearing*, which shows up as the name of the node (see Figure 9-33).

11. Click OK to return to the Material Editor.

The image map is assigned to the distribution of the materials.

12. Change the X, Y, and Z Scale of Distribution Function to 1.

These new settings ensure that the distribution is not smaller than the terrain. If you did not change these numerics, the material would tile on the terrain.

13. Click swap so the rock texture becomes Material 1 and grass becomes Material 2.

The material preview window now shows the shape of the distribution map, with the rock texture in the clearing portion of the map (see Figure 9-34). Perform a quick render to see the materials and how they are assigned (see Figure 9-35).

Now you're ready to assign the Ecosystem.

14. Select Material 1 (the Clumpy Rock texture) and turn it into an Ecosystem.

Assign Rock to this material, and Scale to .2. Set the density of the rocks to 90%. Then click Populate.

15. Select Material 2 (the material that isn't Clumpy rock) and turn it into an Ecosystem.

Choose Plant > Primrose for the Ecosystem. Leave the Scale setting and density as they are, and click Populate.

Perform a quick render (see Figure 9-36). The flowers are positioned in the grassy areas, whereas the rocks are confined to the clearing.

Using image maps, you can create any type of scene, with plants and objects positioned precisely where you want them.

FIGURE 9-34
The material distribution is shown in the Material Editor preview window.

FIGURE 9-35
A quick render reveals the two materials are positioned exactly as you want them.

FIGURE 9-36
A precisely positioned Ecosystem using an image map for placement.

CREATE ECOSYSTEMS THAT INTERACT
WITH FOREIGN OBJECTS

What You'll Do

In this section, you create a complex Ecosystem and then place an object into the scene, removing the Ecosystem from under it.

Creating forests and complex Ecosystems is one thing. There are times when you will want to have an Ecosystem surround a house or some other object in the scene you're creating. By default, you cannot select individual or groups of Ecosystem objects once they have been placed (just take a look at the Layers window after an Ecosystem has been created; none of the objects are listed). But there is a feature that can force the Ecosystem to recognize foreign objects and respond accordingly.

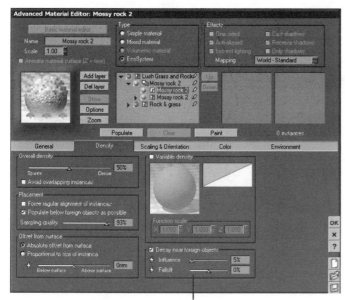

Foreign Object Influence Controls

Control Ecosystem Instances

1. Place a Plane primitive into your scene and scale it so it is nice and large.

 Also reposition your camera so it is facing down at the plane. This way, when you create your Ecosystem, you will see the object interaction much better. The way to reposition the camera is to select it in any of the viewports, and then use the Move and Rotation gizmos to move the camera into place.

2. Create the following Ecosystem:

 Material—Grass.

 Turn Material 1 (dark green grass) into an Ecosystem.

 Set the Density to 100%.

 Populate the Ecosystem with Plum trees. You now have a plane that is totally covered by the trees (see Figure 9-37).

3. Choose Objects > Architecture and select Building 1.

 This will place the building object into the middle of the forest. But it's so small; it is totally covered up by all the trees. In all actuality, the building mesh is being cut into by the tree meshes, and, if you did see the building, it would have branches, leaves, and tree trunks growing through it.

Controlling the Placement of Ecosystem Instances

In this section, you learn how to make objects interact and control the placement of Ecosystem instances in your scene.

FIGURE 9-37

There are so many trees, you can't see the forest (or the plane, to be exact).

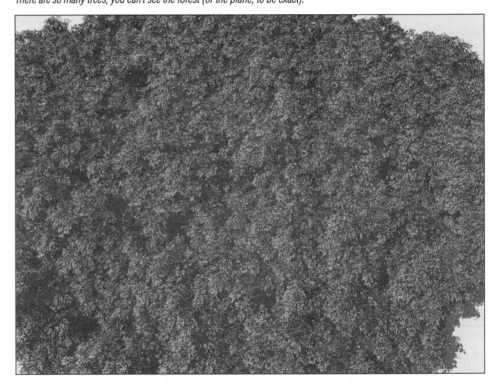

FIGURE 9-38

The Decay Near Foreign Objects control.

FIGURE 9-39

A clearing has been formed using Variable Density.

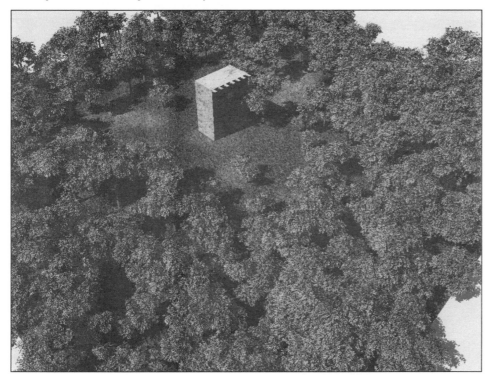

4. Select the Plane object again, and go into the Material Editor.

5. Go to Material 1's Material Editor and go into the Density section.

 Under the Variable Density control section is the Decay Near Foreign Objects control (see Figure 9-38). This controls how the Ecosystem reacts to any objects placed into the scene.

6. With Variable Density active, click Clear, and then the Populate button.

 The trees will magically disappear around the building object.

7. Change the Influence setting to 10 and then repeat Step 6.

 Now the trees are farther away from the building, giving you the look you want (see Figure 9-39). The Influence control basically is a fader; depending on how you set it, trees and other Ecosystem objects will start appearing slowly until they are at full density.

CREATE INTERACTIVE ECOSYSTEMS
WITH THE PAINT TOOL

What You'll Do

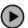

In this section, you discover the Paint Ecosystem tool (or EcoPaint, as I have dubbed it).

Number of Population Instances

Tool Selector

Ecosystem Paint Controls

Population List

Ecosystem Paint Application Selector

Vue 6 doesn't just limit you to assigning Ecosystems to an object; you can now place them on infinite planes through the use of EcoPaint.

QUICKTIP

EcoPaint takes advantage of pressure sensitivity afforded by drawing tablets, such as the Wacom line of tables found at www.wacom.com.

First, let's take a look at the EcoPaint controls, and then you'll modify a scene you made a couple of chapters ago.

To access EcoPaint, click the Paint Ecosystem button in the control bar (see Figure 9-40). Immediately to the right of the Paint Ecosystem button is the Select Ecosystem Instances button, discussed shortly.

Figure 9-41 shows the Ecosystem Painter control window. The controls are defined as follows:

- **Clear/Undo/Redo Buttons**—The Clear button clears the entire Ecosystem you created. Undo removes the last change you made to the Ecosystem. Redo places the just-removed Ecosystem elements back into the scene.
- **Display Options button** (see Figure 9-42)—This button lets you control how the Ecosystem elements are displayed in the workspace. Figure 9-43 shows the choices you have from the pop-up menu.
- **Tool section**— Gives you the tools to paint Ecosystem elements into the scene.

- **Scale/Color section**—Sets the base size of Ecosystem elements and the underlying color for them.
- **Ecosystem Population section**– Like the Ecosystem Material screen, here is where you select what will go into your Ecosystem.
- **Paint What buttons**—Choose to paint on everything in the population list, or an individual element.

FIGURE 9-40

The button on the left accesses the Paint Ecosystem controls. The button on the right accesses the Select Ecosystem Instances control panel.

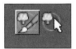

FIGURE 9-41

The Ecosystem Painter control window.

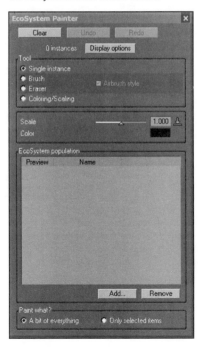

FIGURE 9-42

The Paint Ecosystem Display Options window.

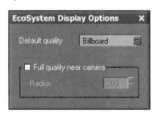

FIGURE 9-43

The display options provided via the pop-up menu.

Paint Your Ecosystem

1. Open the SkyTest scene you created in Chapter 6. (Thought I forgot about that scene, didn't you?).

2. Open the Paint Ecosystem.

 Click the Load button and select the alien plant you probably thought I also forgot about. This plant might take a few moments to load. Also load one or two other alien plants from Vues's plant collection. Your screen should look like you see in Figure 9-44.

3. Select the plant you created by clicking on it once in the population list.

 You could choose the Single Instance tool, which will add one instance of the plant into the scene, but that kind of defeats the purpose, so choose Brush. The window will expand to give you access to the brush controls.

 - **Brush Radius**—The size of the brush.
 - **Brush Flow**—How heavily the selected elements will be placed in the scene. The higher the setting, the more objects will be placed.
 - **Scale**—Sets the maximum size for the objects.
 - **Color**—Sets the underlying color for objects you paint in.

 To the right of each of these selections is a downward pointing arrow and a horizontal line (see Figure 9-45).

Painting Your Ecosystem

Let's go ahead and begin painting an Ecosystem. Remember, you can now add your Ecosystem to the ground plane (which you can't do with a material-based Ecosystem) or any other infinite plane.

QUICKTIP

Before you begin, you will need to download the Chapter 9 folder, which includes the shyAlphaPlane.vob object and two image files (shy.bmp and shy_a.bmp) from the book's website (at www.courseptr.com/downloads) and place them anywhere you would like on your computer. I suggest that you move the .vob file into the Objects folder in your Vue 6 Infinite folder for easier retrieval.

FIGURE 9-44
The alien plants you'll use in this scene.

FIGURE 9-45
These buttons, associated with Radius, Flow, and Scale, let you take advantage of drawing tablet technology.

FIGURE 9-46

A Wacom drawing tablet. This one is the Intuos3 6×11 tablet.

FIGURE 9-47

The alpha plane is too large for the scene.

FIGURE 9-48

Position the alpha plane so it is in the foreground and behind some of the plants you placed.

Click on each instance of this button to have Vue recognize your drawing tablet. In my case, I used a Wacom Intuos3 6×11 tablet (see Figure 9-46).

QUICKTIP

EcoPaint can be used only in the Top View window.

5. With Brush selected, change the Radius to 10, Flow to 25, and Scale to .5.

6. Click Only Selected Items in the Paint What? Section. This way, only the selected plant will be added to the scene.

7. Move your cursor over the Top View window and begin to paint the plant you created onto the foreground terrains and the ground plane.

When you move your cursor into the Top View window, the cursor will change to a red circle. If you use a drawing tablet, depending on the pressure you use, this circle grows larger, up to the maximum size you set.

8. Repeat this process for the other plants in your Ecosystem.

Increase or decrease the size as you wish. This is your scene. Have some fun with it. Make sure to have these two plants appear on all the terrains as well. Once you're done, close the EcoPaint window.

QUICKTIP

If you make a mistake, switch to the Eraser tool and draw over the areas you want to remove. You can erase selected objects, or all the objects if you wish.

9. Press the Load Object button and load the shy.vob file you downloaded.

This little guy is a bit too large for the scene (see Figure 9-47). Scale him down until he fits comfortably in the open space near the foreground and behind some of the plants you put in the scene (see Figure 9-48).

10. Perform a preview render to get an idea of what you have. Looks like you caught the little guy changing. But you don't see him too well...

11. Add a spot light to the scene and move it into position so it is shining on the alien (see Figure 9-49).

 Go to the Aspect window and change the light color to a very pale red. Also, change the light's Spread to 45 (this will control how wide the beam is) and the Power to 30. This will keep the overall color theme of the scene intact (see Figure 9-50).

FIGURE 9-49
A spotlight has been place into the scene to illuminate the alien.

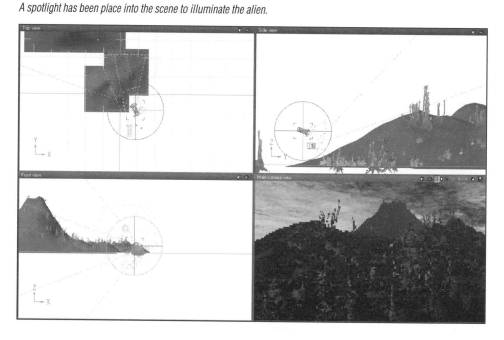

FIGURE 9-50
The spotlight has illuminated the foreground so it is not so dark. A red color helps keep the feel of the scene.

Understanding What the Select Ecosystem Instances Button Does

Earlier, you were told that you cannot select Ecosystem instances once they are placed. They do not add the objects into the layers window. Well, that's true for Ecosystems, but it's not true for EcoPaint. You can convert Ecosystem elements into objects, modify them, and then turn them back into Ecosystem instances using this control window.

FIGURE 9-51

The Ecosystem Selector window.

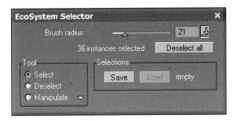

FIGURE 9-52

The selected instances are highlighted in red (or, as in this image, they are light gray).

1. Click on the Select Ecosystem Instances button in the control bar.

 The Ecosystem Selector window will open (see Figure 9-51). Here you can use these controls:

 - **Brush Radius slider**—Change this to encompass a larger or smaller area of the scene.

 - **Deselect All button**—Deselects the selected objects. To the left, it tells you how many instances you have selected.

 - **Tool section**—Choose Select or Deselect to select or deselect Ecosystem instances, or choose Manipulate to rotate or perform other options on the Ecosystem instances, as well as turn them into objects.

 - **Selections**—You can save the Ecosystem instances as objects, or load them again into the scene.

2. Choose Select, and paint over the elements you want to work with.

 The selected items will be highlighted in red (see Figure 9-52).

3. Make the Manipulate control active in the Tool section of the Ecosystem Selector window and choose Convert to Objects from the pop-up list by clicking on the downward pointing arrow.

 Within a few moments, the selected plants will be turned into objects and appear in the Layers window (see Figure 9-53).

4. After you have finished doing whatever you were doing to the objects, right-click on one of the windows (while the objects are still selected) and choose Revert to Instances from the submenu (see Figure 9-54).

 Now everything is back the way it was originally.

FIGURE 9-53

The plant instances have now become objects and are listed in the Layers window.

FIGURE 9-54

Use the submenu to return the objects into instances.

CHAPTER SUMMARY

As you can see, Ecosystems are a powerful way to populate your scenes with plants, rocks, and even objects. Although you did not select any objects to use as an Ecosystem, the processes you learned are the same. You merely select an object, and then add it to the scene using the standard material-based Ecosystem controls or using EcoPaint.

What You Have Learned

In this chapter you

- Learned how to create material-based Ecosystems.

- Discovered how to use bitmap files to assign Ecosystem instances.
- Worked with the Paint Ecosystem controls.
- Learned how to turn Ecosystem instances into objects and change them back.

Key Terms from This Chapter

EcoPaint A Vue 6-specific tool that allows you to *paint* an Ecosystem onto any surface in your scene.

Ecosystem A Vue 5 Infinite- and Vue 6-specific feature that allows users to select plants, rocks, and objects and, with the click of a button, populate a scene. In all

other 3D applications, you have to place the rocks, trees, or objects individually.

Node(s) A processing location. Each node is linked together visually by interconnecting lines showing a tree-like representation of the elements making up a texture.

Spline A control, represented by a line, that either defines a shape that will be turned into a 3D object, or that graphically shows movement or change between a starting and ending point of an animation.

Wacom tablet A pressure-sensitive drawing tablet made by the Wacom company that allows you to use a Pen-shaped mouse to *paint* on your images or 3D objects.

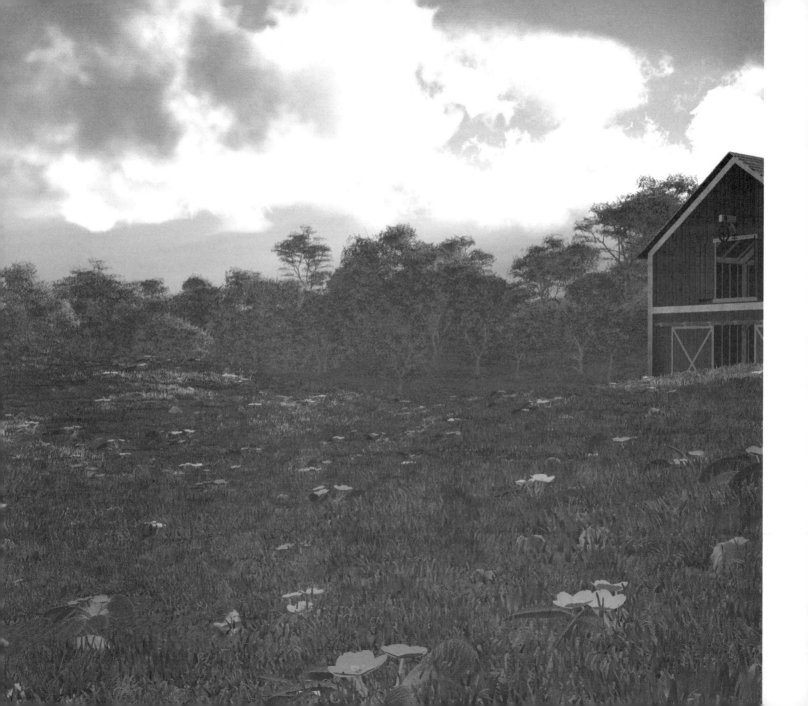

10

THE ATMOSPHERE EDITOR—
PART 2

1. Perform spectral analysis and work with Godrays.

2. Use filters and functions to change cloud appearance.

3. Work with metaclouds.

chapter **10** **THE ATMOSPHERE EDITOR—**
PART 2

In Chapter 6, you learned how to create standard, volumetric, and mapped atmospheres via the Atmosphere Editor. There is one more atmosphere type that wasn't covered in that chapter, and that is **spectral atmospheres**. These atmospheres, for many, have become the atmosphere of choice because, with them, the skies you create go into the realm of ultra-realism.

Spectral atmospheres are based entirely on physical behavior. The spectral engine lets you control the amount of dust and humidity in the air, the sun's corona (see Figure 10-1), the dispersion of light, and

FIGURE 10-1

A sample of how light interacts with the atmosphere. Here, the sun is shown with a small corona and with a more advanced corona, where the light is dispersed due to dust and water particles in the air.

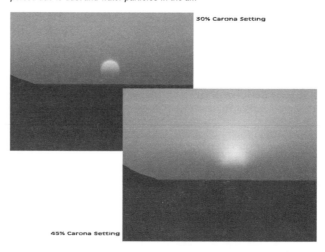

30% Carona Setting

45% Carona Setting

much more. Clouds can have depth and be affected by the sun (controlling color and shadows), and you can create spectral beams of light (called **Godrays**—a term I always hear Sean Connery saying in his Scottish brogue). Figure 10-2 shows Godrays using one of the predefined atmospheres included with Vue.

Clouds also have a new purpose in life for your scenes. In other atmospheric models, the clouds are on a plane; they have no depth and are there just for looks. With spectral atmospheres, the clouds are volumetric and have depth and substance (see Figure 10-3). This means that you can now create scenes with the camera directly inside the clouds or an animation following an object through the clouds. There are also **metaclouds**, which can be used for fog or mist or even smoke coming out of a chimney. These, too, are accessible only when using spectral atmospheres.

FIGURE 10-2

The scene created in Chapter 5 with a spectral atmosphere assigned to it. Godrays, the streaks of light, are one of the features accessible in this atmospheric model.

FIGURE 10-3

Spectral clouds have depth and substance, allowing for greater realism in your scenes.

Tools You'll Use

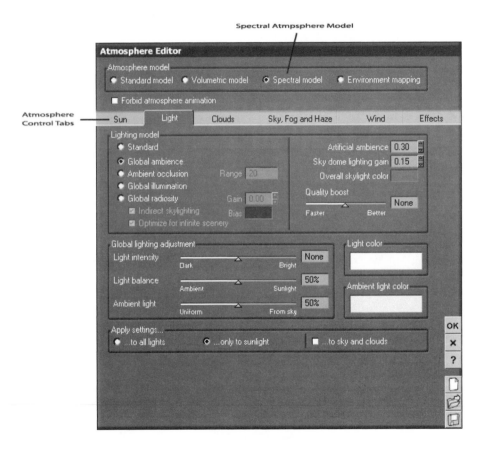

Spectral Atmpsphere Model

Atmosphere Control Tabs

Atmosphere Editor

Atmosphere model
- ● Standard model
- ● Volumetric model
- ● Spectral model
- ● Environment mapping

☐ Forbid atmosphere animation

| Sun | Light | Clouds | Sky, Fog and Haze | Wind | Effects |

Lighting model
- ● Standard
- ◉ Global ambience
- ● Ambient occlusion Range 20
- ● Global illumination
- ● Global radiosity Gain 0.00
 - ☑ Indirect skylighting Bias
 - ☑ Optimize for infinite scenery

Artificial ambience 0.30
Sky dome lighting gain 0.15
Overall skylight color

Quality boost None
Faster Better

Global lighting adjustment
Light intensity None
Dark Bright

Light balance 50%
Ambient Sunlight

Ambient light 50%
Uniform From sky

Light color

Ambient light color

Apply settings...
- ● ...to all lights
- ◉ ...only to sunlight
- ☐ ...to sky and clouds

OK
✕
?

PERFORM SPECTRAL ANALYSIS
AND WORK WITH GODRAYS

What You'll Do

In this lesson, you turn a standard atmosphere into a spectral atmosphere, and then add and modify low-lying and cumulus clouds.

Before you begin this section, let's have a little lesson on clouds and cloud types. It's going to be important as you move through the chapter to understand what cloud types you are adding and how they should look if you want to create a realistic scene. This will be short, I promise. You won't be a meteorologist after reading this.

There are three basic types of clouds (see Figure 10-4):

- Cirrus—These clouds are curly and/ or fibrous.
- Stratus—These cloud types can be both flat and layered.
- Cumulus—These clouds are puffy and stacked.

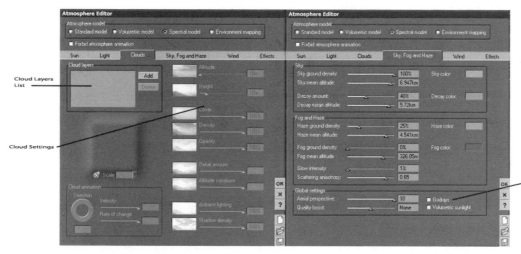

Then there are sub-categories of these based upon their height in the sky:

- Cirro—This prefix is assigned to high clouds whose base is above 20,000 feet.
- Alto—These are mid-level clouds, floating between 6,000 and 20,000 feet.
- Nimbo—A prefix meaning the cloud is producing precipitation of some sort. You can also add the term Nimbus to the end of the cloud name, as in cumulonimbus. It means the same.

And to end this, let's break it down a little further into the different cloud types with and without their prefixes.

- Cumulonimbus—These are thunderheads that hover near to the ground and up to 50,000 feet.

- Cirrostratus—These are thin, wispy clouds that appear above thunderheads, somewhere above 18,000 feet.
- Cirrocumulus—These are small, puffy clouds that usually live above 18,000 feet.
- Altostratus—These are thin, uniform clouds, sometimes having a corduroy appearance, that hang out between 6,000 and 20,000 feet.
- Altocumulus—These are medium-sized puffy clouds that also claim the 6,000–20,000 feet mark as their homes.
- Stratocumulus—These are wide and flat on the bottom but puffy up top and reside below 6,000 feet.

Okay. End of science class. But seriously, if you begin to recognize the types of clouds you are putting into your scenes, it will help as you make your cloud placement. Trust me, there will be people out there who know this stuff and will look at your images and say: "No way! Altocumulus clouds would never be above Cirrostratus clouds!" They'll say that. Really.

Changing to and Setting Up Spectral Atmospheres and Godrays

The process of changing from any other atmospheric model to spectral is easy. The challenge comes in modifying the settings for the particular look you're trying to achieve. In this case, you are setting up a scene that will include Godrays—beams of light streaming through the holes in the clouds.

FIGURE 10-4
The three basic cloud types.

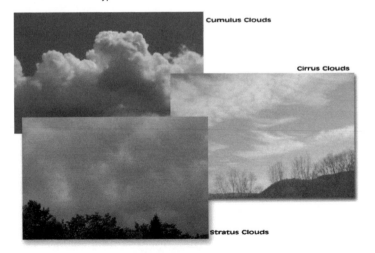

Cumulus Clouds

Cirrus Clouds

Stratus Clouds

> **QUICK**TIP
>
> You will want to change Vue's measurement display to feet to help you better position the clouds. Do this by going to Vue 6 Infinite > Preferences > Display Options (Mac) or File > Options > Display Options (PC) and changing Length Units to Feet.

FIGURE 10-5

There are two types of spectral clouds you can add to the scene: Cumulus and Low Clouds.

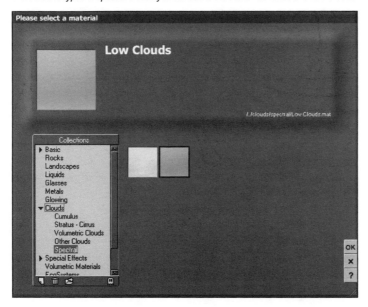

1. Use the Basic > Soft Sunshine atmosphere for this scene.

 You can use any atmosphere you want—all can be changed to spectral—but everyone should start out on an even playing field through this section. Also, assign any water texture you want to the ground plane.

2. Open the Atmosphere Editor and click the Spectral button to change the atmosphere.

 You won't see much of a change, except the scene will get much brighter. This is because of the way the light is being affected by the new atmosphere model.

3. Go to the Clouds tab and, in the Cloud Layers list, remove the Cumulus cloud layer by clicking the Delete button next to the cloud list.

 The cloud layer that was originally placed into this scene is a standard cloud plane. You're going to change this over to a spectral cloud layer that has depth and interacts with the light.

4. Click the Add button and navigate to Clouds > Spectral (see Figure 10-5).

 There are only two types of spectral clouds to add to the scene: Cumulus and Low Clouds. These are both volumetric clouds that can be manipulated to create almost any cloud types you want.

5. Select Low Clouds.

 These are basically altostratus clouds, low-lying clouds that appear under 6,000 feet. After you have assigned the spectral clouds, although they will still be much too bright, shadows appear on the ground plane where the clouds are being blocked by the sun (see Figure 10-6).

6. You will also want to change Scale (immediately underneath the Cloud preview window) to 1 rather than .10.

 Scale of the clouds is important to get any type of definition to them. The default setting for Low Clouds is much too small, making a lot of tiny clouds that look clumpy in the scene. By scaling them up, you stretch the volumetric material to make them look more natural.

7. Change the cloud altitude setting to 1,132 ft.

 As you make these changes, the clouds will have more openings, which will be perfect for later in the chapter.

FIGURE 10-6

The sun interacts with the spectral clouds, creating shadowing on the ground.

FIGURE 10-7

The settings to create the clouds in this scene.

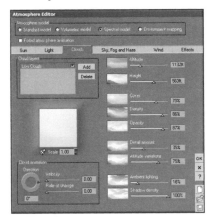

FIGURE 10-8

The settings for the sun's position and corona.

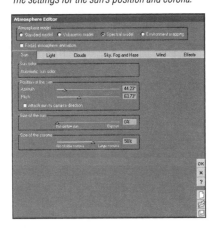

FIGURE 10-9

If, for whatever reason, the sun is not positioned like this, manually move it into place.

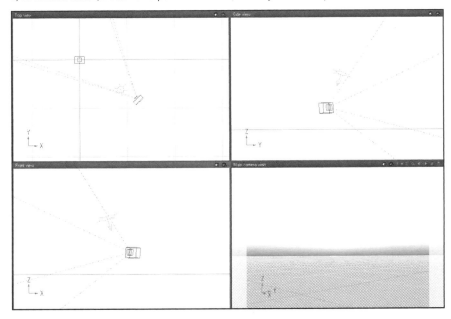

8. Make the following changes to the clouds. Refer to Figure 10-7 to help you out:

 Height—563 ft.

 Cover—70%

 Density—86%

 Opacity—87%

 Detail Amount—35%

 Altitude Variations—75%

 Ambient Lighting—18%

 Shadow Density—100%

 With these settings, you've placed the cloud layer low enough in the sky and made it thick enough that when you change the amount of light and the position of the sun, your sky will come to life.

9. You need to darken the sky so the clouds aren't washed out. First, go to the Sun tab and make the changes you see in Figure 10-8.

 Your sun should be positioned above and very slightly to the right of the camera. If for some reason it isn't, move the sun into the basic position you see in Figure 10-9.

10. Figure 10-10 shows the next set of controls you need to change—Light.

Notice that light intensity has been set all the way at dark. At this stage, because the sun is above the clouds and pointing directly down, its illumination is so bright that the image will become washed out. By putting the Light Intensity setting to its low maximum of −2, you are helping to bring detail into the sky (see Figure 10-11). The RGB values for each of the colors—Overall Skylight Color, Light Color, and Ambient Light Color—are also shown.

FIGURE 10-10

The settings for Light within the scene.

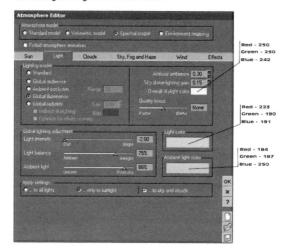

Red - 250
Green - 250
Blue - 242

Red - 223
Green - 190
Blue - 191

Red - 184
Green - 187
Blue - 250

FIGURE 10-11

The Light set to its darkest setting brings out these low-lying clouds. Notice the highlights in the high points.

FIGURE 10-12

The Sky, Fog and Haze settings you should use.

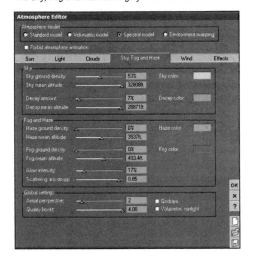

FIGURE 10-13

The scene with Godrays activated. The numerous holes in the cloud layer allow beams of light to shine onto the surface of the water.

11. And now to Sky, Fog and Haze. Select that tab and change the settings to what you see in Figure 10-12.

These settings are not much different than the defaults. Unless you want an extremely foggy or hazy atmosphere, the base settings are usually fine. This is especially true when dealing with Godrays, because the haze and fog can block out the effect.

Let's make some Godrays! After you have set up your atmosphere, creating Godrays, the beams of light streaming through cloud openings, is extremely easy. The hardest part is setting up your clouds and atmosphere.

12. In the Sky, Fog and Haze panel, located in the lower right, is a selection titled Godrays. Activate it by checking the Godrays box.

The sky will darken immensely. Actually, too much so. In order to make this look the best, go back to the Light window and change Light Intensity to -64. The clouds will become less dark, but the rays will remain prominent. Refer to Figure 10-13 for comparison.

Save your scene as **Ch10_FirstProject** before moving on.

USE FILTERS AND FUNCTIONS
TO CHANGE CLOUD APPEARANCE

What You'll Do

 In this lesson, you learn how to edit the cloud layers in order to achieve the look you want for your scene.

Cumulus clouds can be used to make some very interesting looks, from white, puffy clouds meandering slowly across the sky to aerial perspectives looking down at a veritable mountain range of cottony formations. Although you can achieve this look by merely moving the Cloud sliders around, you can actually get much more interesting volumetric cloud effects with the use of functions and filters.

Filtering Clouds (and Functions, Too)

For the next lesson, you need to set up a spectral scene, removing any clouds from the original atmosphere you chose and assigning the Spectral > Cumulus cloud layer to the project.

> **QUICK**TIP
>
> It is perfectly okay, and many times preferable, to use both spectral and standard cloud layers in your scene. The latter can provide a bit more interest to the skies you create.

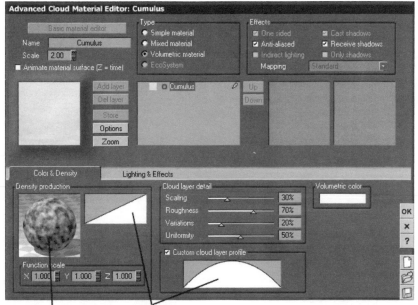

Function Control Filter Controls

FIGURE 10-14

The spectral clouds you add to the scene are represented by a gray bar in the Side and Front viewports.

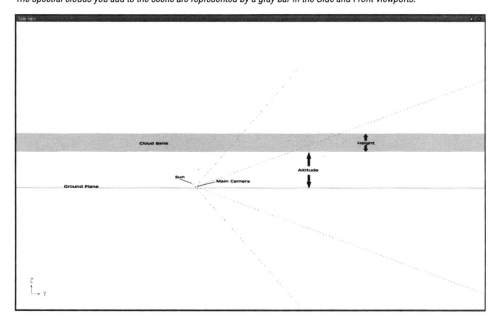

FIGURE 10-15

The sun causes the shadowing in the clouds rather than the atmosphere defining them.

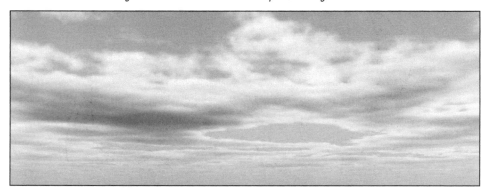

1. After placing the spectral cumulus clouds into your scene, go to the Side view and either click Zoom Out or, if you have a scroll wheel on your mouse, use it to zoom out. Zoom until you see a gray bar stretched across the viewport (see Figure 10-14).

 This is the actual cloud bank you added. It shows its position above the ground (Altitude), as well as how dense the clouds are (Height). By making changes to the Altitude and Height controls, this bar will change its position as well as thickness. Stay zoomed out to see how changing these two controls affects the cloud bank.

2. Make the following changes to the clouds:

 Scale—1.00

 Altitude—328 ft.

 Height—50 ft.

 Cover—73%

 Density—75%

 Opacity—82%

 Detail Amount—50%

 Altitude Variations—98%

 Ambient Lighting—0%

 These changes will ensure that you have a good, puffy cloud bank. With Ambient Lighting turned off, it's the sun that shades the clouds (see Figure 10-15) rather than the ambience in the scene.

3. Move the Main Camera above the cloud layer.

 The camera should sit just above the top of the cloud bank, as you see in Figure 10-16.

4. Move the sun so it is perpendicular to the camera (see Figure 10-17).

 By moving the sun into this position, the details of the clouds will increase so they are not just a sea of white (see Figure 10-18). Take a few moments to move the sun around in the scene, including moving it behind the camera, looking at how its position affects the look of the cumulus clouds.

 QUICKTIP

 For all intents and purposes, after the camera has been moved above the clouds, the cloud bank becomes the horizon. If you move the sun below the cloud bank, you will get a nighttime scene. The closer the sun is to the top of the cloud bank, the more twilight lighting will be added.

 Now let's have some fun.

5. Double-click on the clouds preview window, or click the small globe with the right-pointing arrow located to the lower left of the preview window, to open the Material Editor.

FIGURE 10-16

The camera should be positioned just above the cloud bank.

FIGURE 10-17

The sun moved into position to bring out details in the clouds.

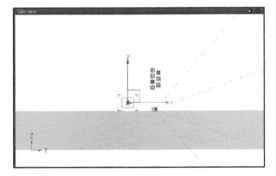

FIGURE 10-18

Cloud details with the sun moved to just above the cloud bank.

FIGURE 10-19

With Cast Shadows active, the material will create shadows upon themselves, adding more depth and realism.

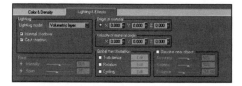

FIGURE 10-20

The cumulus clouds with Cast Shadows turned on.

FIGURE 10-21

Functions and their effects upon the cloud production. Note: The camera has been moved up so you can better see the function results. The Shattered Fields material has also been assigned to the ground plane.

6. Under Lighting & Effects, check the Cast Shadows box in the Lighting section (see Figure 10-19).

 This sets the cloud material to cast shadows upon itself based upon sunlight (see Figure 10-20).

7. In the Color & Density section, double-click on the Density Production thumbnail to open the Functions Selector window.

 When you change the type of function assigned to the material, the clouds take on a totally different appearance. Figure 10-21 shows three different functions assigned to the clouds and how the clouds appear after the assignation.

8. Change the Function to Bumps > Desert Bumps.

 This will change the clouds to a nice, fluffy, realistic looking covering (see Figure 10-22).

9. Open the Filters Selector window for the filter immediately to the right of the material thumbnail.

10. Select Other Filters > Strange #1 and click OK.

 This will reshape the clouds based upon the spline settings. Click OK after setting this to go back to the main Material Editor window.

11. Change the cloud's Scale setting to .3.

 By reducing the scale, more details of the function and filter combination will become apparent (see Figure 10-23).

12. Add a second cumulus cloud layer and move it above the first layer.

 Here are the settings for this layer.

 Altitude—751 ft.

 Height—92.4 ft.

 Cover—75%

 Density—75%

 Opacity—89%

 Detail Amount—82%

 Altitude Variations—93%

 Ambient Lighting—23%

 Also, make sure to go into the Material Editor and assign Cast Shadows to this layer.

FIGURE 10-22
With the Desert Bumps filter, your clouds should look similar to this.

FIGURE 10-23
More cloud details appear when you reduce the scale of the cloud material.

FIGURE 10-24

The sun's new position in the scene.

FIGURE 10-25

The almost finished scene with an old-timey plane flying between the cloud layers.

13. Move the sun so it is in the basic position you see in Figure 10-24.

The Azimuth setting is 78.61 degrees, and the Pitch is 14.20 degrees. After you have positioned the sun, click OK to close the Atmosphere Editor.

14. Choose Objects > Vehicles > Airplanes and place the P40c airplane into the scene.

This airplane model comes with Vue. Move the plane into position between the two cloud planes and render. Your almost-completed scene should look similar to Figure 10-25.

QUICKTIP

A spotlight was added to the scene to illuminate the airplane.

Save the scene before moving on.

Finish and Populate the Scene

1. Add a Plane primitive to the scene.

 Stretch the plane to a very large scale; you want it to fill a good portion of the sky. Move it into position so you see it in its entirety.

2. With the plane selected, go into the Material Editor and set Transparency to 100%.

 You don't want the Plane object to be visible in the final render. This will have no other effect on creating the Ecosystem.

3. Change the plane material to Ecosystem.

 Select Object from the population list, and then choose the P40c model.

4. Make the following changes to Density:

 Placement—Turn on Force Regular Alignment of Instances. Populate Below Foreign Objects as Possible doesn't have any effect on this Ecosystem.

 Offset from Surface—Turn on Absolute Offset from Surface.

 This will make the objects line up in the same direction and keep them aligned on the vertical axis (Y axis).

5. Make the following changes to Scaling & Orientation:

 Overall Scaling—Set to .324.

 Maximum Size Variation—Set X to 0 and Keep Proportions to 100% Uniform.

Direction from Surface—Set to 100% Perpendicular.

Rotation—Set to 0 degrees.

These settings make sure the planes are all the same size and they are all perpendicular to the surface of the Plane object.

6. Populate the scene.

 Your sky will be filled with airplanes. Rotate the Plane object slightly and render. Your scene will look similar to Figure 10-26.

FIGURE 10-26

Your completed scene with a Spectral atmosphere and an Ecosystem filled with airplanes.

Completing Your Scene

So why is this only a semi-completed scene? Because that airplane is going to become a squadron of airplanes. You'll do this by using a Plane object and assigning the aircraft as an Ecosystem to it. Before you begin, remove the P40c from the scene.

WORK WITH
METACLOUDS

What You'll Do

In this lesson, you work with another volumetric cloud material that is accessible only with spectral atmospheres—metaclouds. You use much of what you have learned throughout the book, combining Ecosystems, terrains, spectral atmospheres, and metaclouds, to create a completed scene.

MetaClouds ——————

Another effect available to you are **meta-clouds**. Metaclouds, like the spectral cumulus and low-lying clouds, are a volumetric material available only through the spectral atmosphere model. Metaclouds are large, multi-part masses that can be manipulated to become anything from an errant cloud floating across the sky to smoke rising from a chimney.

QUICKTIP

Metaclouds are only accessible when using spectral atmospheres.

The base metacloud is made up of hundreds (or what seems like hundreds) of spheres (see Figure 10-27), each with a volumetric material assigned to it. Basically, it's monstrous. You can remove spheres from this oversized default metacloud to make it a more manageable size.

There is another cumulus cloud metacloud model available for download on the book's website in the Chapter 10 section. This is the one you will be using during this section of the chapter. You will need to download and install the cumulus1.cld metacloud file, which is made up of fewer spheres and is much more manageable. To install it, drag it into the Clouds folder inside your Vue 6 folder on your computer.

FIGURE 10-27
The base metacloud model is made up of hundreds of spheres.

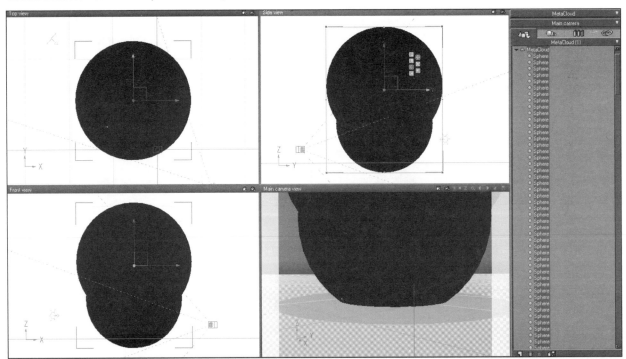

Before starting, let's take a look at the various metacloud controls.

First, notice there is a downward-pointing arrow in the Aspect window (see Figure 10-28). This means there are controls you can access directly from there. Click on that arrow, or right-click on the window. A submenu will appear (see Figure 10-29):

- META Layered Cloud—Tells you the metacloud is selected.
- Collapse Identical Materials—Combines layers of the cloud that have the same material assigned. Clicking on this to deselect it will expand your list of choices, breaking out the various layers of clouds and their materials (see Figure 10-30). You can now select

and modify the material assigned to an individual sphere.

- Edit All Materials—This is the same as double-clicking on the preview window and opening the Material Editor. With Collapse Identical Materials active, all materials are affected by any changes you make.

FIGURE 10-28

The downward-pointing arrow in the material preview window shows there are controls you can access before entering the Material Editor.

FIGURE 10-29

The submenu that appears when you either click on the arrow in the material preview or right-click on the preview window itself.

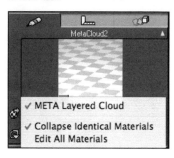

FIGURE 10-30

The expanded list of options when you turn off Collapse Identical Materials.

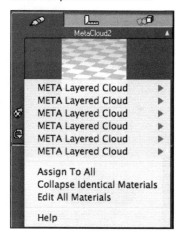

When you open the Material Editor, you have three sections to work with:

- Color and Density—Lets you set up the cloud material to appear as you want using functions and filters.
- Cloud Settings (see Figure 10-31)—Gives you controls to manipulate numerous aspects of the metacloud, including the intensity of Godrays.
- Lighting and Effects (see Figure 10-32)—Gives advanced controls for manipulating shadows and material parameters.

FIGURE 10-31

The Cloud Settings controls.

FIGURE 10-32

The Lighting & Effects controls.

Building a Scene with Metaclouds

You will now build an entire scene incorporating a metacloud object. One of the harder effects to achieve is being able to give terrain objects a true feeling of height, especially when the terrain is the only object in the scene. In this next lesson, you use a metacloud to give that added sense of mountain height.

FIGURE 10-33

A path has been cut down the middle of the terrain.

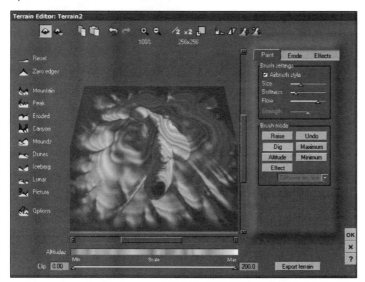

1. Using the default atmosphere when you start the program, change the sun's Azimuth to 87.28 degrees and its Pitch to 163.7 degrees.

This will move the sun a little higher in the sky, giving you a daytime spectral atmosphere.

2. Add a Terrain object.

Go into the Terrain Editor and click Eroded a couple of times (until it looks good to you). Rotate the terrain in the preview window, then, using Paint > Dig, cut a path down the center of the terrain (see Figure 10-33). Do not dig all the way through the terrain; make it more of a crevasse.

3. Click OK when you're finished, and rotate the terrain so the crevasse shows in the middle of the Main Camera View window (see Figure 10-34).

 You will also want to move the terrain into position so it fills the screen and you don't see any of the ground plane.

4. Add the Natural 3 material to the terrain.

 The basic setup is complete. Now it's time to add some clouds in the sky.

5. Go into Atmosphere Editor and put a Spectral Cumulus Cloud layer into the scene.

 The only setting to change for this scene is the cloud's Scale. Change that to 1 and click OK. Your scene will look something like what you see in Figure 10-35. Remember, because everything in this scene is randomly generated, the image you see here will be different than yours. But you should have some cumulus clouds hovering in the background and the terrain in the foreground.

 Save your file before moving on.

 The big problem with the image is that there is no sense of height. This could be a small rise, it could be a massive mountain, but there is no visual clue as to it true height. That's where the meta-cloud will come into play.

FIGURE 10-34
The terrain's position after rotating.

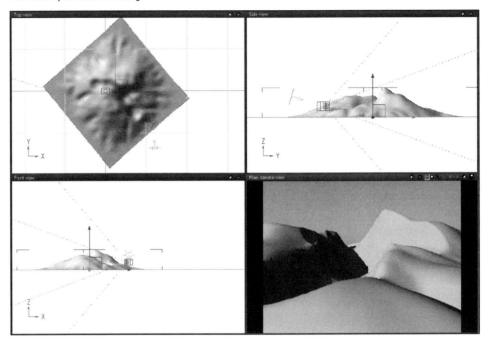

FIGURE 10-35
The scene with cumulus spectral clouds added.

FIGURE 10-36

The metacloud over the Terrain object.

FIGURE 10-37

Rendered, this larger cloud gives more of a sense of scale to the terrain.

6. Add a metacloud to the scene.

Move it into position so it is over the terrain (see Figure 10-36). Perform a quick render and you can see this cloud has already given the mountain a greater sense of height (see Figure 10-37).

7. Now, scale, move, and rotate the cloud so it is placed directly on top of the terrain.

The cloud should be scaled dramatically (see Figure 10-38). When moving it into position, be careful not to place the camera into the cloud. This can cause unwanted results (such as loss of definition of the terrain). In Figure 10-39, you see how the metacloud is interacting with the terrain, making the peaks appear as if they are in the clouds themselves. Also, with some changes to the cloud's Detail settings (Material Editor > Cloud Settings) and repositioning of the sun, more detail is added to the cloud, making it look more realistic (see Figure 10-40).

FIGURE 10-38
Scale the metacloud dramatically to fit into the scene.

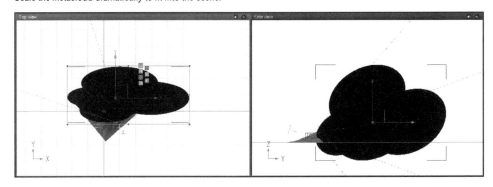

FIGURE 10-40
With more detail added to the metacloud, and the sun moved to the right of the camera, a totally different look is achieved.

FIGURE 10-39
The metacloud interacting with the terrain.

CHAPTER SUMMARY

Spectral atmospheres are powerful tools for creating stunning scenes, helping to create depth and the sense of height in your terrains. When you combine spectral clouds and metaclouds, you can build images that seem to literally jump off the page.

Throughout this chapter, you have learned how to work with spectral atmospheres and objects that are available to you only when you have this type of atmosphere selected. Remember, you can combine these different elements—two metaclouds, for instance, one inside of another to achieve greater depth. You can change sky and light color, because the colors within the clouds are affected by the sun (no other light type will have an effect on them). So, with practice and a sense of discovery, your scenes can literally take on a life of their own when working with spectral atmospheres.

What You Have Learned

In this chapter you

- Learned how to work with spectral atmospheres
- Discovered how to add and modify volumetric clouds
- Created Godrays
- Added metaclouds to give a greater sense of height to your projects

Key Terms from This Chapter

Godray E-on Software's term for streaks of light shining through the clouds.

Metacloud A volumetric cloud object that can be modified in many different ways. Metaclouds are only accessible using Spectral Atmospheres.

Spectral Analysis/Atmosphere The method in which 3D programs display real-world style effects within the atmosphere. This includes light refraction and reflection in dust and moisture within the air.

11

THE NUMERICS
CONTROL PANEL

1. Make changes by the numbers.

2. Reposition objects in a scene.

chapter 11 THE NUMERICS
CONTROL PANEL

Until now, you have been making most object positioning changes interactively, clicking and dragging an object to a certain location in the scene. This is the quickest and easiest way to build your initial layout. But for more precise control of object positioning, you need to use the Numerics controls. With this panel, you can move, scale, rotate, twist, and pivot the selected item by either plugging in numbers or using the interactive control icon.

Even if you prefer to interactively make changes to the objects within one or all of the viewports, it is often a good idea to keep the Numerics window open to watch the numerical changes you make. This can help you understand the X/Y/Z and other coordinates and how the changes you make affect these numbers.

The Numerics panel may look simple, but in many ways, simple can still be powerful. In order to see how it works, you need to place any type of object in the scene—primitive, terrain, or plant.

Tools You'll Use

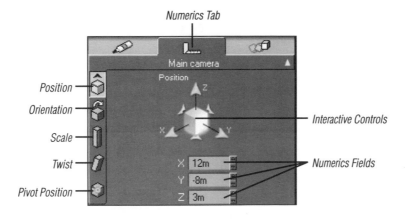

Numerics Tab

Main camera

Position

Orientation

Scale

Twist

Pivot Position

Position

Interactive Controls

Numerics Fields

X 12m

Y -8m

Z 3m

MAKE CHANGES
BY THE NUMBERS

What You'll Do

*In this lesson, you make various changes to objects in your scene using the **Numerics control panel**.*

Numerics
Control Panel

The first thing to do is to learn what controls you have via the Numerics control panel, shown in Figure 11-1.

On the left side of this control set is a series of buttons (see Figure 11-2). These buttons let you switch between the following:

- **Position**—Changes the location of the object on the X/Y/Z planes.
- **Orientation**—Rotates the object along its X/Y/Z coordinates.
- **Size**—Scales the object up or down.
- **Twist**—Reshapes the object by skewing it along the X/Y/Z coordinates.

- **Pivot**—Changes the location of the pivot point. By default, the pivot point is in the center of the selected object.

In the main section of the Numerics window, you have two sets of controls (see Figure 11-3).

- **Adjustment gizmo**—This is an interactive control. Click on one of the control lines and drag in the appropriate direction to make changes to the object.
- **Numerics fields**—Type in a new value to make changes to the object.

FIGURE 11-1
The Numerics control panel located at the top of the World Browser.

FIGURE 11-2
The Numerics selector buttons.

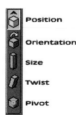

FIGURE 11-3
The interactive and numeric controls.

Understanding 3D Numerics

As you work through this section, you might want to change from metrics to feet, unless you are comfortable with measurements using the metric system. In this section, you make generic changes to see how the controls affect the objects, but in the next section, you make more precise changes to modify a scene you have already built.

QUICKTIP

You can change between measurement settings by going to the Preferences/Options > Display Options window and changing Length Unit. You can do this at any time, and the numerics will change immediately. This is a nice way to get accustomed to Vue's world coordinates (and learn a little metrics as well).

QUICKTIP

Change the world coordinate system to reflect traditional 3D coordinates (this is what this chapter is referring to) by going to Vue 6 Infinite > Preferences > General Preferences (Mac) or File > Options > General Preferences (PC) and changing to Y Axis Up in the World Coordinate System section.

In 3D applications, the exact center of the workspace is coordinate 0,0,0 (X=0, Y=0, Z=0). With the pivot point in the center of the object, that particular object will be perfectly centered on the horizontal (X) and depth (Z) planes. On the vertical plane, it is half buried in the ground (Z), as you see in Figure 11-4. That is because the Y=0 coordinate is centered along the ground plane. If you change the numerics to negative settings (-1, -2, and so on), you will move the object left on the X axis, down on the Y axis, and away from the camera on the Z axis. Figure 11-5 shows the 3D numeric directions.

FIGURE 11-4
The Cube object with a position setting of 0,0,0 is half buried in the ground.

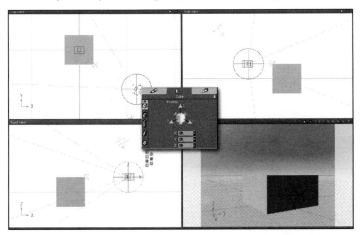

FIGURE 11-5
The direction objects will move using positive and negative values.

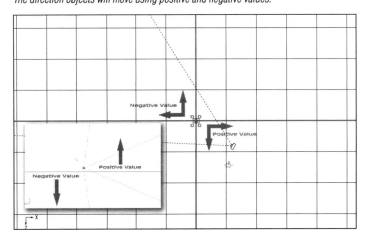

Experiment with 3D Numerics

1. Use any atmosphere you want and place a Cube into the scene.

 The Cube will be this section's "victim." Let the Cube object remain in its default position, which is probably hanging in midair.

2. Drop the Cube to the ground.

 The Y value will change to approximately 9.8422 ft (2.9999m). If you multiply that by 2, you get a Cube measurement of 19.685 ft. That's one large cube. Of course, if you're not good at math or don't have a calculator handy, you can switch to Size to see the dimensions of the cube.

3. Click on the Y axis gizmo in the Numerics window and drag downward.

 As you move your cursor over the coordinate arrows, it will turn into a double-headed pointer. Click and drag when this occurs, and the Cube will move in the direction you chose. The Cube image centered in the direction controls will ghost to show a change is occurring (see Figure 11-6).

4. If you made a change to the Cube's position, return it to where it is sitting on the ground.

 You can do this in one of three ways.

 - Type **9.8422ft** in the Y numerics field.
 - Drag upward until the cube is above the ground plane, and then click the Drop Objects button.
 - Use Cmd/Ctrl+Z to undo that change (as long as you haven't done anything else to the object).

FIGURE 11-6
When you click and drag on a direction control, the gizmo will look like this.

Defining the Other Numeric Controls

These are the basics for working in all of the Numerics panels. Scale is pretty self-explanatory; it will change the width, height, and depth of the object selected. But let's briefly look at the other controls to define terms and effects.

QUICKTIP

As you read this section, change the numerics for the different controls to get a visualization of how they affect the object.

- Orientation—Uses pitch, roll, and yaw terminology to change the way an object points (see Figure 11-7). These three terms are aeronautically based, so if you have any flight experience you know exactly what they will do. For those who don't have your pilot's licenses, here are the definitions:
- Pitch—Rotates the object along the Z coordinate. Think of a helicopter as it speeds up, its nose pointing down until the speed levels off. That's the pitch.

- Roll—Rotates the object left or right (the X coordinate).
- Yaw—Rotates the object along the Y coordinate. Think of your mouth as you *yaw*-n.
- Twist—Skews the object along specific coordinates (see Figure 11-8). The easiest way to see this is by actually changing the numerics to watch the cube change.
- Y=>Z—Changes the value to 10. This will skew the box along the X axis (see Figure 11-9).

FIGURE 11-7
The Orientation control panel.

FIGURE 11-8
The Twist control panel.

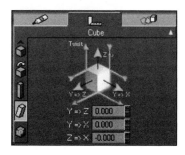

FIGURE 11-9
The cube modified along the Y=>Z coordinate.

- Y=>X—Shifts the front/back Z coordinates left and/or right, stretching along the X axis (see Figure 11-10).
- Z=>X—Shifts the object on the Z axis (see Figure 11-11).

QUICKTIP

Values of 50 were used for the Twist images. In some cases, when you return the settings to 0, you will have to go back into Orientation to reset Pitch, Roll, and/or Yaw to 0 because the Twist effect, after being assigned, has actually rotated the object.

- Pivot—This changes the location of the *center point* of the object (see Figure 11-12). By moving the center point, you can control where an object's rotation or modification point will be, so you can have this cube object rotate from any of its corner points for more precise placement.

QUICKTIP

The easiest way to understand the center point is to think of it as a push pin. When you pin a sheet of paper to a cork board, for instance, that sheet of paper will rotate around that pin. It works the same with the center point; wherever it is positioned, that is the point from which the object will rotate.

FIGURE 11-10
The cube modified along the Y=>X coordinate.

FIGURE 11-11
The cube modified along the Z=>X coordinate.

FIGURE 11-12
The Pivot control panel.

REPOSITION OBJECTS
IN A SCENE

What You'll Do

In this lesson, you create a new scene and, using the various numerics controls, place and modify objects precisely.

The best way to show off how the Numerics panel can help you place and modify your objects is to create a scene— a more complex scene than you have put together up to now. You will utilize much of what you have learned up to now, assigning textures, Ecosystems, spectral atmospheres, and more. You will definitely use this scene in later chapters, so make sure to save it often.

Position Numerics Fields

Use Numerics to Reposition Objects

1. Select the Basic > Clear Blue atmosphere.

2. Choose Vue 6 Infinite > Preferences > Display Options (Mac) or File > Options > Display Options (PC) and change the Length Unit to Miles.

 You will change back to Feet or Meters (whichever you prefer) in a moment. In order to scale this plane as you need to, Miles is the best choice for now.

3. With the Plane object still selected, switch to Numerics.

 Change The X and Z scale settings to 2 miles. The Y coordinate has nothing to do with the plane since there is no height to it. After you have set and accepted the scale, switch back to Feet or Metrics for the Length Units.

 > **QUICK**TIP
 >
 > After changing the scale of the Plane object, you will want to move the camera upward and tilt it down in order to better view the plane. Where you position it is up to you at this point in the scene-building process.

4. Go into the Material Editor and assign Basic > Rubber to the Plane object.

 You will be creating a blacktop-like material. To do this, you also need to go into the Bump control and assign the Layers > Tilted Layers function.

5. Still in the Material Editor, choose Highlights > Highlight Color and change it to R = 6, G=6, B=6.

 This will give a very slight highlight to the blacktop surface, Your material will look like Figure 11-13, where the black-top surface has some variation. Save this material to your Materials Library as **Blacktop**.

FIGURE 11-13

The blacktop-esque material is assigned to the Plane object.

FIGURE 11-14

Performing a Boolean Intersection rounded the corners of the Cube object.

FIGURE 11-15

A city grid created using Ecosystems. The light gray block in the center of this image is the representation of the infinite plane.

6. Add a cube to the scene.

 This is going to become a city block. To set it up, change its Scale to X=49 ft, Y=1.5 ft, and Z=49 ft. You now have a square city block with a 1.5 foot depth. But you're not done yet.

7. Add a Cylinder object and change its dimensions to X=68 ft, Y=1.5 ft, and Z=68 ft.

 QUICKTIP

 The lock icon immediately to the left of the Y scale field must be turned off (not highlighted) in order to set these numbers. If it is turned on, all three coordinates will change to the same numbers.

 You will see a very small portion of the cube's corners sticking out from the edges of the cylinder.

8. Select the cube and cylinder and perform a Boolean Intersection.

 What is left is the Cube object with slightly rounded corners (see Figure 11-14). Remember, Boolean Intersection leaves only the section of the objects where the two original objects intersect.

9. Change back to Miles and resize the City Block object to X=1.5 miles, Z=1.5 miles. Do not change the scale setting for the Y coordinate.

10. Assign the Rocks > Gray Clumps material to this object, and then save the object as **CityBlock** to your Objects Library.

 After you save your object, double-check that it is saved to your Objects folder, and then delete it from the scene. You will use this CityBlock object in an Ecosystem for exact placement.

11. Select the Plane object and go back into the Material Editor.

12. Change the Material to Ecosystem, and assign the CityBlock object to the Ecosystem Population list.

 Make the following changes to the Ecosystem before populating your scene:

 * Density

 Overall Density—60%

 Placement—Force Regular Alignment of Instances

 * Scaling & Orientation

 Overall Scaling—1

 Rotation—0 degrees

13. Click Populate. The city blocks will be added in a grid-like pattern (see Figure 11-15). Save your file before moving to the next step.

Use Cube Primitives for Buildings

1. Add a Cube object to your scene.

 Change the scale of the object to 75 ft. on the X, Y, and Z coordinates.

2. Using the Position numerics, move the building to the following coordinates:

 X = 619.28 ft

 Y = 37.5 ft

 Z = 609.38 ft

 This will position the building on one of the CityBlock objects, as in Figure 11-16.

3. Set the material for this building to Special Effects > Buildings > Building Lights 2.

 Set mapping to Object—Parametric so the material stretches to fit the cube correctly.

4. Create a second building with the following size and placement settings:

 Size: X = 74.39 ft, Y = 121.31 ft, Z = 74.39 ft

 Position: X = 703.25 ft, Y = 60.656 ft, Z = 609.47 ft

5. Assign the Green Glass texture from the Special Effects > Buildings material library.

Adding Buildings

For the sake of brevity, you will create the simulation of buildings to populate the city blocks. You will use Cube primitives for these, assigning specific textures, but modifying their sizes in the Numerics panel.

FIGURE 11-16
The first building in place on the city block object.

6. Create four more buildings using the Scale and Move tools. This will create the rest of the city block.

 The numerics for the buildings are as follows:

 • Building #3

 Size: X = 224.75 ft, Y = 32.71 ft, Z = 400.06 ft

 Position: X = 694.51 ft, Y = 46.237 ft, Z = 852.32 ft

 • Building #4

 Size: X = 311.47 ft, Y = 92.475 ft, Z = 74.182 ft

 Position: X = 905.72 ft, Y = 46.237 ft, Z = 609.16 ft

 • Building #5

 Size: X = 144.44 ft, Y = 75 ft, Z = 244.03 ft

 Position: X = 985.16 ft, Y = 37.5 ft, Z = 776.46 ft

 • Building #6

 Size: X = 246.73 ft, Y = 75 ft, Z = 148.55 ft

 Position: X = 934.01 ft, Y = 37.5 ft, Z = 977.09 ft

QUICKTIP

Why are the Y positions of the buildings different? Because the center points of the cubes are different due to their various sizes. If you tried to make the Y coordinates the same for each building, some would be floating in the air, whereas others would be buried in the ground. Also, the Y positions are set for the ground plane because the city blocks are not seen as objects within the scene.

This is the only city block you will set up for this chapter (see Figure 11-17). Try different materials for the buildings to add some interest, making sure you set the mapping to Object—Parametric. You can come back and build a few more blocks worth of buildings, practicing with Boolean Unions and Differences to create more complex shapes at a later time.

FIGURE 11-17
The completed city block.

7. Reposition the Main Camera to the following coordinates:

Position: X = 289.88 ft, Y = 206.37 ft, Z = 1413.2 ft

Orientation: Pitch = 104.741, Roll = 138.481, Yaw = 0

The scene should now look like Figure 11-18. In this scene, a spectral atmosphere was assigned, along with cumulus clouds.

FIGURE 11-18
A rendering of the city block.

Positioning as a Group

As you were building this scene, you were hopefully creating layers (even though I didn't mention it up to now). If you didn't, now is the time to do so. Place the CityBlock object in its own layer, and then move each of the buildings into its own layer (titled Buildings). Now you're ready to create a group of objects, copy it, and move it into position.

FIGURE 11-19

Two groups of building objects in the Layers window.

1. Select all your building objects in the Buildings layer.

 Click on the building at the top of the list, and then hold down the Shift key and click on the last building in the list. This will highlight all the objects.

2. Right-click on the layer and select Group Objects from the submenu.

 Name this group **Set 1**.

3. Right-click on Set 1, and then copy and paste it.

 You will now have two sets of buildings (see Figure 11-19) in your Layers window.

4. Select Set 2 and change its position and orientation as follows:

Position: X = 1550.7 ft, Y = 39.29 ft, Z = 14.853 ft

Orientation: Pitch = 0, Roll = 90.011, Yaw = 0

Now the city block has been moved onto another sidewalk section (see Figures 11-20 and 11-21). You rotated it so there is a difference in the look of the block. This is a little trick many 3D artists use; instead of creating thousands of original objects for the scene, they copy, paste, and then rotate the elements so there is a difference in their appearance.

FIGURE 11-20
The scene with the copied buildings behind the original.

FIGURE 11-21
The camera at street level.

CHAPTER SUMMARY

There are two distinct advantages to setting up your scene using the Numerics panel—first, you can position your objects precisely, and second, you can set up your scenes and share those settings between programs. In 3D production, setting up camera positions and lighting precisely is of paramount importance. By using numerics, knowing the exact positions of objects, cameras, and lights, you can move easily between programs to create whatever type of scene or animation you want.

What You Have Learned

In this chapter you

- Learned how to use the Numerics panel to scale your objects precisely
- Learned how to position items using the Numerics panel
- Positioned grouped objects into another location in the scene

Key Terms from This Chapter

Numerics control panel A series of controls that modify the selected item through the use of numbers rather than randomly stretching and distorting them. This is a much more exact method for object placement, size, and orientation in a scene.

Pitch Rotation around the side-to-side axis. Remember back to when you were a little child, holding your arms out from your side, and spinning around in a circle. You were changing your pitch.

Pivot point The point from which an object is rotated.

Roll Rotation around the front to back axis. As a piece of meat on a spit spins over the flame, that would be roll.

Yaw Rotation around the vertical axis. A gymnast doing a series of back flips would be changing his/her yaw.

12

LET THERE
BE LIGHT

1. Understand the lighting controls.

2. Use lights to enhance a scene.

12 LET THERE
BE LIGHT

If there is one thing that can ruin an image, it is the lighting. Improper or poorly positioned lights can throw off the ambience of your image, and all that hard work you put into placing everything just so will go for naught. Lighting creates mood, atmosphere, emotion; it generates interest and mystery; it builds depth and definition. The way you light your scene can literally make or break your final render.

There are dozens of books that deal with lighting setup for 3D—it's much different lighting for a computer-generated image or animation than it is for a physical studio. But the concepts are the same. Put enough ambient light into the scene so elements don't disappear into the dark, and then fill in the rest of the scene to get rid of extraneous shadows and errant highlights that detract from the image's subject. Add **gels** and color to the lights to add interest. Turn on volumetrics to send streams of light through a window or from a light source (see Figure 12-1). Assign a **backlight** to silhouette objects. Include a **keylight** to bring focus to the area of the image you want or an **eyelight** and/or **fill light** to remove unwanted shadows.

Vue 6 provides numerous light types that can be used in various ways to illuminate your scenes. The lights—from sun to **light panels**—can each be modified to fit your particular needs, including turning off shadow production so you don't get unwanted shadows in your scene(s).

Tools You'll Use

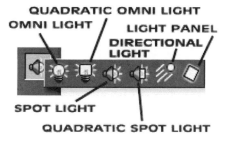

QUADRATIC OMNI LIGHT

OMNI LIGHT

LIGHT PANEL

DIRECTIONAL LIGHT

SPOT LIGHT

QUADRATIC SPOT LIGHT

LESSON 1

UNDERSTAND
THE LIGHTING CONTROLS

What You'll Do

In this lesson, you learn about the various lighting types and their controls.

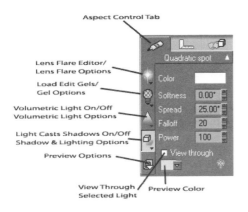

Aspect Control Tab

Lens Flare Editor/
Lens Flare Options

Load Edit Gels/
Gel Options

Volumetric Light On/Off
Volumetric Light Options

Light Casts Shadows On/Off
Shadow & Lighting Options

Preview Options

View Through /
Selected Light

Preview Color

There is a specific purpose for any light you place into your scene; it is used either to illuminate the entire area or to spotlight specific elements. Depending on that purpose, there is a correct light to use—a spotlight, area light, or light panel. Spotlights are, by far, the most versatile of the light types because they can cover a wide area within the scene or pin-point

elements such as eyes. They can also be used to give the effect of a bright star or a sun, for instance, in an outer space scene.

Although you have added lights to scenes in other chapters, it's still smart to take a moment to look at the various lighting types included with the program (see Figure 12-2):

FIGURE 12-1

An example of volumetric light where the beams are visible from the spots.

FIGURE 12-2

The light types in Vue.

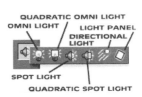

QUADRATIC OMNI LIGHT
OMNI LIGHT LIGHT PANEL
 DIRECTIONAL
 LIGHT

SPOT LIGHT

QUADRATIC SPOT LIGHT

- **Omni and Quadratic Point Light**—Provides light over a full 360°. The Omni and Quadratic Omni lights are shown in Figure 12-3.
- **Spot and Quadratic Spot Light**—Directs a beam of light toward the object it is pointing at. The Spot and Quadratic Spot Lights are shown in Figure 12-4.

- **Directional Light**—Consider this a second sun. It is the light used to illuminate an atmosphere (see Figure 12-5).
- **Light Panel**—Creates a panel that produces light to softly illuminate the scene (see Figure 12-6).

FIGURE 12-3
Omni (round) and Quadratic Omni (square) lights in the workspace.

FIGURE 12-4
Spot (round) and Quadratic Spot (square) lights in the workspace.

FIGURE 12-5
The Directional light is the same light that is used for suns in the atmospheres.

FIGURE 12-6
A light panel on the workspace.

Work with the Light Control Panel

1. Choose Effects > Others > Black Back atmosphere and remove the ground plane from the scene.

This will make your scene's background solid black. When you do this, you can see the lighting effects much better.

QUICKTIP

Even though you have removed the ground plane, you will still see it in the Main Camera View window, which allows you to retain a sense of equilibrium while working on your scene. You know where the ground should be, which can help in placing objects. But when you render the scene, that "ground ghosting" will disappear, and your atmosphere will be totally black.

2. Add a Sphere object to the scene.

3. Place a spotlight in the scene and change its position and rotation to the following:

Position: X = 27.26 ft, Y = 21.126 ft, Z = 29.809 ft

Orientation: Pitch = 240.359, Roll = 19.234, Yaw = 0

The spot will be shining down on the sphere, angled from the top (see Figure 12-7). You will use this light to see how the various controls and effects work.

Understanding the Light Control Panel

To understand how to work with the lights, you will start off with the basic light control panel. Here, you have access to all the controls that determine what the light does in your scenes.

FIGURE 12-7

The general position of the spotlight for this scene.

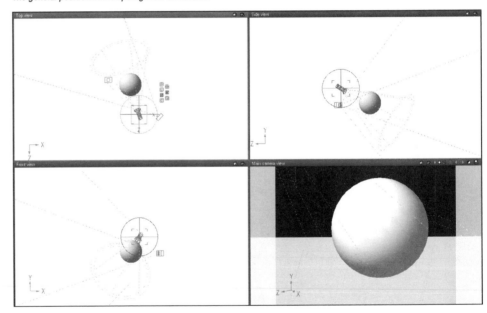

The lighting controls are located in the Aspect window of the World Browser (see Figure 12-8).

The main work area consists of the following:

- **Color**—Sets the color of the beam of light.
- **Softness**—Adds extra blur to the edge of the light.
- **Spread**—Sets how wide the beam of light is, determining how much of the scene will be illuminated by that light.
- **Falloff**—Determines how far the light travels before tapering off into nothingness.

- **Power**—Determines how strong the light is.
- **View Through**—Forces the Main Camera window to show the scene as if you were looking through the light. This is helpful for accurately pinpointing specific targets.
- **Color Pop-up**—Determines the color of the light's wireframe image in the workspace.
- **Exclude from Radiosity**—Determines whether the light is included when Radiosity or a Global Radiosity atmosphere is being used.

The buttons along the left side give you the following controls:

- **Lens Flare**—Determines whether the light produces a lens flare when pointing at the camera. Also determines the type of lens flare effect and how strong that flare is.
- **Gels**—Adds a gel to the light for special effects.
- **Volumetrics**—Determines whether the beam of light is visible in the scene and how it will appear.
- **Shadows**—Determines whether the selected light will produce shadows from any object it hits.
- **View Settings**—Determines how the light appears in the workspace.

With that, let's move on to actually working with the light and seeing how the controls affect it.

FIGURE 12-8
The Lighting control window.

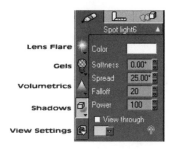

Work with Lighting Controls

1. Double-click on the Color chip to open the Color Picker window.

 Change the color to R = 254, Green = 254, Blue = 42. This will produce a bright yellow color that will give the Sphere a slight yellow cast where the light hits (see Figure 12-9).

2. Change Softness to 10 degrees.

 This change will make the light fade out as it wraps around the object (see Figure 12-10).

3. Change Softness back to 0 and change Spread to 10.

 This will reduce the size of the beam, called *concentrating*, to focus on a smaller area of the sphere (see Figure 12-11).

4. Finally, change Power to 15.

 Now the light hitting the object is much more subtle (see Figure 12-12). Before moving to the next section, reset the light to its default settings (refer back to Figure 12-8 if you don't remember them).

Using the Basic Lighting Controls

Now that the light is set up, you can first make some basic changes to it. In this section, you change the basic light parameters in the main portion of the control window. You then add special effects to the light to add interest to what is now a very blah image.

FIGURE 12-9

The bright yellow light produces a softer, lighter cast to the sphere.

FIGURE 12-10

Softness makes the light fade out as it spreads across the object. In Preview render mode, the effect looks horrible (left), but in higher quality render settings, the light fades cleanly (right).

FIGURE 12-11

The beam of light is now concentrated on a smaller area of the sphere.

FIGURE 12-12

The light's Power setting is lowered, so the light hitting the object is not as bright.

Adding Lighting Effects

So those are the basic controls and how they affect the light. But that is only the beginning. Let's now turn to the buttons along the left side of the control panel to see how they affect the light's appearance.

FIGURE 12-13

The Light Editor window is accessed by accessing Edit from any of the effects buttons in the light's Aspect window.

FIGURE 12-14

The Shutter Gel gives the effect of light shining through vertical blinds.

1. Press and hold down on any of the control buttons and select Edit from the submenu.

 No matter which of the buttons you hold down, when you select the Edit command from the submenu, the Light Editor window will open (see Figure 12-13). You then have access to all the control windows associated with all the buttons in the control window. Whichever effects control button you pressed is the active section of this window.

2. Open the Gel section of the Light Editor window and activate Enable Light Gel.

3. Click the Load button under the preview window and select Shutter Gel from the Materials list.

 The Gel materials are located in Special Effects > Light Gels. This is one of those rare occurrences with Vue where these specific materials are the ones you should focus on for lights. Other materials often do not produce good lighting effects.

4. Perform a quick render.

 You now have a striped effect from the light (see Figure 12-14). These straight-line gels are perfect for creating effects such as light shining through window blinds.

5. Change the gel to Caustics Gel 2.

The Caustics gel can give the appearance of clouds casting shadows upon an object (see Figure 12-15) or even some sort of moon-like effect. Change back to the Shutter Gel.

> **QUICK**TIP
>
> Sometimes, especially when an object is in the background, tricks such as using light gels to create specific looks (like a moon effect) can help speed up your render time because fewer computations have to occur when rendering.

6. Move the light to the following position and orientation:

Position: X = .0293 ft, Y = 21.126 ft, Z = 30.137 ft

Orientation: Pitch = 248.312, Roll = 325.775, Yaw = -5.453

This change will help you better see the volumetric effect you are about to create.

7. Change to Volumetric and select Enable Volumetric Lighting.

In this window, you can select how bright the volumetric effect will be, the quality of the effect, and whether it will cast shadows or if the volumetric effect will appear to have dust or smoke floating through it.

8. Enable both Cast Shadows in Volume and Show Smoke or Dust in Light Beam.

The latter will give you access to filters controls (see Figure 12-16). You can change the filter to give the light beam a distinct appearance, be it more smoke than dust, or choose a speckled filter to just have the look of dust particles.

FIGURE 12-15
Adding a Caustics gel to the light gives a mottled, softer appearance to the object. It can also be used for planetary effects.

FIGURE 12-16
When adding smoke or dust effects to the volumetric light, you gain access to the filters that can be assigned to the beam.

Perform a quick render and you will see the beam of light with smoke and dust "shadows" throughout. The beam also darkens on the far side of the sphere where the sphere is casting a shadow (see Figure 12-17).

QUICKTIP

Be aware that volumetric lighting can increase render times dramatically.

The next three controls give you the ability to change the way the light creates shadows (see Figure 12-18), controls to change the manner in which the light projects itself, be it linear, quadratic, or self-created (see Figure 12-19), and how the light affects objects in the scene (see Figure 12-20). Each of these controls is discussed in the next section, along with Lens Flares.

FIGURE 12-18

The Shadows control window.

FIGURE 12-19

The Lighting control window.

FIGURE 12-20

The Influence control window.

USE LIGHTS
TO ENHANCE A SCENE

What You'll Do

In this lesson, you work with the various lighting controls, assigning them to different lights, to flesh out a scene you have previously created.

Now that you have an idea about the lights, you can go ahead and put them into a scene to make it more interesting. If you remember way back in Chapter 2, you created a space scene with some asteroids and a couple of planets. That's the scene you will modify by adding new lights and lighting effects.

QUICKTIP

Because this scene was created earlier, the positions of your asteroids might be slightly different than those shown here. If lights are not positioned exactly as you see in the images, manually move them into the correct position for your scene.

Positioning Lights in Space

When you originally built the space scene in Chapter 2, there was only one light assigned to it. Well, that light is not going away, and you will add other lights to create the final piece.

FIGURE 12-21
The position of the Quadratic Point light and a quick render of how it is affecting the planet.

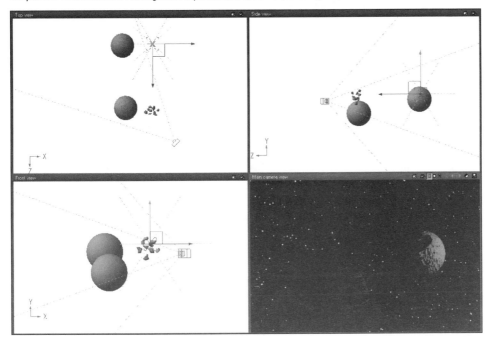

1. Open the space scene you built (Space Scene.vue or spaceScene.vue).

2. Remove the sun light from the scene.

 All lighting in this image will be created by the various lights you are about to add. The scene will go virtually black since there is no lighting.

3. Create a new layer in the Layers window. Title this layer **Lights**.

 All your lights will be grouped into this layer so they are easier to access.

4. Add a Quadratic Point light to the scene.

 Move this into the following position:

 Position: X=22.131 ft, Y = 14.803 ft, Z = -49.94 ft

 Orientation does not matter because the light shines in a full 360 degree arc. The light should be to the right and slightly in front of the back-most planet (see Figure 12-21).

5. Turn off Light Casts Shadows for this light.

6. Place a Quadratic Spot Light in the following location:

Position: X = -6.741 ft, Y = 21.037 ft, Z = -69.3 ft

Orientation: Pitch = 99.976, Roll = 21.807, Yaw = 0

The light will be behind the back-most planet. You will now make some very specific changes to this light. First, change Power to 85 so the light isn't so bright.

7. Open the Light Editor and choose Lens Flare.

Change the following settings in the Lens Flare Editor:

Ring—Activate this and change Intensity to 15% and Radius to 24%.

Random Streaks—Activate this and change the Intensity to 29%, Amount to 50, and Sharpness to 50%.

Flare Intensity—Set this to 38%.

You now have a light peeking out from behind the background planet, with some light streaks emerging from the center of the light (see Figure 12-22). The back planet is looking pretty good right now, so let's focus on another portion of the image.

FIGURE 12-22

The look of the image with the lighting assigned to the back planet.

FIGURE 12-23

The foreground planet is lit with a volumetric light.

8. Next, you'll add a volumetric light to the scene. Place a Quadratic Spot Light into the scene.

 Position the spotlight at the following coordinates:

 Position: X = -12.288 ft, Y = 34.8177 ft, Z = 74.401 ft

 Orientation: Pitch = 243.286, Roll = 356.107, Yaw = -17.216

9. Set the light parameters to the following:

 Softness—10

 Spread—8

 Falloff—100

 Power—-100

 You want the beam to be small since the light is positioned a distance away from the foreground planet, but you also want it to travel far enough to reach the planet. Therefore, you have created a thin beam of light that has very little falloff so the effect will be seen.

10. Turn on Volumetrics and, in the Volumetric section of the Light Editor, make sure you choose Show Smoke or Dust in Light Beam.

11. Perform a quick render.

 The foreground planet will be softly lit, and there will be a cloud-like effect around it, as shown in Figure 12-23.

12. Add one more Quadratic Spot Light and set its position and orientation to

Position: X = 44.112 ft, Y = 12.819 ft, Z = 34.047 ft

Orientation: Pitch = 264.952, Roll = 34.389, Yaw = -8.224

The light now points toward the asteroids; it's coming from the same basic direction as the light hitting the foreground planet.

Set the light's base settings to

Softness—0

Spread—10

Falloff—20

Power—100

The light will hit the asteroids, but then it will dissipate enough that it will not adversely affect the background planet. Figure 12-24 shows the setup for all the lights in the scene.

13. To finish with the light setup, go into the Light Editor.

Go to the Gel section and select the Colored Gel for the light. This will add an interesting look to the asteroids when you render the scene.

FIGURE 12-24
The lighting setup for the space scene.

FIGURE 12-25

The settings for the Lighting section of the Light Editor.
These settings will produce a warmer tone for the asteroids.

FIGURE 12-26

The settings for Influence in the Light Editor.

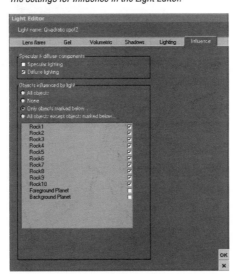

14. Switch to Shadows and turn Shadow Density down to 85%. Also select Use Shadow Map and Soft Shadow Map— No Hard Shadows.

This will reduce the harshness of the shadows so you don't have full black, and the edges of the shadows (wherever they might appear on the asteroids) will have a softer, more realistic look.

15. In the Lighting section, double-click on the filter window in Light Attenuation and choose the Terrain Profiles > Wild Dig filter. Also choose Variable Color. Double-click on the preview window in this section and choose Colorful > Mauve Gray Ochre. Set Distance to 50 (see Figure 12-25).

This will soften the colors being projected onto the asteroids, while giving them a slightly warmer tone due to the browns in the color map you added.

16. Under Influence, turn off Specular because it really has no effect on this scene, and choose Only Objects Marked Below. Select the Rock objects but not the planets (see Figure 12-26).

By choosing these settings, you make the diffuse portion of the light, that being projected onto the surfaces of the asteroids, affect only the asteroids and not the background planet.

17. Set the render quality of the Main Camera View window to Superior and then perform a quick render. This will take a few minutes, so it's not really a quick render, but it will give you a much closer approximation to what a final render will look like. Your scene should look like Figure 12-27.

18. Add one final light, setting it up as follows:

Position: X = -8.751 ft, Y = 12.116 ft, Z = -21.89 ft

Orientation: Pitch = 90.228, Roll = 48.414, Yaw = 0

Color: R = 103, G = 71, B = 0 (produces a brownish tint)

Spread—10

Falloff—100

Power—200

The light should now be positioned behind one of the left-most asteroids, hidden so it doesn't directly shine into the camera.

19. Turn on Volumetrics. Under Smoke/Dust Density Production choose the Spots > Bumpy Fields function. Set Intensity to .39 and make sure Show Smoke or Dust in Light Beam is active.

You have now created the illusion of dust particles flying off the asteroids. This effect also gives the asteroids a sense of motion that was missing from the earlier scene (see Figure 12-28).

FIGURE 12-27
The space scene rendered in Superior mode.

FIGURE 12-28
The final scene, with a volumetric light giving the asteroids a sense of motion.

CHAPTER SUMMARY

As you can see, it took five distinct light setups to create the final image. If you compare this version with the one you created in Chapter 2, there is a massive difference in the quality of the final product. When you're developing a scene, lighting can make all the difference in the world (or in this case, the galaxy). In fact, one light can make a major difference, as you can see when you added the final Quadratic Spot Light.

What You Have Learned

In this chapter you

- Worked with various light types
- Worked with special lighting effects
- Added gels to the lights
- Worked with lights to give a greater sense of realism to your scenes

Key Terms from This Chapter

Backlight The process of lighting a subject from the back rather than the front.

Eyelight A light that highlights the eyes of a subject, removing any errant shadows that might occur from the other lights in the set. Usually these lights are mounted above the camera.

Fill light Used to reduce the contrast of a scene and to provide illumination for the areas of the image that are in shadow.

Gel A thin, transparent sheet that is placed in front of a light to add color or texture to the lighting.

Keylight The brightest light in a scene that casts the main shadows in an image.

Light panel An object that has been turned into a light source. Light panels are created by right-clicking on an object and selecting Convert to Area Light. This feature is available in Vue 6 only.

chapter

13

WORKING
WITH CAMERAS

1. Learn the main camera controls.

2. Change the focal length.

3. Use the advanced camera options and the Camera Manager controls.

chapter 13 WORKING WITH CAMERAS

Although lighting is an extremely important factor in creating emotion in your scene, manipulating the camera also carries importance to your final image. With Vue, you can make the camera perform just as a standard 35mm or digital still camera does, as well as how professional film cameras do. From wide angle to extreme close-ups (ECU), you have total control over all the camera's functions. You can assign link or tracking functions to the camera so it will automatically move or follow the path of a selected object, making animating or scene setup much easier. Plus, you can add cameras to your scene. By doing this, you can switch between them during the animations you create, literally creating a cut to get a different angle of the action.

By using the camera correctly, you can set up your scenes more precisely. It's important that you have an idea of what you want the final outcome to be rather than just rush randomly into creating something. You might find that the image you're creating will have more impact in a widescreen format (16:9 or Cinemascope, for instance) or as a portrait (taller than it is wide). And in some cases you need to compensate for spherical **aberrations** associated with various types of lenses. If you know about these issues going in, you can often fix the problem before it occurs.

In this chapter, you learn how to control the camera(s) in Vue, setting them up for various types of shots, as well as prepare a file for animation (discussed in Chapter 15). You also learn how to add more cameras to the scene and work with the postprocessing functions.

Tools You'll Use

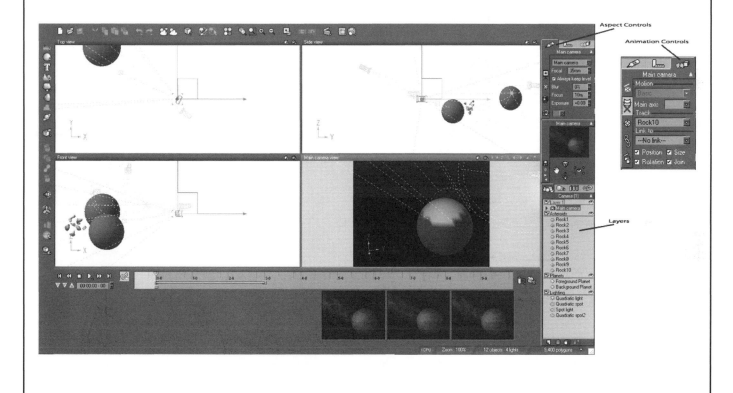

LEARN THE MAIN
CAMERA CONTROLS

What You'll Do

In this lesson, you work with the Aspect window to modify and control basic aspects of the camera.

Initially, much of the work you will do with your cameras will occur using the basic controls located in the Aspect window (see Figure 13-1). In the main section of this window are the following controls:

- **Camera pop-up list**—Select which camera you will work with.

- **Focal pop-up list**—Change the type of lens for the camera (the default **focal length** is 35mm).
- **Always Keep Level check box**—When this option is not checked, you can tilt your camera along the horizontal plane.
- **Blur pop-up list**—Set the amount of blur in the scene. This is associated with Focus (or FoV, if that's the option you have selected).

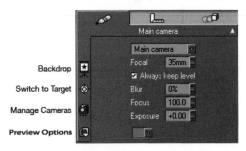

FIGURE 13-1
The camera's Aspect window controls.

- **Focus/FoV pop-up list**—This sets the area of the image that will be in focus when you have a blur setting assigned (see Figure 13-2).
- **Exposure pop-up list**—The amount of light allowed to reach the camera. Changing this can darken (negative settings) or brighten (positive settings) the image dramatically.

- **Color Swatches list**—Choose what color your camera object will be.

To the left are buttons that let you set the following options:

- **Backdrop**—Assigns an image that will be your background rather than the sky.
- **Switch to Target**—Clicking on this button will make the target object active and centered in your workspace.

- **Manage Cameras**—Opens a window that lets you add and/or rename cameras in your scene.
- **Preview Options**—Assigns how your camera object will be displayed on the workspace.

FIGURE 13-2

A diagram showing the workspace's visual display of the camera.

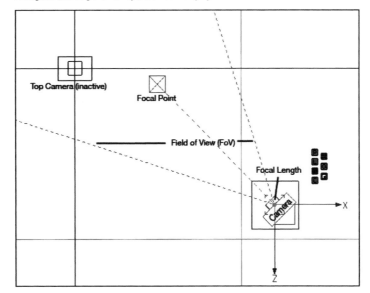

Add Depth with the Focal and Blur Settings

1. Your camera should be set up as follows:

Position: X = 289.88 ft, Y = 68.622 ft, Z = 1297.2 ft

Orientation: Pitch = 93.754, Roll = 132.823, Yaw = 0

The view in the Main Camera View window should be similar to Figure 13-3.

2. There are two ways to change the Focus or FoV:

Type a numeric value into the Focus/ FoV field.

Click on the focal point indicator and move it to the location you want.

When you select the focal point indicator, the Aspect window's controls change to what you see in Figure 13-4. You can decide whether you want the target area to always be visible and whether the camera's focal point will be linked to it at all times. This is something you should be concerned with if you are creating an animation, but for still images, you can leave Always Visible turned off and Focus On set to No Link.

Using the Blur and Focus Controls

To see how these base controls work, open the City Block scene you created in Chapter 11. (This file was named cityBlock. vue or City Block.vue.) In this section, you will change the Focal and Blur settings to add more depth to the image.

FIGURE 13-3
The scene as it should look before making changes to blur and focal length.

FIGURE 13-4
The Aspect window controls for the focal point indicator.

QUICKTIP

If you don't know exactly what numerical value to use for Focus, clicking and dragging the focal point indicator is your best bet for setting the focal distance.

FIGURE 13-5

The basic location of the focal point indicator, against the back edge of the foreground building.

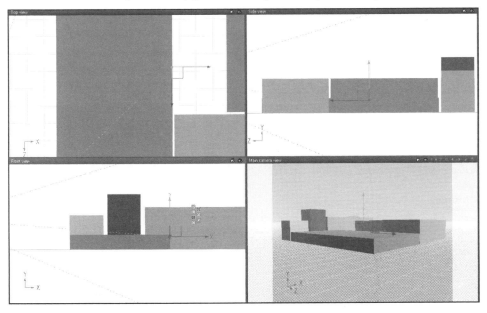

3. Set the focal point so it is positioned on the back edge of the foreground building (see Figure 13-5).

 The numeric value for this is an unrealistic 2161.73-mm, but that's the joy in 3D applications—sometimes the real world has no bearing on what you can accomplish.

Lesson 1 Learn the Main Camera Controls

4. Change the Blur percentage to 5%.

After you set the Blur percentage, an indicator box will appear within the FoV lines showing which part of the image will be in focus (see Figure 13-6). The higher the value, the area in focus will become smaller. So at 100%, the focus indicator bars will become very thin; at 5% they would encompass a larger area.

5. Perform a quick render at Preview quality.

As you can see in your scene and in Figure 13-7, this doesn't look blurred. In Preview render or any render that does not create a high-quality image ready for print, blurred areas are not rendered well. Usually you want the background blurred out and not everything blurred except for a small area as in this image.

> **QUICK**TIP
>
> Because of the increase in render times when using blurs, many artists will render without the blur and then take the image into a program such as Adobe Photoshop to create the blurs.

FIGURE 13-6
The straight lines cutting across the FoV indicators show which part of the scene will be in focus based on the percentage of blurring you assigned.

FIGURE 13-7
In Preview render mode, blurred areas have rough edges, but when rendered at a high quality, those rough edges will be softened and look more like you would expect.

Adding a Background Image

For certain scenes, you might want to add an image file rather than have a sky with clouds. One reason for this could be to place a building you have modeled into an actual city to show how the building would fit in the surroundings. Another reason is, if you work with programs like Poser 6, you might have a human model that is standing in front of a client's logo, but you don't want to add in extra geometry.

In this section, you create a scene that could be used for an ad (just to give a better idea of how this feature can be used). You have been hired to create a print ad for a car company. They're introducing a new sports car called the *Neon*. You will set up your scene, add a car object to it, and use an image as a backdrop.

FIGURE 13-8

The sports car quick rendered using the Sky Dome atmosphere.

1. Create a new scene and select the Daytime > Sunshine > Sky Dome atmosphere.

 It really doesn't matter which atmosphere you use, but this one produces a very soft light that looks great with objects appearing in limbo.

2. Choose Objects > Vehicles > Grounded > X1bdropnmerlin (yes, that's the actual name of the object!) and place it into the scene.

 This is another low-resolution model that comes with Vue.

3. Rotate the car so the open door is facing the camera.

 Numerically, you can set the orientation to Pitch = 0, Roll = 165.404, and Yaw = 0. Then perform a quick render to see what the Sky Dome atmosphere looks like (see Figure 13-8).

4. To add the backdrop, select the Main Camera and click on the Backdrop button.

The Camera Backdrop Options window will open (see Figure 13-9). Here, you can navigate to the image you want to use and set how large the image will be displayed and how it will be displayed in the windows.

5. Click the Load button (the right-pointing arrow in the lower-left corner of the preview window) and select the Neon image from the Picture Selector window.

The Neon picture comes with Vue and, by default, will be part of the list that initially opens when you click the Load button.

6. Don't make any changes to the settings. Just click OK.

The picture will appear as the backdrop in the Main Camera view and will appear in each of the other setup windows (see Figure 13-10). Because this image is assigned to the backdrop, it will move with the camera, no matter how you rotate or reposition it. Also, no matter how you move the camera, as long as the ground plane is in the scene, the ground will cut off the background image. Take a few moments to move and rotate the camera to see how this works.

FIGURE 13-9
The Camera Backdrop Options window.

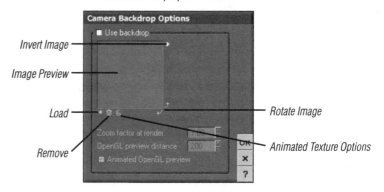

Invert Image

Image Preview

Load

Remove

Rotate Image

Animated Texture Options

FIGURE 13-10
The backdrop image appears in each window. It will move according to the position and rotation of the camera since it is assigned to the camera.

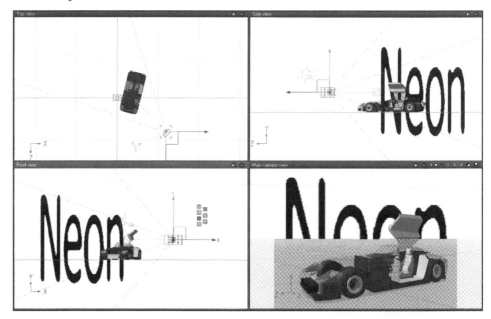

FIGURE 13-11

The car ad image with the ground plane removed from the scene.

7. Remove the ground plane so you can see the entire image.

8. Move the car to the following coordinates:

Position: X = 11.904 ft, Y = 1.4357 ft, Z = -8.094 ft

This positioning will reduce the size of the car slightly so you can read more of the Neon sign.

9. Switch to the Daytime > Sunshine > Destination Unknown atmosphere so your render will not take as long (see Figure 13-11).

Even though you changed the atmosphere, it will not have any effect on the scene other than the way the car is lit.

> **QUICK**TIP
>
> Neon will come out jagged because it is being stretched to fit the render area.

10. Perform a quick render and then save your file as **CarAd**.

11. Now, how do Zoom Factor at Render and OpenGL Preview Distance affect the background image? Click once on the Background button in the Aspect window to re-open the Background Image Options window.

12. Change Zoom Factor to .5 and OpenGL Preview Distance to 400 and then click OK.

The background image will reduce in size and will be a greater distance from the camera in the different display windows (see Figure 13-12). With the reduced size, the image will need to **tile**, so you will see the word Neon repeated over and over and over again. Regarding OpenGL Preview Distance, all this does is move the image display away from the camera so you can better position objects without being given the impression you are cutting into the background picture. It's for setup only.

13. Return to the Background Image Options window and return the Zoom and OpenGL settings to their default settings of 1.00 and 200, respectively.

FIGURE 13-12
The changes in Zoom and OpenGL Preview are reflected in the workspace.

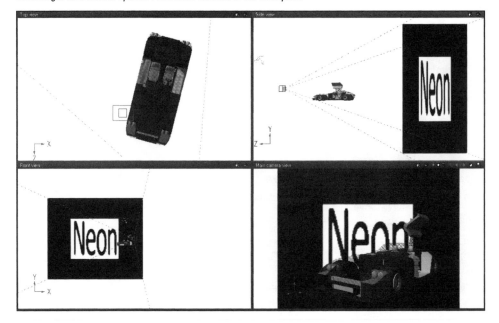

CHANGE
THE FOCAL LENGTH

What You'll Do

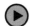

In this lesson, you learn how to change the focal length and add interest to your scene.

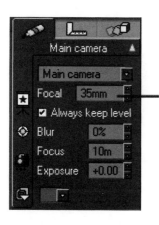

Focal Length Control

Changing the focal length of the camera can add interest to a scene by distorting objects or by separating or bringing them closer together. Remember scenes in movies where a person is standing still but the background seems to draw closer or stretch farther away from him or her? This is accomplished through the change in focal length.

Experiment with the Focal Length

1. If it isn't already, open the CarAd image.

2. Select the Main Camera.

3. In the Aspect window, change Focal to 15mm.

 This change converts the lens to simulate a wide-angle lens. In a wide-angle lens, the glass is more *convex*, or heavily curved, to allow more light to enter and record on the film or digital card. This also causes warping anomalies, where objects become distorted due to the curve of the lens.

 By changing the focal length, you initially have zoomed out from the subject.

4. Move the camera toward the car until the car is positioned as close as it was originally.

 Notice how the car is now warped (see Figure 13-13); the front end is wide and large, with the rest of the car tapering off dramatically. There is a greater sense of power to the vehicle; also, it appears to be larger than in the original image.

Adding Focal Anomalies

In this section, you work with two images to see how focal length can affect the look of the subject in your images. The first image you will work with is the car ad you just created.

FIGURE 13-13
With a wide-angle lens, the car is distorted when framed in almost the same way as originally.

5. Now change the focal length to 70mm.

You have now zoomed in to the car. Because the camera was so close with the wide-angle lens, the car is filling the scene, so you will have to reposition the camera to get the entire car in the ad. Figure 13-14 shows the car rendered with the 70mm lens. Notice that the car is now more in proportion.

> **QUICK**TIP
>
> For portrait work, a photographer typically uses 70-100mm lenses.

FIGURE 13-14

A 70mm lens setting was used for this render.

USE THE ADVANCED CAMERA OPTIONS AND
THE CAMERA MANAGER CONTROLS

What You'll Do

In this section, you modify the style of camera you are using and add post-production parameters to the camera.

Camera/Image Preview

Aspect Controls

Motion Blur Settings

Exposure and Film Effects

Glare Settings

Post Processing Controls

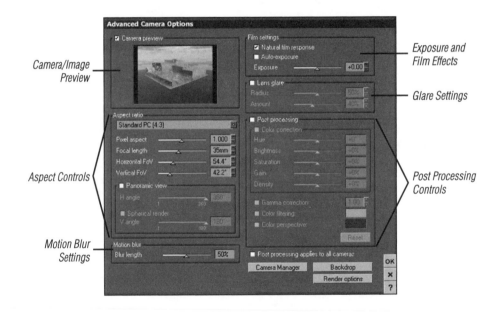

By default, you start off with two cameras in your scene: the Main Camera and the Top Camera. The Main Camera is the default active camera and is the one that you view in the Main Camera View window. The Top Camera gives you an overhead shot of the scene. You can switch the active camera by expanding the Main

Camera object in the Layers window and then clicking on whichever of the two you want to be active (see Figure 13-15).

From this list, you can also set up your cameras to shoot at a specific setting—you can use a standard 3:4 ratio or simulate a widescreen film (16:9) or other real-world camera types. This is accomplished

through the Camera Options window, where you can also access the Camera Manager, which allows you to add more cameras to your scene.

This section will help you become familiar with the controls and learn how they affect your image setup.

FIGURE 13-15

Activate the camera you want to work with by expanding the Main Camera object in the Layers window.

Experiment with the Advanced Camera Options

1. Access the Advanced Camera Options by double-clicking on the camera you want to modify.

 The Advanced Camera Options window will open (see Figure 13-16), giving you access to the following controls:

 - **Camera Preview**—Turn this on or off to show the image preview or not.

 - **Aspect Ratio**—Use this option to change the camera type. The various choices are shown in Figure 13-17. You can change the Pixel Aspect, Focal Length, and Horizontal and Vertical FoVs, all of which will alter the way your image will render.

 - **Panoramic View/Spherical Render**—Create full 360º scenes that can be used for QuickTime VR images or to map onto spherical objects.

 - **Motion Blur**—Determine whether the camera generate a motion blur in an animation and, if so, how much.

 - **Film Settings**—Decide whether the camera will respond to light as it does with actual film and change the exposure settings to lighten or darken the image during rendering.

 - **Lens Glare**—When this option is checked, the camera lens is affected by the light hitting it, washing out areas of the image where the light is hitting the curvature of the lens.

 - **Post Processing**—Set color saturation and light balance before rendering. This is often accomplished in a photo manipulation program such as Adobe Photoshop. You can also make these changes affect every camera in your scene automatically so you don't have to come back to this window every time you switch to a different camera.

 You can also access the Camera Manager window, assign a backdrop image, and set up final render settings via the appropriate buttons at the bottom-right side of the screen.

Learning the Advanced Camera Options

The Advanced Camera Options window gives you a high level of control over the camera and its rendering output. In this window, you can change the camera type, work with FoV settings, add lens glare, and set the color output prior to rendering.

FIGURE 13-16
The Advanced Camera Options screen.

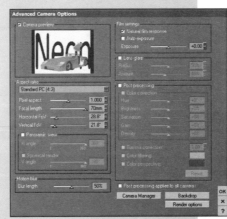

FIGURE 13-17
The different camera types are accessed via the Aspect Ratio pop-up menu.

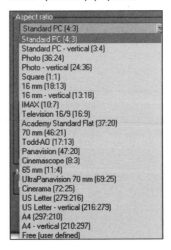

FIGURE 13-18

A comparison between the Cinemascope aspect ratio and Academy Standard, which is the standard aspect ratio used for films today.

Cinemascope

Academy Standard

2. Select the Aspect Ratio pop-up menu and change the camera type from Standard PC (4:3) to Standard PC Vertical (3:4).

 This will change the render area to a vertical (or portrait) **aspect ratio**.

3. Switch to Television 16/9 (16:9).

 You have now change the camera's aspect ratio to work with high definition widescreen broadcast standards.

4. Switch to Cinemascope (8:3).

 This setting produces an extremely wide widescreen effect that used to be used in motion pictures. If you were preparing files to be used in theaters today, you would use the Academy Standard Flat (37:20) aspect ratio. Figure 13-18 shows the difference between Cinemascope and Academy Standard renders.

5. The other area you will work with the most is Post Processing. Check this box, and then change the settings as follows:

Hue: +32º

Brightness: -4%

Saturation: +11%

Gain: +9%

These settings will change the color of the car to orange rather than red, darkening the shadows lightly and increasing the depth of the orange color (see Figure 13-19). By changing the Post Processing settings, you can modify the image to turn out as you want. Remember, though, the changes here affect the overall image, so things such as the interior of the door and panels are affected as well.

FIGURE 13-19

Making changes to the Post Processing settings makes the car orange rather than red in your image.

Using the Camera Manager

The Camera Manager window gives you the ability to add cameras in your scene. There are four ways to access this control window:

- Click the Camera Manager button in the Aspect window.

- Click the Camera Manger button in the Advanced Camera Options window.
- Choose Display > Camera.
- Use the Cmd/Ctrl+, (the comma) shortcut key.

There are three tasks you can perform in this window: You can add or delete a camera from the scene, and you can select which camera is the default active camera.

FIGURE 13-20
The Camera Manager control window.

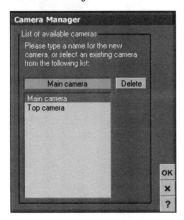

FIGURE 13-21
The new camera is listed in the Layers window and is the active camera.

1. Open the Camera Manager window (see Figure 13-20).

In comparison to every other control window you have used, this is pretty barren. You have a text field where you can type the name of the new camera you are adding and the camera list showing each camera in the scene. To add a camera to the scene, you simply type a name into the text field and click the OK button.

2. Type **Camera2** into the text field and click OK.

The new camera will be added to the Layers window (see Figure 13-21), and you will see it in the viewports in your workspace (see Figure 13-22). Notice in the Layers window that Camera2 is the active camera; it is not only highlighted in the list, but the main camera name has changed to Camera2.

QUICKTIP

You can still select any camera in the list to make it active in the workspace by clicking once on its name.

3. To make the Main Camera the active camera, open the Camera Manager control, click on it once in the list, and then click OK.

 This is the way that you change the render camera as well. By selecting Top Camera, for instance, and making it the active camera, the Main Camera View window will change to reflect it as the rendering camera.

4. To delete the camera, select it in the list and go back to the Camera Manager window.

 Select it in the camera list by clicking on it once, and then click the Delete button next to the text input field. You will be asked if you really, really want to do this (see Figure 13-23). Click Yes, and the camera will be removed from the scene.

FIGURE 13-22

The new camera, by default, is placed over the main camera. Here, the new camera has been moved slightly so you can see it.

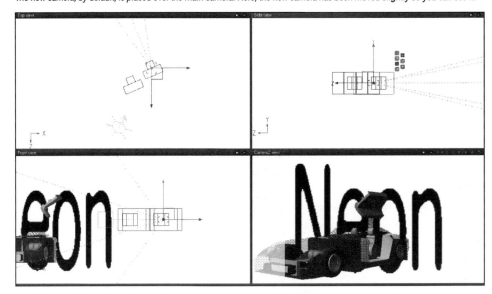

FIGURE 13-23

A warning screen will come up asking if you actually want to remove the camera from your scene.

Linking a Camera to an Object

In preparation for animations, you can link a camera to any object in the scene so that, when the object moves, the camera moves with it. Even in a still image, if you have an object that is supposed to always be visible in the scene but you're not sure where that object will eventually end up, you can link the camera to the object so that when you move the object, the camera moves as well.

QUICKTIP

Any object can be linked to another object for both positioning and animation purposes. You aren't limited to just linking a camera to an object in the scene.

FIGURE 13-24
The selected asteroid and its name in the Layers list.

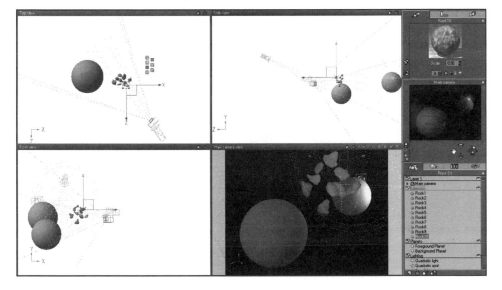

Link Your New Camera to an Object

1. Open the Space scene (called Space Scene.vue or spaceScene.vue) you created.

2. Select the front-most asteroid in the scene.

 Use the Top view to make the selection. You need to make the selection this way to determine which asteroid object you need to link to. The selected asteroid will be highlighted in your Layers window, and you will use that asteroid as the parent object in your animation. Figure 13-24 shows the selected asteroid and its name in the Layers list.

3. Now that you know which asteroid you will link to, select Main Camera and go to the Aspect window.

4. Select the Animation tab.

The window will change to give you some basic animation controls (see Figure 13-25). These controls are as follows:

- **Motion**—The type of motion profile that will be assigned to the selected object. This will be discussed in full in Chapter 15.

- **Track**—When selected, the active object (in this case, the camera) will rotate to keep the linked object in frame.

- **Link To**—When selected, the active object will physically move along with the linked object.

Select the type of tracking you want by checking the Position, Size, Rotation or Join check boxes.

The buttons to the left of the Animation window are defined as follows:

- **Forbid Animation**—Turns off the ability to animate the selected object.

- **Non-Switchable Camera**—By default, this is active. Turning it off allows you to switch cameras in your animations.

- **Pick Tracked Object**—Instead of selecting the object to track from the pop-up menu, select this button and move your cursor over the object you want to track. Click, and it becomes the tracked object.

FIGURE 13-25

The Animation control window in the World Browser.

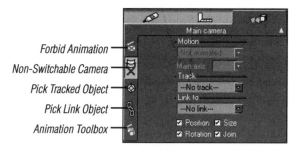

Forbid Animation

Non-Switchable Camera

Pick Tracked Object

Pick Link Object

Animation Toolbox

FIGURE 13-26

Each object in your scene is listed in the Track and/or Link To pop-up menus.

- **Pick Link Object**—Instead of selecting the object to link to from the pop-up menu, select this button and move your cursor over the object you want to link. Click, and it becomes the linked object.

- **Animation Toolbox**—Visual clue as to which screen you are working in.

5. In order to understand linking versus tracking, select the Main Camera and open the Track pop-up window.

 You will see a list of every object in the scene (see Figure 13-26).

6. From this list, choose the asteroid you want to link to.

 The camera will rotate to put this item in the center of the scene. Use the Rotation gizmo to reset your scene to its original layout.

7. Select the asteroid you linked to and move it to another location in the workspace.

The camera will rotate to follow the asteroid (see Figure 13-27). In this manner, you can animate an object coming into frame and passing by the camera, and the camera will rotate to track the motion.

8. Link the light pointing at the asteroid to that asteroid.

When you animate this file, it will remain lit by the Quadratic Spot Light.

9. Save this scene as **AsteroidFieldTrack**.

10. Unlink the camera and the light.

Select those objects and choose No Track from the pop-up menu to unlink them.

11. With the Main Camera selected, choose the asteroid in the Link To pop-up menu.

Now, instead of the camera rotating to keep the subject asteroid in the shot, the camera actually moves with the asteroid.

Save this scene as **AsteroidFieldLink**. You will use both of these saved files in Chapter 15, where you learn how to create animations.

FIGURE 13-27
The camera has rotated to follow the selected asteroid.

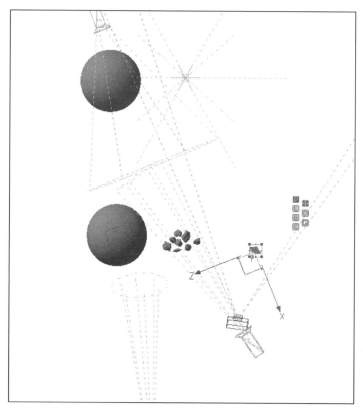

CHAPTER SUMMARY

In this chapter, you learned how to work with cameras, create new cameras, change post processing settings, and set up for an animation by linking to and tracking an object in the scene. You worked with blur settings, and changed the type of camera to fit whatever format you need for your final output. Setting up your scenes by positioning objects is only part of the job; how you set up your camera to capture that scene has a definite impact on how that image is received.

What You Have Learned

In this chapter you

- Added cameras to the Layers list
- Worked with blur and focal settings to change the look of your image
- Set links and tracking so the camera responds to another object in the scene
- Worked with post processing and advanced camera controls

Key Terms from This Chapter

Aberration(s) An optics-based anomaly that is created due to the way light passes into the lens. In many cases, aberrations can be as simple as a slight curvature of the horizon line or as heavy as a box appearing almost round. Rotation and repositioning of objects can sometimes correct this problem. Aberrations can also appear as color shifts (chromatics).

Aspect ratio The width/height measurements for the image determining how the image will render and be used. The aspect ratio is defined by width divided by its height (usually expressed as $x:y$). For instance, the aspect ratio of a traditional television screen is 4:3 or 1.33:1. High-definition television uses an aspect ratio of 16:9, or approximately 1.78:1. For cinematography, an aspect ratio of 2.39:1 or 1.85:1 is used, whereas 35mm film uses 1.37:1 (or the Academy Aperture ratio).

Cinemascope A widescreen format used by the motion picture industry from 1953 to 1967, allowing for a 2.66:1 aspect ratio that produced an image twice as wide as the conventional 1.33:1 ratio.

Field of View (FoV) The field of view of a lens (sometimes called the angle of coverage or angle of view) is defined as the angle (in object space) over which objects are recorded on the film or sensor in a camera. It depends on two factors: the focal length of the lens and the physical size of the film or sensor.

Focal Length The focal length of a lens is defined as the distance from the optical center of a lens (or the secondary principal point for a complex lens like a camera lens) to the focal point (sensor) when the lens is focused on an object at infinity.

Tiling When a background on a web page or in a 3D application is infinite, images will not stretch out to fit the area. Rather, they repeat over and over again, a process called tiling.

chapter

14
RENDERING
FEATURES

1. Use the Select Render Area tool.

2. Use Special Render settings.

14 RENDERING FEATURES

Rendering. If you've taken even the most cursory look at the Render Settings window, you probably shook your head and said to yourself "What is all this stuff?" There are dozens upon dozens of choices facing you. And if you thought you had it all figured out, Vue 6 has added a few more things to the mix. All of this adds up to the power to create the most photorealistic renders possible. This power, however, does not come without a price; in many cases, the elements you have in your scene and the render settings you choose can lead to extremely long render times.

You also have so many choices because not every image or animation you create is going to be used for the same thing. For example, the size and quality of the files you create for Internet use are different than the size and quality of images you make for magazines, newspapers, television, or film. Each has its own unique setup, and again, depending on the number of objects in your scene, the type of objects, and the atmosphere model

and light setups, the settings you choose depends upon the final usage.

If you have multiple computers set up as a network, you can take advantage of network rendering using **RenderBull**. This frees up your main computer so you can work on other Vue scenes or on other programs while the networked computer does the rendering. This won't necessarily speed up the render process, but it does take the burden off of one computer so you can get other work done or even create new scenes.

In many ways, experimentation is your best bet for learning how to render your files. There are so many factors that go into the render settings you choose, it's impossible to cover them all in a single chapter.

QUICKTIP

Some of the renders discussed in this chapter take a lot of time, so you might want to set the parameters and then perform the actual render at a later time.

Tools You'll Use

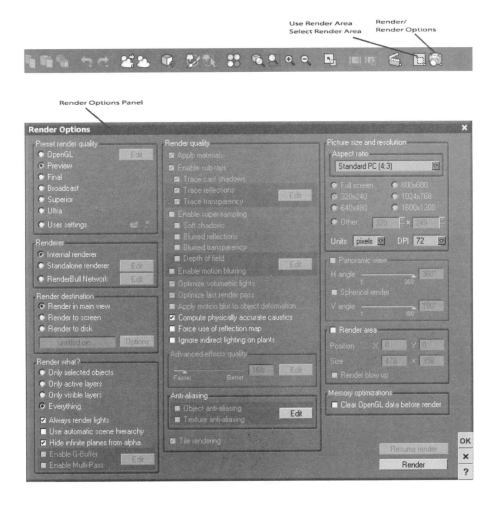

Use Render Area
Select Render Area

Render/
Render Options

Render Options Panel

Render Options

Preset render quality
- OpenGL [Edit]
- Preview
- Final
- Broadcast
- Superior
- Ultra
- User settings

Renderer
- Internal renderer
- Standalone renderer [Edit]
- RenderBull Network [Edit]

Render destination
- Render in main view
- Render to screen
- Render to disk
 - untitled.pic [Options]

Render what?
- Only selected objects
- Only active layers
- Only visible layers
- Everything
- ☑ Always render lights
- ■ Use automatic scene hierarchy
- ☑ Hide infinite planes from alpha
- ■ Enable G-Buffer [Edit]
- ■ Enable Multi-Pass

Render quality
- ☑ Apply materials
- ☑ Enable sub-rays
 - ☑ Trace cast shadows
 - ☑ Trace reflections [Edit]
 - ☑ Trace transparency
- ■ Enable super-sampling
- ■ Soft shadows
- ■ Blurred reflections
- ■ Blurred transparency
- ■ Depth of field
- ■ Enable motion blurring [Edit]
- ☑ Optimize volumetric lights
- ☑ Optimize last render pass
- ■ Apply motion blur to object deformation
- ☑ Compute physically accurate caustics
- ■ Force use of reflection map
- ■ Ignore indirect lighting on plants

Advanced effects quality
Faster Better 16% [Edit]

Anti-aliasing
- ■ Object anti-aliasing [Edit]
- ■ Texture anti-aliasing

☑ Tile rendering

Picture size and resolution

Aspect ratio
Standard PC (4:3)
- Full screen ● 800x600
- 320x240 ● 1024x768
- 640x480 ● 1600x1200
- Other 320 × 240

Units [pixels] DPI [72]

- ■ Panoramic view
 - H angle 360°
 - ■ Spherical render
 - V angle 180°

- ■ Render area
 - Position X 0 Y 0
 - Size 478 × 358
 - ■ Render blow up

Memory optimizations
- ■ Clear OpenGL data before render

[OK]
[x]
[?]

[Resume render]
[Render]

USE THE SELECT
RENDER AREA TOOL

Render/
Render Options

What You'll Do

In this lesson, you learn how to use the Select Render Area tool to render a section of the image.

Throughout this book, you have performed full-screen preview renders. You have either performed a quick preview or final render while in four panel mode, or by expanding the Main Camera Window panel to full screen and rendering that way. Depending on the complexity of the image, such renders can be time consuming. What if you made a change only to one section of the image and you want to see how that change looks when rendered? You don't want to necessarily wait for the entire scene to render again. That's where the Select Render Area button comes into play (see Figure 14-1). This tool is located to the left of the Render/Render Options button in the toolbar along the top of the screen.

FIGURE 14-1
The Select Render Area button, located to the left of the Render/Render Options button.

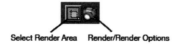

Select Render Area Render/Render Options

Rendering a Select Area

In this section, you work with the alien landscape scene you finished in Chapter 9 (Sky Scene.vue or skyScene.vue). Open this file before moving on. This is a fairly complicated file with a lot of plants. The scene I'm using for this section has just under 5 million polygons, so it can take 20 minutes or more to do a full final-quality preview render. If you make an incremental change, you don't want to take that time to see how it looks. In comes the Select Render Area option.

FIGURE 14-2

The area render and its preview in the Post Render Options window.

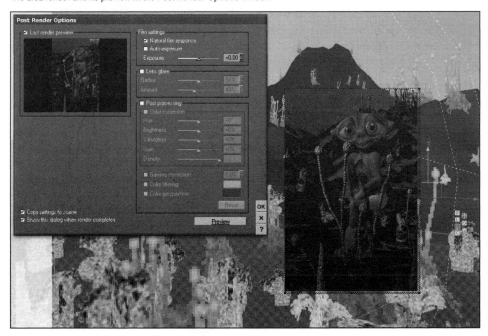

4. You can modify the selected area to encompass more or less of the scene by clicking on one of the control handles on the box that surrounds the area (see Figure 14-3) and then dragging inward or out to increase the size (see Figure 14-4).

5. To re-render the selected area, right-click on the image.

 This will bring up the submenu where you can select Render to re-render the selection (see Figure 14-5).

6. When you're finished, you can get rid of the render area bounding box by right-clicking and selecting Discard Render Area.

FIGURE 14-3

A bounding box shows the area that is to be rendered. This image has been lightened so you can see the handles.

Control Handles

Control Handles

FIGURE 14-4

Drag a control handle to increase or decrease the size of the area render.

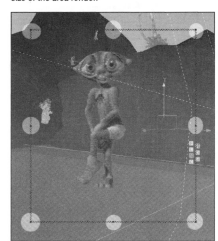

FIGURE 14-5

Right-clicking opens the submenu where you can choose the area render options.

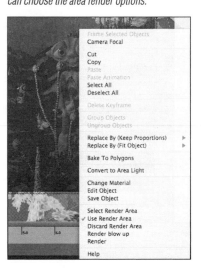

USE SPECIAL RENDER SETTINGS

What You'll Do

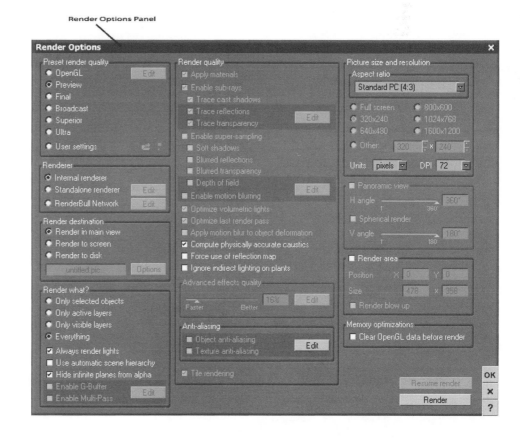

In this lesson, you learn how to perform various types of renders that will help you in putting together a finished piece.

Render Options Panel

The Render Options window is broken into 10 distinct sections (see Figure 14-6). They are as follows:

- **Preset Render Quality**—Provides selections that have preset quality settings to render for a particular output.
- **Renderer**—Determines what type of renderer you will use. You can also save or load a preset you have created using the folder (Load) or the disk (Save) button.
- **Render Destination**—Determines where the file will be rendered and/or saved.
- **Render What**—Determines what will be rendered and how.

- **Render Quality**—Determines what quality features will be rendered.
- **Anti-Aliasing**—Determines how Vue will smooth out the edges along objects after the render is complete.
- **Picture Size and Resolution**—Determines the size and quality of the outputted image.
- **Panoramic View**—Determines whether you want the camera to change and render a panorama.
- **Render Area**—If you only want to render a specific area of the image, this is where you set those dimensions and output size.

- **Memory Optimizations**—Clears unneeded system resources to free Vue's memory.

If the Preset Render Quality settings look familiar, they should be. They are the same as the presets you can assign via the Render button from the Main Camera View window.

QUICKTIP

When you click on a preset, different areas become active or certain settings change. As you click on a preset, look at what becomes available to you and what settings have changed. When you perform the render(s), see how those modifications affect the quality of the render as well as render time.

There are a couple of ways to access the Render Options window. You can

- Press and hold on the Render/Render Options button (see Figure 14-7).
- Right-click on the Render/Render Options button.
- Choose the Render > Render Options pull-down menu.
- Use Cmd/Ctrl+F9.

QUICKTIP

Preview renders are good for one thing, to preview the scene. You literally have no control over size, resolution, or any other factor of the render, which is why you will not work with preview renders in this chapter.

FIGURE 14-6
The Render Options window.

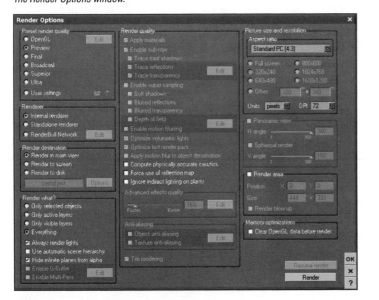

FIGURE 14-7
The Render/Render Options button, which looks like a 35mm camera.

Using G-Buffer and Multi-Pass Rendering

The terms G-Buffer and Multi-Pass might sound like some sort of medical terms or strange new diseases, but they are actually industry-standard rendering techniques that give designers, 3D animators, and video professionals the tools necessary to composite different types of files.

G-Buffer and Multi-Pass renderings give the digital artist the flexibility to combine layer information through the use of channels that contain specific information about the scene, such as alpha, depth, specularity, and diffusion. Digital artists then use these channels to select elements, set their

brightness and contrast, and then combine them into real-world or other types of scenes or layouts.

With Vue, you determine which special elements will be produced in your final render.

FIGURE 14-8
Activate G-Buffer and Multi-Pass in the Render What? section of the render screen.

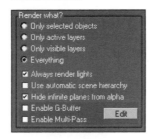

FIGURE 14-9
The G-Buffer/Multi-Pass Options screen.

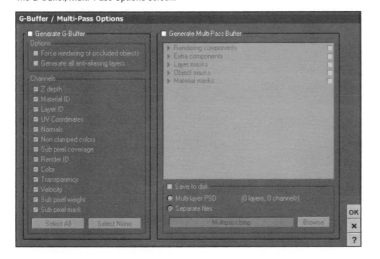

1. Open the Render Options window and activate Final in the Preset Render Quality section.

 You cannot access G-Buffer or Multi-Pass in OpenGL or Preview render mode.

2. Check the Enable G-Buffer and Enable Multi-Pass check boxes.

 These options are accessible in the Render What? section of the screen (see Figure 14-8).

3. After checking these two boxes, click the Edit button, which will open the G-Buffer/Multi-Pass Options screen (see Figure 14-9).

 In this window, you choose which you want Vue to generate. It can be G-Buffer information or Multi-Pass rendering. G-Buffer, again, is used for animations, outputting to either **RLA** or **RPF** format. This information can be stored in still images for use in video compositing.

4. Enable Multi-Pass.

You now have the ability to choose which channels will be included in the final render. Figure 14-10 shows one of the five categories expanded. You can choose everything in any or all of the categories or specific individual channels from within those categories.

5. Choose the type of file(s) that will be created.

You can choose from a single Photoshop Document (PSD) file or have Vue create individual image files for each channel. Select Multi-Layer PSD.

6. Click the Browse button next to the text field under Separate Files.

Your Save navigation window will open. Here, you give your file a name and tell Vue where to save it. Also, if you don't have Photoshop or a program that reads PSD files, you can choose the format you want to create. But be aware, many of the file formats do not support multiple channels.

After you set your file name and its save location, the Picture Format Options will open (see Figure 14-11). Here, you choose the bit depth and the number of colors included in the file.

FIGURE 14-10
You can choose which channels (individually or collectively) will be generated from five different categories.

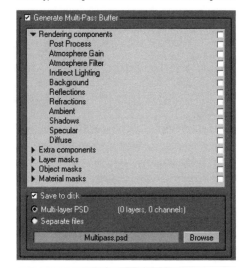

FIGURE 14-11

The Picture Format Options window.

FIGURE 14-12

The layers and channels created with a Multi-Pass render, shown in the Photoshop Layers/Channels windows.

7. For this render, select Rendering Components, Layer Masks, and Object Masks.

8. Click OK to go back to the Render Options window.

9. Click Render to render the file.

Once the render is finished, open the saved file in Photoshop. You will have a set of layers that, when combined, give the final look to the scene and a set of channel layers to make modifications strictly to individual objects (see Figure 14-12). Each layer can be modified to make changes to the image.

To perform a render using G-Buffer, you activate G-Buffer instead and make your buffering selections just as you did with Multi-Pass.

Set Size and Resolution

1. Open the CarAd image.

2. In the Camera Options window, change the Aspect Ratio to Photo-Vertical (24:36).

 Move the camera up so the car is at the bottom of the image as you see in Figure 14-15. The numeric placement of the camera is X = 34.685 ft, Y = 14.559 ft, and Z = 55.087 ft. As you move the camera, the Neon background will not appear to move—it's linked to the camera—but the car will.

3. Choose Render Options.

Setting Size and Resolution

If you want to create an image that is a particular size and resolution, you need to turn to the Render Destination area. In this area you determine whether the image will render to the Main Camera View window, Render to Screen, or set a destination where the image will be saved (see Figure 14-13). If you are rendering to Main View, you have no control over the image size or resolution; if you choose one of the others, the Aspect Ratio's image size controls become active (see Figure 14-14). When they are active, you can choose a size (width/height) and number of pixels/dots per inch (PPI or DPI) that will make up the image.

QUICK TIP

Images used for the Internet or for screen display of any kind are 72 dpi. Images that will be used for print are, traditionally, 300 dpi unless you are told otherwise by your printing service.

FIGURE 14-13
The Render Destination controls.

FIGURE 14-14
When rendering to screen or disk, the image size and resolution controls become available.

FIGURE 14-15
The CarAd image should look like this after you move the camera.

FIGURE 14-16

Choose the type of renderer you want to use in this section of the Render Options window.

FIGURE 14-17

The Batch Rendering window appears when you choose Standalone Renderer or RenderBull Network.

FIGURE 14-18

The RenderBull Network Rendering Options screen.

4. Switch to User Settings and Render to Screen.

 When you render to the screen, you will see the render being made. If you use the Render to Disk setting, the rendering happens behind the scenes. You can't work on another file while this is going on.

 What are these different renderer settings (see Figure 14-16)? These determine whether Vue will do the rendering, or if you have a network or have separate rendering software, you can use them.

 - **Internal Renderer**—Vue's internal render engine does the rendering. Vue will be tied up while this occurs, and you cannot work on other scenes or open saved files.

 - **Standalone Renderer**—Some 3D applications have separate render engines, or you can purchase programs like Renderman to do your rendering. Vue comes with **RenderCow**/RenderBull, which allows you to schedule when the file will be rendered, and it renders in the background. This way, you can select different scenes to render, and they'll be added to a list and rendered in order (see Figure 14-17).

 - **RenderBull Network**—If you have multiple computers and programs like Renderman, you can schedule the renders and have another computer do the rendering. You must enter a command line and choose a location for your file by clicking the Browse button next to the RenderBull Network selector. A screen like you see in Figure 14-18 will appear when you do this.

5. Select 800×1200 in the Aspect Ratio section.

 This is set by pixel dimensions, so this means the file will be 800 pixels wide by 1200 pixels tall. This converts to 11.111 inches by 16.667 inches. By default, the resolution is set to 72 dpi, meaning there will be 72 pixels making up each inch of the image.

6. Make sure Units is set to Pixels, and then change the resolution setting to 300.

7. Turn off Depth of Field and Enable Motion Blurring in the Render Quality section (see Figure 14-19).

 Because nothing is moving in this scene, and the lens has been set up as you want it to make the car look like you want, there is no need to have Vue perform these two functions. You do, however need to have Computer Physically Accurate Caustics turned on so the image will look better.

8. Click the Render button.

The window will close, and your scene will begin to render. Don't worry about the image size on the screen; this will change when the render is complete. Also, the Render timer will start so you can watch the progress and get an idea of how long the scene will take to render (see Figure 14-20).

QUICKTIP

The Time Left indicator will often change mid-render. As Vue encounters more complex areas, the render time will increase; as it encounters less complex sections, the time left to render will go down. It estimates the time based on what it's rendering at the moment. In the case of the car ad, the car will eat up most of the render time. Once the car is rendered, Time Left will decrease dramatically.

9. Once the render is complete, click the Save button (the floppy disk icon), shown in Figure 14-21.

When you turn different rendering features off or on, the quality of the render and features of the render will change. But that's half the fun of working with this panel, exploration. Try different settings, see how the image turns out, and when you're happy with a result, save the settings for future use.

FIGURE 14-19
The Render Quality section has numerous controls to help you add or delete render settings that can add to or subtract from the render time.

FIGURE 14-20
This window will give you an esti-mate of how much of the image has been rendered and the time it will take to finish the rendering.

FIGURE 14-21
The finished render and the Save button, located at the top of the render window.

CHAPTER SUMMARY

In a way, there is really no secret to rendering an image. In some cases, it's trial and error. But as you get used to working with the program and see the results when you turn features on or off, your rendering setup time will decrease exponentially. And if you do a lot of print work, remembering to use Multi-Pass rendering will help you save time and money on aspirin to get rid of those headaches.

What You Have Learned

In this chapter you

- Learned about G-Buffer and Multi-Pass rendering setup
- Learned how to save render settings you have created
- Learned how to work with RenderCow and RenderBull
- Learned how to set up your files for a final render

Key Terms from This Chapter

Composite/Compositing Compositing is the art of creating complex images (either still or video) by combining different sources. It is used extensively in movies to achieve effects that would otherwise be impossible.

RenderBull Vue 6 only. RenderBull is a network render software package that allows users to assign the rendering process to other computers linked together in a network.

RenderCow A program included with the Vue software that allows users to render an image in the background. It stores the image information and renders the scene or animation outside of the program so you can build other scenes while the render is taking place.

RLA Stands for Run Length Encoded A. Previously used with SGI computers, this format is popular because of its support of the inclusion of arbitrary image channels in either 8- or 16-bit mode.

RPF Stands for Rich Pixel Format. This format has additional arbitrary image channel information and is a 3DS Max format. Because of the additional information that can be stored, it has pretty much replaced RLA for higher end post production and effects work.

chapter

15

GETTING
ANIMATED

1. Explore the Animation Setup Wizard.

2. Work with Wind effects.

3. Incorporate Ventilators in your scenes.

4. Link and track objects.

chapter 19 GETTING ANIMATED

Animation is a hot ticket right now. Virtually every 3D artist wants to dabble in it. Animating at its most basic is an easy process; you move a selected object from one point to another, and there you have it. Kind of. There are many intricacies that need to be addressed when you create an animation in order to make it look like you want. In the case of an aircraft, for example, if it turns, it needs to bank correctly. If it's a car, it needs to increase and decrease speed as it starts and then stops. Does the camera follow the object as it passes by, or does it move with it?

Vue can make the initial process much easier thanks to the **Animation Setup Wizard.** You can set up **ease-ins** and **ease-outs.** You can make the object jiggle or spin with just a click of a button. You can even get the object you're animating to react to the terrain. But the Animation Setup Wizard is just the start. You have **splines** that can be modified for literally every animatable element in an object. You have the ability to create **keyframes** on the fly. You can change the path of the object interactively. And in the case of wind effects, with the use of a Ventilator, you can get specific plants to react differently when something moves near them.

This chapter deals with the animation controls at your disposal. You use the Timeline to modify and add keyframes to your animations. You also learn how to render your animations for specific purposes, be they for web, DVD, or broadcast.

QUICKTIP

Some of the renders in this chapter take some time, so you might want to set the parameters and then perform the actual render at a later time. Sample rendered animations are available on the book's website at www.courseptr.com/downloads.

Tools You'll Use

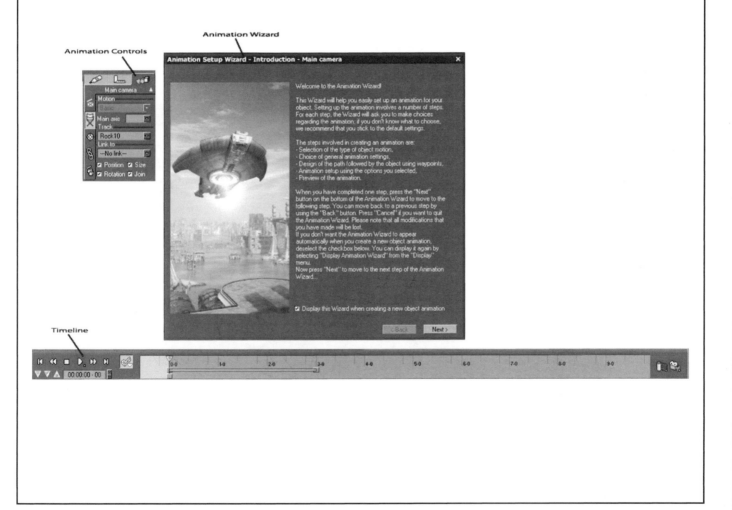

Animation Controls

Animation Wizard

Timeline

Animation Setup Wizard - Introduction - Main camera

Welcome to the Animation Wizard!

This Wizard will help you easily set up an animation for your object. Setting up the animation involves a number of steps. For each step, the Wizard will ask you to make choices regarding the animation; if you don't know what to choose, we recommend that you stick to the default settings.

The steps involved in creating an animation are:
- Selection of the type of object motion,
- Choice of general animation settings,
- Design of the path followed by the object using waypoints,
- Animation setup using the options you selected,
- Preview of the animation.

When you have completed one step, press the "Next" button on the bottom of the Animation Wizard to move to the following step. You can move back to a previous step by using the "Back" button. Press "Cancel" if you want to quit the Animation Wizard. Please note that all modifications that you have made will be lost.
If you don't want the Animation Wizard to appear automatically when you create a new object animation, deselect the checkbox below. You can display it again by selecting "Display Animation Wizard" from the 'Display' menu.
Now press "Next" to move to the next step of the Animation Wizard...

☑ Display this Wizard when creating a new object animation

‹ Back Next ›

LESSON 1

EXPLORE THE
ANIMATION SETUP WIZARD

What You'll Do

In this lesson, you learn how to animate an object using the Animation Setup Wizard.

Animation Setup Wizard Main Screen

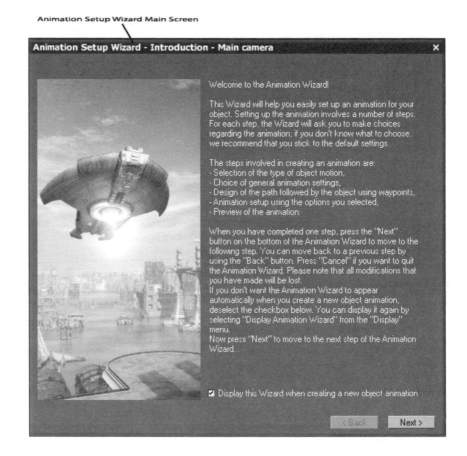

The Animation Setup Wizard (see Figure 15-1) appears whenever you select a new object and want to animate it. You access it by clicking on the Show Timeline button (see Figure 15-2) in the tool panel at the top of the workspace. This screen gives you access to numerous controls that can help you get started with your animations, but as you become more confident with the program and its animation controls, you will probably want to turn this feature off by deselecting Display This Wizard when Creating a New Object Animation.

QUICKTIP

You learn how to create an animation without using the Animation Setup Wizard later in this chapter.

When you have finished setting up your animation and close the window, the animation Timeline will open at the bottom of your workspace (see Figure 15-3). In this area, you can make further modifications and access object-specific controls that can be animated.

QUICKTIP

To remove the Timeline from the workspace, click once on the Show Timeline button. You can then click on the same button to make the Timeline reappear, as long as you don't have a nonanimated object selected.

FIGURE 15-1
The first screen of the Animation Setup Wizard. When you animate a new object, this is the first window you will see.

FIGURE 15-2
The Show Timeline button, located in the tools area of the workspace.

Show Timeline Button ———

FIGURE 15-3
The animation Timeline. This appears when you finish with the Animation Setup Wizard.

Animate an Airplane

1. With a new scene open, select the P40 airplane model in the Vehicles section of the Objects window.

2. Rotate the plane so it is facing to the right in the Top View window (see Figure 15-4).

Animating an Object—The Animation Setup Wizard

To understand the Animation Setup Wizard, you will animate a primitive object. This will be a simple animation whereby the object moves into the scene from screen left and exits screen right.

FIGURE 15-4
After rotating the P40 airplane model, your Top View window should look similar to this.

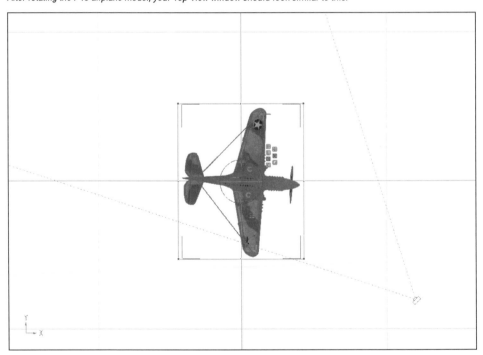

3. Move the airplane to the left in the Top View window so it is off camera (see Figure 15-5).

4. With the airplane still selected, click and hold down the left mouse button on the Show Timeline button until it is highlighted. Then release the mouse button.

The Animation Setup Wizard window will open. This main screen is nothing but an informational panel, which you can read at your leisure. It lists the steps you will use in creating your animation and what to do when you finish setting up the animation.

FIGURE 15-5

The new starting position for the airplane animation.

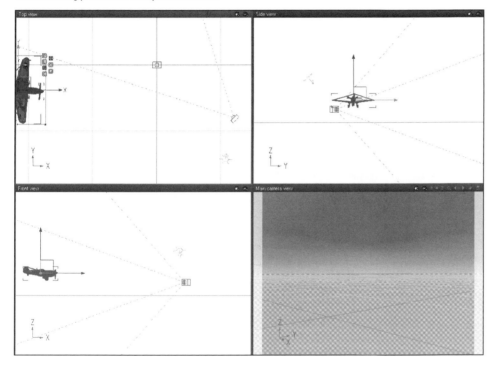

5. Click the Next button to go to the first setup screen (see Figure 15-6).

This is the Type of Motion screen, where you determine how the object will react when it starts up or nears the end of the **motion path**, how it banks around any turns you might set up, and other motion physics. Because you're working with an airplane here, click the Airplane button so the object faces ahead and banks when it turns. Click Next.

QUICKTIP

The Options button in the Type of Motion screen gives you access to the Motion Options window (see Figure 15-7), which gives you controls that will modify the reaction of the object along the path. After you are comfortable with setting up basic motions with the Animation Setup Wizard, try changing some of these settings to see how they make your object react.

FIGURE 15-6

The Type of Motion screen. This is the first control window you access in the Animation Setup Wizard.

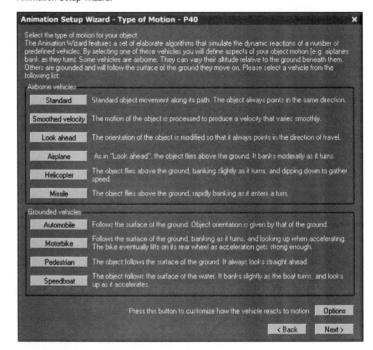

FIGURE 15-7

The Motion Options window gives you more advanced controls to modify the way your object reacts along the motion path.

FIGURE 15-8

The Global Animation Settings window.

FIGURE 15-9

The Advanced Effects window gives you control over object rotation and vibration.

6. Click Next to move to the next section of the Animation Setup Wizard.

The next window is the Global Animation Settings window (see Figure 15-8). Here you set whether your animation repeats or not, along which axis the selected object will point, and its velocity reaction. For this animation, you will not make any changes to any of these. So....

7. Click Next. You are taken to the Advanced Effects window (see Figure 15-9).

One of the hardest things to do, and the bane of many animators' existences, is to make an object vibrate or rotate along the path. Picture this: You have a flying object of some type that is spiraling toward the ground. To get the spirals correct, you would have to set up key frames, rotate the object x-number of degrees, and then continue this process until the object finally hits the ground. In this window, you can tell the object to rotate, along which axis it will rotate, and how that rotation varies over time (the hardest part for the animator).

In this case, you will not set rotation for the airplane—no need to get the pilot or yourself sick—so....

8. Click the Next button to go to the Object Path window (see Figure 15-10).

If you do not see the black dot in this screen, right-click on the window and move the view until you do. The black dot is the center location of your object.

QUICKTIP

You can do four things in the Object Path window:

Create a path—Click to set a new point, which will be connected by a red line (the path the object will follow).

Edit points along the path—Use this to select a point along the path and move it to another position, modifying the overall shape of the path.

Insert points along the path—If you need to extend the animation or have more control over positioning within the animation, use this to add points to an existing path.

Delete points along the path—Remove unwanted or unnecessary points along the path.

Each point you create adds one second (:01, or in **non-linear editing** numerics, 00:00:01;00, with the translation being hours: minutes:seconds;frames).

FIGURE 15-10

The Object Path window is where you create your motion path for the object.

FIGURE 15-11

The motion path is displayed as a red line connecting the two keyframes.

FIGURE 15-12

The finished motion path takes the plane from off camera screen left to off camera screen right.

9. Make sure Add Way Point is selected and click to the right of the black dot representing your object.

 A red line will appear, connecting the two points. This is the motion path. Figure 15-11 shows the Object Path window as it should now appear. Don't worry if your point is in a different spot than what you see; it really doesn't matter for this project. You have just created a **keyframe**, a beginning and ending point in an animation.

10. Add two more way points (or keyframes), the first being approximately centered within the camera's view and the next well outside of the camera's view, screen right.

 You cannot zoom out in this window, so you will probably have to right-click on the display to place your final keyframe point in the correct position. Figure 15-12 shows the approximate path you have created.

 QUICKTIP

 You are not stuck with the path you create in this window. It can be modified in any of the viewports after you have created it.

11. Click Next, which will take you to a review window, Animation Setup (see Figure 15-13) screen.

> **QUICK**TIP
>
> The Plot of Object Altitudes section shows how the program automatically tries to detect obstacles in the path so your object will not fly through a mountain (for instance). Because you are flying over flat terrain, the motion path is perfectly level.

This is where you can review your settings and see a graph of your animation and a time indicator for how long the animation will be. Because you placed three keyframes into this path, your animation will be three seconds (:03;00) in length.

12. Click Next to go to the Animation Preview window (see Figure 15-14).

Here, you get to see what your animation will look like. This is performed in a low-resolution method. If you like what you see, click Next; if you don't, click Back. You can click the Back button to go all the way back to the beginning of the animation setup to make modifications.

13. Click Next. The Conclusion screen (see Figure 15-15) is presented, where you can get some basic information on modifying your path(s) directly within the program.

At this point, the setup for your animation is complete. You have been returned to the main workspace, and the Timeline has appeared at the bottom of the workspace.

FIGURE 15-13

The Animation Setup window gives you one last look at your animation settings before applying them to the scene.

FIGURE 15-14

The Animation Preview window shows a low-resolution preview of your animation.

FIGURE 15-15

The Conclusion window, giving you information on modifying your animations after you exit the Animation Setup Wizard.

Animating an Object— The Timeline

With the creation of your airplane animation, the Timeline shows a yellow bar with squares indicating the keyframes you created in the Animation Setup Wizard (see Figure 15-16). In this section, you will learn how to perform basic animation changes using the Timeline window and the viewports.

The controls consist of the following:

- **Start of Animation**—Click this to move the playhead to the start of the animation.
- **Previous Keyframe**—Move the playhead back to the previous keyframe in the animation.
- **Stop**—Stop the preview render from playing.

- **Play**—Play the preview render animation.
- **Next Keyframe**—Move the playhead forward to the next keyframe in the animation.
- **End of Animation**—Move the playhead to the last frame of the animation.
- **Keyframe Options Window**—Provide controls for creating or editing a keyframe.
- **Time/Frame Indicators**—Shows either in seconds or frames the time of the animation and position of the playhead/scrubber.
- **Generate Preview/Preview Options**—Creates a quick render of the animation.
- **Render Animation/Advanced Render Options**—Gives you controls to set the quality and the format of your animation(s).

- **Show/Hide Properties**—Gives you access to the animated elements and their animatable parts.
- **Show/Hide Splines**—Gives you access to the Spline Editor to make advanced changes to your animation.
- **Show/Hide Preview**—Turns the Timeline's preview windows on or off.
- **Time & Next/Last Frame**—Time shows a numeric value for the position of your playhead, and Next/Last Frame lets you click to move forward or backward one frame at a time.
- **Playhead/Scrubber**—Indicates where in the Timeline you are positioned, or, when you click and drag on the playhead, you can scroll through the animation (called **scrubbing**).
- **Keyframes**—Shows where the keyframes are in the animation.

The first thing you want to do is test your animation, making sure it looks as you want it or find where you want to make changes.

FIGURE 15-16

The Timeline, indicating a :03 animation and its keyframes.

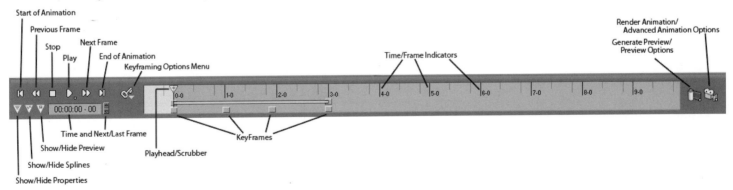

Test Your Animation

1. Click the Generate Preview/Preview Options button once. Do not press and hold, as this will open the options window, which you don't want to do at the moment.

QUICKTIP

The preview render I created is available for download on the book's website at www.courseptr.com/downloads. It's titled planeAnim_160×120.mov.

A small preview window appears directly beneath the Timeline (see Figure 15-17). You can watch as the frames are rendered, and then, when complete, the animation will play. By default, this is a 5 frame per second (fps) render that will be jerky.

QUICKTIP

The standard frame rates for Internet, film, and broadcast are as follows:

Internet–Between 15 and 30fps

Film–24fps

NTSC (American broadcast standards)–29.97fps or 30fps

High Definition–24fps

All media are also low-resolution files, so if you are preparing images for use in broadcast or on a DVD, they need only be 72dpi.

Width and height dimensions for a standard NTSC broadcast file is 720×480 pixels or 720×540 pixels.

FIGURE 15-17
The preview render appears beneath the Timeline.

FIGURE 15-18
This screen, giving you render information, appears when you perform a preview render.

FIGURE 15-19

Moving the scrubber shows which frame of the animation appears at the scrubber's location.

FIGURE 15-20

The Animation Preview Options window lets you set the quality and size of the preview render.

You will also get the screen you see in Figure 15-18, which tells you how large the preview is (width and height), which frame is being rendered, and an approximate estimate of how long it will take to render.

2. When you stop playback, the frames of the animation will be separated. As you move the scrubber by clicking and dragging it along the Timeline, you will cycle through the individual frames (see Figure 15-19).

QUICKTIP

To stop a render in progress, either still or video, press the Esc key on your keyboard.

3. To change the frame rate (the fps), press and hold on the Preview/Preview Options button. When it is highlighted, release the mouse button.

The Animation Preview Options window (see Figure 15-20) opens. Here, you can set the quality of the render, its frame rate, and the preview size. In complicated scenes with a lot of detail, changing it to 4× will almost be a necessity.

QUICKTIP

Changing the quality of the preview render can alter the render time dramatically. If all you are doing is creating a review animation, keep the setting on Preview. If, however, you want to save your preview render for use on a web page or to send to a client, you might consider rendering at Final and 4× size (160×120) and at least a 15fps rate.

Change an Animated Object Interactively

1. Select the Plane object either by clicking on it in one of the viewports or by clicking its name in the Layers window.

2. Move the airplane back using the dotted line of the camera's field of view until it is in approximately the same position as you see in Figure 15-21.

 Notice how there are keyframe markers along the motion path in the various viewports. You will be using those to modify the rest of the animation.

Making Changes to an Animated Object

So let's say you want to make changes to the way the plane flies into the scene. Actually, for this project, you do want to make changes to the way the plane flies into the scene. There are two ways of accomplishing this: interactively or using the numerics panel. In this project, you will make changes interactively using the various viewports and the Timeline.

FIGURE 15-21

The airplane in its original position, and the position you should move it to.

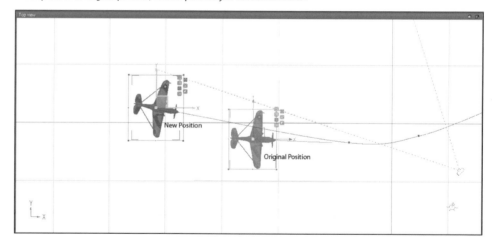

FIGURE 15-22

The new position for the first keyframe. The lines extending from the keyframe marker are called control handles.

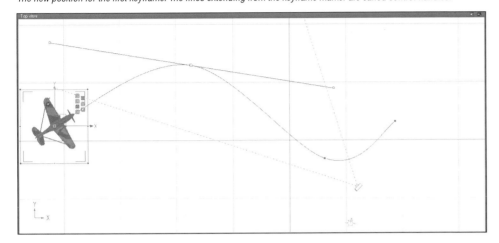

FIGURE 15-23

The new position for the second keyframe.

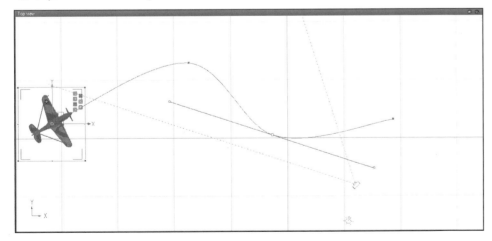

3. Click on the first keyframe marker and move it to the position you see in Figure 15-22 by pressing and holding down the left mouse button and dragging.

The blue lines that jut out from the key-point marker are called *control handles*. You can click and drag on the endpoints of these handles to change the sharpness of the curve you made. If you use programs such as Adobe Illustrator, Photoshop, Corel Draw, PaintShop Pro, and so on, you will be used to working with these control handles.

4. Move the second keyframe marker (the one for the :02 mark in the animation) to the position you see in Figure 15-23.

5. Perform a preview render to see how the plane reacts along this new motion path.

To finish this scene, add a grass texture to the ground plane and some patches of grass, dry weeds, and one tree to the middle and fore-ground of the viewable area. Then save your file as **BuzzingPlane**.

Change Animation Settings

1. With the plane scene still open, click the Show/Hide Properties button in the Timeline.

This button is the left-most triangle in the Timeline, which is shown in Figure 15-24. This will expand the Timeline window to show all animated elements and their respective keyframes within the animation (see Figure 15-25). You also get four more tools associated with those object Timeline(s), located to the right of the Timeline window (see Figure 15-26). These tools give you the following controls:

- **Persistent Path**—Always shows the path of the object when that object is selected.

Working on Individual Object Settings

As mentioned earlier, you can control individual elements of an object within the animation. In the previous section, you made a global change to the position of the airplane and its motion path; now you will make changes to specific settings within the animation.

FIGURE 15-24

The Show/Hide Properties button (left and highlighted) expands or contracts the Timeline in order for you to make precise changes to an object within an animation.

FIGURE 15-25

The expanded Timeline window.

FIGURE 15-26

The advanced motion control buttons.

FIGURE 15-27

The motion path shown as a ribbon, using the Show as Ribbon command.

FIGURE 15-28

Expanding the view to show the various animatable parts of the airplane.

- **Show as Ribbon**—Shows the selected object's path as a ribbon (see Figure 15-27).
- **Show Tangents**—Shows the control handles when in the advanced Tangent editing mode.
- **Animation Toolbox**—Takes you to the Animation Control Options window.

2. Click the toggle switch to the right of the airplane in the Timeline list (see Figure 15-28).

 This toggle switch expands the airplane list to show the model's animatable features. This now allows you to select specific elements of the model—from position to actual pieces of the model—in order to tweak the animation.

3. Click the End of Animation button to go to the...uh...the end of the animation.

4. Select Position Z from the list by clicking on it once.

5. In the Side View viewport, move the plane up slightly (see Figure 15-29).

The motion path line will move with the plane. Essentially, when the plane banks past the tree, it will ascend into the sky.

6. To modify this even more, click the Show/Hide Splines button next to the Show/Hide Properties button (see Figure 15-30).

The animation's **spline** lines will be revealed.

7. Select Position Z from the Position list (you might need to click the Position toggle switch) to bring up the height spline (see Figure 15-31). Notice how the spline dips between the second and third keyframes. This is a common anomaly; when you make a change to one point, the flow prior to or after can often be affected in ways you don't want.

FIGURE 15-29
Your plane should be positioned so it will rise after missing the tree.

FIGURE 15-30
The Show/Hide Splines button (center).

FIGURE 15-31
The Z position spline.

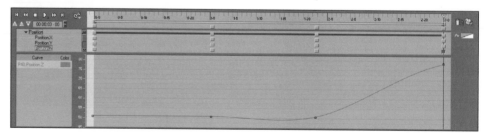

8. Click on the second-to-last keyframe point in the spline and move it up slightly so the spline line between it and the one before is level (see Figure 15-32).

You will also activate control handles for the spline and can change the curve of the path using those.

QUICKTIP

You will also want to check the Position X and Position Y splines as well to make sure changes to these have not occurred.

With this minor change, you have ensured that the plane will not dip down toward the ground as it banks past the tree. If you had not made this change, the wing of the place could well have hit the ground, ruining the look of your animation.

FIGURE 15-32

The active keypoint on the spline reveals control handles for you to modify the curve of the path.

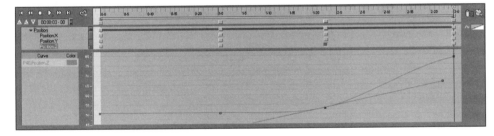

WORK WITH
WIND EFFECTS

What You'll Do

In this section, you work with the Wind Effects section of the Atmosphere Editor.

One of the most compelling aspects of Vue is how you can add wind effects to a scene. Wind, of course, would only be seen in animations, which is why this control has been included in this chapter. Animating foliage can be the bane of any **rigger** and/

or animator's existence. To have to set up individual leaves or blades of grass or flower buds to react to wind is extremely difficult. With Vue, all Solid Growth plants can be affected by wind simulated within the program.

Wind Selector Tab

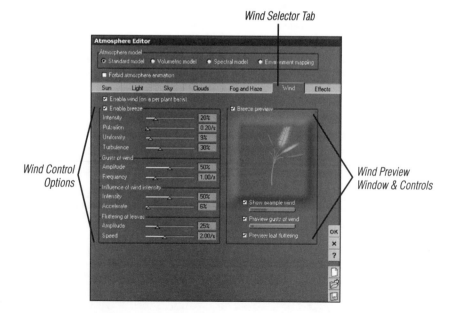

Wind Control Options

Wind Preview Window & Controls

Controlling the Wind

In this section, you continue to work with the airplane animation you just created. To start, you return to the Atmosphere Editor, where the controls for wind are located. In this section of the Editor, you control how breezes affect each leaf and branch. As you practice with these controls, you will find what works best for you when setting up your animations. For this lesson, I give you the most commonly used settings and show you the way I work with the window, but you will soon find the way you like to have this window set up for your workflow.

FIGURE 15-33
The Wind effects window with both controls active.

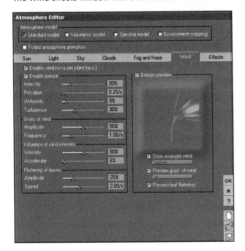

Work with Wind Effects

1. Make sure you are on Frame 1 of your animation by clicking the Start of Animation button.

2. Open the Atmosphere Editor and select the Wind tab.

 This will give you access to the controls that create and modify wind effects in your scene.

3. Select Enable Wind (On a Per Plant Basis) and Enable Breeze (see Figure 15-33).

 By enabling the wind on a per plant basis, you are telling Vue to add wind effects to foliage in the scene. This will assign a default wind or breeze strength to your animation(s). If you want the default, you can leave the Enable Breeze control turned off, but if you're like me, you really don't want a program telling you how your animation will look. Thus, by turning on Enable Breeze, you have access to the controls that set wind parameters. Conversely, if you do not turn on Enable Wind (On a Per Plant Basis), each plant element will move in unison because the wind affects the objects as one solid unit.

4. Turn off Show Example Wind on the right side of the screen beneath the animated thumbnail.

 I find this to actually be more of a hindrance when I want to really know what the plant animation will be.

5. Change the following settings:

 Intensity—18%

 Pulsation—0.35/s

 Uniformity—0%

 Turbulence—30%

 Amplitude—50%

 Frequency—1.00/s

 Intensify—50%

 Accelerate—40%

 Amplitude—25%

 Speed—3.27/s

 /s stands for per second. This tells you how a plant will react over the period of one second (:01;00).

6. Click OK.

7. Move the camera so it is level with the ground and perform a quick render.

 You will see the grass and weeds blowing in the wind, something that would have taken hours (if not days) to do if you were animating them on a per-plant or per-blade basis.

Animate Clouds to Add Reality

1. Choose the Clouds tab of the Atmosphere Wizard.

 The cloud animation controls are located in the lower-left corner of this window. The controls are very straight-forward—set the direction, the speed (velocity), and the rate of change.

2. With Lower Layer selected in the cloud list, change the direction by either clicking and dragging on the direction indicator's triangle (see Figure 15-34) or clicking in the numerics field and typing **18°**.

3. Set Velocity to .44.

 The movement of the clouds will be just strong enough to go with the wind effect.

 QUICKTIP

 If you want to animate all the cloud layers, you must set the animation for each cloud layer individually. Don't set them all the same; there would be differences between the cloud levels, causing differences in the rates of change and speed. You might also consider not animating a couple of layers as well.

4. Set Rate of Change to 1.02.

 This will make the clouds change their shape through the course of the animation.

5. Click OK to set the changes.

6. Perform a preview render. In order to see it better, go into the Preview Animations Options window and change to 30fps with a preview size of 4×. It will take a little longer to render the preview, but you will have a much better idea of how the wind animation looks.

 QUICKTIP

 A preview render animation of the scene with all cloud layers animated is located in the Chapter 15 folder for the book. It's titled windEffect.mov and was made with a preview render setting of Final.

 QUICKTIP

 You can save atmosphere effects by clicking on the floppy disk icon in the lower right of the Atmosphere Editor and saving your changes into the Atmosphere folder.

What you will notice is how the taller plants—the weeds and the tree—blow more heavily in the breeze, whereas the plants sitting lower to the ground don't blow as much. Each branch or stem moves independently. The clouds move across the sky fairly quickly, giving the sense you have a fairly strong breeze across this field.

Animating Clouds

To finish the basic animation features in Vue, you will now animate the clouds in your scene. Up to this point, you have made animation decisions for all the elements in your scene—the plane and the foliage. But the clouds, if rendered at this point, would remain static in the scene. Viewers would see this and any sense of reality will be gone.

FIGURE 15-34

Change the direction of the wind to 18 degrees.

INCORPORATE VENTILATORS
IN YOUR SCENES

What You'll Do

In this lesson, you learn how to use Ventilators to simulate specific wind effects.

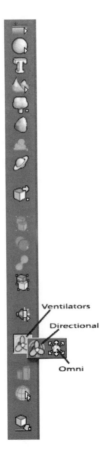

Ventilators are new to Vue 6. These are very powerful tools that will add even more realism to your scene. Ventilators are actually fans that control wind movement over and above the wind effects. In the last scene you made, you might have noticed that the tree and ground foliage didn't react as they actually would when the plane passed over them. Ventilators allow for specific wind effects to occur based upon their locations in the scene. Basically, they are glorified fans that churn up the atmosphere.

Learn to Use Ventilators

1. Add a Directional Ventilator to the scene.

 The Directional Ventilator is the default one, so just click on the Ventilator button.

2. Move the Ventilator so it is positioned directly under the nose of the airplane (see Figure 15-36).

Adding, Attaching, and Animating Ventilators

The Ventilator objects are located near the bottom of the objects bar on the left of the workspace. There are two types: Directional and Omni (see Figure 15-35). Directional Ventilators blow the air in a specific direction, whereas Omni Ventilators set the air in motion in a 360-degree area.

Select the BuzzingPlane animation you created earlier in the chapter. You will attach and set Directional Ventilators to make the plants react to the plane flying over them.

FIGURE 15-35
The two Ventilator types—Directional (on the left) and Omni (on the right).

FIGURE 15-36
The Directional Ventilator positioned under the airplane's nose.

FIGURE 15-37

Use the Link field in the Animation control window to link the Ventilator to the plane.

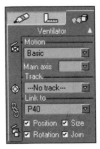

FIGURE 15-38

The Aspect window controls for the Ventilator.

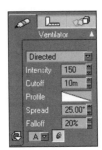

FIGURE 15-39

The position of the plane is important for the changes you will make.

3. Before anything else, link the Ventilator to the plane.

To do this, go to the Animation control window and, in the Link To field, select P40 from the list (see Figure 15-37). Now, no matter where you move the airplane, the Ventilator will move along with it.

4. Switch to the Aspect window (see Figure 15-38).

Here, you have the controls for how strong the Ventilator's effect will be, the affected distance, how wide it is, if it slowly dissipates from the center, and access to Vue's filters to change the way in which the Ventilator works. You will start off with a very strong Ventilator, and then you will modify the strength over time.

5. Change the Intensity setting to 150, Cutoff to 30, and Falloff to 0.

The wind generated will be almost hurricane level, the better to see the effect on the ground.

6. Use the scrubber to move the playhead to the point where the plane is immediately next to the tree (see Figure 15-39).

7. Make the following changes to the Ventilator:

 a. Rotate the Ventilator so it is pointing directly at the tree

 b. Intensity—75

 c. Cutoff—10m

 d. Spread—25.00º

 e. Falloff—20%

8. Move the scrubber until the plane is just past the tree (see Figure 15-40) and make the following changes:

 a. Rotate the Ventilator so it is pointing down at the ground again

 b. Intensity—150

 c. Falloff—0%

 Now the Ventilator is pointing at the ground, affecting the grass and weeds.

FIGURE 15-40
The relative position in which your plane should be to make more changes to the Ventilator.

9. Move the plane back to the point just before the plane reaches the tree (see Figure 15-41).

You don't want an abrupt change to the strength of the Ventilator. So in order to make a smoother transition, you need to modify some of the Ventilator's settings. To do this, the Ventilator should point at the tree, but its intensity, cutoff, and falloff should vary. The new settings should be as follows:

a. Rotate the Ventilator so it is pointing directly at the tree

b. Intensity—85

c. Cutoff—11

d. Falloff—10%

After performing a quick render, you will see the tree blowing in the breeze, and as the plane zooms by, the tree almost collapses from the back draft. Although much stronger than you would want it to be in a final render, you get the idea of how Ventilators can add that extra semblance of reality to your work.

QUICKTIP

The preview render for this section is located in the Chapter 15 folder on the website, under the name ventilator.mov. There are other videos based on the same animation with some variations in frame rate so you can see the differences. One was assigned 60fps, which makes a 30fps slow motion animation.

You can also attach Ventilators to each of the wings in order to get them to cause elements in the scene to react to the plane's passing. Each Ventilator would have to be controlled individually, with specific settings for each one. For instance, the center Ventilator—by the propeller—would create the greatest effect on the environment, whereas the wings would only cause a slight variation.

FIGURE 15-41
The plane just before it reaches the tree.

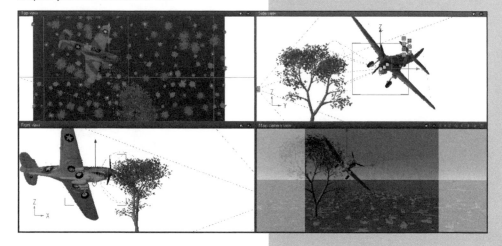

LINK AND
TRACK OBJECTS

In this lesson, you learn how to link and track objects.

You can combine linking and tracking to effectively make a more interesting video. Along with some extra effects afforded by the Animation Setup Wizard, you will use the asteroid scene you created way back at the beginning of the book and animate it.

Track Control

Link Control

Linking Asteroids to Each Other

In this section, you learn how to link all the other asteroids to the foremost asteroid in order to more easily create an asteroid field and make changes to it.

FIGURE 15-42

The rock object (in this case, Rock10) is selected as the object the camera will follow.

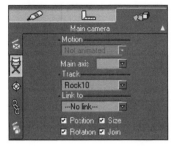

FIGURE 15-43

The position of the asteroids behind the foremost planet.

Link Asteriods

1. Open the asteroid scene you saved.

2. Select the Main Camera and, in the Animation control window, have it track the foremost asteroid by clicking on the Tracking pop-up menu and selecting the asteroid from the list (see Figure 15-42).

 QUICKTIP

 When you track an object with the camera, the camera view will change to center the object in the scene. You will need to rotate the camera so the asteroids are positioned in the scene as you originally had them.

3. Select all the rock objects by clicking on the Asteroid layer in the Layers window.

4. Move the rock objects so they are hidden behind the foremost planet (see Figure 15-43).

 You will need to once again rotate the camera (go ahead, it's great practice!) so the two planets are in the center of the Main Camera View window.

5. Select the foreground rock object (making sure all the other asteroids are deselected) and go to the Animation Setup Wizard.

6. Set Type of Motion to Smooth Velocity.

These asteroids have been traveling through space for some time now; they do not need to speed up and/or slow down during this animation.

7. In the Advanced Effects screen, turn on Spin and set the Revolution Axis to Y Axis (see Figure 15-44).

8. In the Object Path screen, create a path that is similar to that in Figure 15-45.

9. Link the other asteroids to the foremost asteroid.

Do this by selecting the asteroid and then, in the Link To field, select the parent asteroid it will follow.

10. For each asteroid, go back to the Animation Setup Wizard. Ignore every screen except for the Advanced Effects screen, and set a rotation for each of them. Make sure to set the rotation axis differently for each asteroid so they don't all rotate in the same manner.

QUICKTIP

To easily go to the Animation Setup Wizard after an animation has been set, right-click on the Show Timeline/Animation Wizard button.

11. Scrub through the animation to see how the asteroids follow the foreground asteroid and how the camera tracks that asteroid's movement.

12. Tweak the Main Camera's position at various points throughout the animation in order to keep the scene framed as you want.

Perform a quick render to see how your animation turned out. I suggest changing the frame rate to 60 or 90 to create a nice, slow-moving asteroid field. There are some modifications you need to make, such as to the lights, which add a strange glow as the asteroids move past the planets—but, hey!, this is science fiction; you can come up with an explanation for why that is there.

QUICKTIP

The animation has been saved and is available for download under the title asteroidField.mov.

If you want to make changes to the path of the asteroids, all you need to do is select the foremost rock object and change its trajectory. The other asteroids and the camera will follow. It's as simple as that.

FIGURE 15-44

The rotation of the asteroid is set to the Y axis.

FIGURE 15-45

The motion path for the foremost asteroid. The other asteroids will follow along because they are going to be linked to this one.

CHAPTER SUMMARY

Congratulations. You are now, officially, well on your way to creating stunning scenes and animations in Vue 6.

In this chapter, you learned how to animate objects, make modifications to them using the Animation Setup Wizard and the Timeline, link and track objects within a scene, and incorporate wind effects and Ventilators so you can create complex animations more efficiently. Now all that is left is for you to practice and hone your skills.

There is much more to discover in Vue than what can fit into this book. I have also included a free chapter you can download by going to this book's website at www.courseptr.com/downloads. This chapter deals with the Function Editor, giving you a starting point to create more advanced textures and effects within Vue.

Take some time to play with the controls and join some of the online boards at sites like cornucopia3d.com, runtimedna.com, and renderosity.com; there are hundreds upon hundreds of new, intermediate, and expert users willing to help you achieve some great things with Vue 6.

What You Have Learned

In this chapter you

- Worked with the Animation Setup Wizard
- Modified animations using keyframes and splines
- Added wind effects
- Animated clouds
- Used Ventilators
- Learned how to link and track objects

Key Terms from This Chapter

Animation Setup Wizard A set of pre-defined animation settings that allow users to quickly animate an object in their scenes.

Ease-in In an animation, ease-in controls the speed at which an object will begin its movement.

Ease-out In an animation, ease-out controls the speed at which an object will end its movement.

Keyframe The starting and ending points for a specific motion within an animation. Most animated objects will have multiple keyframes assigned to them in order to create realistic movement.

Motion path An invisible line the object follows when traveling from one spot to another.

Non-Linear Editing (NLE) The method used for editing video on a computer. Instead of laying down video and/or audio in a linear fashion—start to finish—you can place the video and/or audio in any location in time and move back and forth to complete your project without regard to where in the Timeline you're editing.

Rigger (Also rigging, rig) A rigger is a person who specializes in "rigging" a model—adding bone structures to the model in order to make it move correctly.

Scrubbing The act of moving the play-head along the Timeline in order to view the animation or to move to a point in the animation where you add keyframes or make changes.

Spline This term comes from its drafting counterpart, where flexible strips (or paths) are controlled by points on paper. These are mathematical equations that define a curve from point A to point B, modifiable by control handles or repositioning of the points along the path.

Ventilators Virtual fans that can be added to an object in a scene to make specific wind effects.

GLOSSARY

Aberration An optics-based anomaly that is created due to the way light passes into the lens. In many cases, aberrations can be as simple as a slight curvature of the horizon line or as heavy as a box appearing almost round. Rotation and repositioning of objects can sometimes correct this problem. Aberrations can also appear as color shifts (chromatics).

Alpha map A black-and-white image that tells the program to create transparencies. Although most 3D applications use white to retain opacity, Vue uses black. So white areas of an alpha map become transparent, and black areas' visual information is retained.

Alpha plane A primitive object that supports transparencies (alpha maps). Alpha planes are located in the Primitives area of the program.

Alpha A channel added to an image that allows for quick selection of an image element in a photo-manipulation program like Photoshop or transparencies in 3D and video editing applications.

Animation Setup Wizard A set of predefined animation settings that allow users to quickly animate an object in their scenes.

Anisotropic A highlighting method whereby the light literally creates a ring around the point where the light hits. Good for glass highlights.

Aspect ratio The width/height measurements for the image, determining how the image will render and be used. The aspect ratio is defined as width divided by its height (usually expressed as $x:y$). For instance, the aspect ratio of a traditional television screen is 4:3 or 1.33:1. High-definition television uses an aspect ratio of 16:9, or approximately 1.78:1. For cinematography, an aspect ratio of 2.39:1 or 1.85:1 is used, whereas 35mm film uses 1.37:1 (or the Academy Aperture ratio).

Atmosphere The representation of the atmospheric conditions of a scene, including clouds, sun/sun position, and fog or haze within the scene.

Backlight The process of lighting a subject from the back rather than the front.

Bit In the case of images, a bit is the smallest unit of visual information in a pixel. Each bit is made up of one shade of gray out of a maximum 256 shades of gray. Most photographic images are 8-bit, meaning each pixel is broken into eight segments, each segment having a value of

0 (pure black) to 255 (pure white) assigned to it. In a 32-bit HDRI image, each pixel is comprised of 32 segments, each with a shade of gray assigned to it.

Bitmap An image created in a photo manipulation or paint program that is made up of pixels and mapped to an object.

Boolean, Boolean operations An effect in 3D applications that allows the user to combine two or more objects, making them interact by combining them in such a way as to create more complex shapes.

Bump map A grayscale image that gives the visual representation of bumpiness in a texture without actually modifying the shape of the mesh. Can be created in a paint or photo manipulation program.

Cartesian Coordinates The way in which height, width, and depth are measured in 3D space.

Caustics Calculates photons of light starting at a light source (like real light), which can then be reflected, refracted, bounced off mirrors, or concentrated by a lens, accurately simulating more of the ways real light can move through a scene.

Cinemascope A widescreen format used by the motion picture industry from 1953 to 1967, allowing for a 2.66:1 aspect ratio that produced an image twice as wide as the conventional 1.33:1 ratio.

Clipping If an object gets too close or too far away from the camera or goes below a certain point in the scene (such as below the ground plane), the program will not draw out the polygons in that portion of the object.

Cloud plane An infinite plane that adds cloud layers into your scene.

Collections A group of objects, scenes, plants, and so on that are grouped into specific categories for easy inclusion in your scenes.

Composite/Compositing Compositing is the art of creating complex images (either still or video) by combining different sources. It is used extensively in movies to achieve effects that would otherwise be impossible.

Digital Elevation Maps (DEMs) Grayscale images created by the US Geological Department that show height information for real-world locations around the globe.

Dispersion The effect of light as it passes through materials.

Displacement map A grayscale image that actually affects the shape of the mesh to show true bumpiness and texture. Can be created in a paint or photo manipulation program.

Ease-in In an animation, ease-in controls the speed at which an object will begin its movement.

Ease-out In an animation, ease-out controls the speed at which an object will end its movement.

EcoPaint A Vue 6-specific tool that allows you to *paint* an Ecosystem onto any surface in your scene.

Ecosystem A Vue 5 Infinite- and Vue 6-specific feature that allows users to select plants, rocks, and objects and, with the click of a button, populate a scene. In all other 3D applications, you have to place the rocks, trees, or objects individually.

Extension The three letter code following the dot at the end of a file name that describes what type of file it is (such as .doc, .jpg, .tif, or .pdf).

Eyelight A light that highlights the eyes of a subject, removing any errant shadows that might occur from the other lights in the set. Usually, these lights are mounted above the camera.

Field of View (FoV) The field of view of a lens (sometimes called the angle of coverage or angle of view) is defined as the angle (in object space) over which objects are recorded on the film or sensor in a camera. It depends on two factors: the focal length of the lens and the physical size of the film or sensor.

Fill light Used to reduce the contrast of a scene and to provide illumination for the areas of the image that are in shadow.

Focal length Very simply, it is the distance from the lens to the film, when focused on a subject at infinity. In other words, focal length equals image distance for a far subject. To focus on something closer than infinity, the lens is moved farther away from the film. This is why most lenses get longer when you turn the focusing ring.

Fractal mesh Mathematically calculated series of lines and shapes that, when combined, can create highly complex and resolution-specific 3D elements.

Gel A thin, transparent sheet that is placed in front of a light to add color or texture to the lighting.

Geometry Another term for the mesh that defines the shape of an object.

Gizmos The Move, Rotation, and Scale control buttons that appear in the viewports when an object is selected.

Godray E-on Software's term for streaks of light shining through the clouds.

Graphic User Interface (GUI) Describes the look of an operating system's screen display and a software application's graphic design.

Ground plane An infinite plane that adds a ground surface to your scene. By default, a ground plane is added to your scene when you open Vue or create a new scene.

HDRI (High Dynamic Range Imaging) The intention of HDRI is to accurately represent the wide range of intensity levels found in real scenes, ranging from direct sunlight to the deepest shadows.

HSL Stands for Hue, Luminosity, Saturation. Another system for determining displayed colors in an image. Also known as HSB, with B standing for Brightness.

Infinite plane A flat surface that has no beginning or end point. It will extend to infinity in your scenes.

Instance One appearance of a particular object. For example, if you have five palm trees in your scene, each individual palm tree is considered an instance of that plant.

Isotropic A highlighting method whereby the light spreads evenly from the point where the light hits the object's surface until it fades out.

Keyframe The starting and ending points for a specific motion within an animation. Most animated objects will have multiple keyframes assigned to them in order to create realistic movement.

Keylight The brightest light in a scene that casts the main shadows in an image.

Keypoint An indicator of a change in either a profile or the Timeline of an animation.

Light panel An object that has been turned into a light source. Light panels are created by right-clicking on an object and selecting Convert to Area Light. This feature is available in Vue 6 only.

Mesh density Describes the resolution, or quality, of the object's mesh. The higher the mesh density, the more detailed and smooth the object will render out. But the higher the mesh density, the more system resources are used in creating your scene.

Metablobs An effect in some 3D applications that combines two or more shapes into interactive forms that create more complex organic shapes. Metablobs can be likened to Mercury in that, when two forms move closer to each other, they attract in a fluid manner to combine into one object. This feature is used to create what are called organic shapes—elements that are more rounded and supple. All objects assigned as metablobs will be rounded, losing any sharp edges.

Metacloud A volumetric cloud object that can be modified in many different ways. Metaclouds are only accessible using Spectral Atmospheres.

Motion path An invisible line the object follows when traveling from one spot to another.

Node A processing location. Each node is linked together visually by interconnecting lines showing a tree-like representation of the elements making up a texture.

Nondestructive When two or more objects interact with each other during Boolean or metablob operations and do not make a permanent change to the mesh(es).

Non-Linear Editing (NLE) The method used for editing video on a computer. Instead of laying down video and/or audio in a linear fashion—start to finish—you can place the video and/or audio in any location in time and move back and forth to complete your project without regard to where in the Timeline you're editing.

Numerics control panel A series of controls that modify the selected item through the use of numbers rather than randomly stretching and distorting them. This is a much more exact method for object placement, size, and orientation in a scene.

OpenGL The hardware and software feature that allows your computer and the program to display textured and shaded 3D information.

Organic shapes (Organic) Shapes that have more fluid angles. Angles are rounded rather than sharp. In 3D, organic shapes include humanoid and animal figures, water, and other shapes that do not have sharp edges.

Parametric Texturing procedure that maps coordinates so the 2D image will fit onto a surface.

Pitch Rotation around the side-to-side axis. Remember back to when you were a little child, holding your arms out from your side, and spinning around in a circle. You were changing your pitch.

Pivot point The point from which an object is rotated.

Polygon count/resolution The number of polygons that create a shape/element in your scene. The higher the number of polygons, the higher the resolution and the smoother a surface will be.

Polygons Three- or four-sided shapes that, combined, make up the mesh that describes the shape of an object. Each 3D object is made up of polygons. The number of polygons in a mesh describes how detailed, or high quality, an object is. For instance, with fewer polygons, a globe shape could would have sharper corners along the edge, whereas more polygons would make the curve look smoother.

Populate The act of adding elements to your scene in order to create your final image.

Primitives Pre-defined shapes such as blocks, spheres, or cylinders used to create objects in your scenes.

Profile Just like a photograph of your profile, this shows the height or the height variations as if viewed from the side.

Projection mapping Adds a texture to an object that does not move with the object. It is as if the image were being projected onto a screen; when you move the screen, the image stays in place, ultimately repositioning the image on the object.

Quick render A preview render of low quality that allows you to see a detailed representation of your image. Also used to generate a preview image in your Scene Selector window.

Ray tracing Traces rays of light as they would flow from the eye back to an object. These "rays of light" are then tested against all objects in the scene to determine how colors will appear in the scene. Ray tracing allows for soft shadows and reflections in your scene.

RenderBull Vue 6 only. RenderBull is a network render software package that allows users to assign the rendering process to other computers linked together in a network.

RenderCow A program included with the Vue software that allows users to render an image in the background. It stores the image information and renders the scene or animation outside of the program so you can build other scenes while the render is taking place.

RGB Stands for Red, Green, Blue, the three color channels that make up basic photographs and illustrations. The three channels combine to produce up to 16.7 million colors.

Rigger (Also rigging, rig) A rigger is a person who specializes in "rigging" a model—adding bone structures to the model in order to make it move correctly.

RLA Stands for Run Length Encoded A. Previously used with SGI computers, this format is popular because of its support of the inclusion of arbitrary image channels in either 8- or 16-bit mode.

Roll Rotation around the front to back axis. As a piece of meat on a spit spins over the flame, that would be roll.

RPF Stands for Rich Pixel Format. This format has additional arbitrary image channel information, and is a 3DS Max format. Because of the additional information that can be stored, it has pretty much replaced RLA for higher end post production and effects work.

Scrubbing The act of moving the playhead along the Timeline in order to view the animation or to move to a point in the animation where you add keyframes or make changes.

Solid Growth™ technology Solid Growth technology is used to generate fresh, original plant meshes each time a species is added to a scene, ensuring that no two plant species ever look the same. This is trademarked by E-on Software and is not found in any other program.

Spectral Analysis/Atmosphere
The method in which 3D programs display real-world style effects within the atmosphere. This includes light refraction and reflection in dust and moisture within the air.

Spline This term comes from its drafting counterpart, where flexible strips (or paths) are controlled by points on paper. These are mathematical equations that define a curve from point A to point B, modifiable by control handles or repositioning of the points along the path. Also, a control, represented by a line, that either defines a shape that will be turned into a 3D object or graphically shows movement or change between a starting and ending point of an animation.

Submenu A list of options that appears when you right-click on an object or control window.

Subsurface scattering (SSS) Light penetrates the surface of a translucent object, is scattered by interacting with the material, and exits the surface at a different point. The light will generally penetrate the surface and be reflected a number of times at irregular angles inside the material before passing back out of the material at an angle other than the angle it would reflect at had it reflected directly off the surface.

Tiling When a background on a web page or in a 3D application is infinite, images will not stretch out to fit the area. Rather, they repeat over and over again; a process called tiling.

Tilting/Panning The act of moving the camera head up or down (tilting) or left to right (panning).

Toggle switch A small triangle to the left of a group's name in the Layers window that, when clicked on, expands the list so you can see the individual elements that are combined or contracts the list to hide those elements.

Translucency The effect of light traveling into a surface, lighting a surface from the inside (see Subsurface scattering).

UV coordinates System used for placement of image maps on a 3D object. U defines the horizontal position, whereas V defines the vertical position of the image.

UV mapping Actually assigns the texture to an object, so that when the object is moved or rotated, the image moves and/or rotates with the object. U represents the X (horizontal) coordinate of the image, and V represents the Y (vertical) coordinate.

Ventilators Virtual fans that can be added to an object in a scene to make specific wind effects.

Viewports/Windows The windows in which your scene is displayed and where you can make modifications to the positions and layout of your elements.

Volumetrics Simulates the interactions of light and air as light travels through the atmosphere. Can also apply to textures, where the light interacts with the material elements to create realistic light interaction.

.vue extension An extension that describes the file type when opening that file. This particular one represents a file created with the Vue program.

Wacom tablet A pressure-sensitive drawing tablet made by the Wacom company that allows you to use a pen-shaped mouse to *paint* on your images or 3D objects.

Water plane An infinite plane that represents water in your scene. This can be used to create lakes, rivers, or oceans.

Wireframe A surface that defines the shape and quality of a 3D object. The number of polygons making up a mesh determines its resolution (quality).

Yaw Rotation around the vertical axis. A gymnast doing a series of back flips would be changing his/her yaw.

INDEX

V

variable reflection, 265–266
vegetation and Solid Growth technology
 discussed, 136
 Drop/Smart command, 147–151
 Plant Editor feature
 discussed, 155
 Export Plant option, 158
 Leaves/Petals option, 158
 New Plant/Save Plant option, 157
 plant species, 157
 Render Options option, 156
 Render Preview option, 156
 Response to Wind option, 157
 Simplify/Refine Plant option, 158
 Trunk/Branches option, 158
 zoom options, 158
 plants
 adding to scene, 143–146
 alien, 144, 163–164
 categories, 162
 collections, 144
 color options, 159
 edited, 144
 generic, 144
 leave/petals, 160–161
 placement considerations, 142
 positioning, 146
 selection, 146
 terrain objects, 152–153
 trunk and tree branches, 160
 water effects, 154
 wind options, 157
 Solid Growth technology, 145
 tools needed, 141
 trees, real-world, 156–162
ventilator objects, 447–451
Ventilators button, 26

View Background Options button group (Display Options preferences), 41
View Display Options button, 10
View Options button group (Display Options preferences), 39–40
view settings lighting control, 365
view through lighting control, 365
viewports
 activating, 12, 15
 defined, 43
 display options, 10, 13
 expanding, 12
 Front
 discussed, 8
 representation, 9
 full screen, 12
 Main view
 buttons in, 10–11
 discussed, 8
 representation, 9
 View Display button, 10
 objects in
 moving, 17–18
 rotating, 17–18
 scaling, 16
 selecting, 17
 returning to quad view, 12
 Side
 discussed, 8
 representation, 9
 size, changing, 12
 Top
 discussed, 8
 ground plane, 9
 representation, 9
 windows, resizing, 13
visible layers, 68
volumetric material, 238
Volumetric model (Atmosphere Editor), 172, 197–199

volumetrics, lighting controls, 365, 368
.vue file extension, 59
Vue program
 flexibility of, 4–5
 overview, 4

W

wacom tablet, 311
water effects, vegetation and Solid Growth technology, 154
Water plane, 52, 73
wind options
 animation, 444–446
 vegetation and Solid Growth technology, 157
 ventilator objects, 447–451
 wind control, 445
wireframes, 73, 230
workspace
 main environment, 8–11
 View Display Options button, 10
 viewports
 discussed, 8
 display options, 10
 representation, 9
World Coordinate System button (General Preferences), 35
World panels
 Aspect/Numerics/Animiation panel
 overview, 28
 Main Camera panel, 29
 Materials area, 29
 Objects/Materials/Library/Links window, 30
 windows in, 27
World Standard setting (Basic Material Editor), 224

X

XYZ coordinates, Numerics panel, 345

Y

Yaw option (Numerics panel), 347
Yellow Alto Stratus material, 189
Y=>X option (Numerics panel), 348
Y=>Z option (Numerics panel), 347

Z

zoom controls
Plant Editor feature, 158
terrain, 84
tools, 66
Zoom Into View button, 22
Zoom Out of View button, 22
Z=>X option (Numerics panel), 348